# PHOTOGRAPHING
## AMERICA'S FIRST ASTRONAUTS

# Purdue Studies in Aeronautics and Astronautics

**SERIES EDITOR**  James R. Hansen, Emeritus, Auburn University

Purdue Studies in Aeronautics and Astronautics builds on Purdue's leadership in aeronautic and astronautic engineering, as well as the historic accomplishments of many of its luminary alumni. Including scholarly works and memoirs, books in the series will explore cutting-edge topics in aeronautics and astronautics enterprises, tell unique stories from the history of flight and space travel, and contemplate the future of human space exploration and colonization.

## RECENT BOOKS IN THIS SERIES

*The Sky Above: An Astronaut's Memoir of Adventure, Persistence, and Faith*
John H. Casper

*In Their Own Words: Forgotten Women Pilots of Early Aviation*
Fred Erisman

*British Imperial Air Power: The Royal Air Forces and the Defense of Australia and New Zealand Between the World Wars*
Alex M. Spencer

*Through Astronaut Eyes: Photographing Early Human Spaceflight*
Jennifer K. Levasseur

*A Reluctant Icon: Letters to Neil Armstrong*
James R. Hansen (Ed.)

*John Houbolt: The Unsung Hero of the Apollo Moon Landings*
William F. Causey

*Dear Neil Armstrong: Letters to the First Man from All Mankind*
James R. Hansen (Ed.)

*Piercing the Horizon: The Story of Visionary NASA Chief Tom Paine*
Sunny Tsiao

*Calculated Risk: The Supersonic Life and Times of Gus Grissom*
George Leopold

*Spacewalker: My Journey in Space and Faith as NASA's Record-Setting Frequent Flyer*
Jerry L. Ross with John Norberg

# PHOTOGRAPHING
## AMERICA'S FIRST ASTRONAUTS

*Project Mercury Through the Lens of Bill Taub*

**J. L. Pickering and John Bisney**

Foreword by Eugene Kranz

**Purdue University Press**

West Lafayette, Indiana

Printed in the United States of America.

Cataloging-in-Publication Data is available from the Library of Congress.

978-1-61249-856-0 (hardback)
978-1-61249-857-7 (epdf)

Cover image: Portrait of Gordon Cooper by Bill Taub, NASA photographer

# CONTENTS

# Foreword

Bill Taub's photography provides a powerful reminder of America's first manned space program. Each of the photos brings me (and will bring others) back to the beginning of Project Mercury. Writing this foreword, I found myself reliving the pioneering years when NASA began to fulfill President John F. Kennedy's mandate to wrest away Russia's leadership in space. Taub's photos remind me of "our time," the convergence of the destinies of a small group of aviators, engineers, and the seven test pilots selected to travel beyond the earth's atmosphere as astronauts.

President Kennedy's 1961 inaugural address provided a message of freedom, responsibility, and challenge: "The torch has been passed to a new generation of Americans—born in this century, tempered by war, disciplined by a hard and bitter peace, proud of our ancient heritage—and unwilling to witness or permit the slow undoing of those human rights to which this nation has always been committed, and to which we are committed today at home and around the world." The president concluded with, "My fellow Americans, ask not what your country can do for you, ask what you can do for your country."

These words were included to establish the context for America's early work in space. The Soviet Union and the United States, the two world superpowers engaged in a Cold War on Earth, were also competing for mastery of space. The Soviets had captured the high ground with the first artificial satellite, *Sputnik*, in October 1957, and by putting the first man into space, Yuri Gagarin, in April 1961.

Three weeks after Alan Shepard became America's first astronaut, President Kennedy issued an audacious challenge to NASA and the world: "I believe that this nation should commit itself to achieving the goal, before the decade is out, of landing a man on the moon and returning him safely to Earth."

With these words, "our time" became one of challenge, triumph, and tragedy, and we needed heroes. Bernard Malamud, author of the baseball novel *The Natural*, said, "Without heroes, we are all plain people and don't know how far we can go." At the time, America's heroes were Ted Williams, Willie Mays, Mickey Mantle, and Hank Aaron, who were pursuing Babe Ruth's 500 home run record. This quickly changed as America's sports heroes were overshadowed by silver-suited astronauts with the "right stuff."

Their exploits appeared in newspapers and magazines and on black-and-white TVs. The astronauts were space test pilots, launched atop modified Redstone and Atlas rockets first developed for the military. Weightless, they flew in a vacuum around the Earth at 5 miles per second in an environment of radiation and extreme temperatures in a spacecraft with a working space comparable to the driver's seat of a Volkswagen Beetle, but were so cool that they drove Chevrolet Corvettes provided by a lease from General Motors for one dollar a year.

Even the word *space* had a magic, extraordinary attraction. It had a resonance, a newness, a job that offered challenges. When I decided to enter work in space, I could only imagine that, whatever happened, I would be there when it all began. Before coming to NASA, I had served as a fighter pilot during the Korean War; and as a flight test engineer for the B-52, I developed the systems that would protect that aircraft when

entering Soviet airspace. Completing the test program in 1960, I joined NASA as a member of the original Space Task Group in Langley, Virginia. Flight test was the common fabric of the STG, led by Walt Williams, Robert Gilruth, Chris Kraft, and Sigurd Sjoberg, who had been project engineer for the first aircraft to reach Mach 2.

The first day I walked into the Mercury Control Center (MCC) at Cape Canaveral, I knew space operations would be the focus of my career. The large world map with the tracking stations marked and the small model showing the spacecraft's location demonstrated the global scope of circling the Earth every ninety minutes. The room, with brand-new consoles, conveyed the vision of the effort to come.

Mercury provided the essential training ground, our boot camp. We had routinely exceeded the speed of sound in atmospheric flight, but the physics changes for objects to remain in orbit. Computers and communications were in their infancy, and digital systems were yet to come. We relied on undersea cables and voice relayed by radio. Teletypes provided communications with tracking stations. "High-speed" tracking data, when available by cable, was at a sluggish 2 kilobits per second.

I did not know that the chattering teletype machines would become a critical asset for my communications to the teams at land-based sites spanning the globe and ships in the Atlantic, Indian, and Pacific oceans. During launches, for example, I dictated mission events to a teletype operator, who would transmit messages to another operator in Bermuda, who would then voice my message to the Bermuda flight controller.

The Mercury control team and those at the tracking stations were all rookies borrowed for the mission from the engineering staff. There were no manuals, so we had to write them. In flight test, there was always an option in case of trouble (find a landing site or bail out), but this option did not exist in space; and without an onboard computer, the astronauts depended on us to even confirm they were in orbit. Subsequent stations would advise they were GO for more orbits.

We developed rules to provide our best judgment for mission termination in case of emergency. Search and rescue capabilities were supported by Navy ships in the contingency landing areas.

The astronauts served as spacecraft communicators, and their training was in a rudimentary simulator in the same building. The simulation and pad test debriefings, mission rules, and flight planning were conducted in the MCC, or at the Cocoa Beach barbecue restaurant Fat Boy's, or after hours at the Holiday Inn.

Taub's photos establish the close, intimate, and informal relationship among the astronauts, their family members, and support personnel, providing a perspective of the joyful informality that existed within the Mercury team. We put six astronauts in space, and with more than our share of luck, returned all safely. These photos provide a window to the early space generation and the individuals who provided the spark to ignite American manned spaceflight. The book is a visual journey to what was once, but will never be again.

Project Mercury was the foundation for all future work in space. The unmanned and manned missions provided the awareness that "good enough" was inadequate in the arena of manned spaceflight. Achievement through Excellence became the standard, as highly skilled engineers with hands-on experience as an integrated team under the direction of a flight director were trained to take the actions necessary for crew safety and mission success. It was critical to achieving President Kennedy's goal and the rest of the Apollo program.

The history of spaceflight is replete with the stories of those who were willing to take the risk and find out how far they could go. I was one of those fortunate to walk among the early space pioneers.

**Eugene F. Kranz**
Houston, Texas

# Introduction

Project Mercury holds a special place in the pantheon of space exploration. Not only did it successfully send the first four Americans into orbit to keep pace with the Soviet Union during a worrisome 1960s Space Race between nuclear superpowers, it was also a remarkable engineering achievement on its own.

Locked in an uneasy Cold War with the USSR, the American public had not been focused on space until the launch of the Soviets' *Sputnik* in October 1957. A US Army team matched the feat four months later, but in April 1961, the USSR scored another alarming first with the one-orbit flight of cosmonaut Yuri Gagarin.

President Dwight D. Eisenhower had decided that manned flights (and most US space efforts) should be conducted by a new civilian government agency, the National Aeronautics and Space Administration (NASA), which began operations on October 1, 1958. Just a week later, the US program to send men into space was approved, and two months later, it was named Project Mercury.

Started from scratch in many areas and operating in a pre-digital world using slide rules, typewriters, and telephone calls, Mercury was largely based on analog technology, so, in retrospect, its rapid planning, testing, and successful execution were stunning. Although some studies had begun several years earlier, virtually nothing was known about human spaceflight, and the undertaking would require, among other things, a new spacecraft, a new control center, new pressure suits, new ocean recovery procedures, and a new worldwide tracking network.

Mercury's approach to safety and reliability was key. It was based on two principles: first, no single failure shall cause an abort; and second, no single failure during an abort will result in the loss of life of the crew. The program proved an astronaut could be launched into Earth orbit, function there as a combination pilot–observer–experimenter for at least thirty-four hours, survive the intense heat of atmospheric reentry, and be safely recovered.

Just six weeks after America's first astronaut, Alan Shepard, made his fifteen-minute suborbital hop in May 1961, President John F. Kennedy set a manned moon landing as a national goal. Mercury suddenly represented the country's—and in some minds, the free world's—crucial starting point.

The program was conducted over more than four and a half years and involved two million people from government and aerospace contractors at a cost of $400.6 million. It comprised twenty-five flights using fifteen spacecraft, but our focus in this book is on the six missions that were manned. We do so thanks to the images taken by NASA's first photographer, Bill Taub, few of which have ever been published, as J. L. details.

Researching and writing the text was, as always, an education in some of the fine points of hardware and procedures. We also, as in our previous books, identify as many people as possible. Two editorial notes: we use Eastern Standard Time year-round because Florida had not yet adopted Daylight Saving Time. We use the term "manned" in no pejorative sense, but rather as the adjective was used historically (and accurately for US flights until Sally Ride's space shuttle mission twenty years later).

My earliest memories of Project Mercury are watching launches on TV in elementary school sitting on the gym floor with classmates, and how much my mother admired John Glenn. I was fortunate to eventually meet

each of the seven except for Gus Grissom. As a news correspondent, I covered Deke Slayton in his role managing the space shuttle test flights and Glenn during his years in the US Senate and his shuttle flight.

Mercury today may seem like distant history, reflected by an era of magazine covers, newspaper clippings, and black-and-white newsreels, but from 1959 to 1963 it captured the imagination, pride, and hope of the American people. Somewhat forgotten today is the fame the astronauts achieved as national heroes.

But it was the many men and women on the ground who made it possible that six of their countrymen could first pioneer the new frontier of space. We had the honor to meet many of them. As NASA engineer Don Phillips put it, "I would have to say that nothing was more exciting than work on the Mercury program because we were doing things for the first time. It was all new."

More than sixty years later, we hope this volume visually conveys the excitement, newness, and achievements of this remarkable national effort.

**John Bisney**
Seminole, Florida

# About the Photography

This book had its beginnings, curiously enough, just after my coauthor, John Bisney, and I had seen *Apollo 11*, the theatrical release with newly discovered "lost" 70 mm footage in March 2019 for the flight's fiftieth anniversary. When we got back to the car, I checked my phone messages and found a voicemail from someone named Ron Specht. He identified himself as the son-in-law of NASA photographer William "Bill" Taub, the space agency's first photographer. Bill's work was iconic, and John and I had once visited him at his home near Washington, DC, in 2008.

Bill had recently passed away, and Ron and his wife, Myra (Bill's daughter), had discovered some letters I had exchanged with Bill in the 1990s. My radar was immediately on high alert, and I listened to the message a second time to make sure I was hearing everything correctly. Ron was telling me that he had "a roomful" of photos, negatives, slides, and related material that were part of Bill's estate, and he wanted to know if I would be interested in taking a look. *Yes, I would be!*

After a number of phone conversations, Ron and Myra invited me to their home in Bowie, Maryland, two months later, and I finally got a look at what Bill had been holding on to for so many years. After archiving NASA imagery for more than fifty years, I am not easily impressed with individual photo collections, but I was happily overwhelmed with what they showed me.

It was clear that Ron and Myra had a genuine desire to get this massive collection scanned and organized, and to also discuss how to share it with the world. Over four days, Ron and I combed through every aspect of the collection, and I soon knew it could easily generate a book or two.

It was a sizable task to first just get everything organized. Then during the next eight months, I made high-resolution scans of an estimated 3,000-plus 35 mm negatives, 2,000-plus 35 mm color slides, 500-plus 4 × 5 negatives, 150-plus 4 × 5 transparencies, and hundreds of prints of varying sizes. I was exposed to more "new" images of Project Mercury during this effort than I had seen in my half century of archiving.

While most of the material had been stored well, many negative strips were in individual envelopes or 35 mm film canisters. These scans required significant cleaning and repair work. This is where I decided to bring my friend and photo collaborator from the Netherlands, Ed Hengeveld, into the mix. Ed and I have been working hand-in-hand with NASA-related photography for many years, and the dating and restoration of this collection would not have happened without his expert assistance.

During 2020, Ron and I decided to move forward with a book. Bill's archives had an abundance of images from the Mercury era, and enough from the Gemini and Apollo programs to include as well. But I kept coming back to the fact that there were so many unique Mercury photos that a book on that program alone would be a true historical treasure. Indeed, it did not take long to find a publisher. My next step was to bring in John as the writer. He knew I was working on organizing this large collection, but we had not had any formal discussions about a book. Ron agreed that we needed John and his top-notch research skills to make this happen.

Now some comments about the images and chapters. As mentioned, the collection was quite unorganized, with no dates or captions for the negatives, and glossy NASA prints released at the time often used release dates instead of actual event dates. This meant Ed and I had to do some extensive detective work. Mercury was an exceptional challenge because it was tricky to determine whether photos were taken on launch day, or a scrubbed launch attempt. A similar situation was determining whether an image showed an astronaut training for his flight, or as a backup to another astronaut. Even so, we feel confident with the results.

The images in this book come almost entirely from the Taub collection. Although the great majority were taken by Bill, a number of others were taken by fellow photographers working with him. Among them was *National Geographic*'s Dean Conger, on loan to NASA. As senior NASA photographer, all Mercury photography operations went through his office.

Chapter 1 opens with the extensive medical tests the astronaut candidates endured and provides an overview of a wide variety of their activities once chosen. It also showcases many images that could not be directly tied to a specific Mercury mission. My favorites are of the inquisitive astronauts' first trip to Cape Canaveral and the great views of the crew quarters at Hangar S.

Mercury was a success because of the unique blend of talented and dedicated NASA and military personnel, and chapter 2 sets the stage for the missions by introducing many who worked in the shadow of the astronauts, supporting them from training through launch and recovery. We selected unpublished images of NASA and contractor managers, medical staff, and the hardworking technicians at the Cape. Special thanks to Ben Powers for providing the photo of his father, John "Shorty" Powers, with the seven astronauts in their iconic fighter jet group photo.

The hardest part of putting together the Alan Shepard chapter was trying to decide what not to include from the abundance of available images. We could have easily put together an entire book just on Shepard and his *Freedom 7* mission. Special thanks go to his daughter Julie Shepard for helping with some detective work.

I had always seen the same forty or so images of Gus Grissom during training and suiting up for launch attempts. The Taub collection provided more images of Grissom and *Liberty Bell 7* than I had ever imagined existed. Suddenly there were now four hundred–plus images. Grissom appears quite relaxed, an example of how comfortable the astronauts felt around Bill. When wondering why so relatively few Grissom images were released back 1961, Ed and I would often joke that Bill must have hidden them at home under his bed.

Of the Mercury astronauts, Bill was probably closest to John Glenn. This was another chapter where it was difficult to determine what images to exclude. The result is what might be my favorite chapter. Glenn was a perfect photo subject, and his *Friendship 7* mission provided the perfect narrative. Special thanks to daughter Lyn Glenn for providing added caption information.

Grounded by a medical issue, Deke Slayton did not have the opportunity to fly his planned Mercury mission. It was scheduled after Glenn's, however, so this is where we put his chapter. I did not have an abundance of material, but what was available worked well here. My favorites are the images of Slayton suited up during training; with his mission canceled, NASA did not release many of these at the time.

Scott Carpenter and *Aurora 7* was another chapter where we could put together an entire book on the mission alone with the wealth of images. My favorite section is postflight, when Bill captured the Carpenter family traveling to Washington, DC, to meet with President Kennedy. Special thanks to Kris Carpenter Stoever for some identification help.

Putting together Wally Schirra's chapter was somewhat of a challenge because we had less material to work with. However, we did have an amazing number of portraits to choose from, and we also include some wonderful images from Schirra's postflight trip to his hometown in New Jersey, which have a charming "America in the '60s" vibe.

The chapter on Gordon Cooper and *Faith 7* is probably the most wide-ranging. I was able to use images from 1959 through 1964 to produce a well-rounded chapter to wrap up the program.

The final chapter follows the varied lives of the seven astronauts after Mercury. We begin with their 1972 reunion for the tenth anniversary of Glenn's mission and a few images from 1991 when the group gets together for the final time in public. We then provide highlights of each astronaut's remaining years.

As a space photo historian, it was a real privilege to have the opportunity to organize and archive the Taub collection, and I hope you enjoy the story of America's first astronauts as told through these highlights, many seen here for the first time.

**J. L. Pickering**
Bloomington, Illinois

# Acknowledgments

The authors thank the following people for their generous assistance in preparing this book. We would like to especially recognize the contributions of Ed Hengeveld for his excellent photo identification, fact-checking, and proofing skills.

| | |
|---|---|
| Lou Chinal | Earl Mullins |
| Mike Clark | Dee O'Hara |
| Jessica Fredericks | Ben Powers |
| Lyn Glenn | Don Purdy |
| Lowell Grissom | Alan Rochford |
| Teresa Hornbuckle | Kris Carpenter Stoever |
| Juliana Shepard Jenkins | Ann Stroink |
| Steven Kovachevich | Larry Titchenal |
| Howard Minners | Mark Usiack |
| Gerry Montague | Ron Woods |

# 1

# Steps to Space

The decision by the Eisenhower administration on October 7, 1958, to proceed with a federal program to send humans into space triggered a rapid national effort that would involve not only the National Aeronautics and Space Administration, the new government agency, but also the US military and thousands of companies across the country.

As contracts were approved and hardware was designed, the search began for the men who would pilot the spacecraft under development for what was officially named Project Mercury on December 17, 1958. Although President Dwight Eisenhower stressed the program would be civilian in nature, he agreed that the astronaut candidates must come from the Pentagon's pool of pilots. An original group of 508 applicants screened the next month was eventually winnowed to 32 candidates.

Little was known about aerospace medicine at the time, and NASA and the military formed teams to investigate and plan for human space flight. The candidates first underwent basic medical exams starting in February 1959 at the Lovelace Clinic in Albuquerque, New Mexico, followed by a battery of elaborate physiological and psychological tests in March at the Aeromedical Laboratory at the Wright Air Development Center in Dayton, Ohio.

On April 9, 1959, NASA held a news conference in Washington, DC, to introduce the seven finalists, and three weeks later, they visited Cape Canaveral, Florida, for the first time. Preparations were already underway there to support manned launches, missions, and recoveries.

The Mercury Seven, as they were soon dubbed, were based at Langley Research Center, Virginia, home to NASA's Space Task Group (STG), but embarked on a busy travel schedule to contractors, the Cape, and other government facilities as the program geared up.

The STG would establish operations at a United States Air Force (USAF) hangar at the Cape Canaveral Missile Test Annex north of Patrick AFB, Florida. It would house spacecraft checkout facilities and astronaut living quarters. Redstone and Atlas, contractors for the launch vehicles selected for Mercury, began modifying two existing launch complexes (LCs).

In keeping with NASA's civilian mission, the astronauts rarely appeared in military uniform. Yet as new warriors in the Space Race, they became national idols.

The astronauts divided their responsibilities into specific areas: Gordon Cooper and Deke Slayton kept a liaison with the Army Ballistic Missile Agency (later Marshall Space Flight Center) and launch vehicle contractors; Scott Carpenter specialized in communications and navigation; John Glenn focused on cockpit layout; Gus Grissom handled in-flight control systems; Wally Schirra's specialty was life-support systems and pressure suits; and Alan Shepard concentrated on tracking, range, and recovery systems.

They would soon shoulder the risks to become America's space pioneers and to help open a new vista of human exploration.

NASA engineer Edward Brummal checks an escape tower rocket nozzle on a Little Joe/Mercury scale model in the 16-foot Transonic Wind Tunnel at Langley Research Center in Hampton, Virginia, in 1959. Langley, the oldest NASA field center, designed the solid-fueled booster to test the Mercury spacecraft's escape system and other capabilities; it was built by North American Aviation. Five Little Joe launches from Wallops Island, Virginia, included sending two Rhesus monkeys, Sam and Miss Sam, on suborbital flights in December 1959 and January 1960. Sam flew 55 miles into space before returning, providing flight engineers with a better idea of how astronauts would be affected.

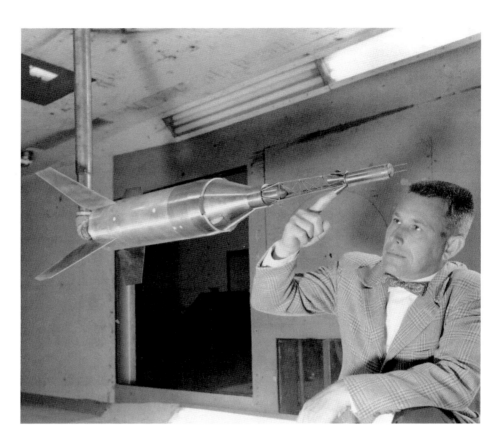

A one-sixth scale model of a Mercury spacecraft and its emergency escape tower is tested in the 7-by-10-foot Wind Tunnel at Langley in 1959. The goal was to determine how firing the escape system would affect the attached spacecraft's stability in flight. Water is forced through the escape system nozzles to help with visual observations.

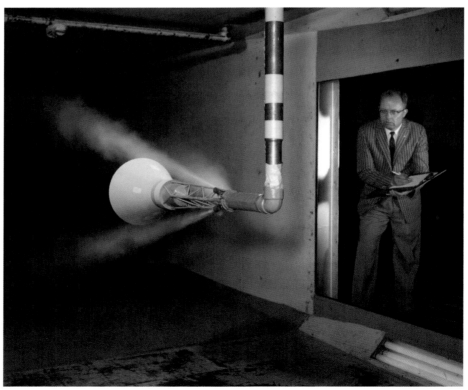

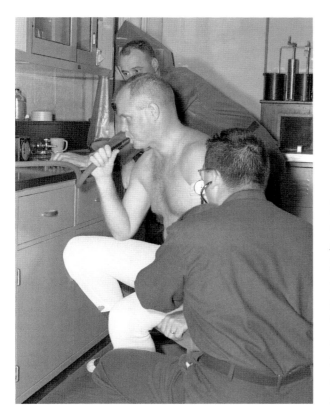

John Glenn blows into a mouthpiece to support a column of mercury during a Valsalva overshoot test at the USAF Aerospace Medical Laboratory in Dayton, Ohio, in March 1959. The test was related to measuring systolic blood pressure. He was one of thirty-two astronaut candidate finalists who then underwent a battery of tests at the lab at Wright-Patterson AFB. The process had begun in February with weeklong intensive physical exams at the Lovelace Clinic in Albuquerque, New Mexico. At right, USAF captain and physician Edmund Weis, associate investigator, monitors Glenn with a stethoscope.

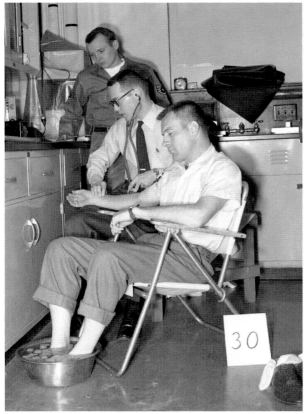

Capt. Charles Wilson, a USAF physician, checks Deke Slayton's pulse as he sits with his feet in a bucket of ice water for seven minutes. Wilson was the lab's Candidate Evaluation Program task officer. Behind them is SSgt. Joseph Young. Slayton (candidate no. 30 for photo documentation) later wrote he lost feeling in his feet by the end. The candidates were not told about this cold pressor test in advance and were instructed to not mention it to the others.

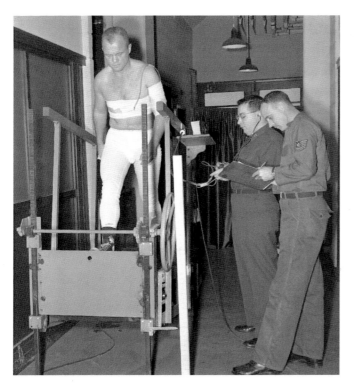

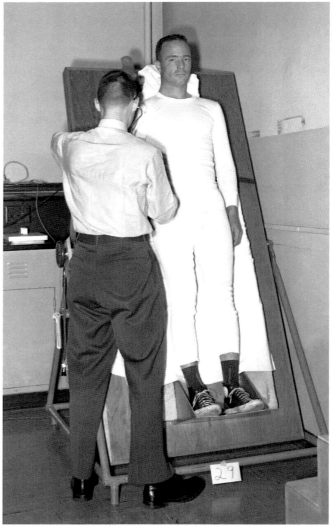

**TOP LEFT** Glenn on the treadmill, which ran at 3.4 miles per hour. It was slowly raised from horizontal in one-minute increments to about 8 degrees during the ten-minute test while the candidate's blood pressure was monitored. At right are Capt. Weis, associate investigator, and SSgt. Young.

**TOP RIGHT** Glenn during his isolation test; his face was illuminated only for this photo. Each man was confined to the dark, soundproof room for three hours.

**BOTTOM RIGHT** Capt. Wilson works with Carpenter during a twenty-five-minute tilt table test. Each candidate first performed the Harvard step test for three minutes before moving to the table, which was set to 65 degrees from horizontal. None of the test results would be added to the candidates' military records unless they asked.

**FACING PAGE** Capt. Wilson prepares Grissom for an altitude chamber test. He wears a USAF MC-1 partial pressure suit used by B-36 bomber crews, with an MA-2 helmet. The test simulated being at 65,000 feet high (about 12 miles) for an hour, but the complete test lasted for four hours. Candidates were also subjected to various g-forces in a centrifuge.

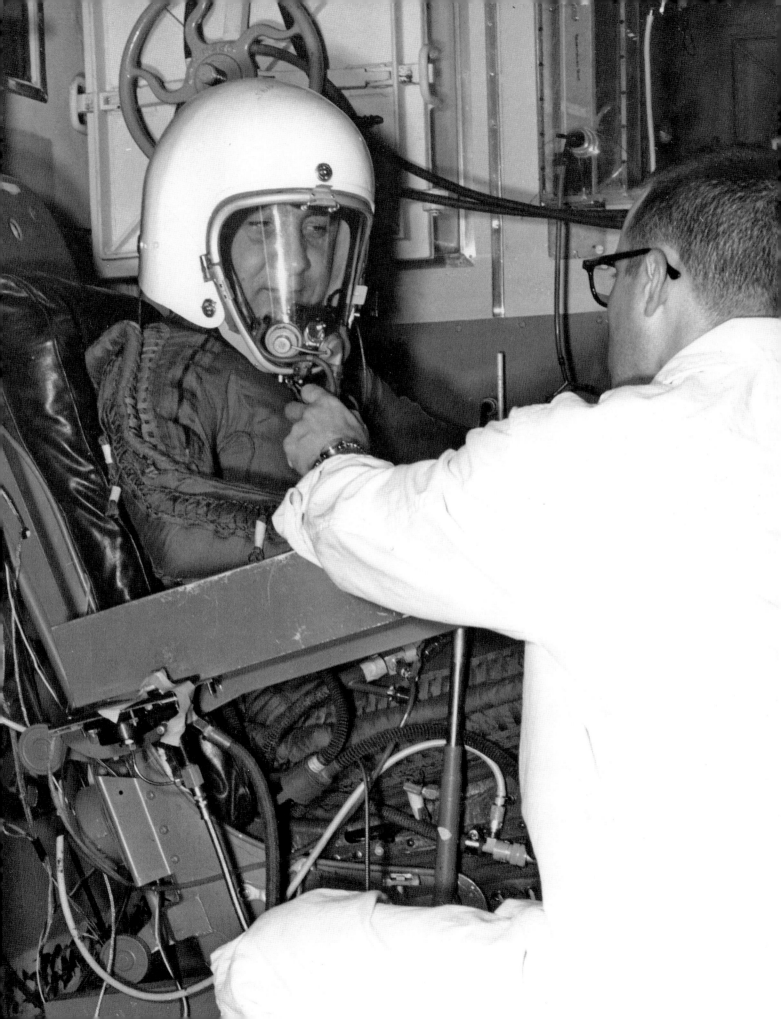

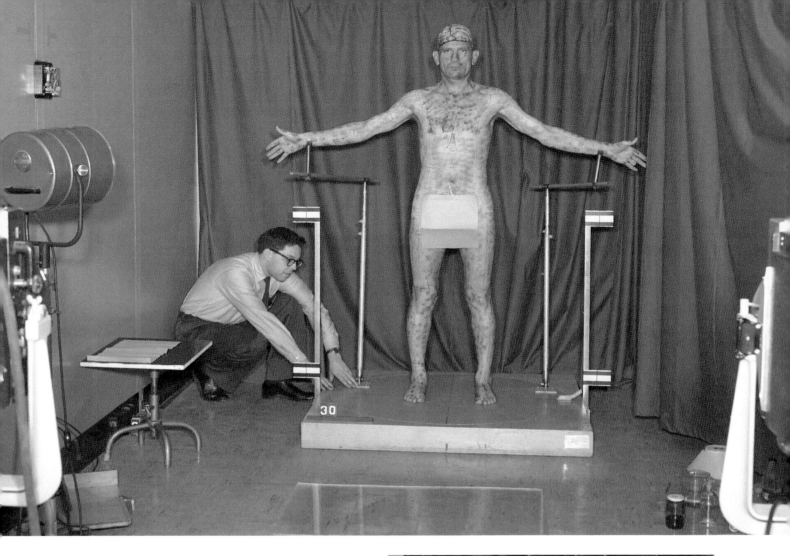

**TOP** Slayton poses for a somatotype photo, with lines drawn on his body to provide more contrast for stereo photos taken at four different angles. These were used to gather anthropometric data on each candidate. The negatives were then sent to an aerial photogrammetry company in Texas, where extremely precise topographical maps of the candidates' bodies were created. At left is USAF Capt. Robert Ziegen, associate investigator.

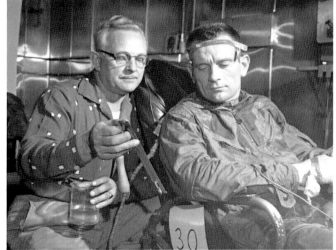

**BOTTOM** Slayton, wearing a K-2B flying suit, watches a thermometer held by Capt. Joseph Gold, a physician and the USAF principal thermal tests investigator, as Slayton sits in an environmental chamber during a heat test. A thermocouple is attached to his forehead and hand. Candidates were subjected to 135°F conditions for two hours to test their tolerance to heat and their ability to do useful work under such conditions. NASA would introduce the top seven finishers as the nation's new Mercury Seven astronauts at a Washington, DC, news conference on April 9, 1959.

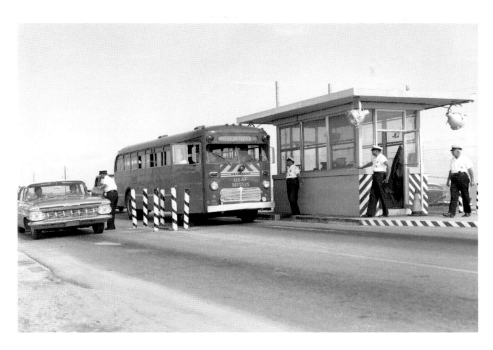

TOP Six of the Mercury astronauts arrive for the first time at Cape Canaveral Missile Test Annex on the morning of May 21, 1959, for a drive-through bus tour at the south gate on State Road 401. They had flown from Langley AFB and landed in secrecy at Patrick AFB the previous evening. Schirra was busy moving into a new home near Langley from Hackensack, New Jersey.

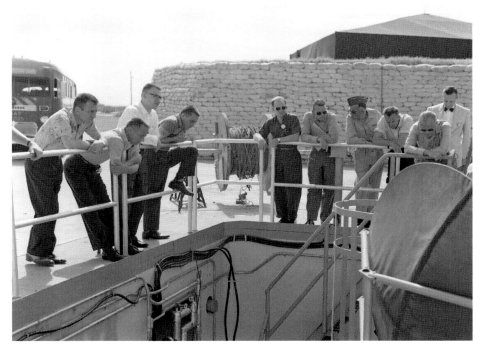

BOTTOM The astronauts return the next day for a more detailed tour, stopping at various facilities. Here they inspect a new Minuteman missile silo at LC-31. *Left to right:* Slayton, Carpenter, Navy Lt. Robert Voas, Grissom, NASA public affairs officer John "Shorty" Powers, Cooper, tour guide USAF Col. George Knauf, Shepard, Glenn, and unidentified. Voas, a psychologist, joined the STG in 1958 and was involved with the astronaut selection process and training. He became close to Glenn and served as campaign manager during Glenn's 1964 Senate campaign. Knauf, a surgeon, would soon be named assistant for bioastronautics for Defense Department support of Mercury. In 1987, debris recovered from the space shuttle *Challenger* would be buried in the silo.

**TOP** The astronauts pose in front of Atlas 8C at LC-12 on May 22. *Left to right:* Carpenter, Cooper, Glenn, Grissom, Shepard, and Slayton. The Atlas ICBM would be launched July 21 on a suborbital test, the first in a string of successes during the summer and fall after five straight failures. A man-rated version would successfully send four of the Mercury astronauts into orbit starting less than three years later. The Atlas is topped by an RVX-2 reentry vehicle that would have protected a nuclear warhead of 1.44 megatons.

**BOTTOM** A Convair manager explains LC-12 operations. *Left to right, front row:* Dr. Voas, Grissom, Shepard, Slayton, Glenn, and Carpenter. The Convair Division of General Dynamics, based in San Diego, was the prime contractor for the Atlas, first launched in 1957. The astronauts, wearing "V" (visitor) badges, also stopped at LC-5 (Redstone) and LC-26 (Jupiter) and toured both blockhouses.

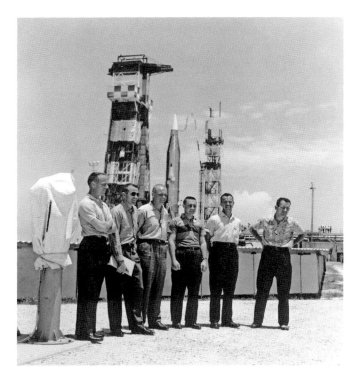

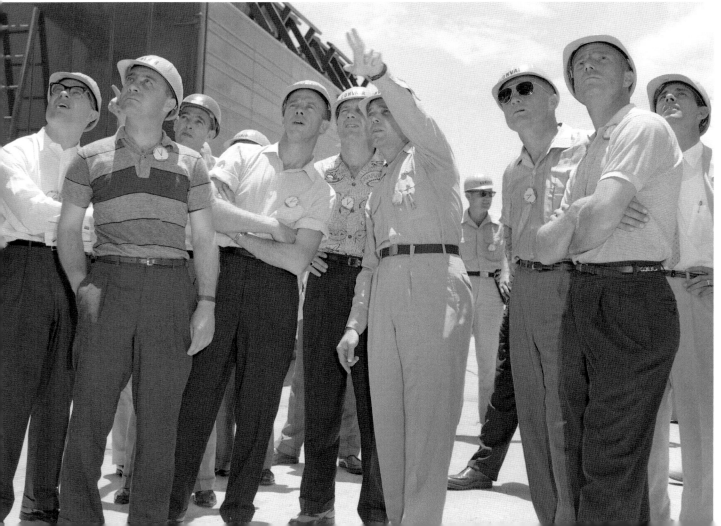

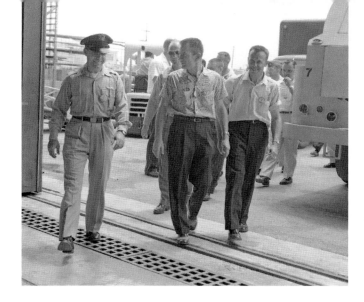

**TOP** The astronauts, led by Slayton and Shepard, enter Hangar S in the Cape Canaveral Industrial Area for a tour. Built by the USAF in 1957 for aircraft maintenance and storage, it soon housed operations of the Navy's Project Vanguard, which attempted to launch the first US satellite. NASA acquired the hangar in 1959 from the USAF and modified it for use by the STG's Pre-Flight Operations Division.

**MIDDLE** Grissom speaks with an employee in Hangar S. The 61,300-square-foot facility would be home to almost all Mercury activities at the Cape, including the astronauts' living quarters, training, and spacecraft processing. A clean room spacecraft checkout area was built in the northeast corner of the high bay. An altitude chamber for spacecraft systems checkout would be added in April 1960. The hangar also included a primate training area.

**BOTTOM** The astronauts wrap up their second day with the liftoff of Thor 184 from LC-18 at 9:42 p.m. EST on May 22. They watch from a camera position 3,500 feet from the pad under a full moon. It was a successful fifteen-minute flight down the Atlantic Missile Range. After visiting the Cape's Central Control Facility at about 7:30 p.m., they observed most of the countdown from the LC-18 blockhouse but went outside for launch. Powers told reporters they were "somewhat surprised at the amount of sound and vibration." The next morning, the six received briefings at Patrick and met with Maj. Gen. Donald Yates, Air Force Missile Test Center commander. They also held a brief midafternoon session for reporters where they posed for photos but Powers would not let them answer questions.

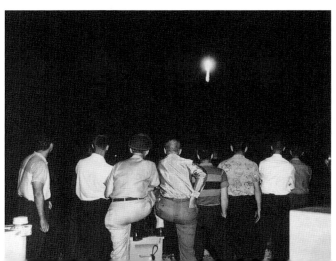

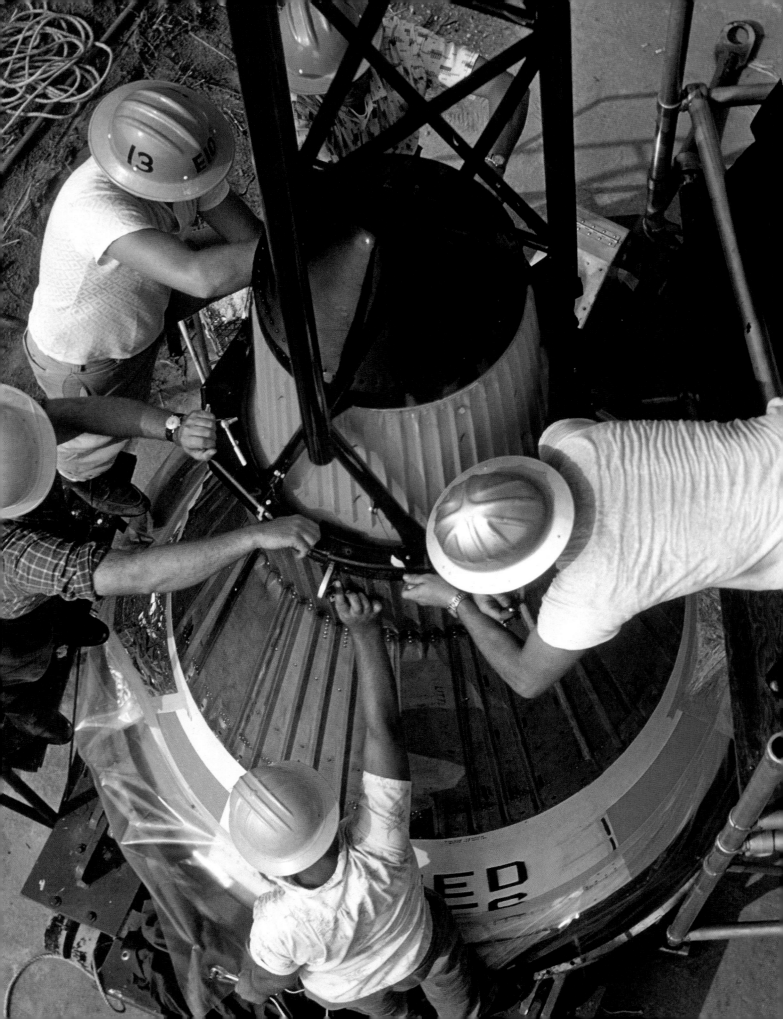

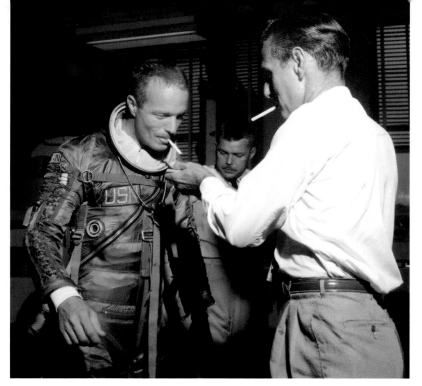

Carpenter, wearing a US Navy Mark IV pressure suit, takes a break during training at Langley in 1959. The new suit had been developed for Navy fighter pilots by the B.F. Goodrich Company, and in July 1959, NASA awarded the Akron, Ohio, firm a contract to fabricate twenty-one Mercury suits. The astronauts had reported to Langley for training on April 27, 1959. Carpenter, Slayton, Schirra, and Shepard were smokers at the time.

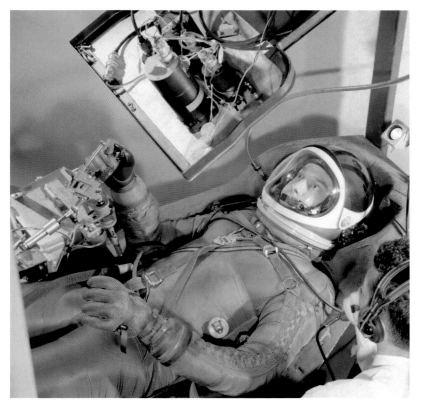

Shepard trains on an analog flight simulator at Langley in 1959 using a three-axis hand controller supplied by McDonnell Aircraft. It also used rudder pedals. The Mark IV pressure suits would be modified by Goodrich for space flight, including replacing the green nylon cover layer with an aluminum-coated nylon for thermal control.

FACING PAGE In 1959, technicians at NASA's Wallops Station on Wallops Island, Virginia, secure an escape tower to the top of a boilerplate Mercury spacecraft fabricated at Langley on a Little Joe booster. Little Joe 5 in 1960 would be the only launch of the eight boosters with a true Mercury spacecraft (no. 3).

Slayton on the air-lubricated free-attitude (ALFA) trainer in late 1959 at Langley, which provided the astronauts with a better feel for controlling a spacecraft by simulating physical and visual flight sensations. They used a Mercury hand controller to operate compressed air jets to provide pitch, roll, and yaw movements. The circular screen below Slayton's feet showed a simulated periscope view of Earth. Compressed air retro-rockets were later added to the back of the trainer to allow for practice controlling retrofire and it was enclosed. Each astronaut received about twelve hours of ALFA training, and Shepard, Grissom, and Glenn all agreed postflight it was very valuable.

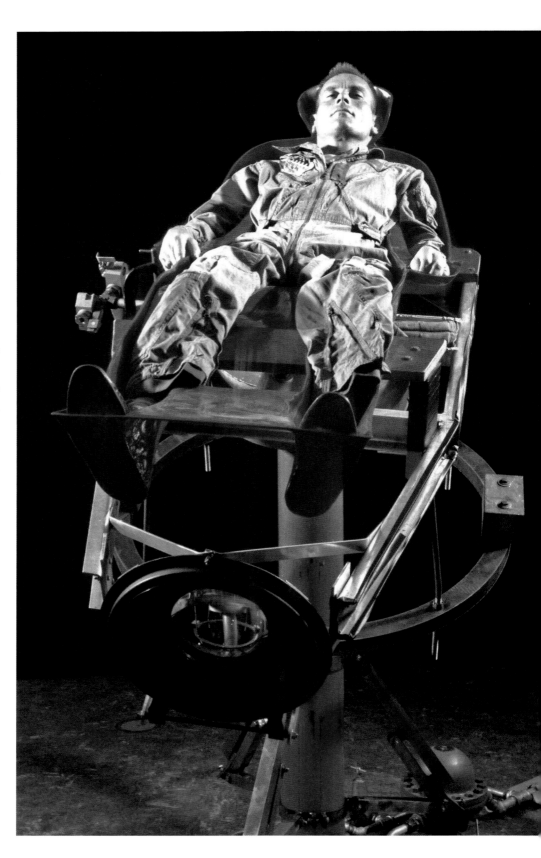

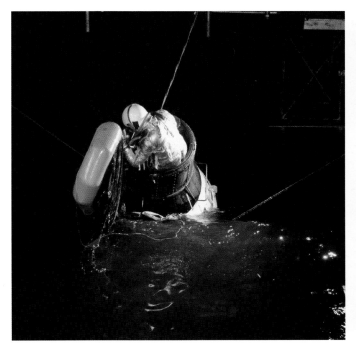

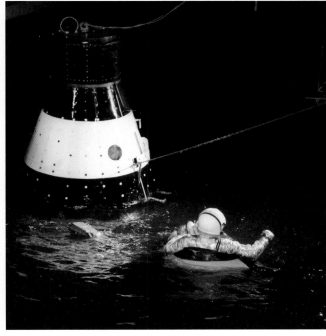

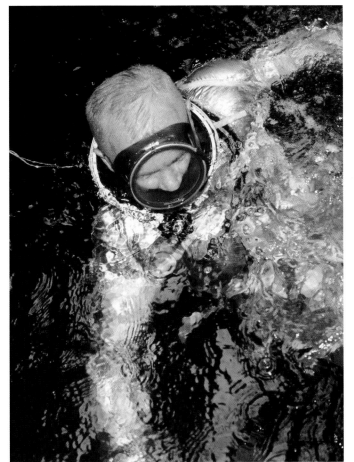

**TOP TWO IMAGES** Glenn emerges through the neck of a Mercury training spacecraft in the Hydrodynamics Research Facility tank at Langley in March 1960. He first pushed the recovery raft out from the top.

**BOTTOM** Glenn floats in the tank with a face mask. Normal egress was through the side hatch, but an alternative was to remove part of the instrument panel, release an interior hatch, push the parachute container out of the way, and squeeze out through the parachute housing at the top. Only Carpenter used this method after splashdown to avoid taking on water through the side hatch as he waited for recovery. Such training also took place in the Back River behind the Langley East area.

A fully suited Schirra (*right*) is assisted by Shepard in 1961 in the Hydrodynamics Research Facility tank at Langley.

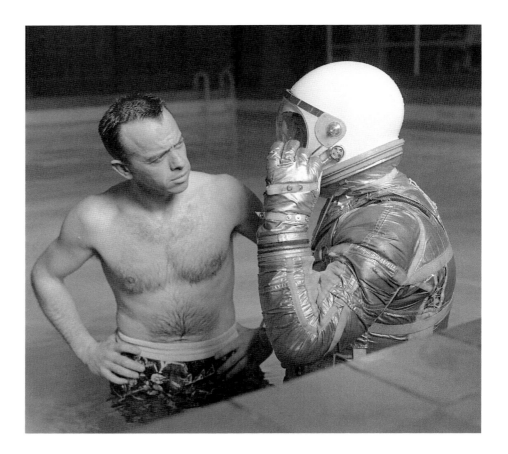

A Sikorsky CH-37A Mojave helicopter hovers while pulling a pressure-suited subject from the Gulf waters off Pensacola, Florida. The heavy-lift chopper was the largest helicopter in the Western world at the time. Moving its engines and landing gear to twin outboard pods left the fuselage free for cargo, which could be loaded and unloaded through the large clamshell doors in the nose.

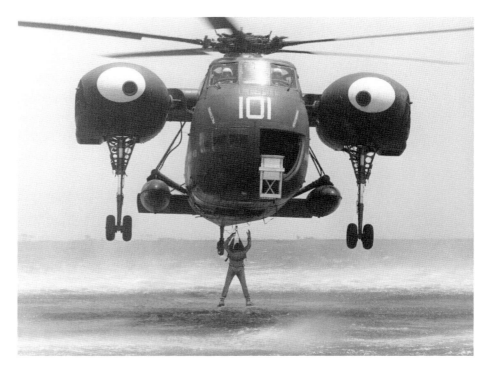

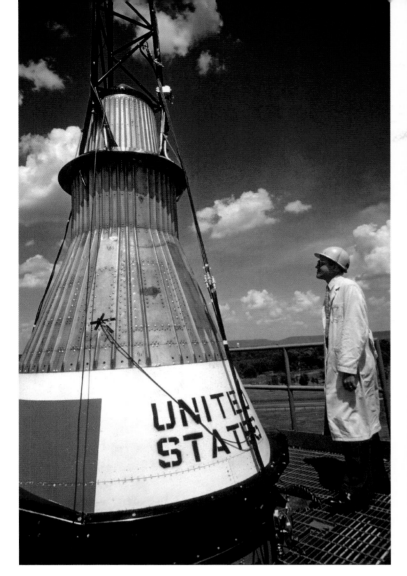

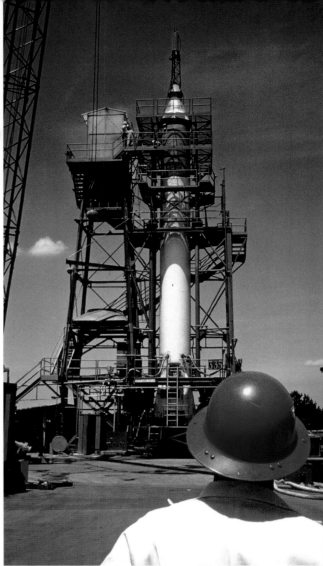

**TOP TWO IMAGES** Topped by a boilerplate Mercury spacecraft, each of the six Redstone boosters used for Mercury underwent a static test firing at the Interim Test Stand at the US Army's Redstone Arsenal near Huntsville, Alabama. Cooper gets a close look at left. The structure, retired in 1961, was declared a National Historic Landmark in 1985. Redstone, developed as the first US short-range ballistic missile, was manufactured by the Chrysler Corporation in Warren, Michigan.

**BOTTOM** In May 1960, Cooper (*right*), whose responsibilities included the Redstone, meets with Joachim "Jack" Kuettner, a German American atmospheric scientist and Redstone project director. About one month later, NASA personnel transferred to the new Marshall Space Flight Center at the arsenal.

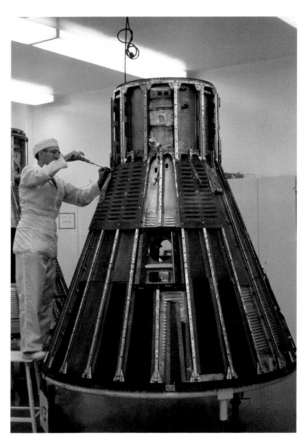

ALL IMAGES McDonnell Aircraft had a NASA contract to produce twenty Mercury spacecraft and several boilerplates. These early versions under construction in St. Louis in 1960 each had two small portholes instead of a window; the change was made for Mercury-Redstone 4 (MR-4; Grissom) at the astronauts' request. The inner titanium shell of each spacecraft is exposed; corrugated nickel–chromium alloy (Rene 41) outer shingles will be bolted to the thin stringers. Images on this page are from August; image on facing page is from October.

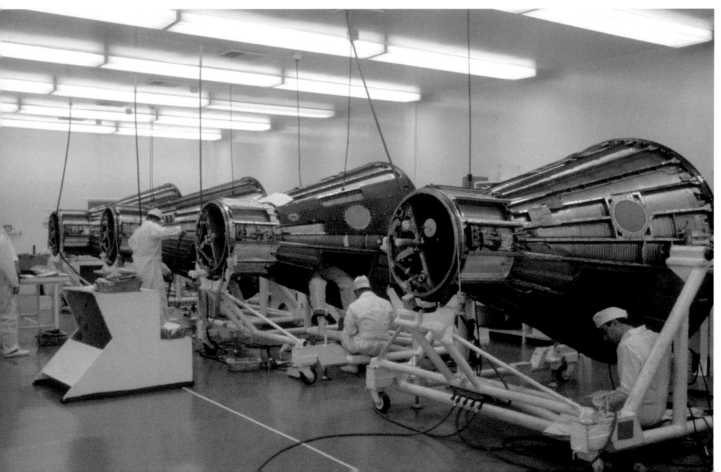

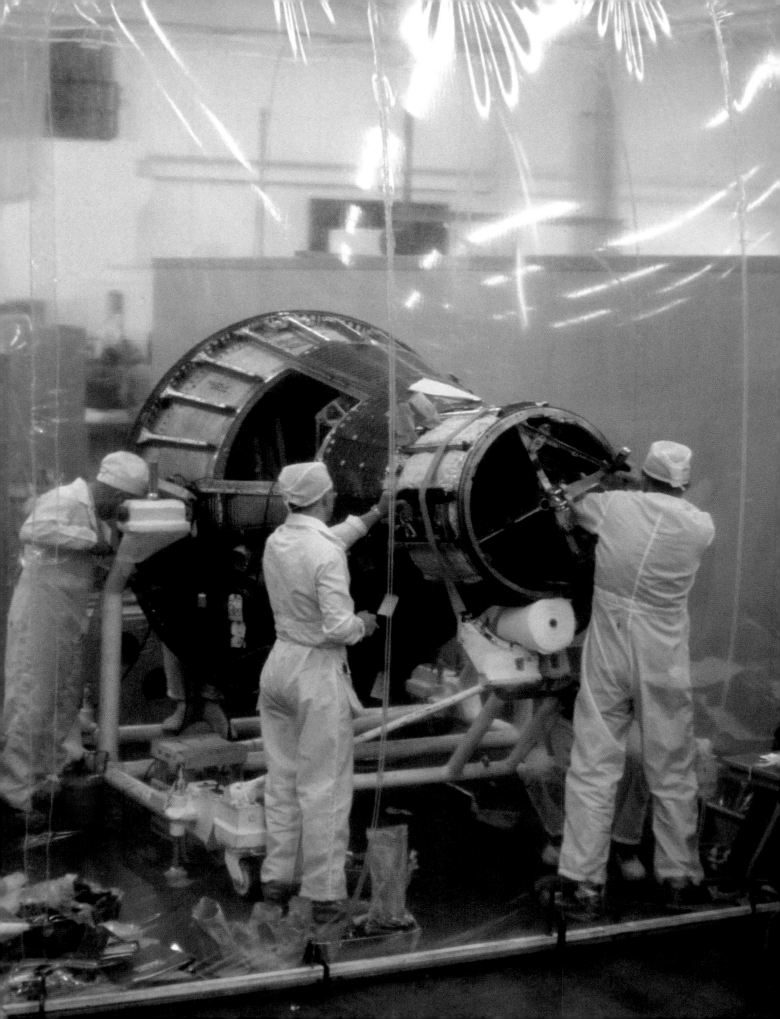

**TOP** Carpenter discusses a Mercury Earth Path Indicator with James "Mac" McDonnell, company chairman, on August 17, 1960. The device on the instrument panel, manufactured by Honeywell, contained a small globe driven by a clockwork mechanism. Once in orbit, the astronaut would wind the spring and set his position with a tiny model of the spacecraft, under which the globe would rotate. The device was only used during Glenn's and Carpenter's flights.

**MIDDLE** Carpenter (*right*) chats with a McDonnell engineer in St. Louis on August 17, during the design engineering inspection meetings for spacecraft no. 7, being built for the first manned flight.

**BOTTOM** Grissom (*left*) and Glenn confer. The astronauts made a number of requests for changes to the instrument panel during the two days of meetings August 16 and 17.

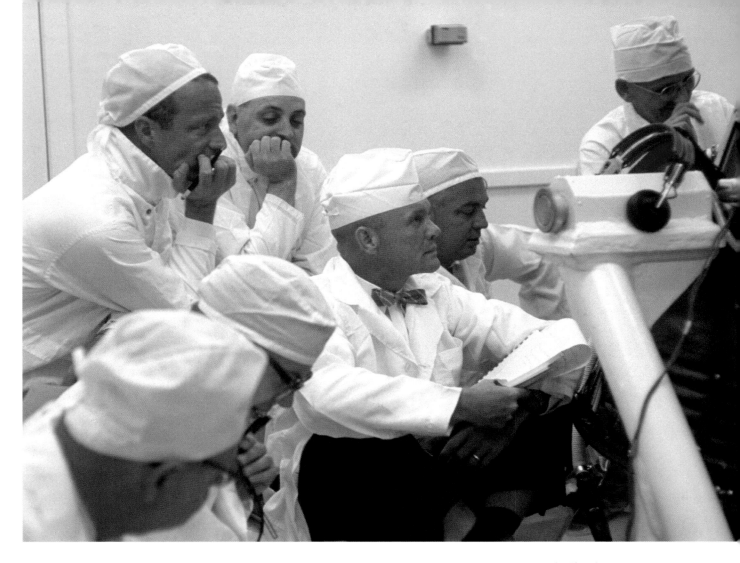

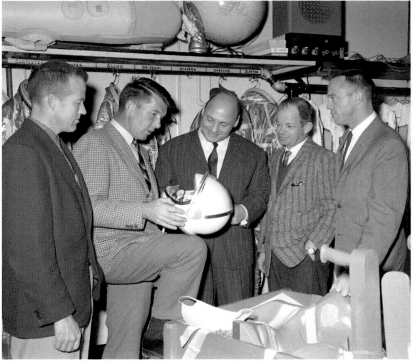

TOP Astronauts and officials examine a production spacecraft in a clean room at McDonnell Aircraft on August 17. Carpenter (*left*) and Dr. Stanley White, chief of NASA's Life Science Division and a space medicine pioneer, crouch behind Glenn and Mercury program director Walt Williams.

BOTTOM Schirra shows a Mercury helmet to a visitor at the Cape on December 7, 1960. *Left to right:* Cooper, Schirra, unidentified, Powers, and Shepard in the Hangar S suit room. The helmet represented about half of each suit's total cost of about $5,000 and had interior liners custom-molded to each crewman's head. Suits and underwear hang in the background, with one glove on the shelf above. Goodrich provided three suits for each crewman for training, flight, and backup.

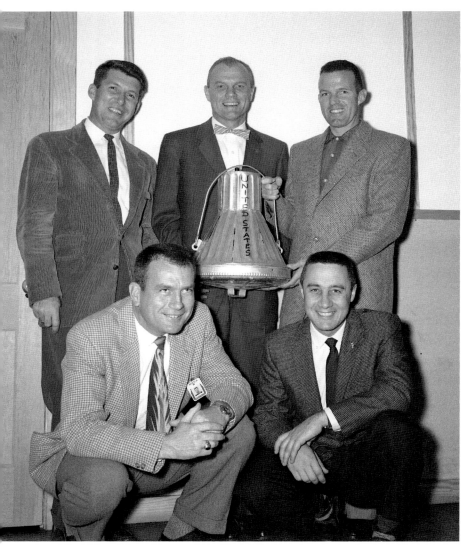

**LEFT** Five astronauts pose with a Mercury model made from a metal trash can, including a lid for a heat shield. *Left to right, back row:* Schirra, Glenn, Cooper; *front:* Slayton and Grissom. The gag is possibly a reference to the disparaging "spam in a can" label given the astronauts by some test pilots, suggesting they would do little "flying" of their spacecraft.

**FACING PAGE TOP** Six astronauts appear at a news conference at Patrick AFB on February 22, 1961, following the unexpected revelation the day before that either Shepard, Grissom, or Glenn would be America's first man in space. STG director Robert Gilruth made the announcement less than three hours following the successful recovery of the unmanned Mercury-Atlas 2 (MA-2) spacecraft after an eighteen-minute suborbital flight. Shepard had already been named the prime candidate the month before, but that decision would be kept confidential until shortly before his flight in May. Asked about the program's overall progress, he replied to laughter, "Maybe this is the midpoint between Ham and the human."

**FACING PAGE MIDDLE** Reporters prepare for the news conference, with cameramen using 16 mm and 35 mm film cameras behind them. Sitting in the rear at center is NASA motion picture photographer Larry Summers. The hour-long session was a rare media availability for the astronauts.

**FACING PAGE BOTTOM** Lt. Dolores "Dee" O'Hara, a USAF nurse assigned to the astronauts, furnished their new living quarters on the second floor of the south wing of Hangar S, seen here in early 1961.

**TOP** The crew's quarters, which could sleep six, combined a living room and bedroom. The walls were partially painted a shade of aqua deemed to be calming. An intercom is mounted on the wall above the desk.

**BOTTOM TWO IMAGES** Glenn (*left*) and Grissom (*right*) go over paperwork in the astronaut quarters in early 1961. Glenn preferred to sleep in a top bunk bed when he was staying there.

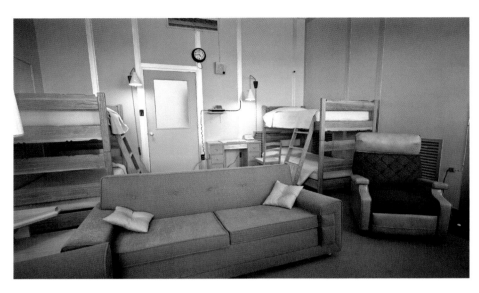

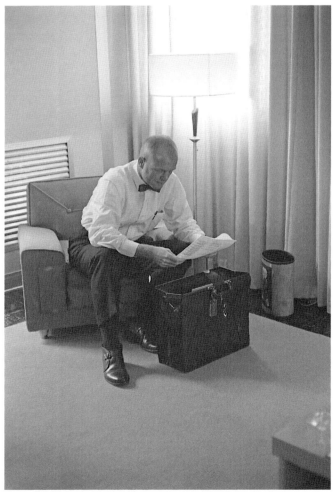

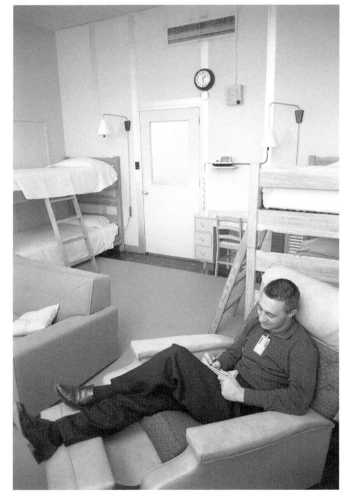

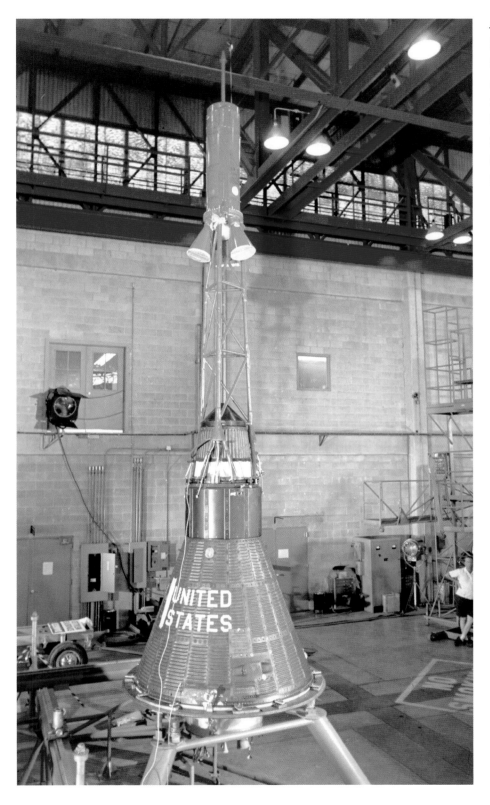

A Mercury spacecraft topped with its escape tower during checkout in the Hangar S high bay. Each spacecraft arrived from St. Louis at the Cape Canaveral Skid Strip on a USAF cargo aircraft. The American flag was painted below "United States" starting with Glenn's MA-6 mission.

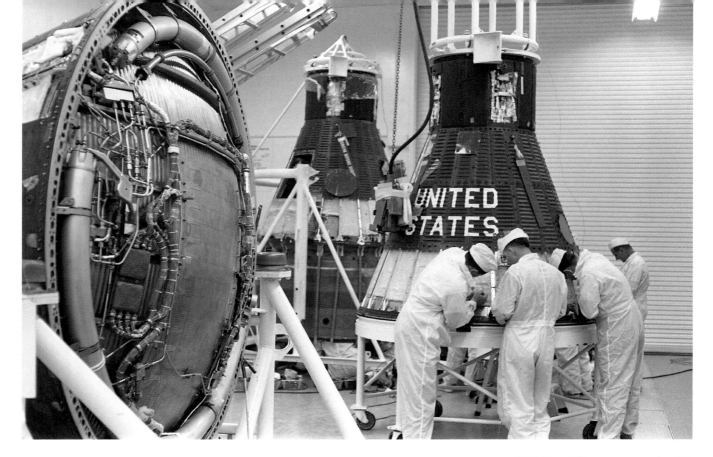

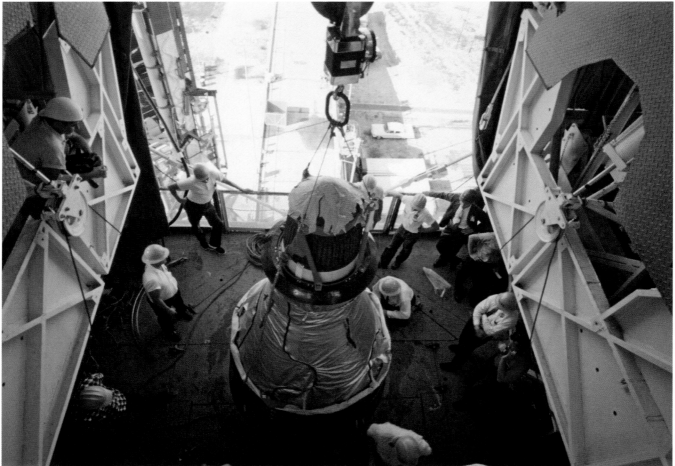

**FACING PAGE, TOP** McDonnell technicians work on several spacecraft during checkout in the Hangar S clean room in 1960. The missing heat shield on the spacecraft at left reveals the large pressure bulkhead, the curved hydrogen peroxide fuel tanks, and piping for six reaction control system jets as well as for the heat shield release pneumatic system. The landing bag, attached to the heat shield, would also be stored in this space.

**FACING PAGE, BOTTOM** NASA and McDonnell technicians in the white room at LC-14 mate a Mercury spacecraft to its Atlas booster. The pad's red service structure can be partially seen outside at left. The folding work platforms will allow access to the escape tower once it is installed to the top of the spacecraft by attaching it with explosive bolts to a ring and three red triangular supports surrounding the recovery section.

**THIS PAGE** On April 15, 1961, Cooper helps demonstrate the mobile aerial tower he devised, dubbed the "cherry picker," at LC-6. He was chairman of the Emergency Egress Committee, which focused on pad safety. Observing the test are Shepard's backup, Glenn; and Dr. Carmault Jackson of the Life Sciences Division, responsible for the astronaut medical program. LC-5 with Mercury-Redstone 3 (MR-3) in place can be seen in the background (*top image*). Although it was never used for an emergency during Mercury, Cooper insisted the crane be moved to LC-19 for Gemini launches. On July 22, 1965, the device retrieved him and Charles Conrad from the Gemini V spacecraft when the pad's erector could not be raised after a launch rehearsal.

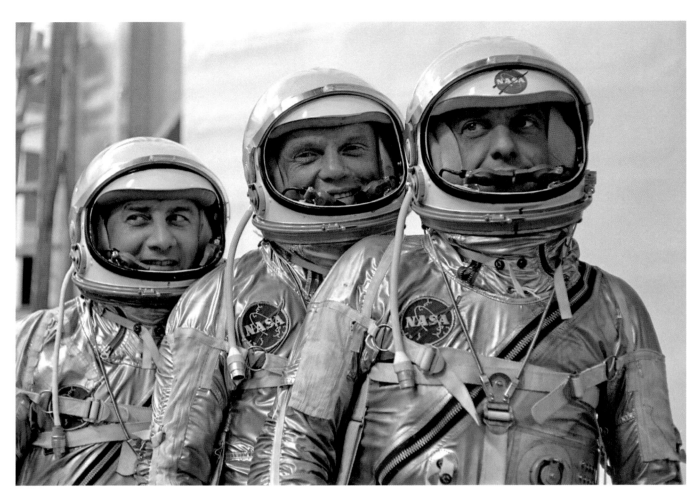

**FACING PAGE, TOP** *Left to right:* Grissom, Glenn, and Shepard pose in pressure suits for fashion photographer Richard Avedon in a hangar at Langley on March 31, 1961.

**FACING PAGE, BOTTOM** Avedon's unofficial studio manager was actress and model Suzy Parker, who had appeared on magazine covers and in several movies and was brought along to perk up the astronauts. During preparations for the shoot, a thunderstorm knocked out the power. Shepard saved the day by showing Avedon's assistant, Earl Steinbicker, how to tap into emergency circuits.

**THIS PAGE** *Life* magazine published a photo of actors Bob Hope and Bing Crosby in costume spacesuits in its November 10, 1961, issue, taken while they were in London filming *The Road to Hong Kong*. They sent a copy to Shepard and Grissom, signing it "We're ready! Bing & Bob." The astronauts replied as vaudevillians, signing their photo, "To Crosby & Hope, we're ready too!"

**TOP** Cooper (*left*) at the controls of his single-engine Beechcraft Bonanza F35 private aircraft with passengers Grissom (*center*) and Shepard in October 1961. He kept the plane at Patrick AFB.

**BOTTOM** The astronauts have an opportunity to show their families their workplace, Hangar S, on February 23, 1962. They had come to see President Kennedy present the NASA Distinguished Service Medal to Glenn following his orbital flight three days earlier. Grissom goes over the attitude instrument display with his sons Mark, 9, and Scott, 12 (*partially hidden*), and Carpenter's 10-year-old son, Jay, in the Hangar S conference room. The half-scale transparent mock-up of a section of a Mercury spacecraft was mounted in a four-gimbal support and included actual Mercury rate and attitude indicators. The covers were removed, however, to show the trainee how the attitude gyros moved. The device was used to teach the astronauts how to recover these instruments if they tumbled.

**FACING PAGE** Grissom's son Mark tries out the couch in the suit room, where the astronauts would get final checks on their pressure suits before flight.

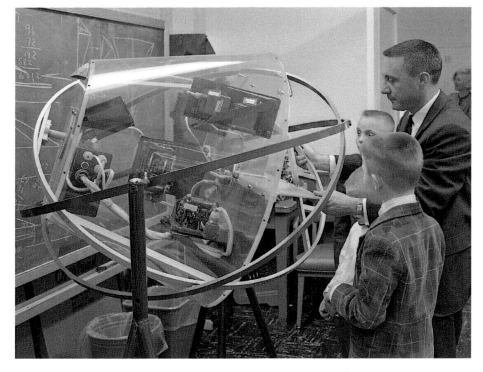

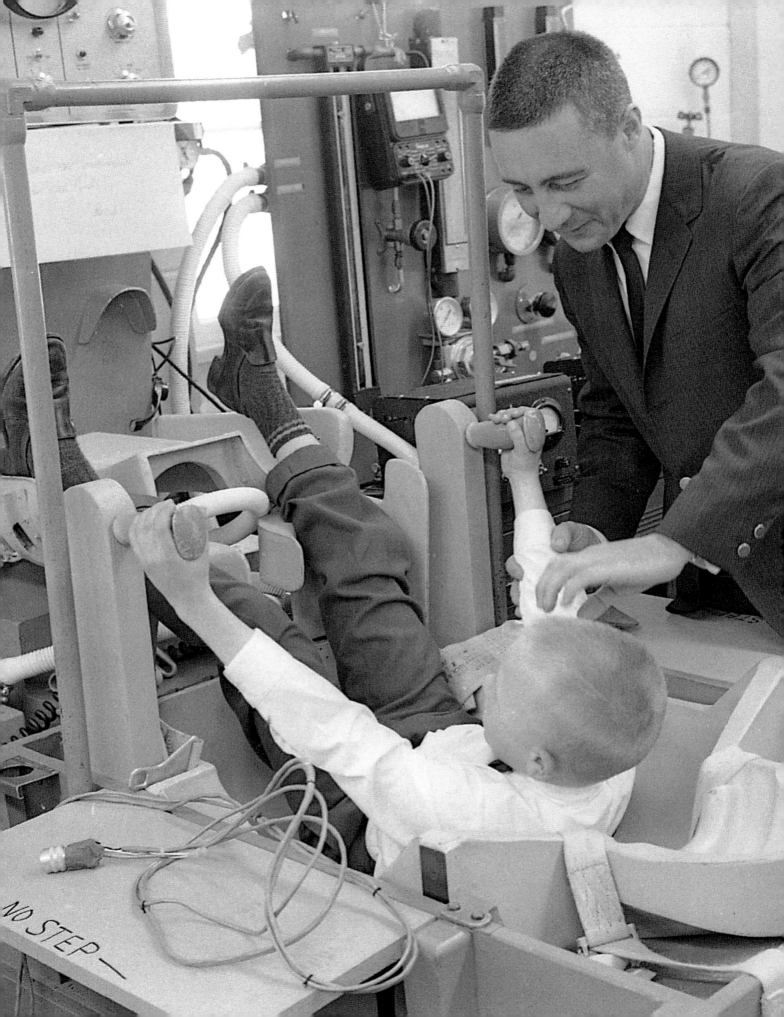

TOP Kristen and Scott Carpenter in the suit room during the visit to Hangar S, with the conference room next door.

BOTTOM Eight-year-old Kristen also likes the couch.

O'Hara visits with Rene Carpenter, wife of Scott Carpenter, with the suit room behind them.

O'Hara greets Kristen Carpenter as her father looks on.

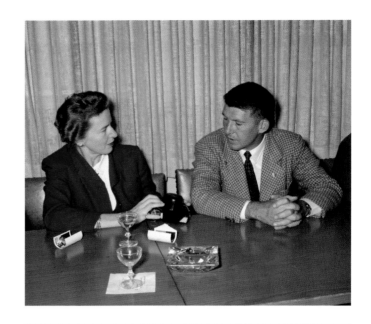

**TOP** Schirra, a camera buff, discusses a Polaroid camera with an unidentified woman at the Carnival Club in Cocoa Beach in April 1962; two instantly developed photos are on the table. The nightspot was a popular stop for visiting celebrities and identified by Pinky, a large pink fiberglass elephant in front. Located at 3901 N. Atlantic Avenue near the corner of State Road A1A and the State Road 520 Causeway, it was the area's largest music venue.

**MIDDLE** Grissom (*right*) chats with club owner John "Lee" Caron. Caron would serve as Cocoa Beach mayor from 1971 to 1975.

**BOTTOM** Shepard relaxes at the outing. The seven astronauts were in the process of investing in several real estate deals at the time, including becoming minority owners of the Cape Colony Resort, a local motel a few miles south on State Road A1A.

# 2

# The People of Mercury

As a complex national undertaking, Project Mercury meant not only expanding existing government and industry capabilities, but also developing new ones. Questions about how a manned capsule could safely reenter the atmosphere, for example, led to coming up with new materials, techniques, and procedures on multiple fronts. The US Navy had no experience recovering spacecraft from the ocean, and NASA had no worldwide tracking network.

One key area for investigators was how spaceflight would affect humans. Although they could draw on a foundation of aviation medicine, much was largely unknown, such as the impact of solar radiation and weightlessness. Could astronauts survive in orbit, let alone function?

And while the seven astronauts were key participants, the six who flew were well-trained solo pilots who were successfully launched and recovered only thanks to the efforts of the support personnel and thousands of others in the public and private sectors. Mercury used 12 prime contractors, 75 subcontractors and 7,200 various suppliers, all of which employed about 2 million people. NASA personnel alone grew from 35 scientists and engineers in October 1958 to 3,345 by June 1963.

The government team was led by Robert Gilruth and the Space Task Group (STG) of NASA, which soon became the Manned Spacecraft Center (MSC) with its first offices at Cape Canaveral. Much of the work could be grouped into Preflight Operations, Flight Operations, Life Sciences, Launch Operations, and Recovery Operations. Gilruth was able to build an organization from a deep bench of primarily government aviation and aerospace engineers, designers, and scientists initially based at Langley Research Center, Virginia.

An extensive astronaut training team was led by USAF and Navy physicians and psychiatrists. They worked closely with a pair of pressure suit technicians, a new job description. Just as integrated was the medical team, led by flight surgeon (and USAF lieutenant colonel) Dr. William Douglas and composed of a number of specialists and astronaut nurse Lt. Dee O'Hara.

Many Cape facilities required modification for the program, so close coordination was required among all of NASA's fledgling divisions, especially between the Launch Operations Directorate (LOD), led by Kurt Debus (still based at Marshall Space Flight Center), and plans for the Mercury Control Center at the Cape, where MSC's Chris Kraft would be in charge. The new worldwide tracking network had its own operational division and involved all branches of the US military.

As a Cold War competition with the Soviet Union focused on the new American astronauts, the program essentially sold itself. To avoid public relation missteps, however, NASA public affairs officer John "Shorty" Powers became the spokesman for the Mercury Seven. And to both satisfy the demand of newspapers and magazines for photos as well as to document the Mercury program for history, NASA relied on several new staff photographers.

These various teams worked together to accomplish Mercury's goal relatively quickly, but not as a crash program. Their coordinated and often simultaneous efforts meant an astronaut was first safely orbited just thirty-seven months after NASA signed the spacecraft productions contract with McDonnell Aircraft.

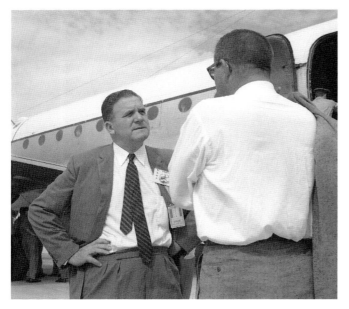

The official with ultimate responsibility for Project Mercury, NASA administrator James Webb, prepares to fly back to Washington on July 21, 1961. He was the first to greet Gus Grissom on Grand Bahama Island after his Mercury-Redstone 4 (MR-4) flight. "Congratulations on a wonderful job," Webb told him. He was a former budget director and State Department official in the Truman administration and was named NASA's second chief by President Kennedy days after Kennedy took office.

Robert Gilruth was in charge of Mercury. He had joined NASA's predecessor agency, the National Advisory Committee for Aeronautics (NACA), as an engineer in 1937. He became director of the STG at Langley Research Center in Hampton, Virginia, when NASA was created in 1958. He was named director of the new MSC in November 1961, which supplanted the STG. Gilruth's first office was in one of several temporary MSC facilities in southeast Houston.

Marshall Space Flight Center director Wernher von Braun (*center*) chats with McDonnell vice president Walter Burke (*left*), company chairman James McDonnell, Gordon Cooper (*back to camera*) and Launch Operations Directorate (LOD) chief Kurt Debus at Launch Complex 5 (LC-5) on May 2, 1961. Alan Shepard's MR-3 launch, scheduled for that morning, was delayed by poor weather. The LOD would become the Launch Operations Center in 1962, renamed Kennedy Space Center the next year.

*Left to right*: Langley associate director Charles Donlan, NASA Headquarters Manned Space Flight chief George Low, and STG engineer Max Faget before the unmanned Mercury-Atlas 2 (MA-2) launch from LC-14 on February 21, 1961. Donlan had served as Gilruth's deputy at the STG, assigned to oversee the astronaut selection process. Faget developed the basic design of the Mercury spacecraft. The successful MA-2's objectives were to test the booster's orbital insertion capabilities and the Mercury spacecraft's heat shield.

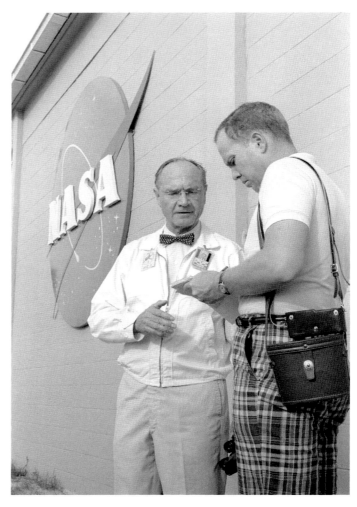

**TOP** James McDonnell talks to a reporter outside the MCC during the MR-4 countdown on the morning of July 21, 1961. The company's stock recovered by the end of the day, having suffered a minor dip after Grissom's spacecraft sank.

**BOTTOM** Office of Manned Space Flight director Brainerd Holmes (*left*) and MSC director Gilruth during preparations at the Cape for MA-5 on November 21, 1961. The flight sent chimpanzee Enos on two orbits, paving the way for John Glenn's MA-6 mission three months later. Holmes had just joined NASA from RCA, where he had helped oversee development of a missile warning system for the USAF.

**TOP** Walter Williams, STG associate director, in the Hangar S suit room on July 21, 1961, as Grissom prepares for launch. The engineer had joined NACA in 1940, conducting research into supersonic flight including the X-15, later serving as chief of NASA's High-Speed Flight Station at Edwards, California. In 1958, Williams joined the STG at Langley.

**BOTTOM LEFT** Robert Thompson in the MCC during the successful unmanned MA-4 flight on September 13, 1961. Another STG member, he was a Navy veteran who was in charge of Mercury recovery operations.

**BOTTOM RIGHT** Two NACA veterans share a light moment: flight chief George Low (*left*) and chief flight director Chris Kraft. Low was an aerospace engineer with great organizational skills who had moved to NASA Headquarters in 1958. Kraft had worked under Gilruth at Langley and became an STG member, joining NASA when the new space agency absorbed the STG in late 1958. He was assigned to the flight operations division and created the concept of a team of engineers monitoring all aspects of a mission from a control center.

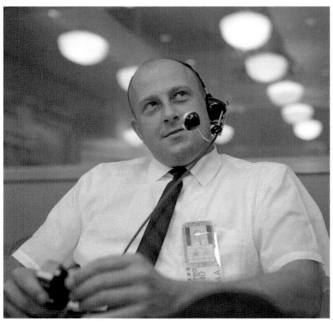

G. Merritt Preston chairs a meeting about MR-3 preparations in April 1961. At NACA, he had worked at Langley and the Lewis Flight Propulsion Center in Cleveland, Ohio. Preston joined the STG in 1959 and became chief of the Preflight Operations Division for Mercury in 1961.

Charles Mathews during the preflight meeting for MR-3 on May 1 at Hangar S. He had brought Kraft into the STG, grooming him to be Mercury flight director; Mathews would soon move on to Gemini and Apollo program planning and was named Gemini program manager later that year. His deputies as operations division chief at Langley had been Kraft and Preston.

The May 1 preflight meeting at Hangar S cleared the first manned mission for launch five days later. *Seated, left to right:* Deke Slayton, Gus Grissom, and Warren North. North was a former test pilot who joined NACA and was chief of manned satellites when it became part of NASA. He had gone through the astronaut candidate tests with them at the Lovelace Clinic. He later moved to Houston and reported to Williams as MSC Flight Crew Operations chief. His twin brother, Gilbert, was a McDonnell engineer who served as a "test astronaut." Behind North is Kenneth Nagler with the US Weather Bureau.

*Left to right:* Scott Carpenter, Glenn, and Walter "Kappy" Kapryan during a meeting in December 1961 about Glenn's upcoming MA-6 flight. Kapryan was an aeronautical engineer who joined NACA in 1947, moved to the STG, and was named project engineer for the MR-1 spacecraft. He would eventually become director of Launch Operations at the Kennedy Space Center during Apollo.

Webb talks with NASA Cape security officer Charles Buckley on Grand Bahama Island after MR-4 on July 21, 1961. A former Massachusetts state trooper, Buckley joined the Atomic Energy Commission Security Force in 1947. He came to NASA at the Cape in 1960 and was a racing partner of Cooper.

Gilruth (*left*) with Langley Research Center director Floyd Thompson and Williams in Hangar S. Thompson was an aeronautical engineer who joined Langley in 1926, becoming associate research director in 1952 and center director in 1960.

 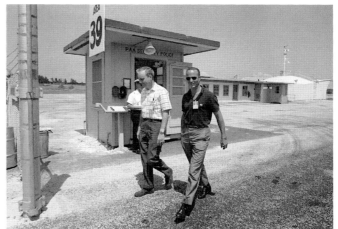

TOP  A Pan American World Airways police officer stands watch at Building 5-1540, the Forward Medical Station, in Area 39 where the Mercury Seven were having lunch with Dr. William Douglas several days before MR-3 in May 1961. Pan Am provided security, fire, and ambulance service to Cape Canaveral Missile Test Annex and the Atlantic Test Range under contract with the USAF. This facility, near Hangar S, could provide emergency surgical services for the astronauts and included a dining room and a kitchen that prepared the preflight astronaut meals.

BOTTOM LEFT  *Left to right:* Wally Schirra, Glenn, and Cooper, gesturing to NASA senior photographer Bill Taub, pass the guard shack, with Dr. Douglas and Carpenter behind them.

BOTTOM RIGHT  Dr. Douglas and Carpenter depart. At launch, Dr. Douglas and a scuba diver would be stationed here in a helicopter to speed toward the astronauts in case of an emergency.

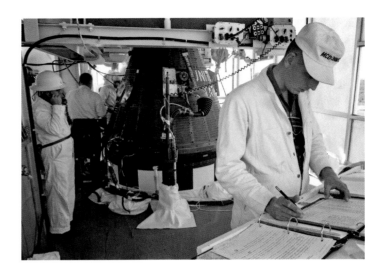

**TOP** McDonnell technicians conduct checkouts of MR-3 in the white room at Pad 5 in April 1961. An open door at center exposes the periscope and the ground checkout umbilical receptacle below it, which supplied freon for cabin and suit cooling. The umbilical plug was ejected forty-five seconds before launch. The total Cape work-force, numbering several thousand for Mercury, was a mix of NASA civil servants, contractor employees, and military personnel.

**BOTTOM** LC-5 workers at the base of the 59-foot-tall Redstone MRLV-7 prepare it for the MR-3 mission. The military version of the reliable liquid-fueled inter-continental ballistic missile, however, lacked sufficient thrust for Mercury, so modified Redstones were used with lengthened fuel tanks. The mast at left supported an outboard cooling unit to reduce the heat inside the instrument compartment in the aft section at the top, which contained electronics, instrumentation, and the guidance system. Its black-and-white markings were to aid in tracking the booster's movements in flight.

**FACING PAGE** McDonnell's Joe Trammel peers out from the MR-4 hatch during checkout at LC-5 on July 17, 1961. Launch was set for the next day but was postponed by heavy clouds that would have limited photography. This spacecraft (no. 11) included the first actual window for the program and the first side hatch with explosive bolts to expedite crewman egress after splashdown.

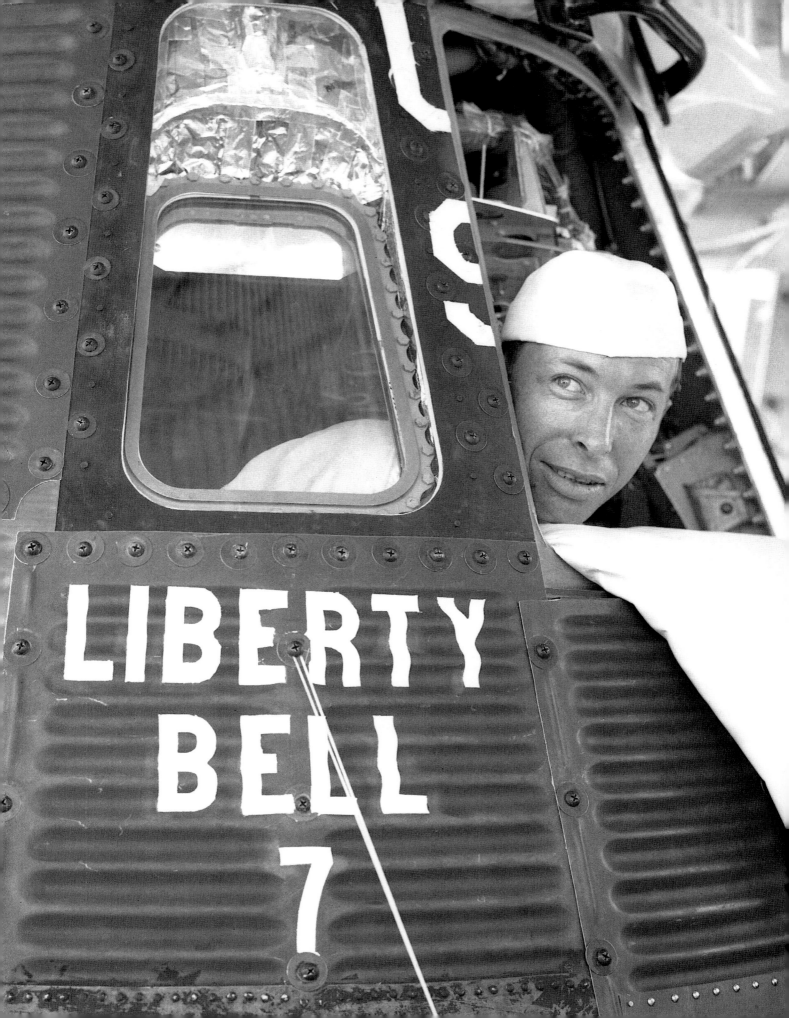

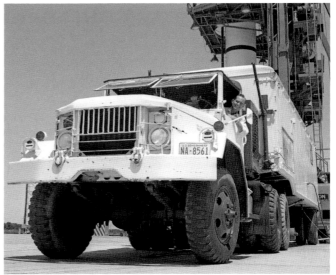

NASA's Phillip Whitaker rests on a tire during the countdown simulation on April 28.

**TOP RIGHT** The driver poses with NASA TV no. 1, the astronaut transfer "van" at LC-5 on April 28, 1961, during preparations for MR-3 in May. The combination was a customized semitrailer pulled by an REO tractor. It brought the crewmen from Hangar S to LC-5 (or LC-14 for orbital flights) in about twenty minutes on launch mornings.

**BOTTOM RIGHT** A worker monitors the final MR-3 simulated countdown at LC-5 with the transfer trailer parked next to him. The news that Shepard would likely be aboard leaked out the next day.

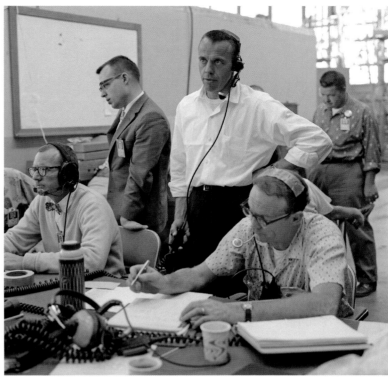

Schirra decided he would keep his preselection hair length, eschewing the closer military crop favored by the other six astronauts. Here he gets a trim in Cocoa Beach.

Shepard (*center*) monitors an altitude chamber test of his spacecraft in Hangar S in April 1961. Navy lieutenant and psychologist Dr. Robert Voas stands at left.

Glenn signs a "best regards" autograph for a Cape Canaveral police officer in front of Hangar S. Glenn was the most prolific signer of the Mercury Seven.

In a twist on the iconic Mercury Seven group photo in front of a Convair F-106B training jet at Langley AFB, Glenn tries his helmet on Powers (*center*) on January 20, 1961. *Left to right:* Carpenter, Cooper, Grissom, Glenn, Powers, Schirra, Shepard, and Slayton.

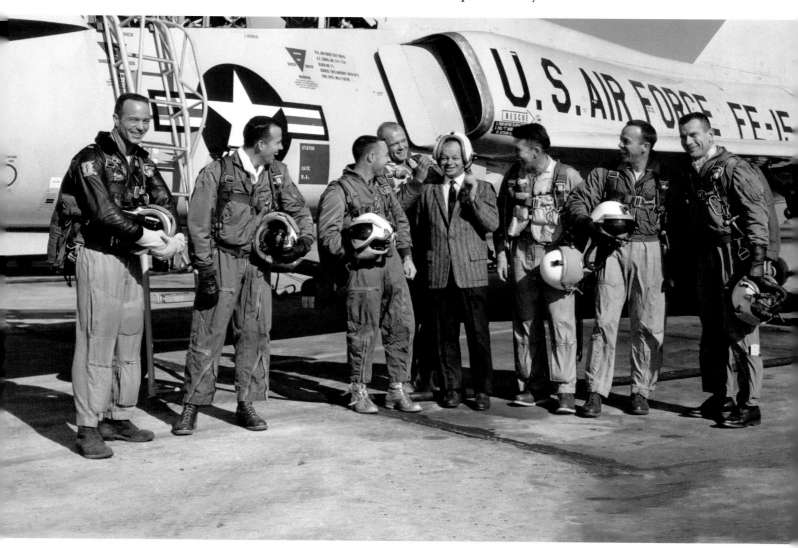

**TOP LEFT** Dr. Voas (*right*) goes over a chart of the Atlantic off the Florida coast with Grissom (*left*) and Glenn during an MR-3 briefing in Hangar S in May 1961.

**TOP RIGHT** Powers takes notes during an MR-3 management meeting on May 1, 1961. A World War II cargo pilot, he was assigned to the personal staff of Maj. Gen. Bernard Schriever with the Air Research Development Command in Los Angeles in the late 1950s. Powers handled the public information for the USAF's ballistic missile program, and his experience with public affairs caught the attention of T. Keith Glennan, NASA's first administrator. Powers was detailed to the STG in April 1959 as its public affairs officer.

**BOTTOM LEFT** Powers (*left*) and Carpenter attend a presentation at Langley in 1960, when Max Faget and Shepard explained various aspects of Project Mercury for members of Congress.

**BOTTOM RIGHT** Powers monitors communications from his console in the MCC. Very early on April 12, 1961, a UPI rewrite man in Washington, DC, roused Powers from sleep at Langley seeking comment on the flight of Soviet cosmonaut Yuri Gagarin, the first person in space. Powers replied, in part, "We're all asleep down here," which made headlines.

**TOP RIGHT** Powers and Buckley head for Grand Bahama Island aboard a USAF C-54 Skymaster to greet Shepard following his MR-3 flight on May 5, 1961.

**MIDDLE RIGHT** *Left to right:* Dr. Voas, Grissom, Slayton, and USAF Col. Keith Lindell wait for Shepard to arrive on Grand Bahama Island on May 5, 1961. Lindell had joined the STG as the USAF's liaison for the Astronaut and Training Group and became its chief.

**BOTTOM RIGHT** Powers (*left*) with Col. Lindell. Some thirty-two specialists joined in the Grand Bahama debriefing, including program managers, operations physicians, engineers, photographers, and public relations personnel.

**BOTTOM LEFT** Powers, en route to Grand Bahama Island, goes over the public affairs plans for Shepard's postflight activities.

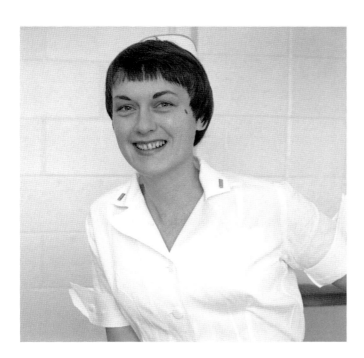

Lt. O'Hara at Hangar S in July 1961. Born in Nampa, Idaho, the 24-year-old USAF nurse came to Mercury from the Patrick AFB Hospital in 1960. She was the crewmen's primary medical contact and personally supervised preflight meal preparation and service for the astronauts by a dietitian.

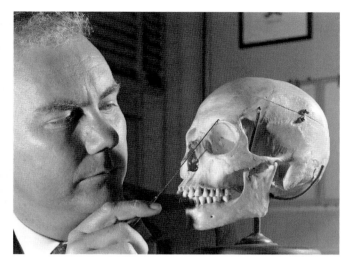

FACING PAGE O'Hara works with a temperature and humidity stability chamber in the Hangar S clinic. She stayed with NASA through 1997.

TOP LEFT Dr. Douglas goes over an EKG graph readout of Grissom after a centrifuge run on April 4, 1961. Douglas, who sometimes wore his own Mercury pressure suit in the centrifuge, carefully monitored the astronauts before and after each session.

TOP RIGHT Dr. Douglas examines a human skull in his office at Patrick AFB. A USAF lieutenant colonel and flight surgeon at the Langley AFB hospital, he was named as the Mercury Seven's personal physician on April 1, 1959. Douglas served through the first four manned flights before becoming assistant deputy director for bioastronautics at Patrick.

BOTTOM LEFT Dr. Bill Augerson (*left*) with Dr. Douglas during centrifuge training for Shepard, Grissom, and Glenn at the Aviation Medical Acceleration Laboratory at the Navy Air Development Center in Warminster, Pennsylvania, on April 4, 1961. Augerson came to the STG in 1958 from Redstone Arsenal and was assigned to the Human Factors Section, where he worked on the development of life systems for Mercury. A Navy veteran, he later joined the US Army and was Army liaison officer for bioastronautics research at the USAF Aeromedical Laboratory in 1958. He and Douglas both took centrifuge runs themselves.

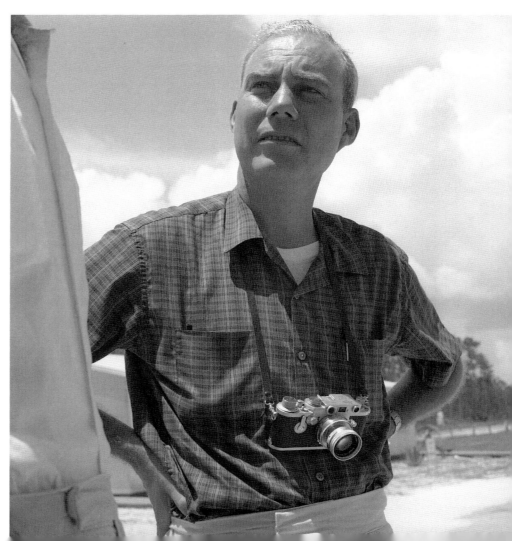

**TOP** Dr. Douglas in the white room during MR-4 checkout at LC-5 on July 12, 1961. As flight surgeon, he accompanied the astronauts to the pad in the transfer trailer, and the spacecraft hatch could be closed only after he was satisfied that the pressure suit, biosensors, and pilot were all ready. He then moved to the forward medical station to wait for launch.

**BOTTOM** Dr. Douglas at Grand Bahama Island following Grissom's MR-4 mission on July 21, 1961. His daily routine would often mirror that of the astronauts, and he would undergo many of the same tests. Goodrich also produced "research" Mercury pressure suits for Douglas, Schirra, and Warren and Delbert North.

Dr. Graybiel goes over a cochlea model with Carpenter in Pensacola, Florida, in August 1961. He conducted many experiments on how acceleration affects the structures of the inner ear, the circulatory system, and muscle control and was a pioneer in studying equilibrium and microgravity.

*Left to right:* Dr. Douglas, Grissom, Slayton, and Lt. O'Hara aboard the flight from Patrick AFB to Grand Bahama Island after MR-3.

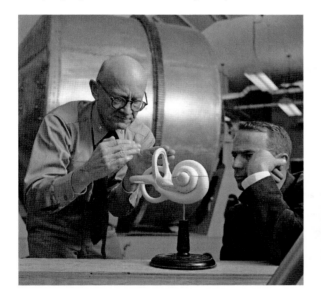

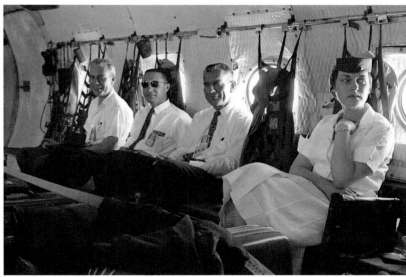

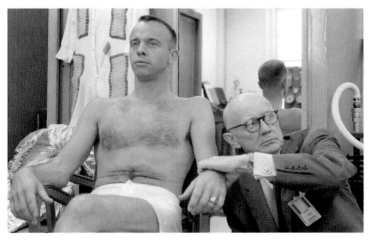

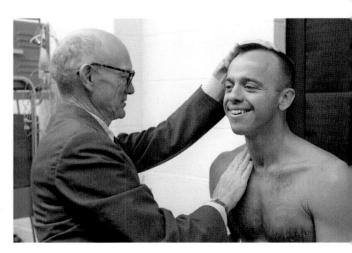

**BOTTOM TWO IMAGES** Dr. Ashton Graybiel, director of the US Navy School of Aviation Medicine in Pensacola since 1940, examines Shepard during a preflight physical on May 1, 1961. Graybiel was a cardiologist who had been an early Mercury consultant.

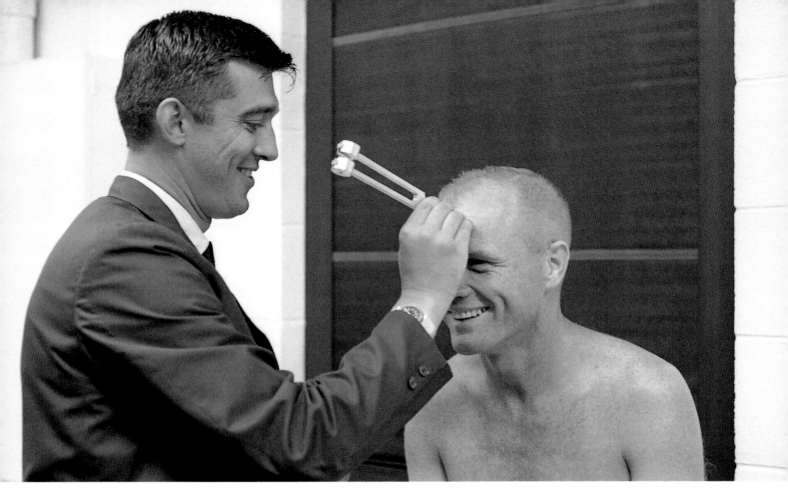

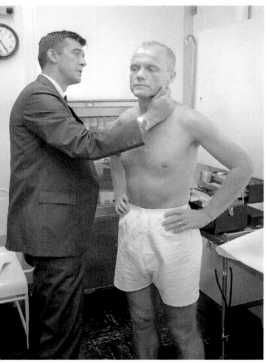

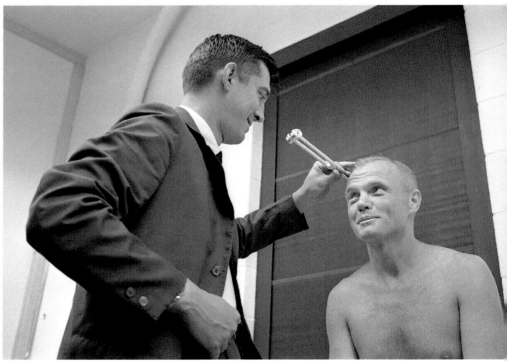

Dr. Carmault Jackson of the Aerospace Medical Branch examines Glenn in Hangar S during his physical as backup before Shepard's planned MR-3 launch on May 1, 1961. He uses a tuning fork to check Glenn's hearing. Jackson, another former STG staff member, was a USAF internist who was responsible for the pre- and postflight astronaut medical examination protocols.

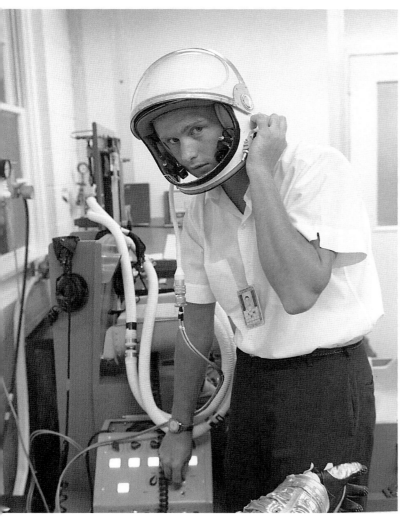

**TOP LEFT** NASA suit technicians Alan Rochford (*left*) and Joe Schmitt, formally known as equipment specialists, enjoy coffee at an MA-6 party and dance at the Cocoa Beach Holiday Inn in March 1962. Glenn and his family attended. The hotel also served as a hub for NASA and the news media.

**TOP RIGHT** Schmitt relaxes inside the astronaut transfer trailer during MR-4 preparations. He was the primary suit tech for all Mercury fights except Schirra's, when Rochford took the lead. A NACA and STG veteran, Schmitt's Army Air Corps experience as an aircraft mechanic and parachute rigger led to his selection as NASA's first suit tech.

**BOTTOM** Rochford checks the mic and earphones in Grissom's helmet in the Hangar S suit room on July 19, 1961. The thin white cable on the helmet's right side was connected to the spacecraft's audio system once the astronaut had ingressed. Rochford had been a Navy corpsman at the School of Aviation Medicine who taught pilots about high-altitude oxygen use. He joined the STG at Langley in 1960 to support the new Hangar S altitude chamber.

**TOP**  Schmitt carefully prepares a fitting for the hex nut that was part of each suit's blood pressure monitoring connector. The suits weighed no more than 22 pounds and were custom-tailored for each astronaut.

**BOTTOM**  Rochford pressurizes an empty suit in the Hangar S suit room. He missed Carpenter's launch because of his wedding in Pennsylvania two days earlier.

**FACING PAGE**  Schmitt monitors a leak check in the suit room at Hangar S. He had designed the instrument panel at center to check out the suits. The closed-loop system provided pure oxygen to the astronaut; his exhaled carbon dioxide was filtered and reused.

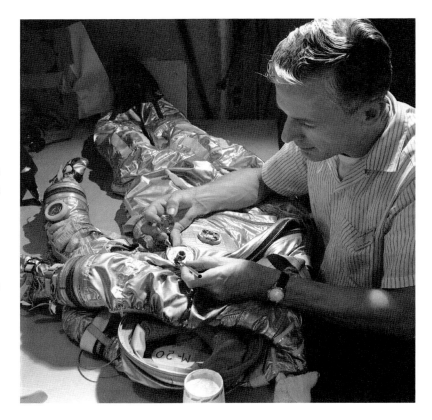

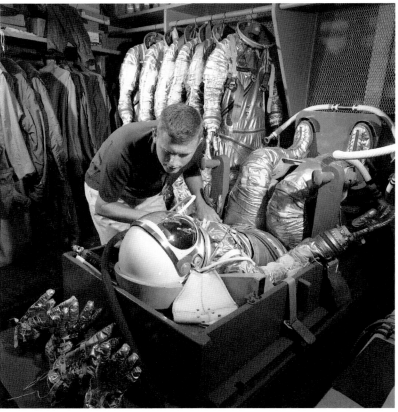

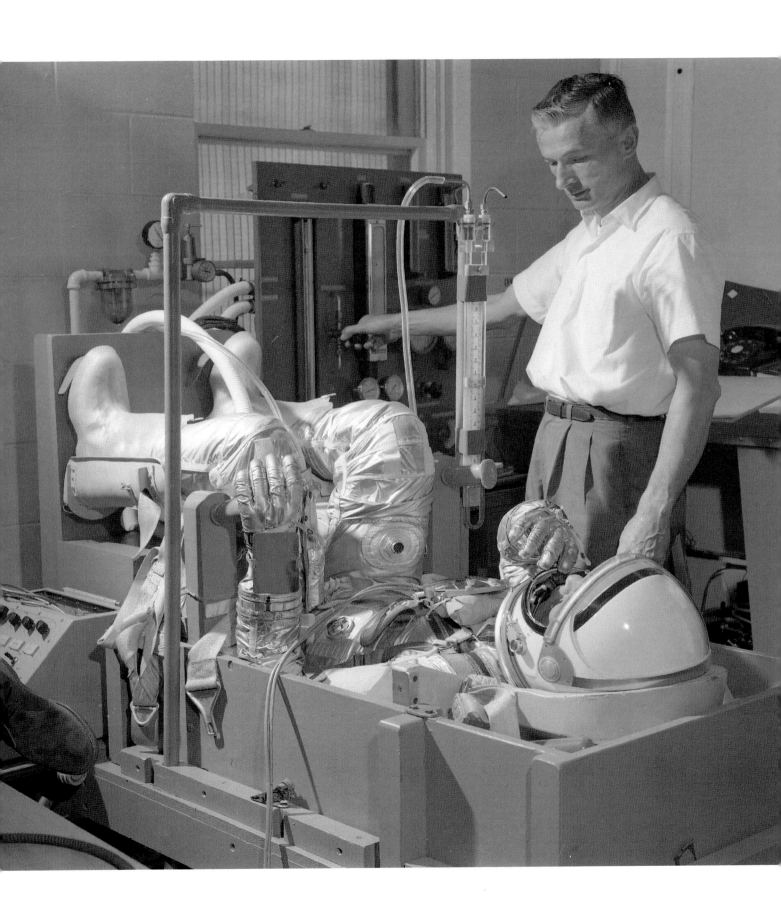

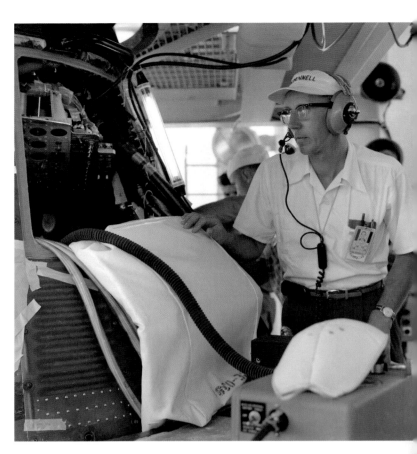

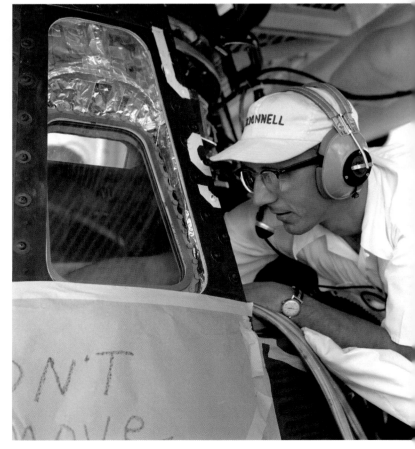

**TOP LEFT** McDonnell pad leader Guenter Wendt in the white room during MR-3 checkout on April 28, 1961. Dubbed the "pad fürher" for his German accent and a strict commitment to procedures and safety, he was the last face the astronauts saw through their window before the pad was cleared for launch.

**TOP RIGHT** Wendt during the MR-4 simulated flight at LC-5 on July 10, 1961. A German-born mechanical engineer hired by McDonnell in St. Louis after he became a US citizen in 1955, Wendt was firmly in charge of white room operations.

**BOTTOM** Wendt reaches into spacecraft no. 11 during a simulated MR-4 flight at LC-5 on July 10, 1961.

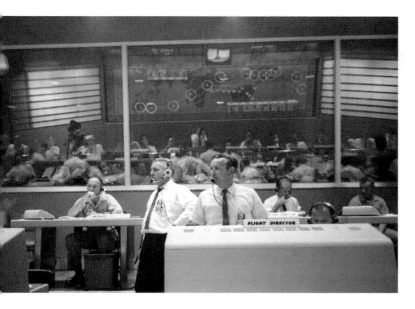

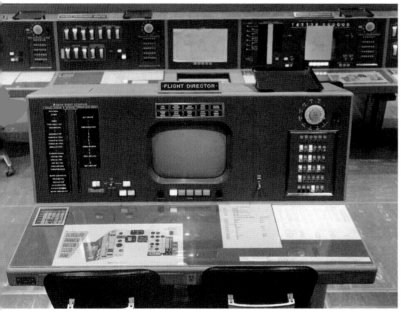

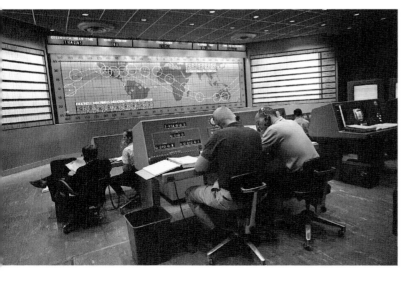

**TOP** Chief flight director Kraft stands behind his MCC console at center, with Williams at left during the unmanned MA-4 flight on September 13, 1961. The tracking display and side screens are reflected in the large windows of the viewing room at rear. The building was a little more than 1.5 miles from LC-5; the blockhouse was just 300 feet from the pad.

**MIDDLE** Kraft's console included a display of mission events at left, indicator lights above the video screen showing the status of each controller, and buttons to select various communication loops at right. An illustration of the spacecraft's control panel is beneath glass at lower left.

**BOTTOM** The front of the MCC was dominated by a large Earth orbital tracking map, flanked by data readout screens. Controller Eugene Kranz (*left*) sits at the recovery status console during a simulation.

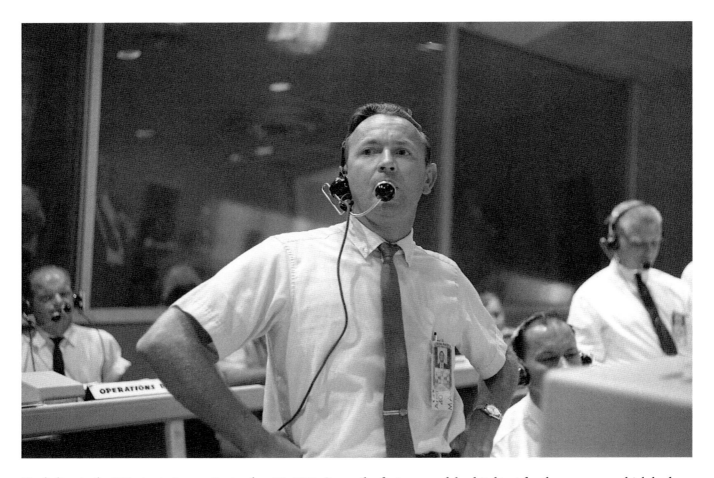

Kraft directs the MA-4 mission on September 13, 1961. It was the first successful orbital test for the program, which had the so-called "talking robot" (the Crewman Simulator instrument package) in the cockpit. Voice tapes aboard tested the tracking network. Kranz stands at right.

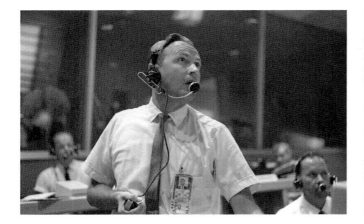

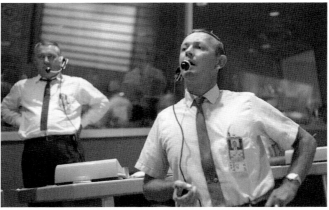

Powers is at left.

Williams stands at left.

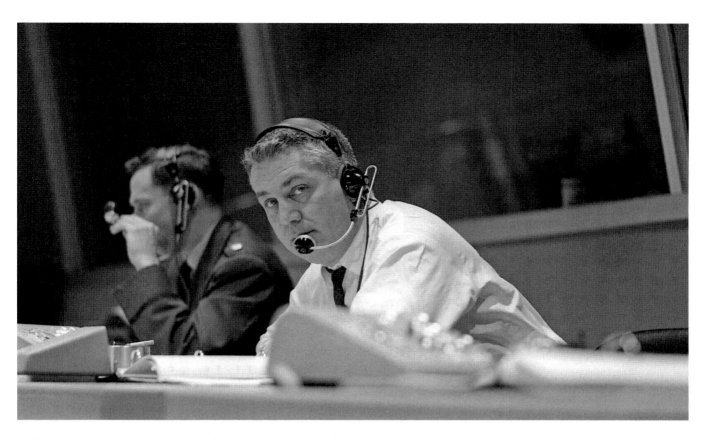

Williams at his operations director desk in the back row of the MCC, with the USAF Network Control officer at left.

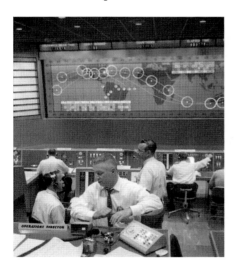

Williams pauses in front of his desk, with Kraft behind him at right. NASA's worldwide network of eighteen tracking stations and ships is shown by illuminated circles on the front display screen.

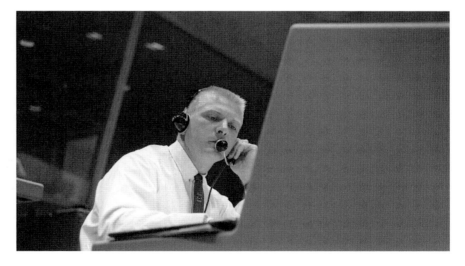

Kranz, who had been part of the STG staff, was initially assigned by Kraft to be the MCC procedures officer, coordinating with other Mercury operations such as tracking and recovery.

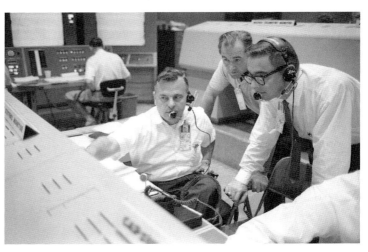

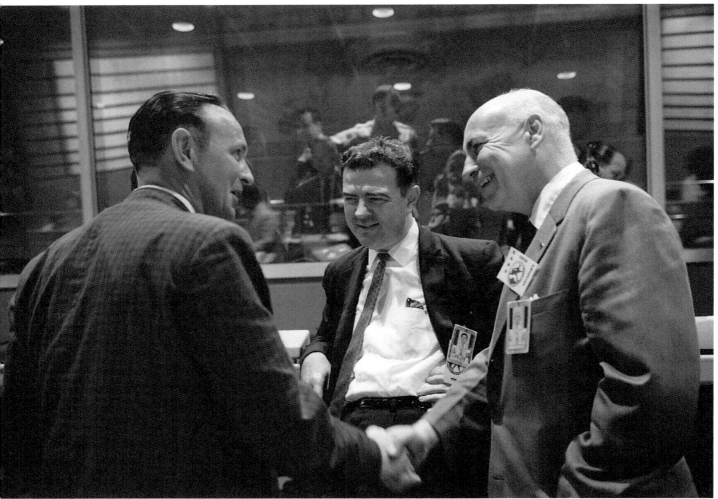

**TOP LEFT**  Shepard (*left*) and Kraft are all smiles in the MCC after the MA-4 mission on September 13, 1961.

**TOP RIGHT**  Kapryan (*left*) at his capsule systems monitor console in the MCC during MA-4 confers with Richard Hoover, MCC Design Section chief (*right*).

**BOTTOM**  Gilruth congratulates Kraft in the MCC, with Mathews at center, following the MA-5 mission on November 29, 1961.

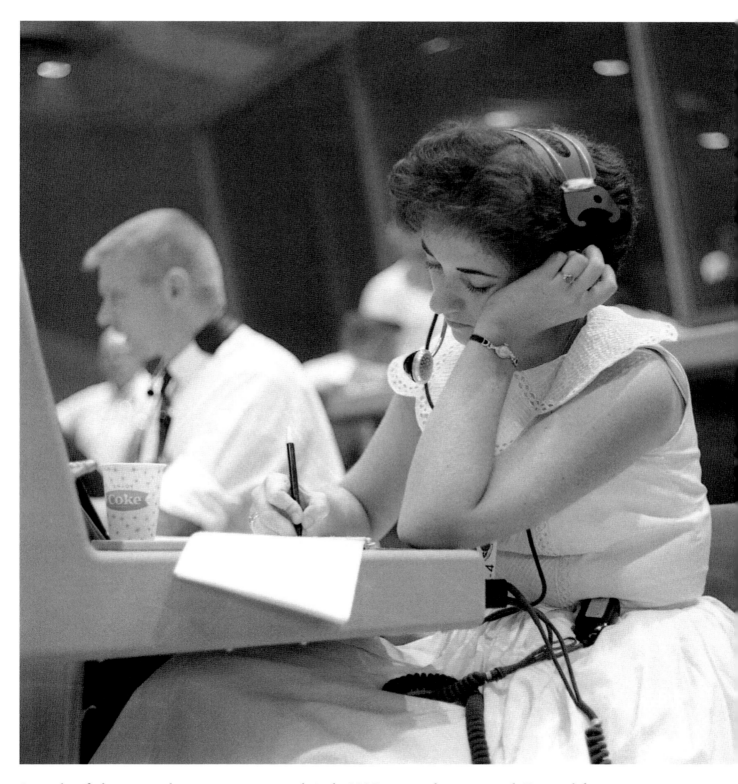

An unidentified woman at the recovery status console in the MCC, a rare sight in 1961, with Kranz at left.

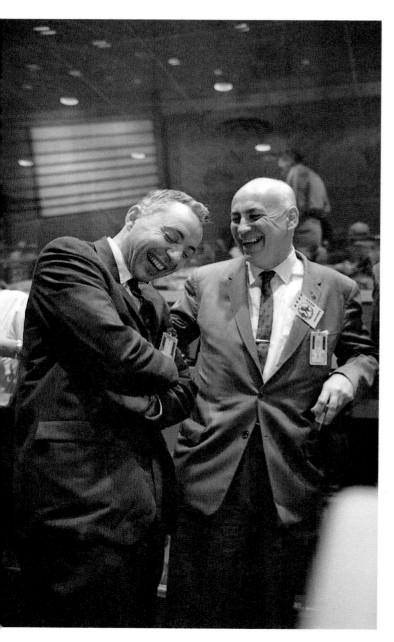

Holmes and Gilruth in the MCC after the MA-5 mission on November 29, 1961.

Kraft wraps up a long day after the MA-4 mission.

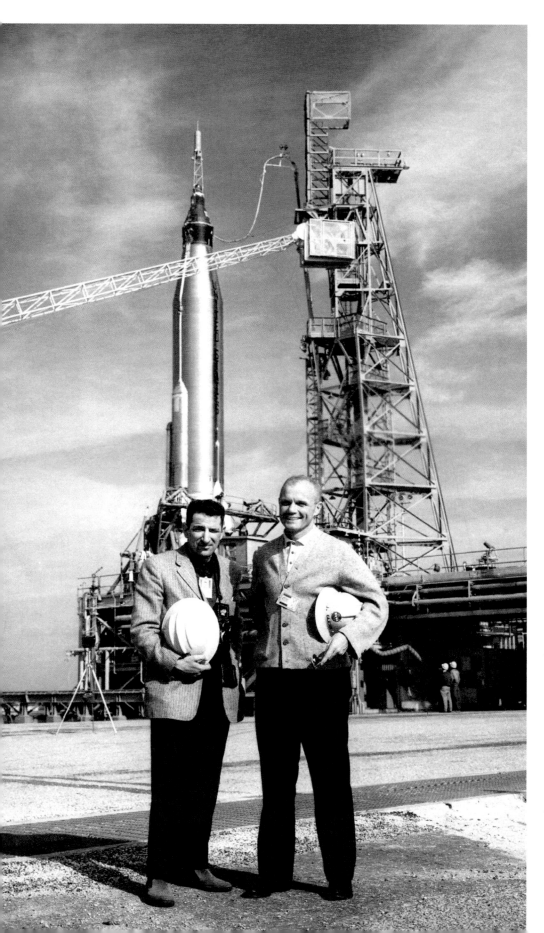

Taub poses with Glenn at LC-14 during preparations for Glenn's MA-6 launch. The agency's first official photographer, Taub had worked for NACA and joined the agency as part of the STG in 1958. The service structure has been rolled away from the Mercury-Atlas behind them, with the cherry picker extended near the umbilical tower.

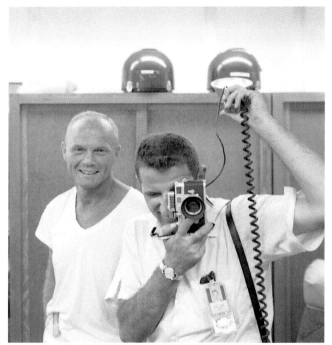

**TOP** Motion picture photographer Larry Summers, with NASA contractor Technicolor, flies from Grand Bahama Island to Andrews AFB near Washington, DC, with Shepard on May 8, 1961. He holds an Arriflex S 16 mm silent film camera. Shepard was heading for a White House medal ceremony with President Kennedy.

**BOTTOM LEFT** Taub at LC-5 with the no. 8 Redstone booster for MR-4 behind him.

**BOTTOM RIGHT** Taub (*right*) with Glenn in the Hangar S suit room in early 1961.

# 3

# Alan Shepard

Mercury-Redstone 3

On April 12, 1961, the Soviet Union startled the world by launching cosmonaut Yuri Gagarin on a one-orbit flight with no advance notice—the first human in space. Three weeks later, the United States lofted astronaut Alan B. Shepard Jr. 116 miles above the Earth—about as high as Gagarin but only about 300 miles out over the Atlantic Ocean, splashing down off the Bahamas. The fifteen-minute flight put the US in the game of manned space flight, but to the American public also disappointingly behind. Many worried the Soviets, locked in a Cold War with the US, had gained a dangerous military superiority.

Shepard's flight, the first manned mission of Project Mercury, was aboard a spacecraft he named *Freedom 7* launched by NASA on a modified Redstone missile from Launch Complex 5 (LC-5) at the Cape Canaveral Missile Test Annex, a USAF facility on Florida's central Atlantic coast.

The primary goals were familiarizing a man with a brief but complete space flight experience, evaluating his ability to perform useful functions, including controlling the spacecraft and communicating with the ground. The final objective was studying the pilot's physiological reaction to even such brief space flight.

The flight was planned for May 2, but rainy weather forced delays until May 5. Although NASA officials had selected Shepard from among three of the seven Mercury astronauts weeks earlier, his choice wasn't disclosed until the morning of the May 2 launch delay.

More than four hundred reporters from around the world were on hand, and although the hallmark of the US program, in contrast to that of the Soviet Union, was as much openness as possible, the White House was initially cautious about broadcasting the launch live in case of failure.

Shepard could distinguish major land masses using a periscope and make out coastlines, islands, and major lakes but had difficulty identifying cities. Earth photos were taken by an automatic camera in one of the spacecraft's portholes. He also briefly tested small thrusters to adjust the spacecraft's position, unlike Gagarin.

After recovery by USS *Lake Champlain*, Shepard spent two days on Grand Bahama Island for examinations and debriefings. He then flew to Washington, DC, to receive the NASA Distinguished Service Medal from President Kennedy at the White House and to hold a news conference for a grateful nation.

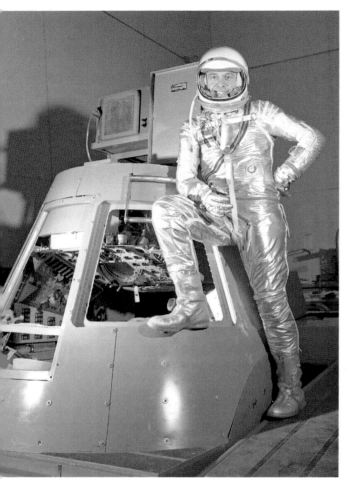

Shepard poses with Mercury Procedures Trainer no. 1 in Building 643 at Langley Research Center, Virginia, in 1960. It was one of two flight simulators built by the Link Trainer Company for McDonnell Aircraft at a cost of $2 million each. The second trainer was installed at the Mercury Control Center at the Cape. The trainer could simulate all Mercury system operations and about 275 separate system failures. In November 1961, this unit was moved to a Manned Spacecraft Center building at Ellington AFB near Houston.

Shepard had tried to attend the US Naval Academy at 16, and after a year of prep school, he enrolled and was graduated in 1944. He was commissioned as an ensign and served in the Pacific. Shepard won his Navy wings in 1947, and as an experienced test pilot he was among those invited to apply to become a Mercury astronaut. The commander is seen in this 1961 portrait at age 37.

## March 1961

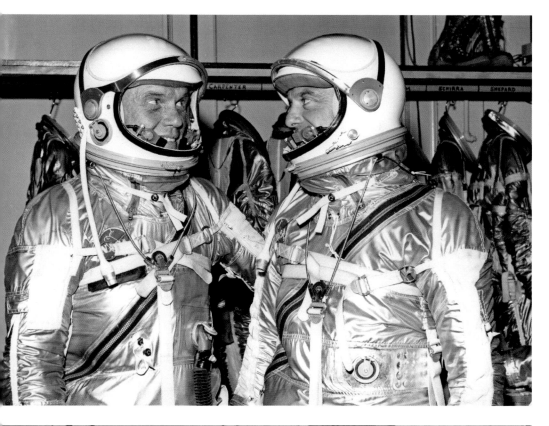

Shepard and John Glenn in the suit room at Hangar S for a session with ABC News. Footage would air in the TV special *Road to the Stars* on April 28, 1961.

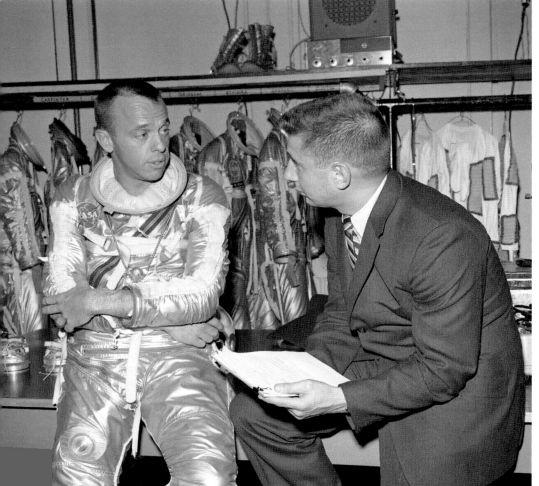

With the other crewmen's pressure suits behind them, Shepard (*left*) talks with ABC News science editor Jules Bergman before filming an interview. Bergman was a pilot and the first full-time network TV science editor.

**TOP TWO IMAGES** Shepard reacts to Bill Taub photographing him reading the *Miami Herald* in Hangar S. Schirra's and Deke Slayton's hard hats are seen in the closet at left.

**BOTTOM** Shepard (*left*) chats with Glenn, with Warren North of NASA Headquarters in the background.

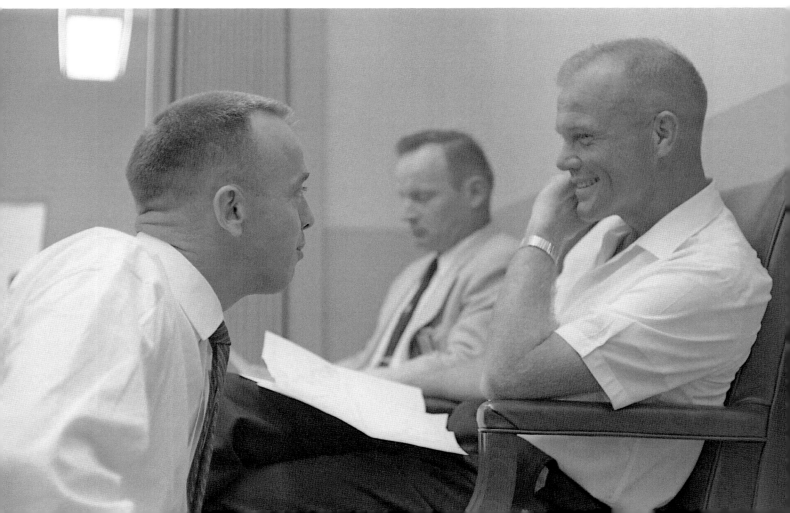

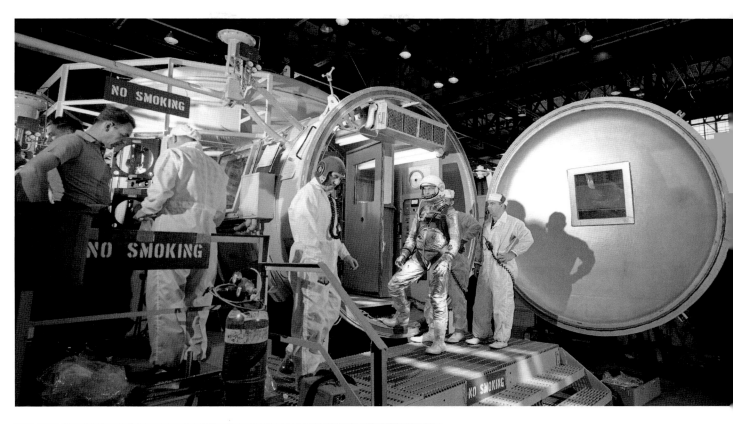

## April 1961

**TOP** Shepard prepares to enter the Hangar S altitude chamber airlock in early April. The chamber tested each spacecraft and allowed the astronauts to conduct simulated missions in a vacuum environment. It could simulate 42.6 miles in altitude and was 12 feet in diameter and 14 feet high. The chamber entered service in July 1960.

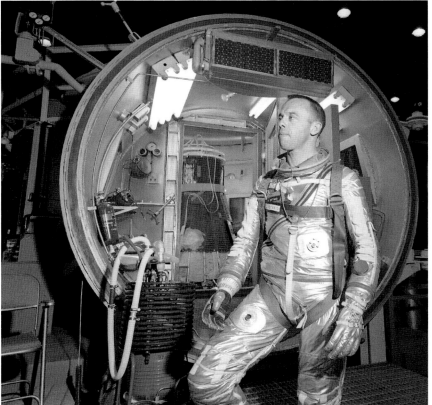

**BOTTOM** Shepard after an altitude test, with a Mercury spacecraft in the chamber behind him. For runs involving a spacecraft, the spacecraft was lowered through an opening in the top of the chamber. He used the portable suit oxygen compressor at lower left.

**TOP LEFT** Shepard goes over procedures during the checkout of *Freedom 7* in the Hangar S clean room. He had spent eighteen days getting more familiar with the spacecraft during the previous month alone. The name originally referred to spacecraft no. 7, but the other astronauts adopted the "7" theme as well as a tribute to the group.

**TOP RIGHT** Shepard poses at LC-6. Behind him, Mercury-Redstone 3 (MR-3) is on the pad at LC-5 surrounded by its service structure.

**BOTTOM** Shepard talks with McDonnell pad leader Guenter Wendt at LC-5 on April 6.

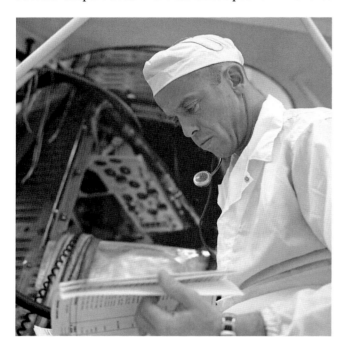

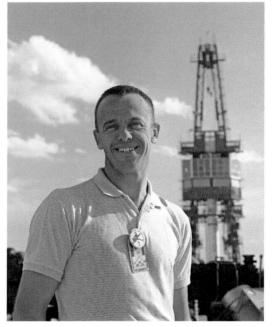

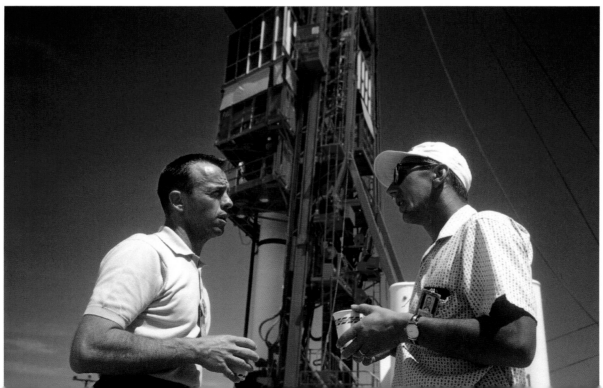

Shepard (*right*) poses with Taub in the LC-5 white room on April 6. They wear round area access buttons with their NASA ID badges.

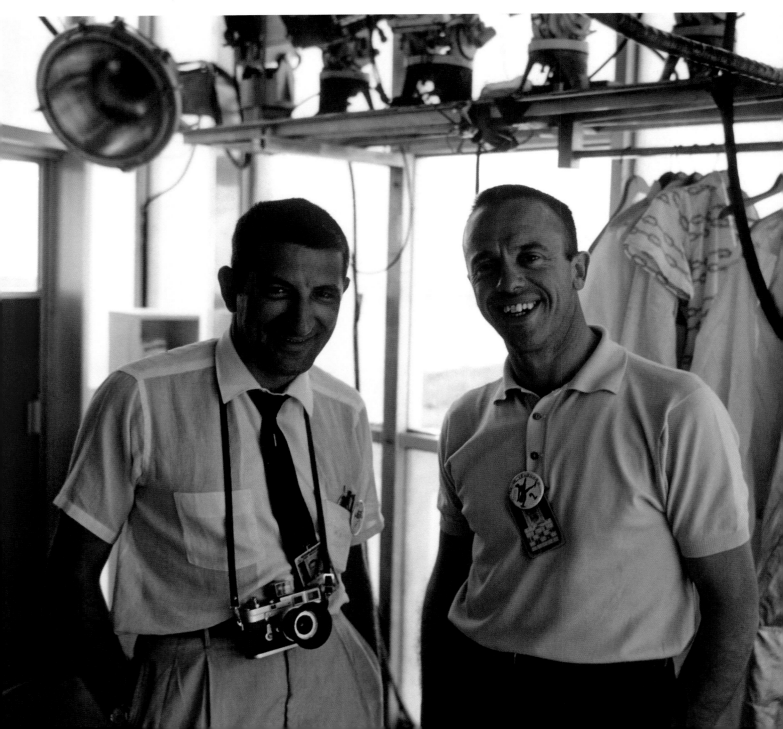

**TOP LEFT** Shepard goes over documents in the crew quarters in Hangar S. On April 12, cosmonaut Yuri Gagarin had stolen his thunder by not only becoming the first man in space but also the first to orbit the Earth.

**TOP RIGHT** Shepard visits *Freedom 7* shortly after it was mated to its Redstone booster at LC-5 on April 15.

**BOTTOM IMAGES** The cherry picker is tested at LC-5. The protective green fiberglass-covered enclosure was added to the mobile service structure after Hurricane Donna passed north of Cape Canaveral in September 1960. The structure was moved to and away from the booster on rails.

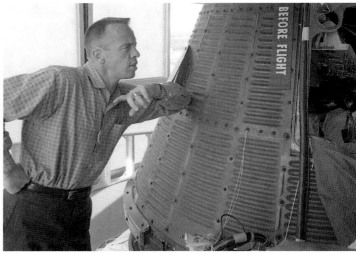

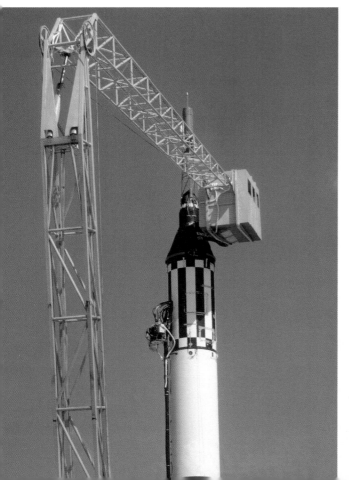

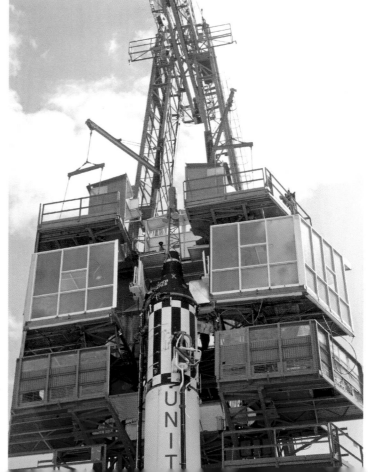

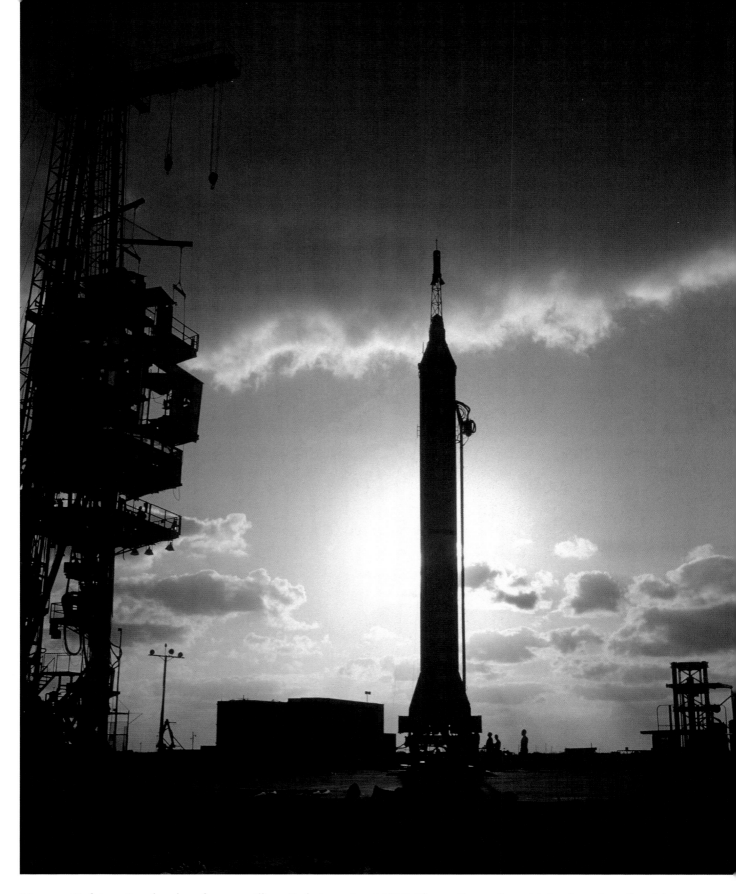

Mercury-Redstone 3 and pad workers are silhouetted at sunrise at LC-5. The cooling unit mast is in place along the right side of the booster, with the service structure parked at left.

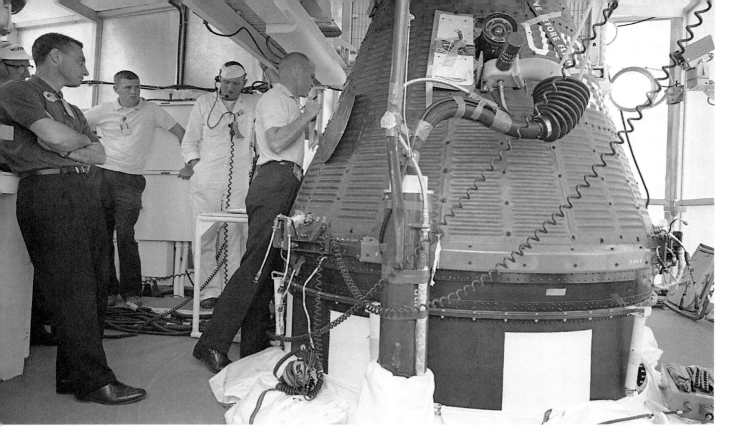

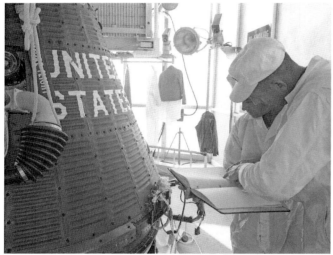

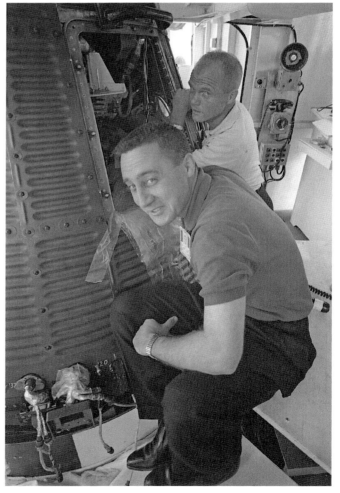

## April 28, 1961

**TOP** *Left to right:* Wendt, Gus Grissom, suit technician Alan Rochford, an unidentified technician, and Glenn participate in the final full flight simulation in the white room.

**BOTTOM LEFT** Technicians go over the procedures during the simulated countdown and flight.

**BOTTOM RIGHT** Grissom (*left*) and Glenn work at the spacecraft's hatch.

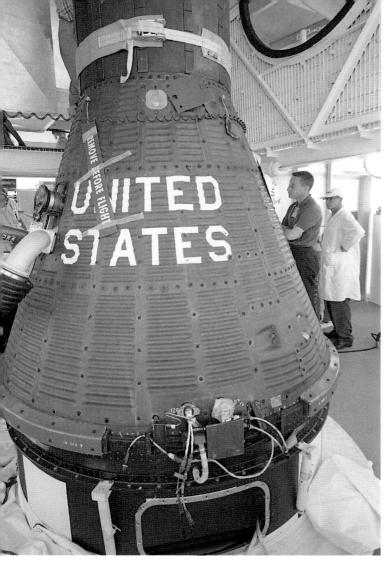

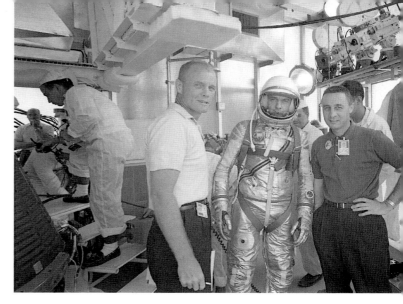

**TOP LEFT** An uncommon photo of the opposite side of *Freedom 7*, with Glenn visible at left and Grissom at right. A work platform is hinged open at upper right.

**TOP RIGHT** Glenn and Grissom pose with Shepard as he arrives for the simulation. Note the bank of 35 mm Mitchell movie cameras with 1,000-foot film magazines at upper right.

**BOTTOM** Shepard prepares to enter *Freedom 7*. His flight suit is no. M-22 from Goodrich. The helmet used twin Roanwell mics and two earphones, which were each on individual circuits for redundancy. They were the smallest compatible mics and earphones available.

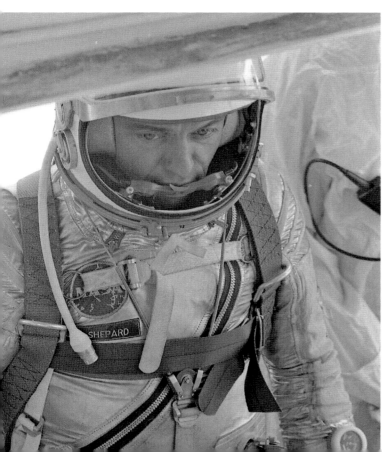

**TOP LEFT** Glenn examines a document near the spacecraft's extended periscope lens, with Grissom at center. The gantry for LC-6 is visible through the window at right.

**TOP RIGHT** Shepard gets settled aboard *Freedom 7* for the flight simulation.

**BOTTOM** Wendt inspects the spacecraft hatch cover, with one of two porthole windows and its preflight cover at right. Grissom looks on. The temporary grab bar above the hatch facilitated ingress and egress.

**FACING PAGE** Technicians monitor a Redstone fueling test at LC-5. Frost on the LOX tank obscures some of the lettering on the booster.

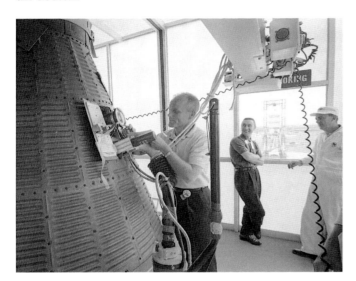

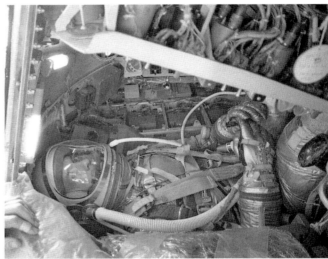

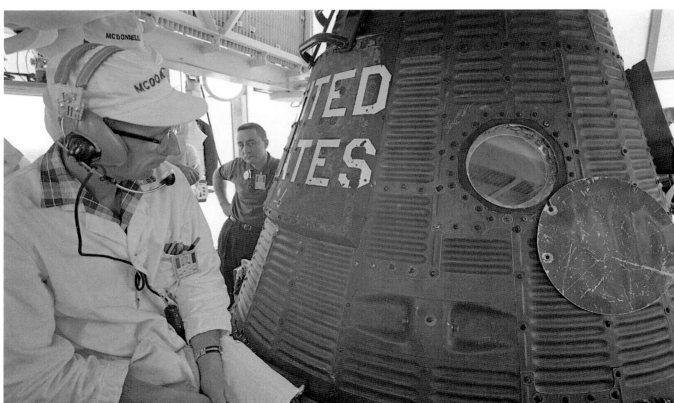

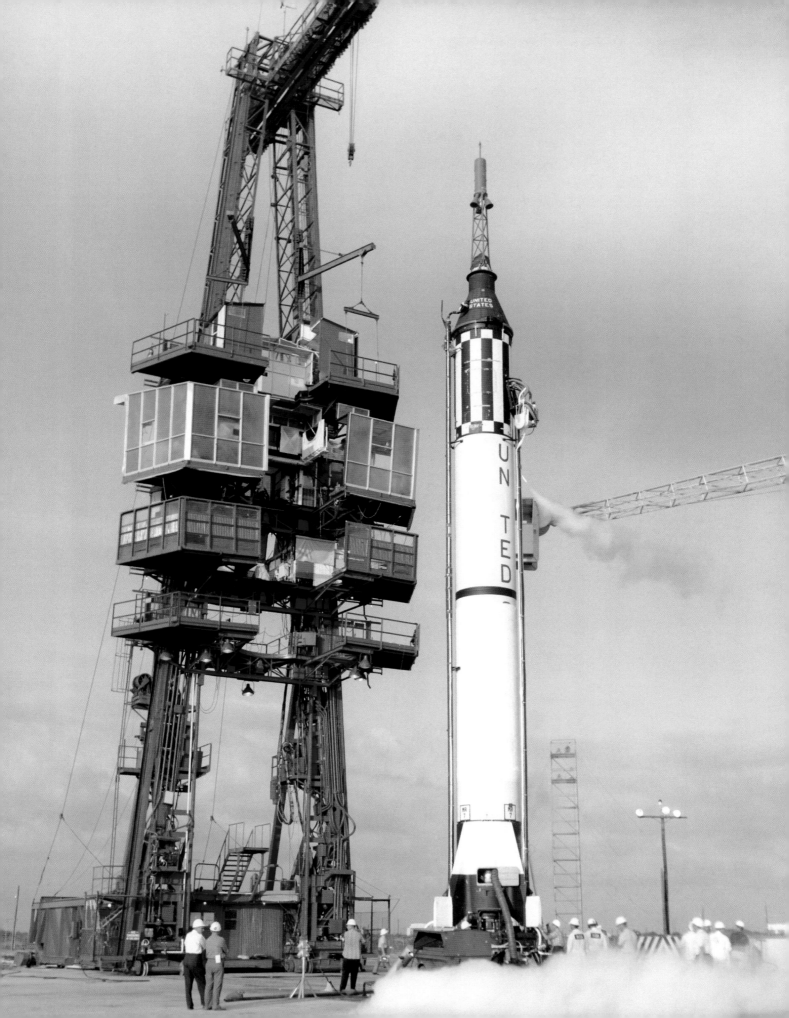

## May 1, 1961

**TOP** Shepard at part of the L–1 (liftoff minus 1 day) medical examination at Patrick AFB. He and Glenn had been otherwise quarantined at Hangar S, where the exam would conclude, for three days. Shepard's selection to be the first American in space, however, would not be publicly announced until before his planned launch the next morning. News reports had predicted it would be Shepard or Glenn, with Shepard the favorite.

**MIDDLE** Flight surgeon Dr. William Douglas (*left*) joins Glenn and Shepard for the final preflight briefing in the Hangar S conference room on May 1.

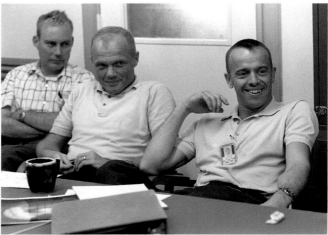

**BOTTOM** Suit technicians Joe Schmitt (*left*) and Rochford make sure Shepard's suit will be ready for the next morning.

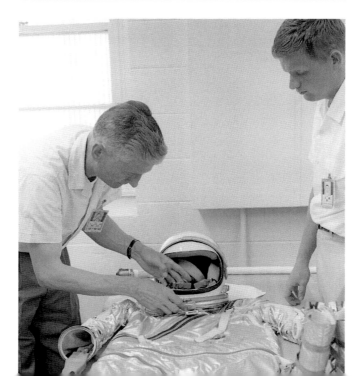

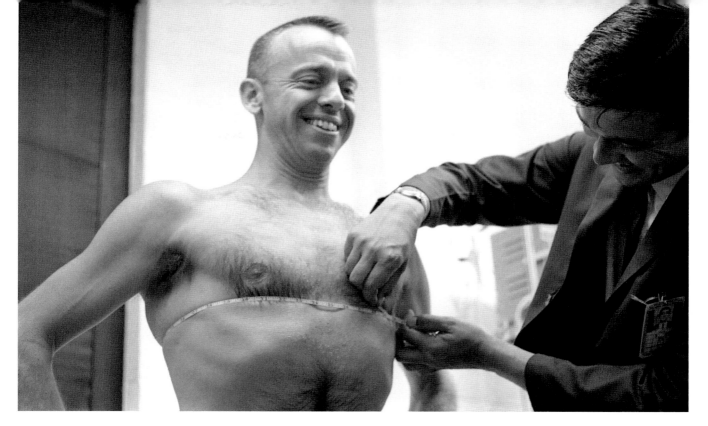

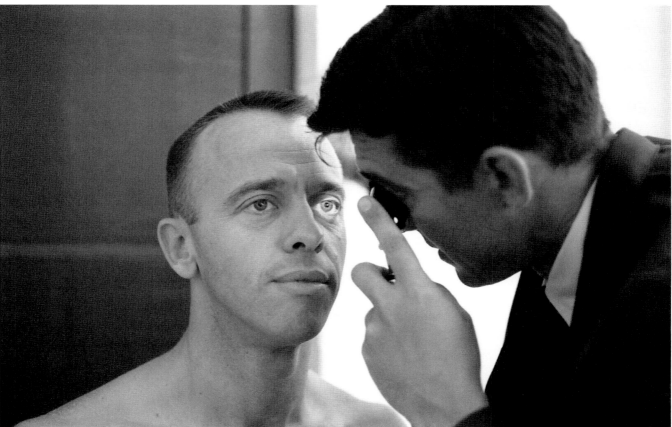

Shepard is examined by Dr. Carmault Jackson in the Hangar S clinic on May 1. The attending psychiatrist noted the "pilot appeared relaxed and cheerful. He was alert and had abundant energy and enthusiasm." Most of the examining team then left for the NASA clinic on Grand Bahama Island, where Shepard would be brought after recovery.

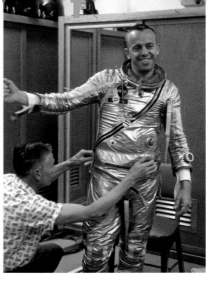

## May 2, 1961

**TOP** Schmitt (*left*) adjusts Shepard's custom-tailored suit in the suit room on the morning of the first launch attempt, May 2. The suit had thirteen zippers.

**MIDDLE** Dr. Douglas tests Shepard's mics and earphones while they wait for a decision to head to the pad. This first attempt was scrubbed, however, because of rainy weather at 7:40 a.m. EST, two hours and twenty minutes before the launch time, and Shepard never left Hangar S. The flight was delayed forty-eight hours, in part to make a repair to the Redstone's liquid oxygen (LOX) feed line. CBS-TV interrupted *Captain Kangaroo* with an eight-minute special report.

**BOTTOM** Shepard's gloves, boots, and helmet in the suit room at Hangar S. The small oxygen bottle and hose, which could be connected to the left side of the helmet, would pressurize an inflatable seal when the visor was closed.

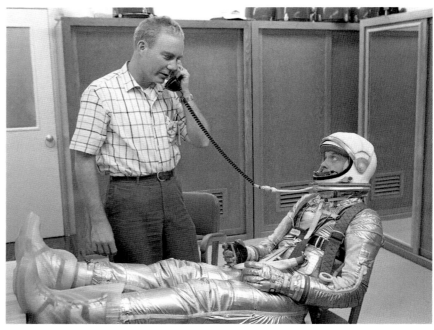

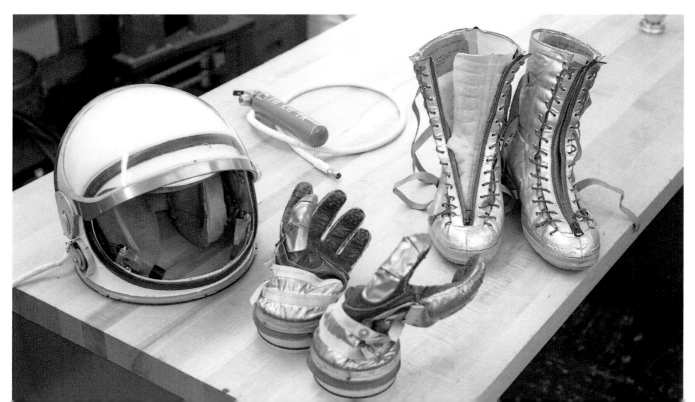

## May 5, 1961

**TOP** Launch Operations Directorate (LOD) chief Kurt Debus (*left*) and Space Task Group (STG) associate director of operations Walter Williams check weather maps on launch morning, May 5, at Hangar S. At right is Hulen "Luge" Luetjen, McDonnell spacecraft test conductor. The final phase of the countdown had begun at 12:30 a.m. EST.

**BOTTOM** Shepard (*left*) and his backup, Glenn, have a steak and poached eggs breakfast with peaches, sherbet, and orange juice on launch morning in the Hangar S conference room about 1:50 a.m. Others ate the same meal to better detect any pathogens.

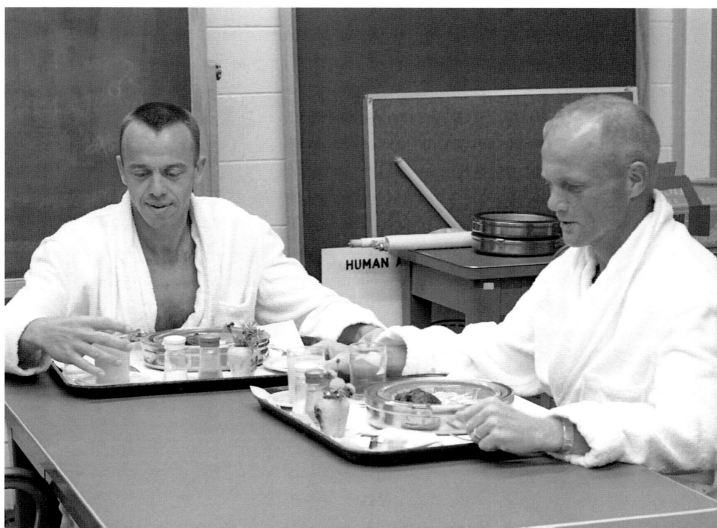

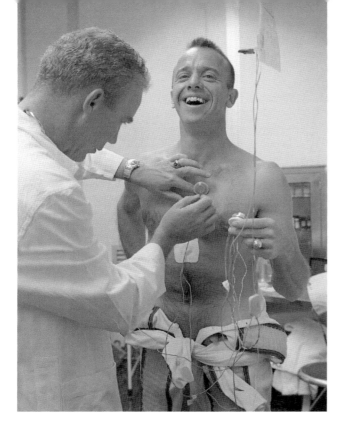

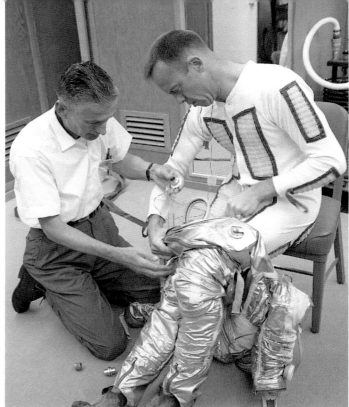

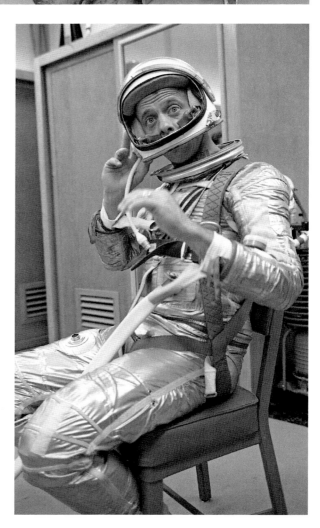

**TOP** Dr. Douglas glues one of four electrocardiogram electrodes to Shepard about 2:25 a.m., a process that takes some twenty-five minutes; each astronaut had the locations marked with small tattooed dots. Douglas also examined backup Glenn.

**MIDDLE** Schmitt (*left*) assists Shepard during suiting; the astronaut wears a cotton undergarment with vented Trilok panels for better air circulation, supplied by Goodrich.

**BOTTOM** Shepard, holding his communications cable, dons his helmet shortly after 3:00 a.m. The harness would secure him to the couch once inside the spacecraft.

**FACING PAGE, TOP** Shepard lies in the suiting couch as his pressure suit is checked for leaks. No Mercury spacecraft ever lost pressure during a mission, however, so the suits were never fully inflated. His closed visor is sealed with oxygen supplied from the test equipment through the thin white hose connected to the left side of his helmet.

**FACING PAGE, BOTTOM LEFT** Schmitt (*right*) adjusts a glove as Grissom waits in the background. The suit includes a pressure gauge on the left wrist.

**FACING PAGE, BOTTOM RIGHT** Shepard is ready to depart for the pad at 4:00 a.m. The wire cable would hold his helmet in place if the suit were fully pressurized.

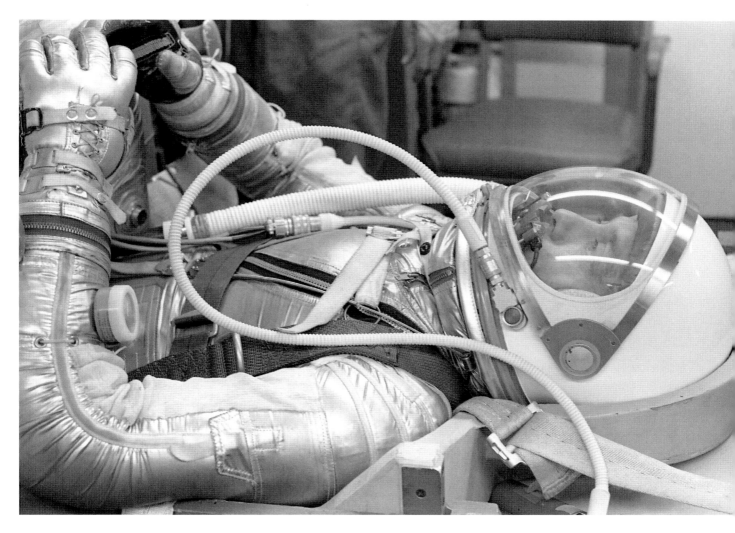

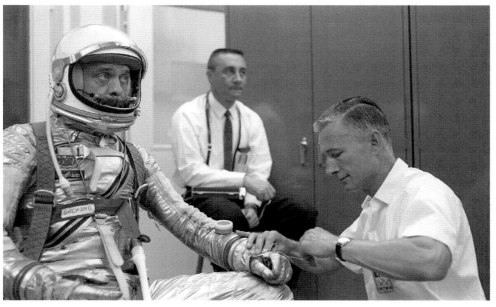

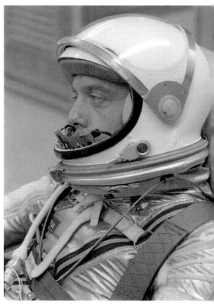

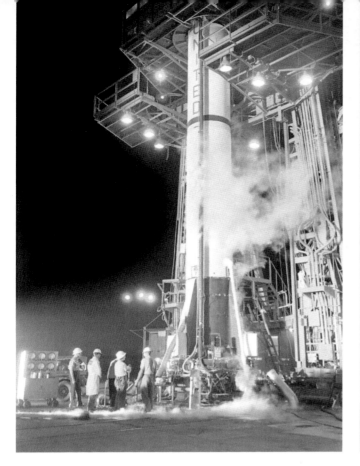

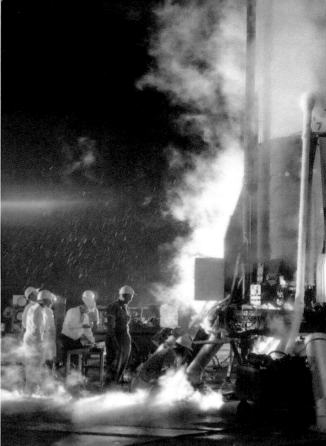

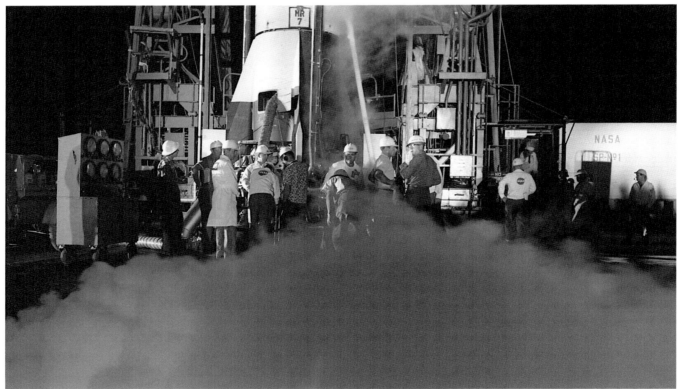

Technicians monitor loading the Redstone's oxidizer tank from a trailer. Vapor from the LOX vents from the tank in the predawn darkness at LC-5. LOX fueling took about forty minutes and concluded just before Shepard arrived at the pad; the booster's upper alcohol fuel tank had been filled by about 1:30 a.m.

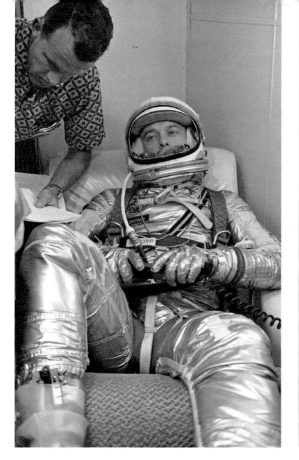

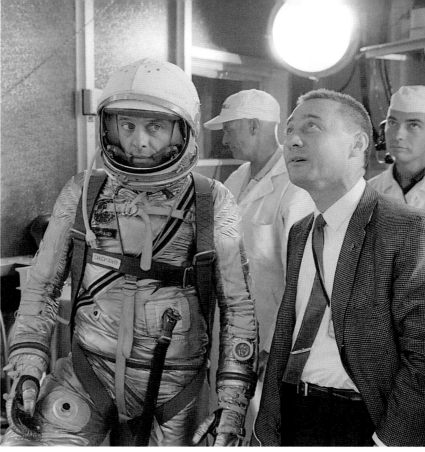

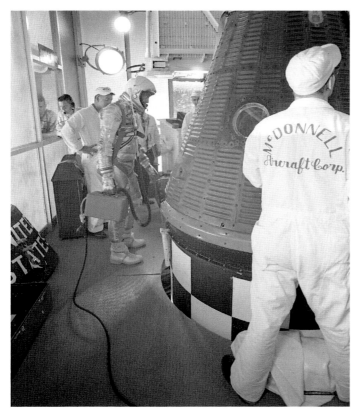

**TOP LEFT** Gordon Cooper (*left*) talks with Shepard in the transfer trailer during the twenty-minute trip from Hangar S to LC-5. He arrives at the pad at 4:26 a.m., emerging from the trailer forty-nine minutes later.

**TOP RIGHT** Shepard (*left*) enters the white room accompanied by Grissom after an elevator ride. Shepard's Plexiglas visor on top of his helmet is protected by a white cloth cover.

**BOTTOM** Holding his portable suit ventilator, Shepard waits to ingress. The spacecraft hatch cover rests against the wall at left with its release crank inserted.

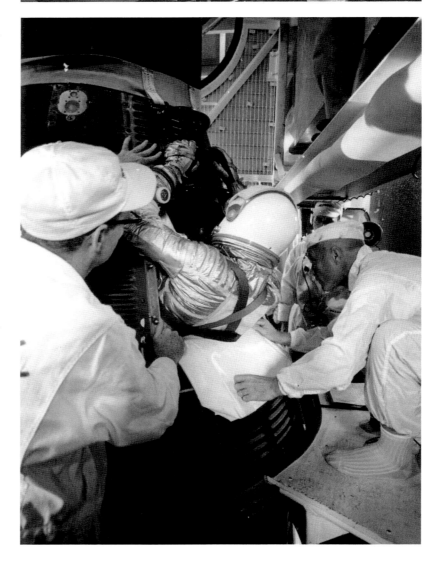

**TOP** Backup Glenn, with Wendt behind him, signals to Shepard the cabin is ready for insertion.

**BOTTOM** Glenn (*right*) helps Shepard carefully ease into his couch. He would be inside by 5:20 a.m. EST.

**FACING PAGE, TOP LEFT** Shepard gets settled aboard *Freedom 7*. His oxygen outlet hose is attached to the right side of his helmet, a location the astronauts would later evaluate as noisy and an eye irritant.

**FACING PAGE, TOP RIGHT** McDonnell technicians bolt the cover over the sealed hatch on the 4,040-pound spacecraft.

**FACING PAGE, BOTTOM** CBS News correspondent Walter Cronkite waits for launch at press site no. 1, less than 2 miles from the pad, with the viewing stand behind him. Provisions in his 1961 Chevrolet Nomad station wagon include insect repellent, Pepsi, and Hunt's tomato juice. He wrapped up his coverage that day with, "There is high drama in the risks a man is asked to take to ride a rocket into space. There is high drama, too, in the risks a free nation is asked to take to publicize that effort. Today America took the gamble and America won."

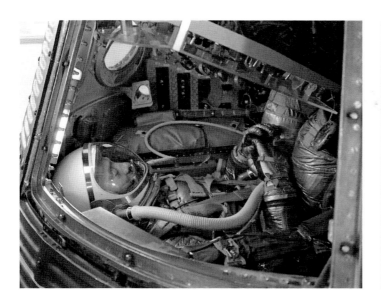

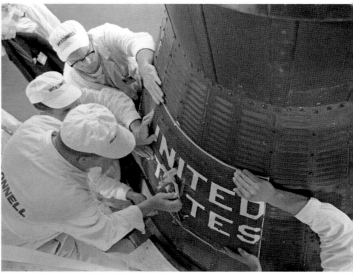

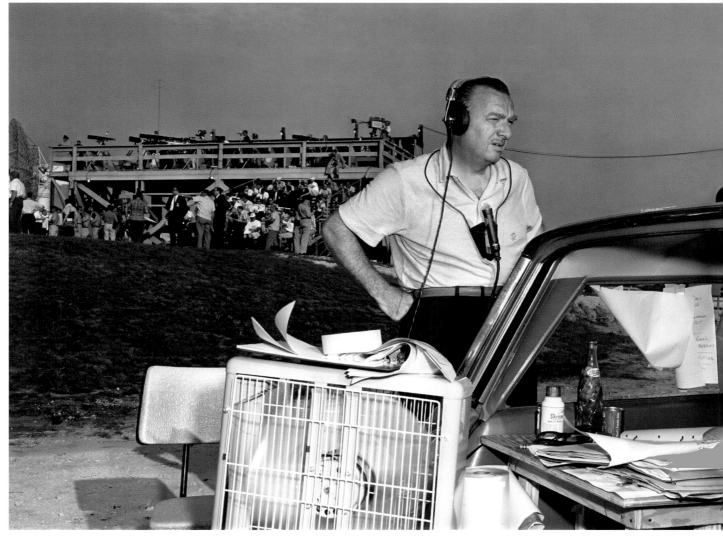

Don Arabian, spacecraft project engineer, at his Mercury Control Center (MCC) console. A Navy, National Advisory Committee for Aeronautics (NACA), and STG veteran, he was a brilliant engineer known for his flamboyant, demanding style, which eventually earned him the nickname "The Mad Don."

Chief flight director Chris Kraft waits for launch at his console. Note the four video feeds from the pad on his console screen. Liftoff, orchestrated at the separate pad blockhouse, was delayed by more than two hours—first to improve visibility and then to replace a power inverter for the Redstone.

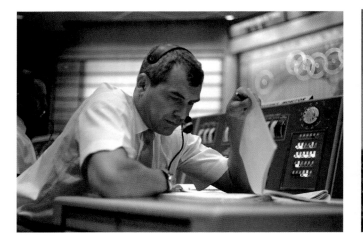

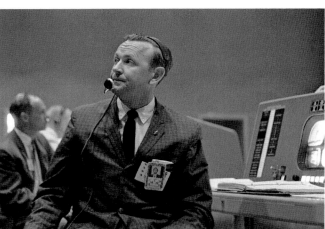

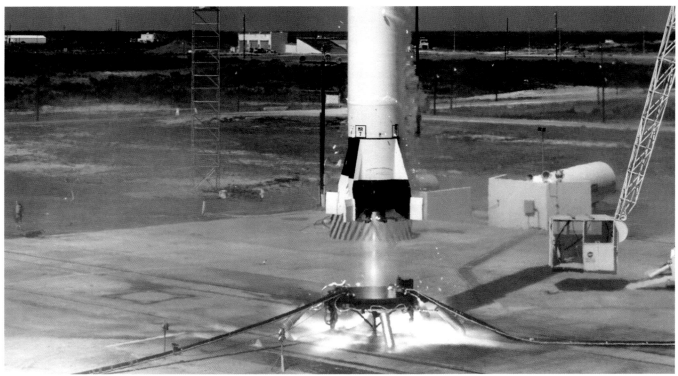

MR-3 heads skyward at 9:34 a.m. EST with the end of the cherry picker at right. Scott Carpenter and Schirra flew F-106 chase planes high above. The booster burned for two minutes and twenty-five seconds before *Freedom 7* separated, and the spacecraft then reached its peak altitude of 166.5 miles two and a half minutes later.

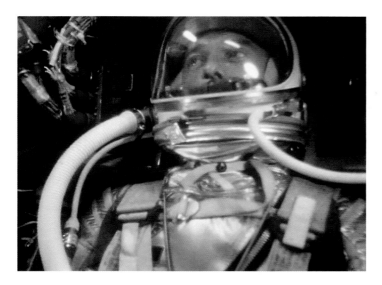

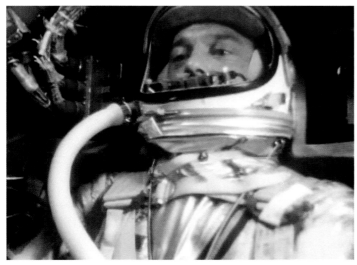

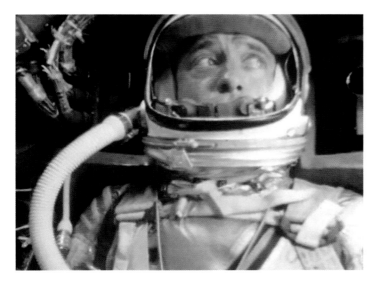

Three still frames from the 16 mm astronaut observer camera (filming at six frames per second) capture Shepard during the fifteen-minute, twenty-two-second flight. "What a beautiful sight," he radioed. He could distinguish major landmasses using a periscope and could make out coastlines, rivers, and major lakes but had difficulty identifying any cities. In the bottom two images he has disconnected the hose that inflated his visor seal.

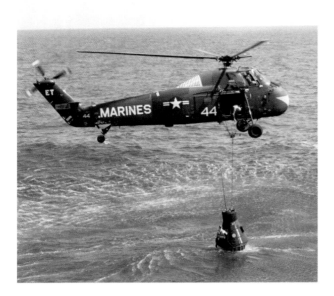

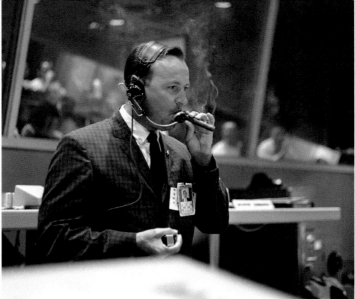

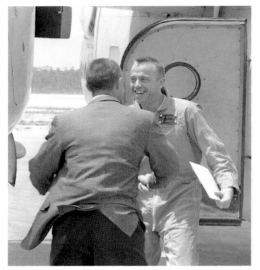

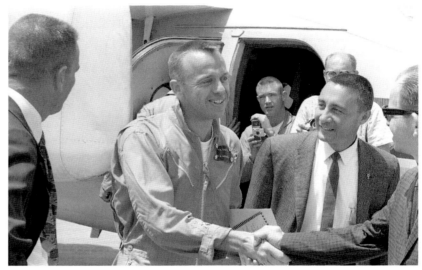

**TOP LEFT** Shepard emerges from the hatch of *Freedom 7* after the Marine Sikorsky HUS-1 Seahorse helicopter snared the spacecraft's recovery loop. The chopper raised the spacecraft slightly so the hatch is above water. The spacecraft splashed down at 9:49 a.m., 302 miles east-southeast of the Cape. "Man, what a ride!" he told the copilot. Astronaut and spacecraft were both aboard the aircraft carrier USS *Lake Champlain* eleven minutes later. Shepard would spend almost two and a half hours aboard undergoing examination before being flown to Grand Bahama Island.

**TOP RIGHT** Kraft celebrates the splashdown in the MCC with a cigar.

**BOTTOM LEFT** Shepard (*right*) is greeted by Grissom after arriving at the Grand Bahama Auxiliary AFB just after noon for two days of examinations and debriefings. The island, a British possession, was the site of the closest Mercury tracking station to Cape Canaveral.

**BOTTOM RIGHT** Shepard receives congratulations from NASA public affairs officer John "Shorty" Powers at right, with Grissom between them and Slayton at left. Shepard wears an orange flight suit borrowed from Rear Admiral George Koch aboard *Lake Champlain* with a snapped-on name tag reading "ALAN B. SHEPARD JR. U.S. ASTRONAUT." Behind Grissom is *National Geographic* photographer Dean Conger, on loan to NASA. He had shot the helicopter recovery pictures looking down at Shepard in the water.

**TOP LEFT** Powers (*left*) and Shepard share the back seat with Slayton up front during the short drive from the air strip to the new NASA hospital about a mile away. (*Grissom out of frame to the left.*) The driver at far left is USAF Capt. Hugh May, commander of Atlantic Missile Range Station No. 3.

**TOP RIGHT** Shepard (*left*) and Slayton arrive, with training manager Col. Keith Lindell at right. Grissom exits the car at left. The astronaut carries his mission events cue cards.

**BOTTOM** Shepard smiles at reporters and photographers but says nothing as he heads into the hospital and debriefing facility. The 20-by-60-foot prefabricated aluminum building was a one-patient surgical hospital built for suborbital flights; a similar facility was built on Grand Turk Island for astronauts following orbital missions. *Left to right:* Powers, Col. Lindell, Shepard, and Slayton.

Shepard (*left*) undergoes a vision examination by Dr. James Culver of the USAF Aerospace Medical Center at Brooks AFB in San Antonio, Texas.

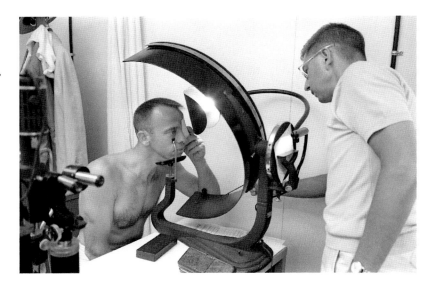

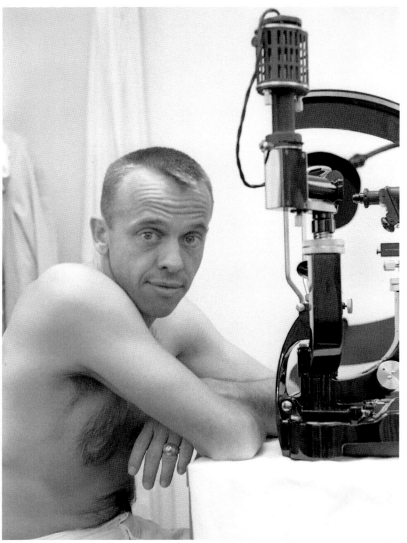

Dr. Ashton Graybiel (*left*) checks Shepard's ear canal, balance, and blood pressure.

TOP  Shepard briefly attended a reception on the evening of May 5 in his honor by Capt. May, which included champagne and sandwiches.

BOTTOM  *Left to right:* Schirra, Glenn (*behind Schirra*), Cooper, and USAF nurse Lt. Dee O'Hara at the reception for the tracking station personnel.

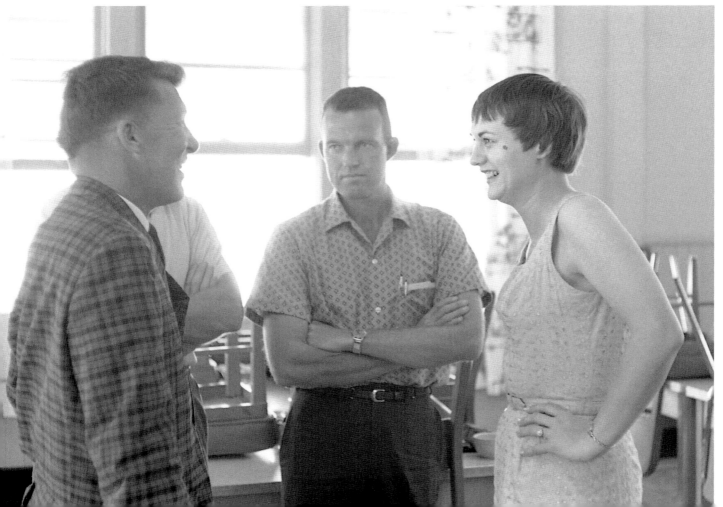

## May 6, 1961

**TOP** *Left to right:* Dr. Douglas, Carpenter, and Glenn take a break. Douglas told reporters, "[Shepard]'s in the best of shape, the best of health, the best of spirits, and just like he was before he left the Cape, only happier."

**BOTTOM** The six astronauts gather around Shepard inside the hospital. The psychiatrist observed that Shepard initially "felt calm and self-possessed. Some degree of excitement and exhilaration was noted. He was unusually cheerful and expressed delight that his performance during the flight had actually been better than he had expected. It became apparent that he looked upon the flight as a difficult task about which he was confident, but could not be sure, of success. He was more concerned about performing effectively than about external dangers."

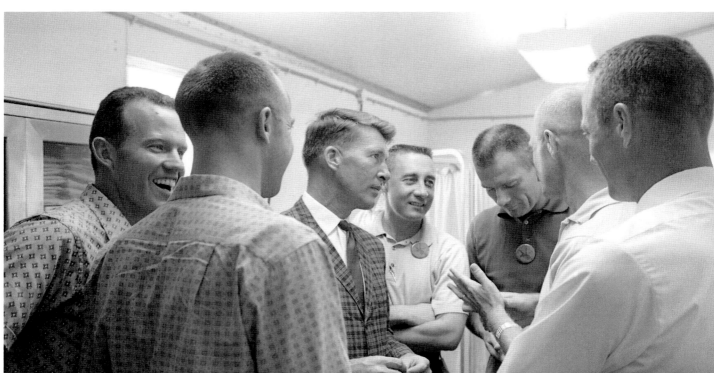

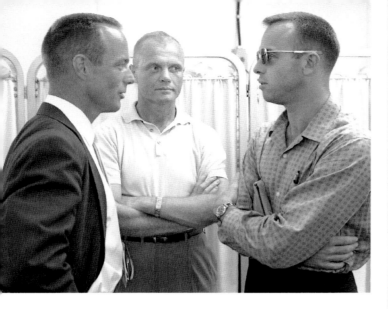

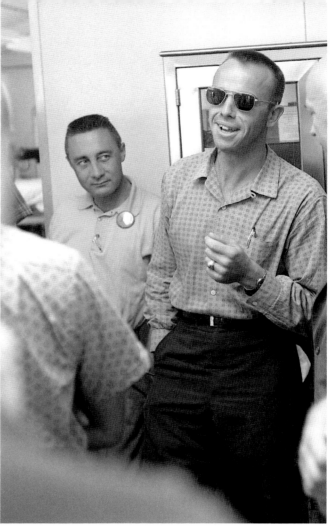

**TOP LEFT** *Left to right:* Carpenter, Glenn, and Shepard, who wears his sunglasses after having his pupils dilated.

**TOP RIGHT** *Left to right:* Grissom, Shepard, and STG director Robert Gilruth. Shepard and the others took their meals in the mess hall and downplayed their VIP status.

**BOTTOM** Grissom shadowed Shepard during his stay and spent both nights sleeping at the tiny clinic to keep him company in case of any problems.

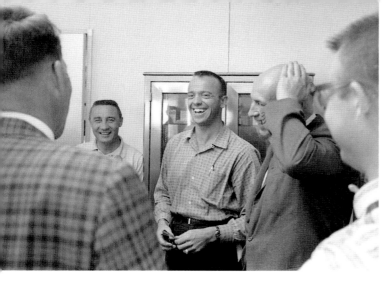

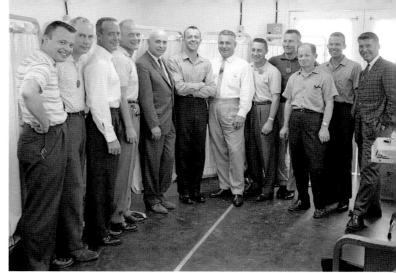

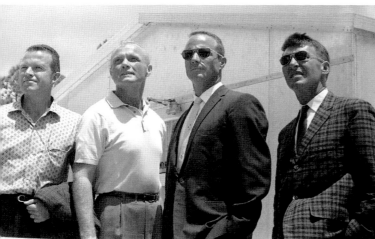

**TOP LEFT** *Left to right:* Schirra, Grissom, Shepard, Gilruth, and Navy lieutenant and psychologist Dr. Robert Voas enjoy their achievement.

**TOP RIGHT** The NASA team poses for a group photo. *Left to right:* Dr. Voas, Dr. Douglas, Carpenter, Glenn, Gilruth, Shepard, Williams, Grissom, Slayton, Powers, Cooper, and Schirra.

**BOTTOM LEFT** *Left to right:* Cooper, Glenn, Carpenter, and Schirra outside the hospital. These four astronauts would make Mercury's orbital flights.

**BOTTOM RIGHT** Powers provides some shade for Gilruth before a news briefing. Although the other astronauts would take a few questions, Shepard's only public comment during his stay was a written statement issued by Powers which said, "The only complaint I have is that the flight wasn't long enough." Sunday, May 7, was a day to relax; the astronauts went to the beach, went swimming, and tried fishing.

## May 8, 1961

**TOP**  Shepard (*left*) and Grissom (*right*) talk with USAF personnel before their flight from Grand Bahama Auxiliary AFB to Andrews AFB, Maryland, at about 7:15 a.m. on May 8.

**BOTTOM**  The seven astronauts pose before boarding the flight to Andrews AFB at 7:30 a.m. *Left to right:* Slayton, Grissom. Glenn, Carpenter, Cooper, Schirra, and Shepard. The aircraft is a KC-135A Stratolifter assigned to USAF vice chief of staff Gen. Curtis LeMay.

**FACING, TOP LEFT**  Cooper relaxes during the flight.

**FACING, TOP RIGHT**  Carpenter manages a slight smile for Taub.

**FACING, BOTTOM**  Williams (*left*) enjoys a cigarette as Shepard and Powers share a laugh during the two-hour-and-eleven-minute flight.

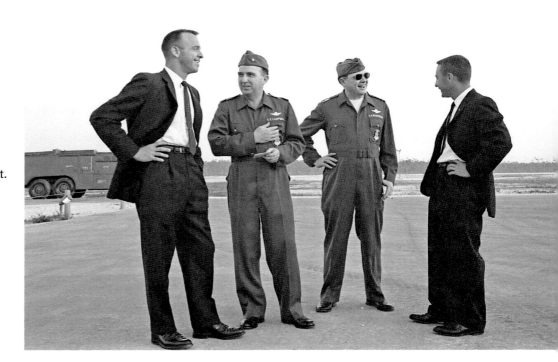

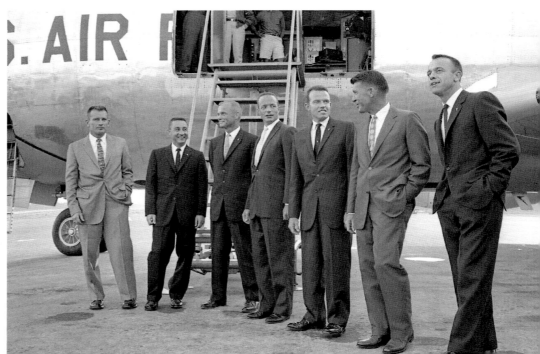

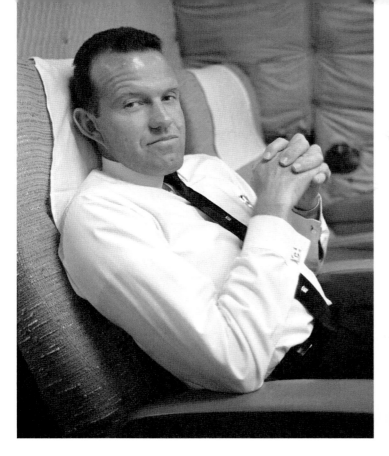

**TOP**  Grissom (*left*) chats with Gilruth.

**BOTTOM LEFT**  Slayton (*left*) and Dr. Douglas doze en route.

**BOTTOM RIGHT**  Schirra (*left*) and Buckley.

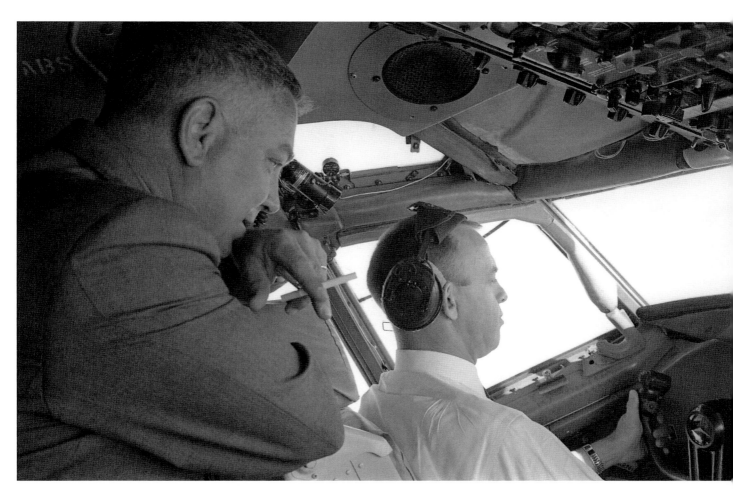

Shepard takes the controls of the KC-135A during the flight from Grand Bahama Island to Andrews AFB. Williams looks over his shoulder (*top*).

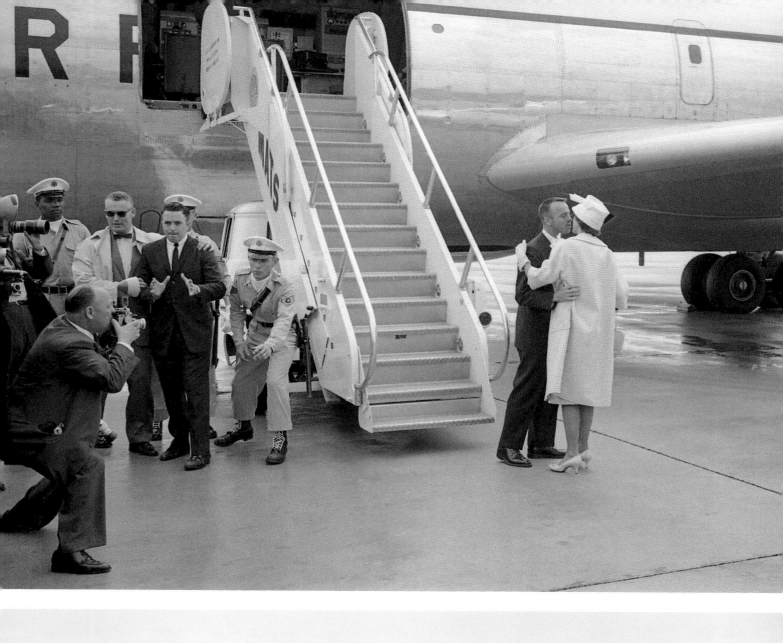

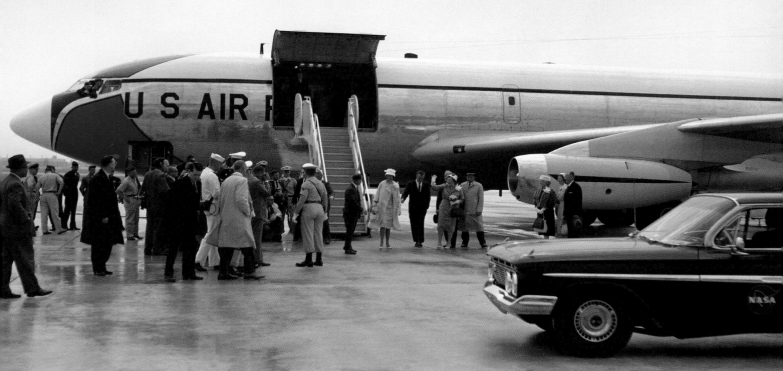

**FACING PAGE** Shepard and his wife, Louise (*right*), are reunited after he landed at Andrews AFB, Maryland, outside of Washington, DC, at 9:45 a.m. His arrival and brief remarks to a crowd of about one thousand well-wishers were also televised live. The Shepards and others in the NASA party then left by helicopter for the White House.

**TOP LEFT** With the other astronauts and NASA administrator James Webb behind him, Shepard speaks in the White House Rose Garden after President Kennedy presented him with the NASA Distinguished Service Medal at 10:00 a.m. "Today surpasses even last Friday," Shepard said, "and as a matter of fact, I got far less sleep last night than I did before the flight." The astronauts were then guests of honor at a congressional reception at the US Capitol, cheered by large crowds along their motorcade route.

**TOP RIGHT** Shepard answers questions at a 1:00 p.m. nationally televised news conference in the new State Department auditorium, with the other astronauts seated on stage. As he described his flight in response to questions, reporters repeatedly applauded, apparently for Shepard's calm, forthright answers—an unusual tribute.

**MIDDLE AND BOTTOM LEFT** Reporters, including UPI's Helen Thomas (*standing left*) speak with Shepard's mother, Renza (*seated left*), and wife, Louise, before the news conference. Shepard began his remarks by introducing them as well as his father and sister.

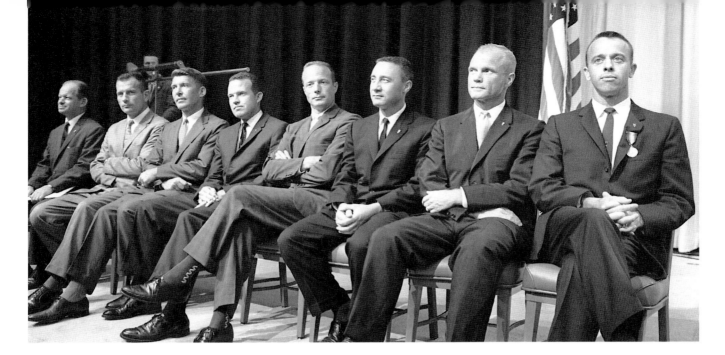

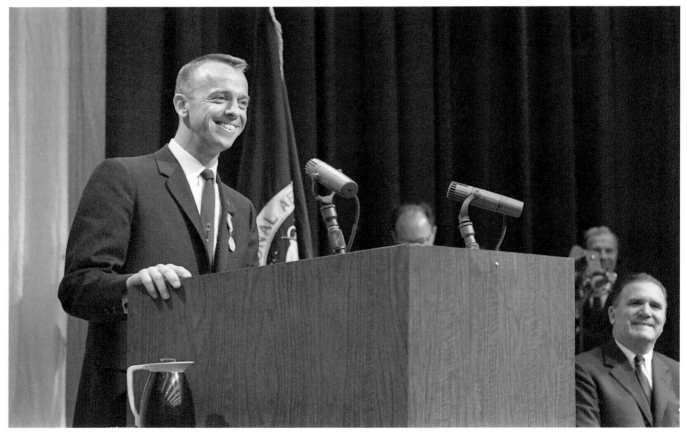

**TOP** *Left to right:* Powers, Slayton, Schirra, Cooper, Carpenter, Grissom, Glenn, and Shepard listen to Gilruth introduce Shepard. The other astronauts all raised their hands when Shepard, in response to a question, asked them who would like to be next in space.

**BOTTOM** Shepard grins during the news conference, with Webb at right. "All-in-all, we were very much pleased with the flight, very much encouraged, and we intend to press ahead with the program," he said. Webb hosted a private luncheon for the astronauts and the Shepard family afterward in the State Department dining room.

**TOP** Louise Shepard is interviewed at the State Department after the luncheon by White House reporters Thomas of UPI and the AP's Fran Lewine (*hidden*) beside her.

**BOTTOM LEFT** Grissom (*left*) and Glenn listen. Glenn prompted laughter when he claimed he had won a bet with Shepard that he would be able to see stars. "I'm claiming foul because he didn't take his eyes off the instruments long enough and I figure I'm owed a steak dinner payoff," said Glenn.

**BOTTOM RIGHT** Powers (*left*) and Slayton listen during the event, with a shotgun mic behind them to pick up reporters' questions.

**TOP LEFT** Shepard prepares to depart Andrews AFB for Langley. Movie photographer and NASA contractor Larry Summers is behind Shepard.

**TOP RIGHT** Louise Shepard (*left*) with her father, Russell Brewer, before they returned to Langley.

**BOTTOM** Louise Shepard shows off the medal her husband received that morning from the president.

# 4

# Gus Grissom

Mercury-Redstone 4

Exactly eleven weeks after Alan Shepard's flight, USAF Capt. Virgil I. "Gus" Grissom was aboard Project Mercury's second and final manned suborbital mission on July 21, 1961. It was almost identical to Shepard's, with the exception of unexpected and dramatic spacecraft recovery problems; and at 15:37, it was 15 seconds longer than Mercury-Redstone 3 (MR-3).

The 35-year-old Grissom, a test pilot who had flown a hundred combat missions during the Korean War, named his spacecraft *Liberty Bell 7*, complete with a painted white crack on one side. He also had a new control system to adjust the spacecraft's movements with a hand controller, a redesigned hatch that opened with a small explosive charge, and the first true window in a US spacecraft. He later said he was easily distracted by the opportunity to look out the window and predicted it would be the "best friend" of orbiting astronauts.

After splashdown north-northwest of the Bahamas, Grissom spent about five minutes preparing to egress. The hatch blew off unexpectedly, however, and he quickly pulled himself out of the spacecraft, which began to take on seawater. A Navy recovery helicopter from the aircraft carrier USS *Randolph* hooked onto *Liberty Bell 7* as planned but struggled to lift it with the added weight of the water.

In the meantime, Grissom kept feeling air escape through a rubberized seal around his neck. The more air he lost, the less buoyancy he had; he'd also forgotten to close his suit oxygen inlet valve and was weighed

down by some coins and jewelry he'd carried as souvenirs. Swimming was becoming difficult, and with a second helicopter now assigned to retrieve him, he found the rotor wash between the two aircraft making it worse. Grissom was either swimming or floating for about four or five minutes, "although it seemed like an eternity to me," he said afterward.

The second helicopter dropped a "horse collar" harness to an exhausted Grissom, who gratefully pulled on the sling and was hoisted aboard. The flooded *Liberty Bell 7* now weighed over 5,000 pounds, some 1,000 pounds beyond the helicopter's lifting capacity. The spacecraft was cut loose and sank.

Grissom later insisted he had done nothing to cause the hatch to blow, and NASA officials eventually concluded he was right. During a 1965 interview, Grissom said he thought the hatch may have been triggered by a loose external release lanyard. On *Liberty Bell 7* it was held in place by a single screw, so it was better secured on later flights.

On July 20, 1999, one day shy of the thirty-eighth anniversary of the mission, the spacecraft was found at a depth of nearly 15,000 feet but was in surprisingly good condition. A team financed by the Discovery Channel lifted the spacecraft off the floor of the Atlantic Ocean and onto the deck of a recovery ship. The Kansas Cosmosphere and Space Center in Hutchinson disassembled and cleaned the spacecraft, where it is now on permanent display.

**TOP** This portrait, with an early Mercury-Atlas scale model, is an outtake from a 1960 session with Taub.

**BOTTOM** Grissom, 35, poses with an F-106B jet for a photo session with Bill Taub at Langley AFB on January 20, 1961, apparently wearing his Mercury suit boots.

## 1959–July 1961

Grissom (*left*) with his wife, Betty, and sons Scott, 9 (*front left*), and Mark, 5, in 1959 at their home in Newport News, Virginia.

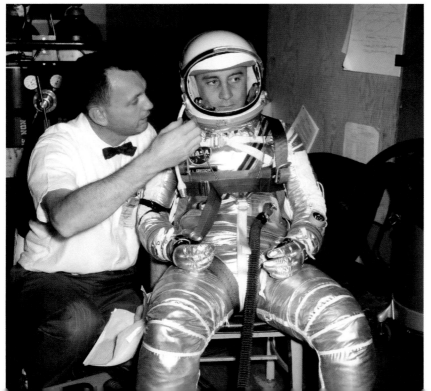

A technician (*left*) readies Grissom for a training session in the Johnsville centrifuge at the Naval Air Development Center near Philadelphia in Warminster, Pennsylvania, in October 1960. The most powerful centrifuge in the world, it could accelerate from 0 to 173 miles per hour in just seven seconds and could produce 40 *g*'s, four times the forces Grissom would experience. X-15 pilots including Neil Armstrong had trained there.

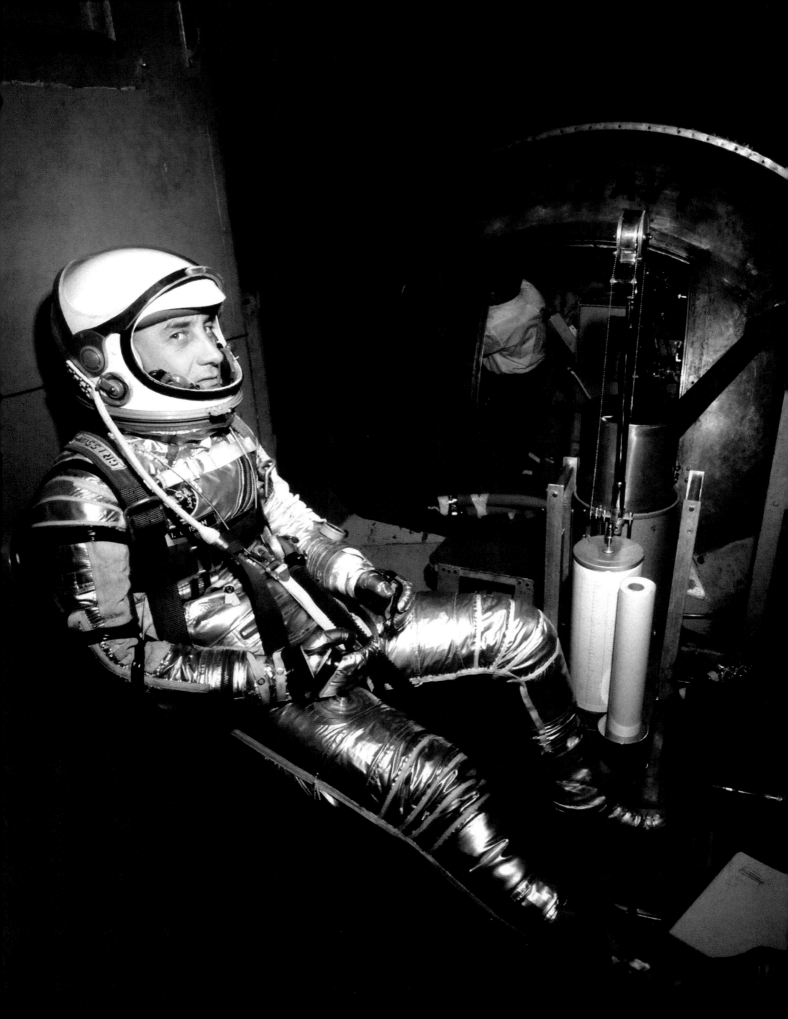

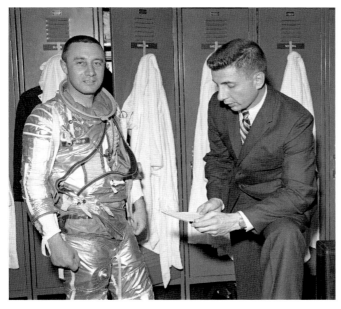

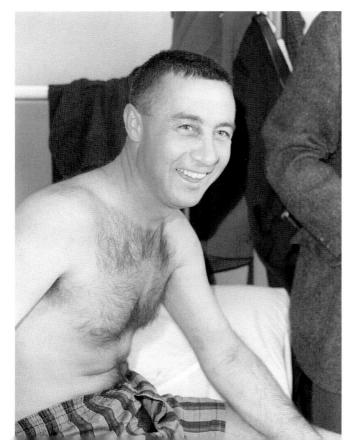

**FACING PAGE** Grissom prepares for the centrifuge run at Warminster. He logged seventeen sessions in the gondola, pulling as many as 16 *g*'s. He would experience just more than 11 *g*'s during reentry. The gondola included a Mercury instrument panel mock-up and could be turned around to simulate reentry forces. Grissom later reported the mission *g*-forces were much easier to withstand.

**TOP** Mercury Procedures Trainer no. 2 at Cape Canaveral could be tied directly to the Mercury Control Center (MCC) consoles for effective full flight simulations. The other fixed-base trainer was at Langley Research Center.

**MIDDLE** Grissom (*left*) before a filmed interview by ABC News science editor Jules Bergman in the Hangar S suit room in March 1961. Bergman also interviewed the other two astronauts under consideration to be first into space, Shepard and Glenn.

**BOTTOM** Grissom during a medical examination as he prepares for a centrifuge training session in Warminster before MR-3 on April 4, 1961. Shepard and Glenn also trained that day.

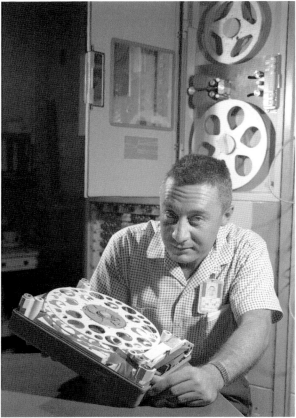

**TOP LEFT** Grissom aims a flashlight at Taub while waiting for Shepard to arrive for the final MR-3 flight simulation at Launch Complex 5 (LC-5) on April 28, 1961.

**TOP RIGHT** Grissom holds an onboard telemetry data tape recorder, which could only record; playback would happen postflight on the tape units behind him.

**BOTTOM** Grissom relaxes in the crew quarters in Hangar S in early 1961.

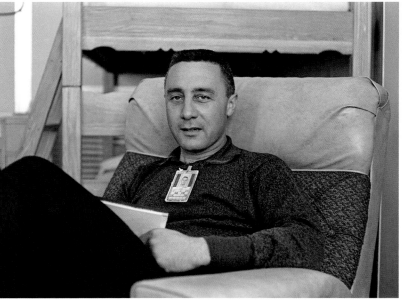

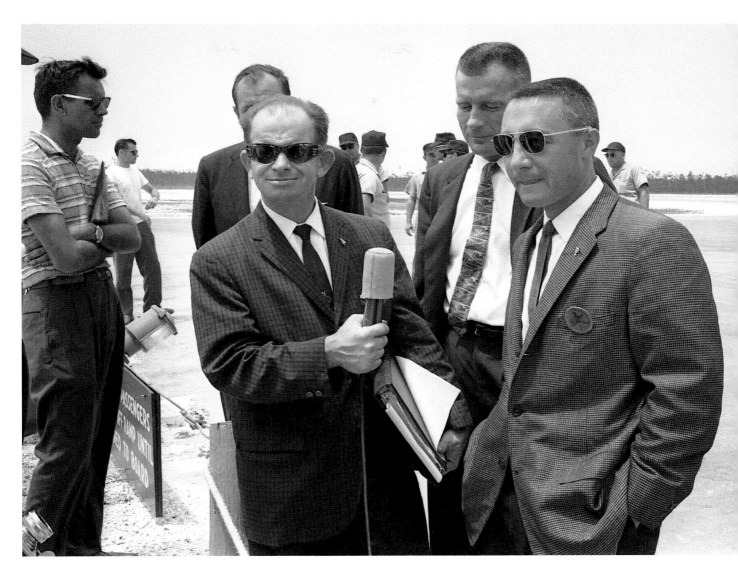

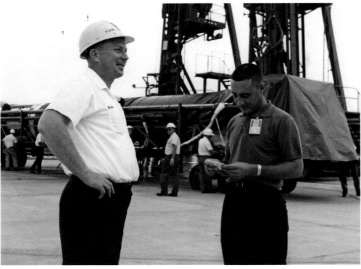

**TOP** NASA public affairs officer John "Shorty" Powers holds a mic for a film crew interviewing Grissom on Grand Bahama Island while waiting for Shepard to arrive from his recovery ship. NASA security chief Charles Buckley is behind Powers, with Deke Slayton to his left.

**BOTTOM** NASA test conductor Paul Donnelly (*left*) talks with Grissom after the Redstone booster for MR-4 has arrived at LC-5 for erection on June 22, 1961.

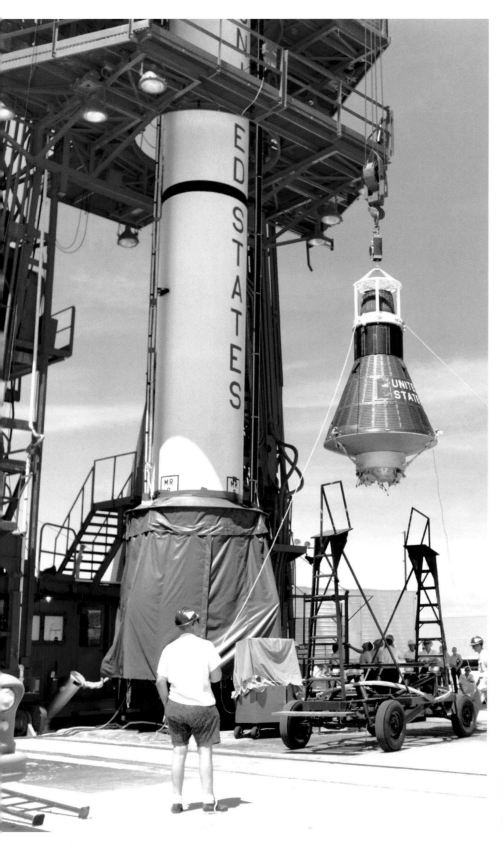

**LEFT** Just nine days later (July 1), a McDonnell technician (*left*) and his partner (*unseen out of frame at right*) use lines to steady MR-4 (spacecraft no. 11) as it is raised from its transporter trailer to be mated to the Redstone at LC-5. Grissom and Glenn, his backup, watch from directly under the spacecraft. Press reports ten days later said Grissom would make the flight. The spacecraft had undergone more than a month of tests at Hangar S.

**BOTTOM** NASA suit technician Joe Schmitt supervises as workers prepare to paint MR-4's name and a white diagonal line representing the historic Liberty Bell's crack.

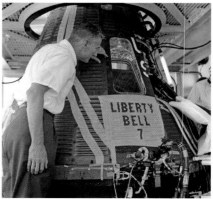

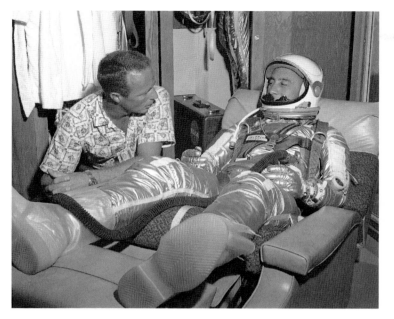

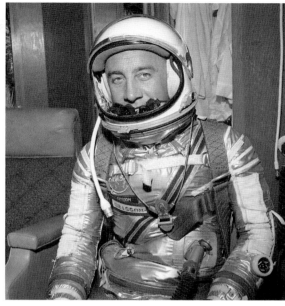

## July 15, 1961

**TOP LEFT** Scott Carpenter (*left*) talks with Grissom in the suit room as he prepares for a mission simulation.

**TOP RIGHT** Grissom poses for Taub before leaving for the pad. "It is good to get into the flight capsule a number of times; then on launch day, you have no feeling of sitting on top of a booster for launch," he said. "You feel as if you were back in the checkout hangar—this is home, the surroundings are familiar, you are at ease. You cannot achieve this feeling of familiarity in the procedures trainer because there are inevitably many small differences between the simulator and the capsule."

**BOTTOM** Grissom is followed by flight surgeon Dr. William Douglas as they come down from the second floor south annex at Hangar S.

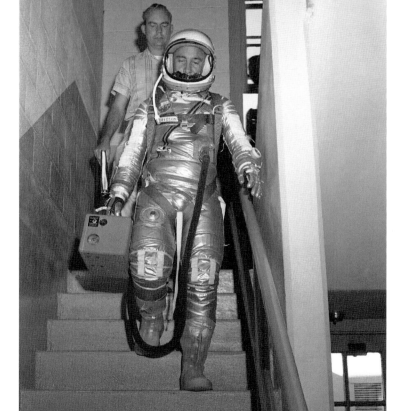

**LEFT** McDonnell pad leader Guenter Wendt checks on Grissom though the new window. The "J" numbers on the spacecraft identified various cable connections. Umbilical releases were simulated, and all systems of the spacecraft, booster, and range were operated for the sixteen-minute "flight." Some instrument panel controls and indicators were rearranged for MR-4, but the Earth-path indicator was inoperative. By the end of the day, UPI cited "usually reliable sources" that Grissom would be the pilot. Powers made it official at a news conference the next morning.

**RIGHT** Grissom pauses in front of his Redstone booster (no. 8) at LC-5 with the transfer trailer at right as the simulated countdown proceeds.

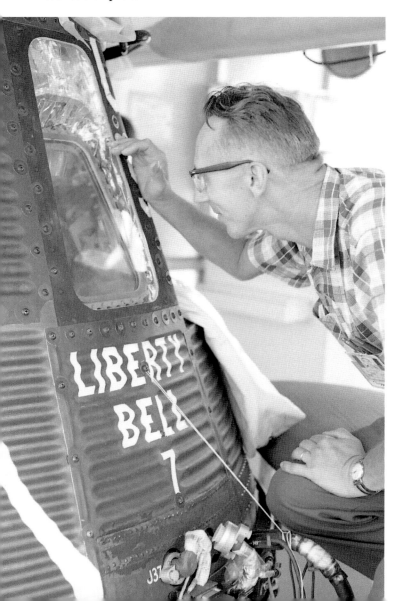

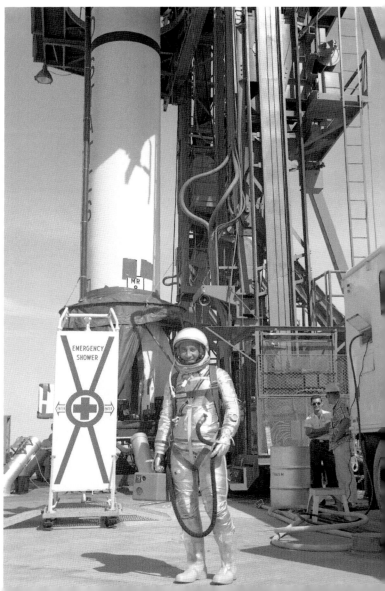

## July 17, 1961

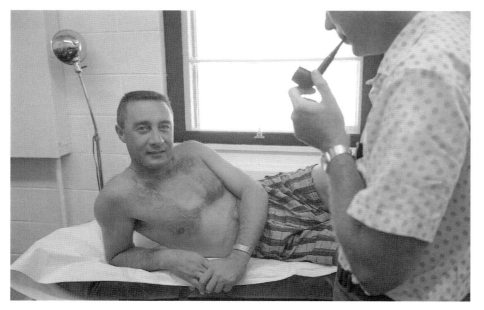

Grissom (*left*) undergoes the L–1 (liftoff minus 1 day) medical examination by Dr. Douglas at Hangar S. The exam included a chest X-ray, an EKG, and equilibrium and blood and urine tests.

Lt. Dee O'Hara talks with Schmitt while Grissom's empty suit undergoes a leak check in the suit room, standard practice the day before launch. Suit technician Alan Rochford stands behind the USAF nurse.

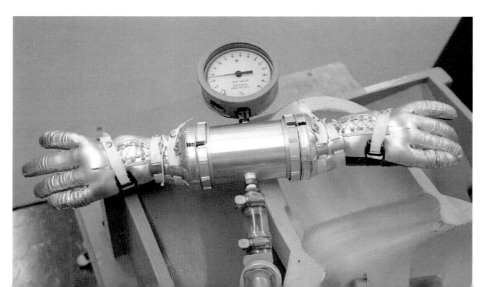

Grissom's suit gloves are tested for leaks. Late that night, the launch date was moved from July 18 to July 19 because of a forecast of unacceptably cloudy skies the next morning.

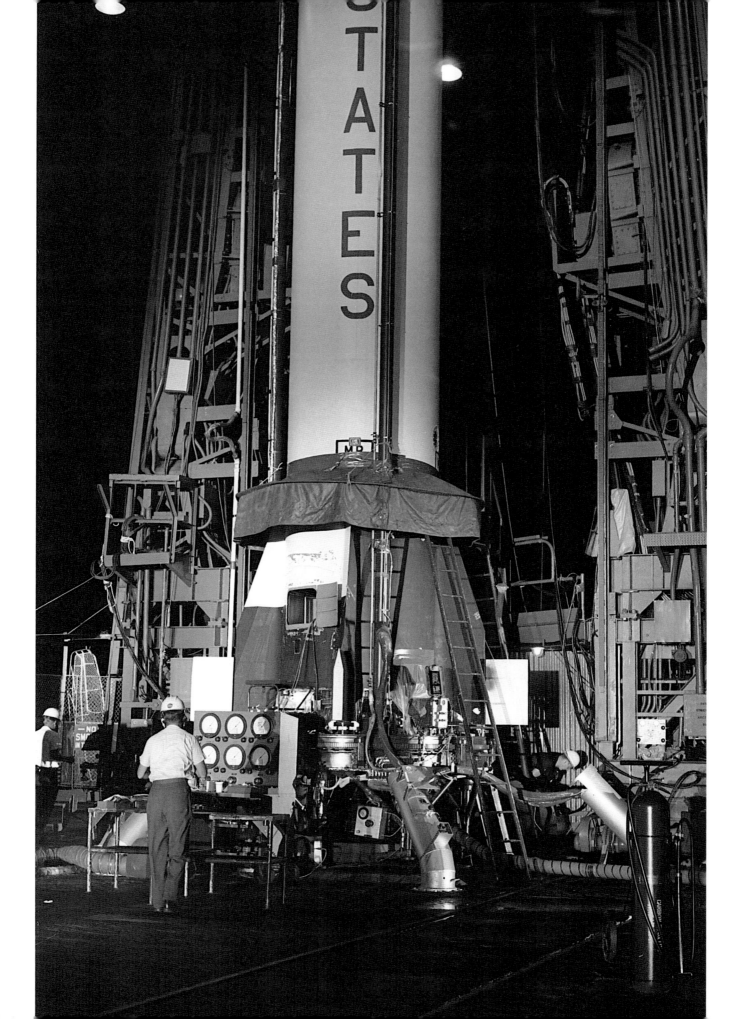

## July 19, 1961

**FACING PAGE** Chrysler technicians prepare the Redstone for fueling in the predawn darkness.

**THIS PAGE** An ABC-TV cameraman on the roof of a Chevrolet Impala station wagon focuses his camera on pad activity. As with MR-3, these video feeds were shared by the three networks, with CBS-TV again serving as the pool coordinator.

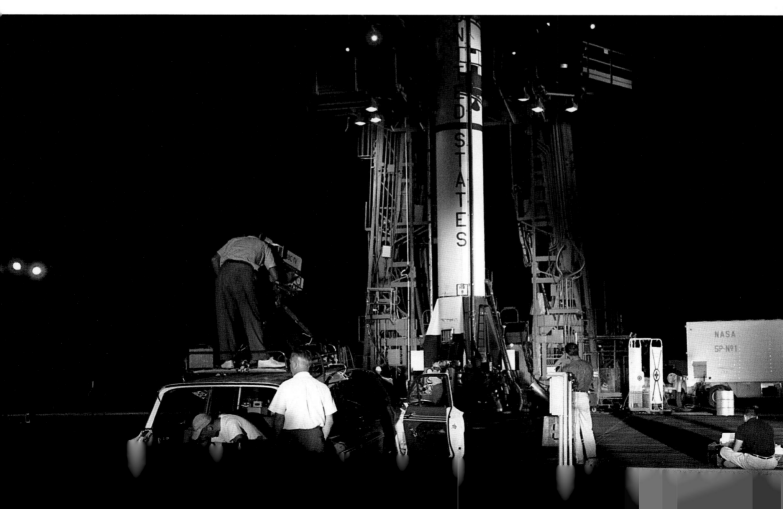

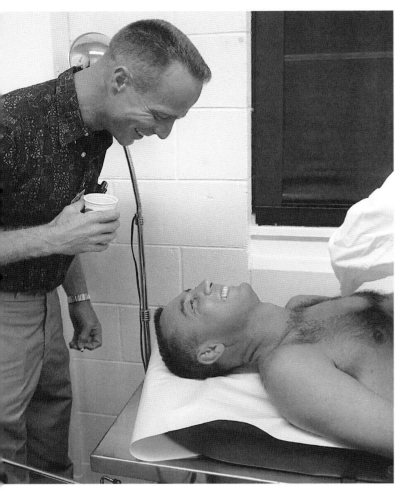

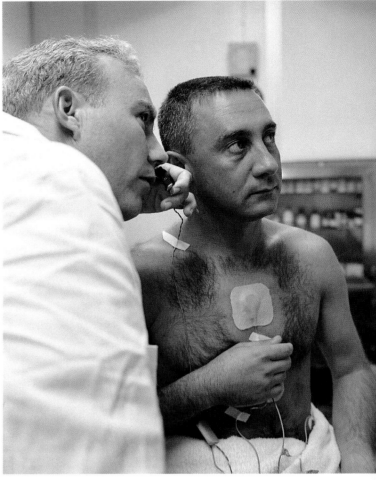

**TOP LEFT** Carpenter (*left*) jokes with Grissom during his physical at about 1:45 a.m. EST. The examination was primarily meant to make sure Grissom was fit for flight and to turn up last-minute symptoms of any illness.

**TOP RIGHT** After breakfast, Dr. Douglas (*left*) affixes the electrode harness to Grissom at 3:00 a.m. The sensors were developed just for Mercury and were wired to a connection pad on his lower abdomen, which in turn would be connected to a cable in the spacecraft. Other sensors measured his pulse, blood pressure, and temperature.

**BOTTOM** Carpenter monitors the status of the countdown and weather conditions.

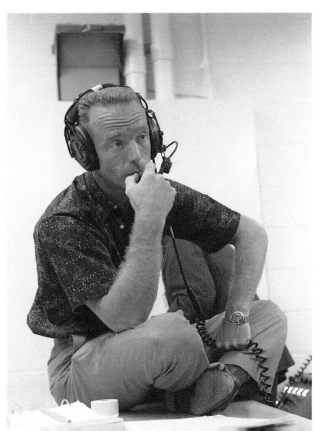

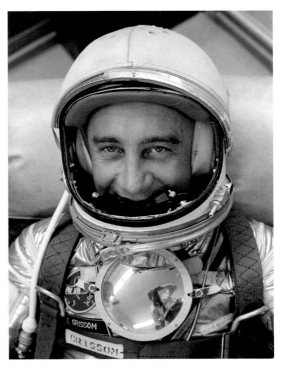

**TOP LEFT**  Grissom dons his cotton undergarment at about 3:10 a.m.

**TOP RIGHT**  Taub is reflected in Grissom's convex chest mirror, new for this mission, which was dubbed the "hero medal." It would reflect the instrument panel for the pilot observer camera during the flight; here, it shows the photographer. Both men would head downstairs to the transfer trailer at 4:20 a.m.

**BOTTOM**  Wally Schirra (*left*) attends to Grissom at about 3:30 a.m. as Schmitt attaches his visor cover.

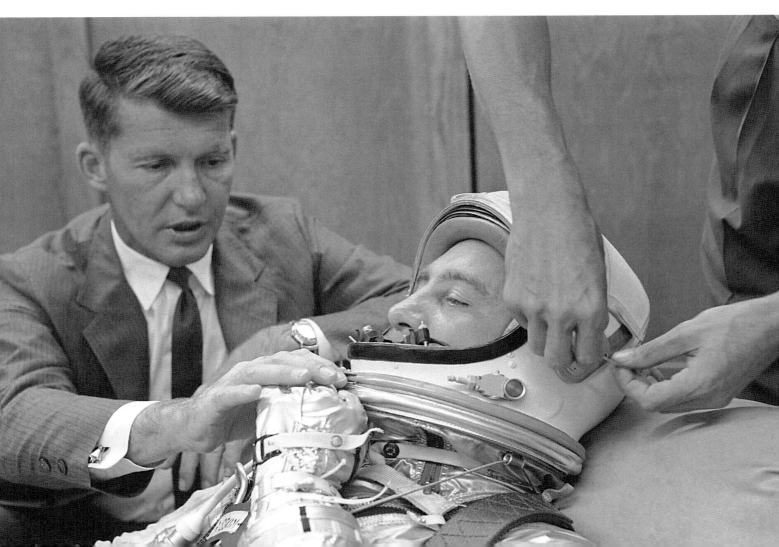

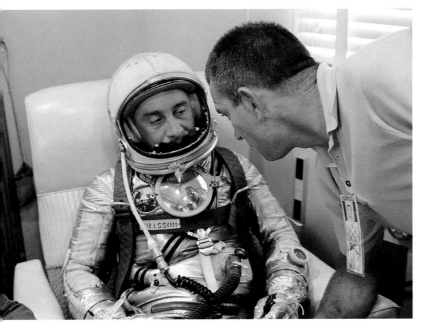

**TOP** Slayton (*right*) gave Grissom his final operational briefing during the trip to the pad at about 4:30 a.m. It saved 15 minutes since Shepard had only been briefed after arrival. On July 21, however, Slayton briefed Grissom at Hangar S. The trailer carried Grissom's backup suit and a set of electrodes in case either was needed.

**BOTTOM** Liquid oxygen tanking for the Redstone is underway; Grissom arrived at 4:40 a.m. just after it concluded but would remain inside the trailer for about fifty minutes.

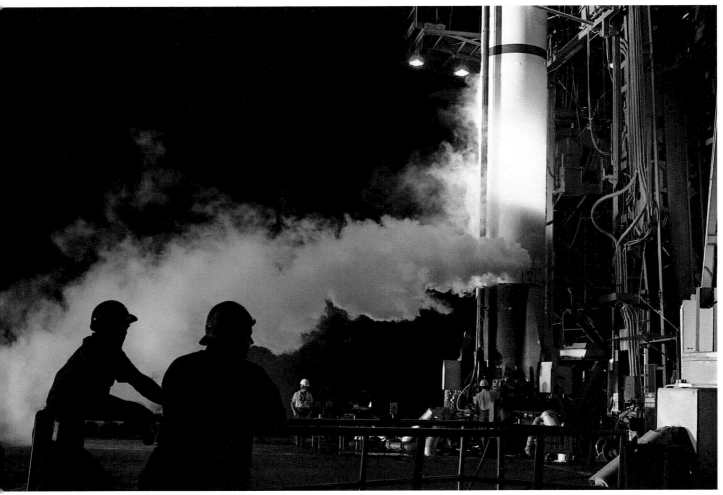

**TOP LEFT** Wendt prepares for Grissom to board at 5:40 a.m. Once inside, the astronaut noticed fingerprints and nose prints on the outside of the window; for the next launch attempt it remained covered until the hatch was closed. The spacecraft also had a new hatch that used the gas pressure from a mild detonating fuse to fracture seventy bolts with weak points holding it in place.

**BOTTOM LEFT** Slayton enjoys some coffee in the LC-5 blockhouse. He would serve as the prelaunch capcom.

**RIGHT** With white room operations completed, the work platforms that form the flooring around the spacecraft have been hinged up, and the service structure begins to move toward the edge of the pad. It had also been rolled away on rails earlier for a forty-minute photography session.

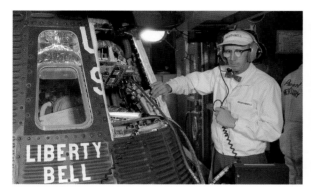

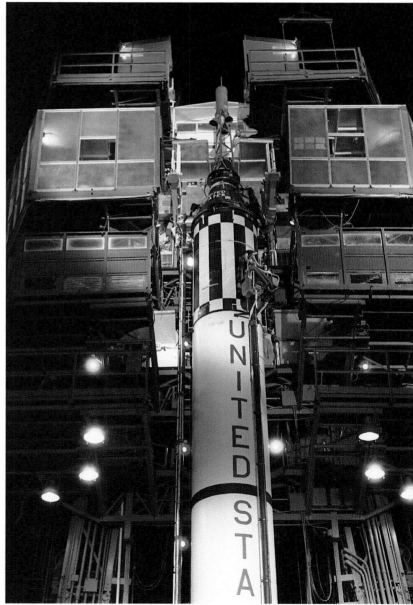

**TOP LEFT** Slayton (*left*) sits next to McDonnell spacecraft test conductor Hulen "Luge" Luetjen in the blockhouse, with Carpenter behind them. All wear no. 2–type MR-4 badges which authorized blockhouse access for the entire flight.

**TOP RIGHT** Preflight Operations Division chief G. Merritt Preston (*left*) and Launch Operations Directorate chief Kurt Debus monitor the countdown in the blockhouse. Isom "Ike" Rigell, electrical network systems chief, stands in the foreground with his back to the camera. The Mercury-Redstone can be seen behind Debus.

**BOTTOM** CBS News correspondent Walter Cronkite provides updates on launch morning activity and the eventual weather scrub. Twice as many viewers, however, watched NBC's coverage than that of CBS and ABC combined. The Cape's Manned Space Flight Network radar and tracking antenna is visible through the window. Roughly 350 reporters from around the world were on hand, about half as many as for MR-3. After several delays, however, the launch was scrubbed at 9:00 a.m. because of cloud cover, meaning a forty-eight-hour recycle to refurbish the Redstone's fuel tanks.

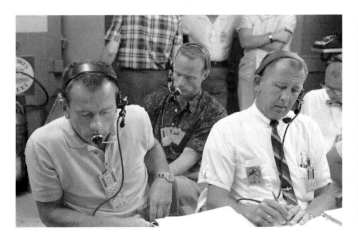

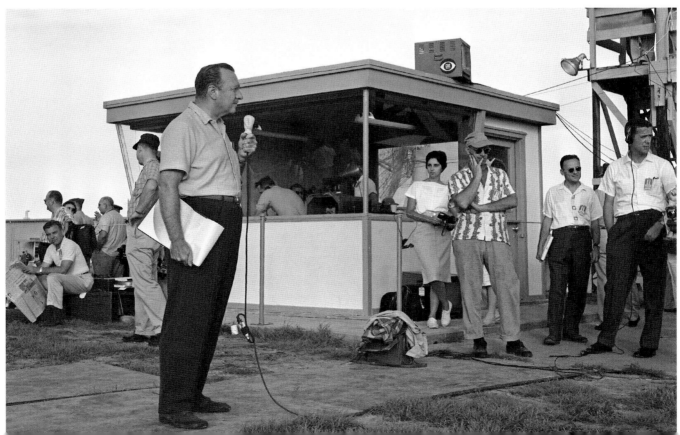

## July 21, 1961

**TOP LEFT** Dr. Douglas (*right*) attaches electrodes to Grissom at 2:25 a.m. Grissom had earlier told the psychiatrist "he felt somewhat tired, and was less concerned about anxiety than about being sufficiently alert to do a good job."

**TOP RIGHT** Grissom smiles for photographer Taub as Dr. Douglas checks the electrodes with an oscilloscope.

**BOTTOM** Grissom (*left*) and Dr. Douglas enjoy breakfast at 1:30 a.m. EST for the second launch attempt in the conference room in Hangar S. Grissom and Glenn had been on a low-residue diet for several days.

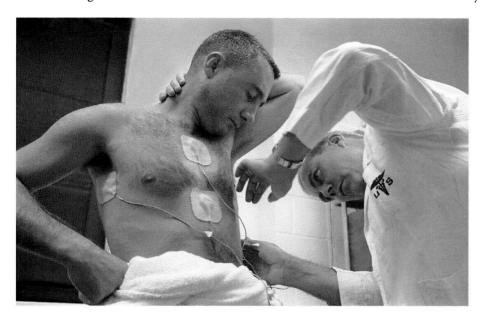
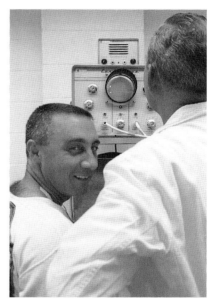

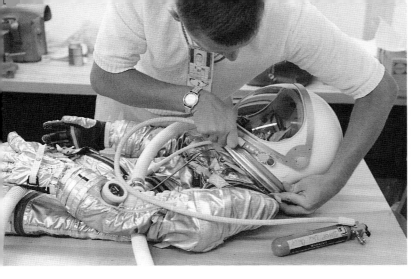

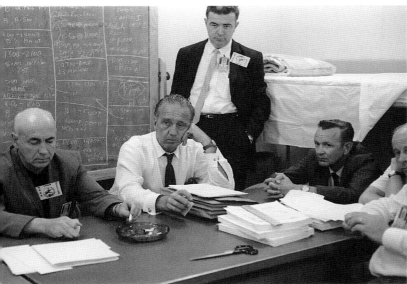

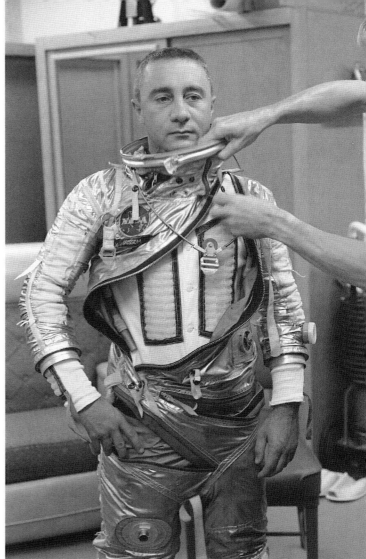

**TOP** Rochford attaches the oxygen bottle hose to test Grissom's visor seal.

**BOTTOM** *Left to right:* Space Task Group (STG) director Robert Gilruth, Debus, STG Operations Division chief Charles Mathews, flight director Chris Kraft, and Marshall Space Flight Center deputy director Eberhard Rees (*partially out of frame at right*) monitor the countdown at the MCC.

Schmitt gets Grissom zipped into his pressure suit at about 2:30 a.m. The astronaut found that he was calm, with the medical and suit personnel instead doing their best to hide their nervousness.

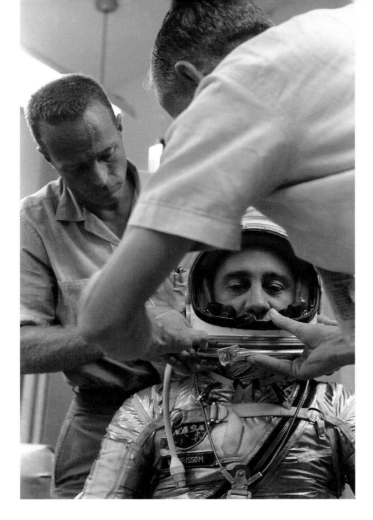

Carpenter (*left*) assists Schmitt with Grissom's suiting at 2:50 a.m.

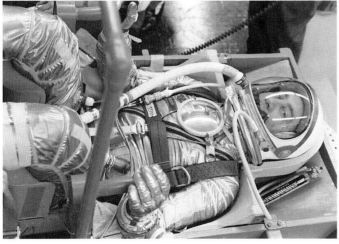

Grissom undergoes suit pressure and leak checks at 3:05 a.m.; the suit was inflated to 5 pounds psi.

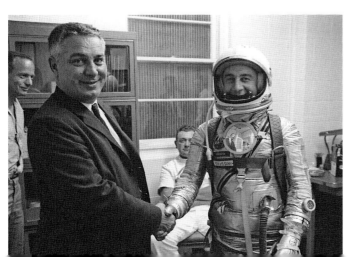

With Carpenter at left, STG associate director of operations Walter Williams gives Grissom a good luck handshake before he departs at 3:30 a.m.

**THIS PAGE, TOP LEFT** Grissom poses in front of his spacecraft.

**THIS PAGE, BOTTOM LEFT** Dr. Douglas jokes with Grissom about a piece of paperwork as Carpenter (*left*) and Glenn (*right*) look on. Grissom's visor cover reads "Bert North," a McDonnell astronaut stand-in and the twin brother of NASA's Warren North. White room photos with gag captions are taped to the wall in the background.

**THIS PAGE, RIGHT** Carpenter observes prelaunch activity in the white room.

**FACING PAGE, TOP LEFT** Grissom (*left*) moves toward steps to enter *Liberty Bell 7* with Glenn ready to assist.

**FACING PAGE, TOP RIGHT** Grissom eases into his spacecraft with Glenn and Wendt helping. He'd be inside by 3:58 a.m., with the hatch sealed at 5:45 a.m.

**FACING PAGE, BOTTOM** The cherry picker is placed in standby position near *Liberty Bell 7* after the service structure was moved away at 5:50 a.m. A phone call from Grissom's wife, Betty, was patched through during the three hours and twenty-two minutes he waited for launch.

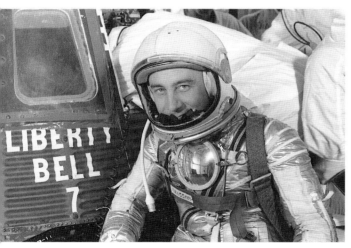

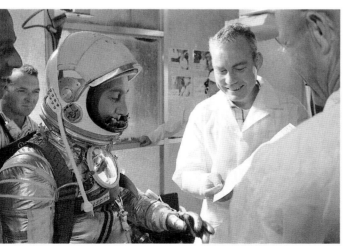

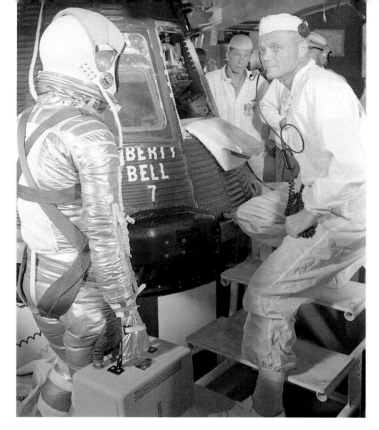

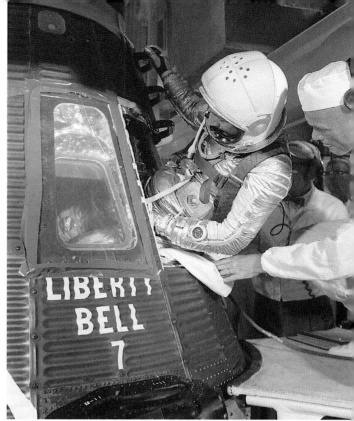

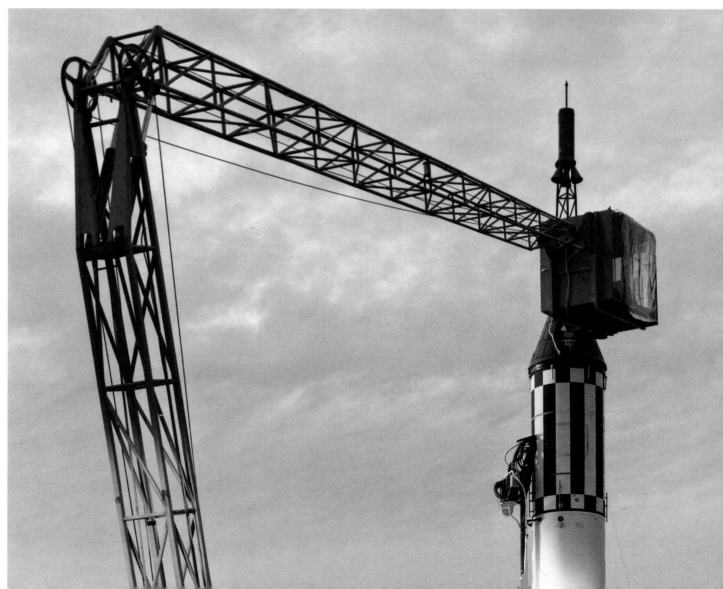

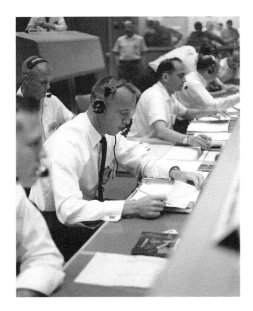

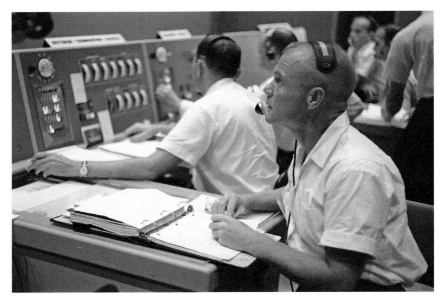

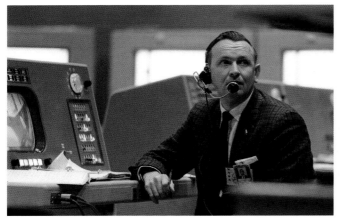

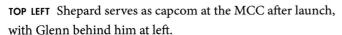

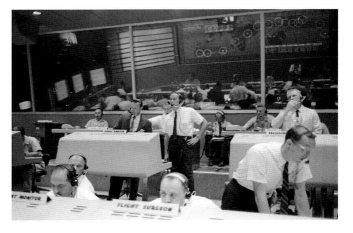

**TOP LEFT** Shepard serves as capcom at the MCC after launch, with Glenn behind him at left.

**TOP RIGHT** Glenn follows the countdown. The astronauts would be dispersed to staff various worldwide tracking stations for orbital Mercury missions.

**BOTTOM LEFT** Flight director Kraft, wearing a Mercury spacecraft lapel pin, waits at his MCC console for launch, which was delayed for an hour to allow clouds to clear.

**BOTTOM RIGHT** Kraft monitors the flight's progress, with controller Eugene Kranz at far right. Powers lights a cigarette in the background at center. Glenn sits one row down (*second from left*).

**FACING PAGE** MR-4 rises from the pad at 7:20 a.m. EST with the Redstone providing 78,000 pounds of thrust. "José, don't cry too much," Shepard told Grissom three seconds later, referring to popular comedian Bill Dana's character José Jiménez, a wary astronaut. Gordon Cooper piloted an F-106 jet to observe. It would be the final launch from LC-5.

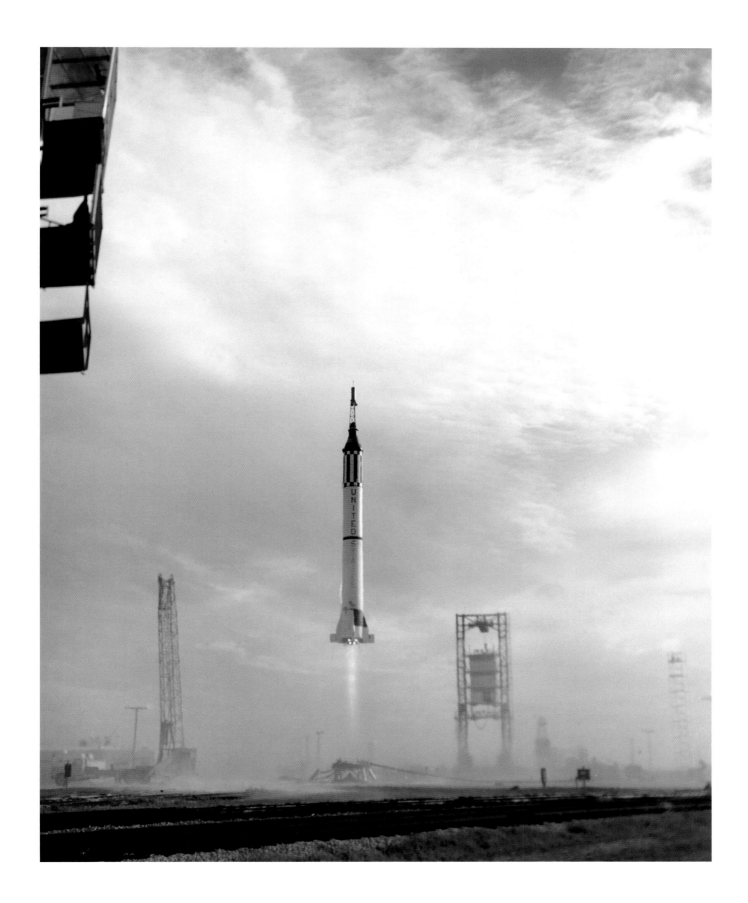

Kranz follows the sixteen-minute flight with a cigarette.

Kraft (*left*) confers with Schirra and Glenn with Kranz at right.

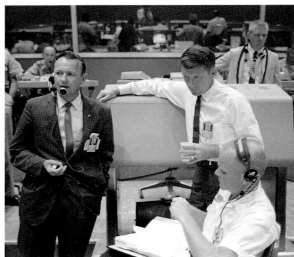

Schirra (*right*) in the MCC. At left is NASA X-15 test pilot Joe Walker. The seven astronauts had visited Edwards AFB, California, on September 14, 1959, when Walker gave them a tour of the X-15 cockpit. He was the first NASA pilot to fly the X-15 in 1960 and would earn his astronaut wings by taking the spaceplane to 68 miles in altitude in 1963.

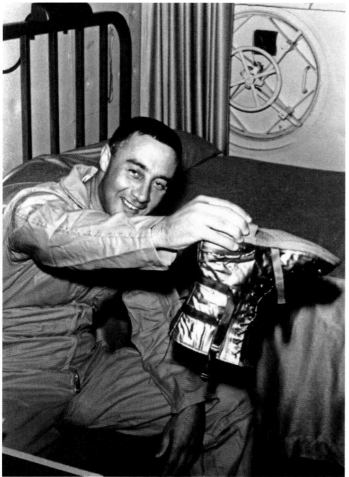

**TOP** Grissom is pulled from the Atlantic by the backup HUS-1 Seahorse helicopter after his hatch blew off unexpectedly and he was forced to evacuate. He had splashed down at 7:36 a.m., 303 miles downrange and 145 miles east of Grand Bahama Island, after reaching an altitude of 118 miles. Another helicopter, however, was unable to lift waterlogged *Liberty Bell 7*, which sank in an estimated 16,000 feet of water.

**BOTTOM** Aboard USS *Randolph*, Grissom jokingly makes sure his boot is empty. "My head is full of water," he said upon arrival on the aircraft carrier. He also underwent a medical examination, received a congratulatory phone call from President Kennedy, ate breakfast, and took a nap during his three hours onboard.

**TOP LEFT** Grissom arrives at Grand Bahama at about 11:20 a.m. and is welcomed by Powers (*hidden on left*), Glenn, Schirra, and NASA administrator James Webb (*partially hidden on right*). Grissom had flown in the Navy S2F Tracker's copilot seat from the carrier. *National Geographic* photographer Dean Conger is standing in the aircraft doorway. The other astronauts had arrived from Florida just thirty minutes earlier.

**TOP RIGHT** Powers and Grissom arrive at the NASA hospital with Capt. Hugh May driving at right. Webb is in the back seat.

**BOTTOM** Grissom waves to reporters as he walks to the hospital. Trailing him are (*from left*) Schirra, Glenn, NASA public information director O. B. Lloyd Jr., and Powers. "You're in danger if you are in the middle of the ocean in a pressure suit," Powers replied to a reporter who asked if the astronaut had been at any real risk.

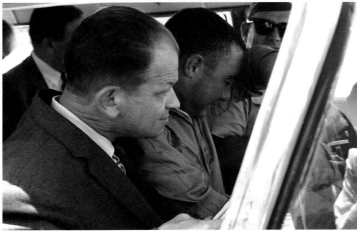

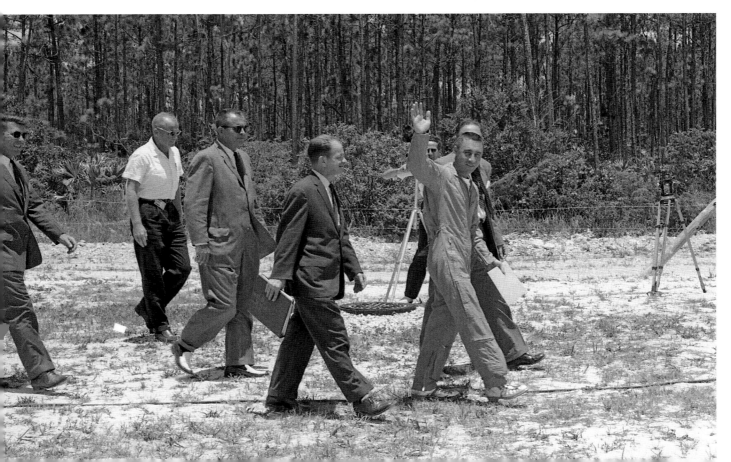

**TOP LEFT** Grissom undergoes an ophthalmic examination by Dr. Culver; one eye was found to be irritated from sea water.

**TOP RIGHT** Dr. James Culver of the USAF Aerospace Medical Center at Brooks AFB, San Antonio, Texas (*left*), shares a laugh with Grissom.

**BOTTOM** Powers (*left*) and Grissom share a light moment.

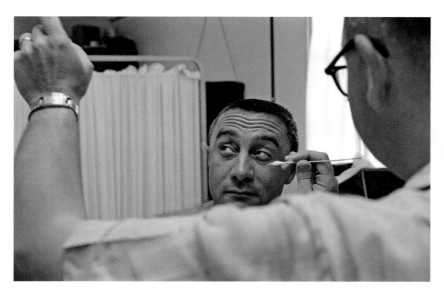

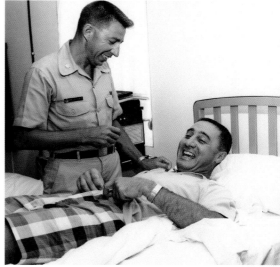

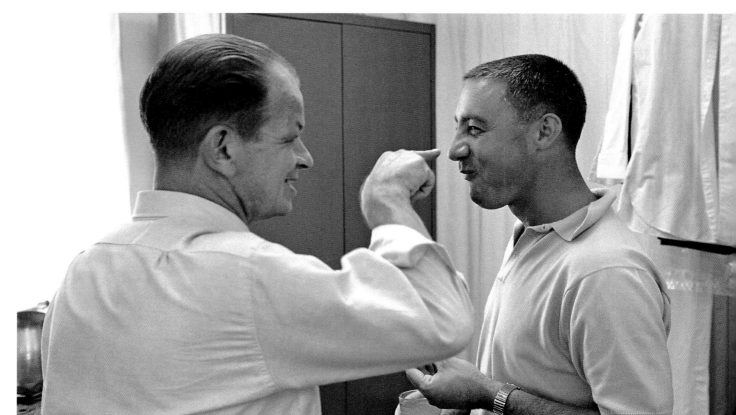

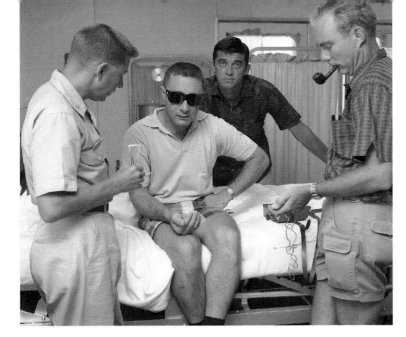

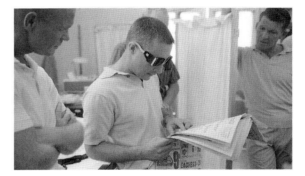

**TOP LEFT** Drs. Culver (*left*), Jackson (*behind Grissom*), and Douglas conduct a hearing test on the astronaut; his pupils were previously dilated. Dr. Douglas found Grissom in "tiptop shape" but a little tired. "He swallowed lots of water and spent a lot of energy staying afloat. But he didn't become sick."

**BOTTOM LEFT** *Left to right:* Gilruth, Williams, Cooper, and Carpenter listen to Grissom (*back to camera*) discuss his flight. A central topic was why the hatch had blown prematurely; a NASA investigation would eventually clear Grissom of any responsibility.

**TOP RIGHT** Grissom continues his debriefing.

**BOTTOM RIGHT** Grissom reads the *Miami Herald*'s July 22 front-page account of his flight as Glenn (*left*) and Schirra (*right*) look on. The headline reads "Man in Orbit Seen Step Nearer As 2nd Astronaut Probes Space," with the secondary headlines "Historic Flight Ends In Dunking" and "Grissom Swims, Capsule Sinks."

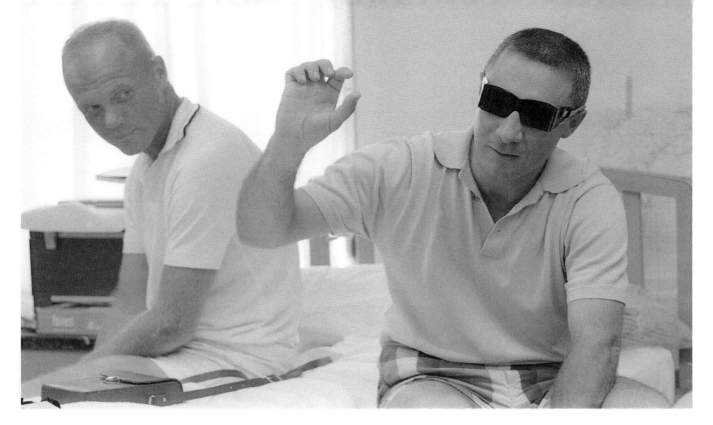

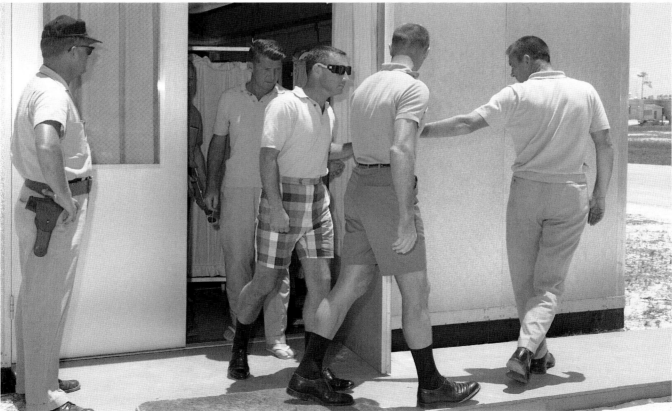

**TOP** Glenn (*left*) listens as Grissom describes his mission.

**BOTTOM** *Left to right:* Powers (*behind door*), Schirra, Grissom, Shepard, and Slayton leave the hospital, heading to the mess hall for lunch. That evening the astronauts attended a reception in Grissom's honor.

## July 22, 1961

Grissom aboard the bus headed for the plane back to Patrick AFB. He was cleared to return to Florida almost a day earlier than originally planned because of his good condition.

Grissom prepares to board a VC-118 Liftmaster.

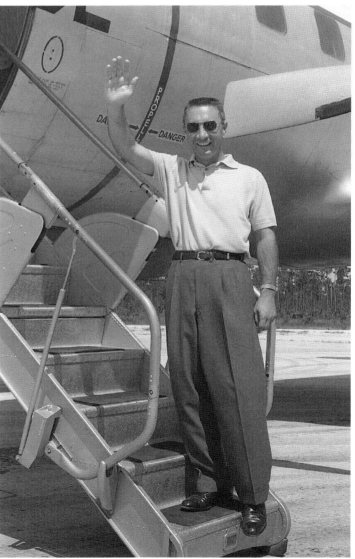

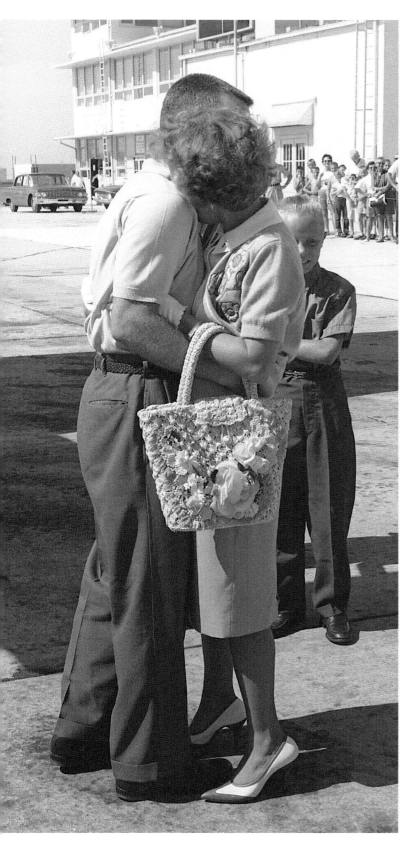

**LEFT**  The Grissoms embrace.

**TOP RIGHT**  Grissom is reunited with wife Betty and sons Scott (*center*) and Mark (*hidden*) at Patrick AFB that afternoon as Webb applauds at right. Mrs. Grissom wears a Mercury 7 pin in her collar. A WRKT-AM news car from Cocoa Beach is parked near the terminal, its call letters standing for "rocket."

**BOTTOM RIGHT**  Powers (*left*) manages a brief interview opportunity with reporters. Mary Bubb of Reuters (*sunglasses*) listens at center as a film crew soundman crouches at right.

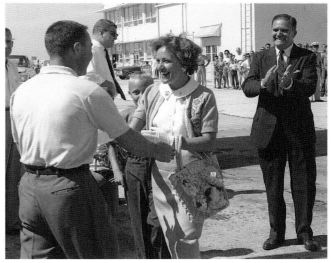

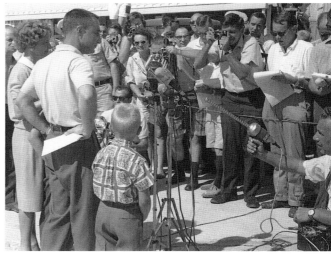

Two hours later, Grissom begins his news conference at the Starlight Motel banquet room in Cocoa Beach with a chronological account of his flight. Webb had just presented him with NASA's Distinguished Service Medal. "First you have noise and the g's begin to build up and then there is vibration at 36,000 feet when you pass Mach 1," he said of his launch.

**LEFT** Reporters take notes as Grissom takes questions. Asked if he'd been frightened at any time during the flight, Grissom replied with a grin, "I was scared." ABC's Jules Berman is second from left in the second row, with Mary Bubb seated in front of him. An NBC TK-30 camera at right provides the network pool feed in black and white.

**RIGHT** *Left to right:* Carpenter, Shepard, Glenn, and Cooper listen to Grissom. Glenn's wife, Annie, is in the far background.

**TOP** Grissom responds to questions with Betty Grissom and sons Mark and Scott in the background at left. Behind them are Marge Slayton and Rene Carpenter. Williams and Gilruth sit on stage. Grissom said that as he reentered the atmosphere, the flight was smooth with a gradual buildup to 10.2 *g*'s. Main chute deployment, he reported, "was the most comforting part of the flight."

**BOTTOM LEFT** Betty Grissom, wearing a new corsage, and son Scott look on. Behind them are Marge Slayton, Schirra, and Cam and Jan Cooper. Asked if his flight was as interesting as Shepard said his was, Grissom replied, "It certainly was. I'd recommend the trip to anyone."

**BOTTOM RIGHT** "When the hatch went off, my first thought was, 'get out.'" Grissom said. "I was lying on my back minding my own business when '*pow!*' The next thing I knew I could see blue sky and water coming over the sill." He added that he could remember removing his helmet and grabbing the instrument panel but told the conference, "I don't remember going out the door."

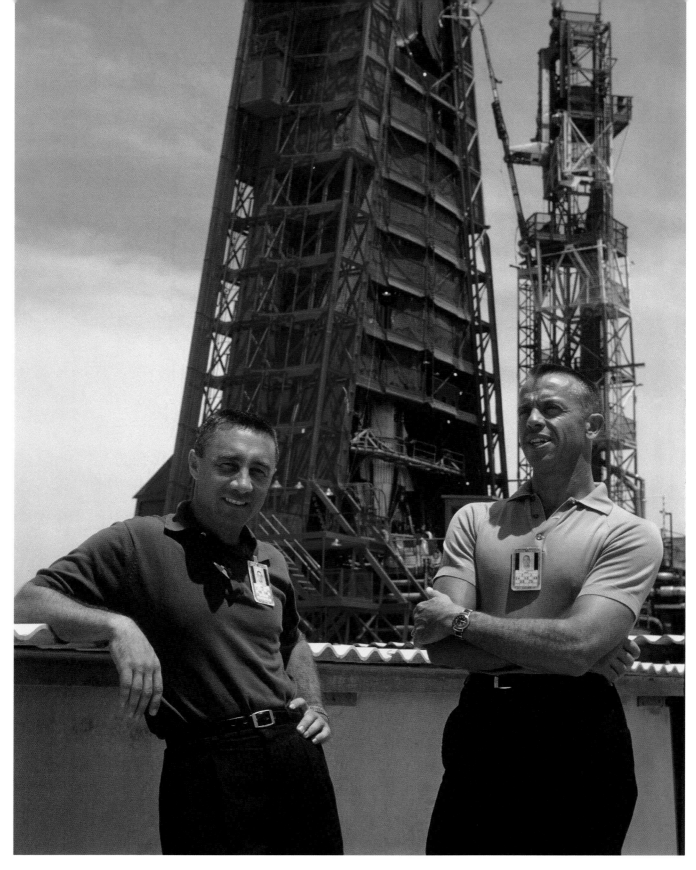

America's first two astronauts, Grissom and Shepard, pose in front of Mercury-Atlas 4 at LC-14. The unmanned mission would send a "crewman simulator" instrument package into a single orbit on September 13, 1961, paving the way for the next phase of Project Mercury.

# 5

# John Glenn

<div style="text-align: right">Mercury-Atlas 6</div>

Only weeks after Gus Grissom's suborbital flight, the Soviet Union launched its second cosmonaut, Gherman Titov, into orbit for a full day on August 6, 1961. Titov's seventeen revolutions seemed to give the Soviets a huge lead in the Space Race. Americans had to wait another six-and-a-half long months for the first American to orbit the Earth: 40-year-old US Marine Corps Lt. Col. John H. Glenn Jr., a World War II and Korean War fighter pilot.

Glenn was launched by an Atlas booster on February 20, 1962, from Launch Complex 14 (LC-14) aboard a spacecraft he named *Friendship 7*. Tens of thousands of spectators had gathered on Cocoa Beach, Florida, just south of Cape Canaveral to watch as an estimated sixty million Americans tuned in on live television.

Five minutes and twenty seconds later, Glenn was in orbit, traveling 17,544 mph. During his three revolutions of the Earth over nearly five hours, he described sunrises and sunsets, remarked on geographical features, and carried out tests of the spacecraft and his abilities in weightlessness. On his first orbit, Glenn reported "brilliant specks, floating around outside the capsule." He nicknamed them fireflies, which were later identified as ice crystals venting from the spacecraft's reaction control jets.

Glenn soon encountered problems, however, with the spacecraft's flight control system. *Friendship 7*'s small thrusters were malfunctioning, leaving only his larger jets to control the spacecraft when it began to drift. But they were using up fuel needed to control Glenn's reentry. He solved the problem by switching to manual control.

Then a worrisome issue cropped up. A signal indicated that his heat shield had become unlatched, something that was not supposed to happen until shortly before Glenn splashed down. That's when it was to release and pull out a cloth landing bag that would fill with air to cushion the impact.

Mercury Control asked him to flip a switch to check whether the landing bag had deployed. When a light did not go on, it seemed that the signal was false. But flight controllers, taking no chances, changed the sequence of reentry events to try to make sure that, even if loose, the heat shield would stay in place.

Strapped to the shield was a package of three braking rockets, used to slow the spacecraft to drop it out of orbit. The flight plan called for then cutting the straps and jettisoning the pack, leaving the exposed heat shield to handle the heat of atmospheric friction during reentry. But flight director Chris Kraft and associate director of operations Walter Williams decided to keep the retropack attached so its straps could hold the heat shield in place.

When the instructions were relayed to Glenn, he realized there must be a problem. He asked, "What are the reasons for this? Do you have any reasons?" "Not at this time," came the reply. The decision meant the retrorocket pack would burn up harmlessly during reentry; and it turned out that the original warning light was caused by a faulty sensor.

As *Friendship 7* reentered and began to heat up, pieces of the retropack began to stream past Glenn's window, and he feared his heat shield might be disintegrating.

"That's a real fireball outside," he radioed. Finally, the drogue and then the main chute deployed. He manually released the landing bag and safely splashed down north-northwest of the Dominican Republic.

The destroyer USS *Noa*, about 6 miles away, reached him seventeen minutes later. After the problems recovering Grissom's spacecraft, NASA had implemented new procedures. Glenn remained aboard *Friendship 7*, and rather than using a helicopter to retrieve the spacecraft, *Noa* snared it with a hook and hoisted it aboard. Once *Friendship 7* was on deck, Glenn blew the hatch and climbed out. He was flown to Grand Turk Island for two days of examinations, debriefings and recreation. He would return as a new national hero.

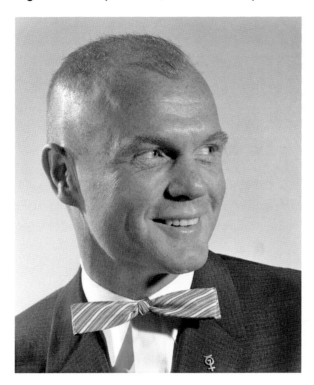 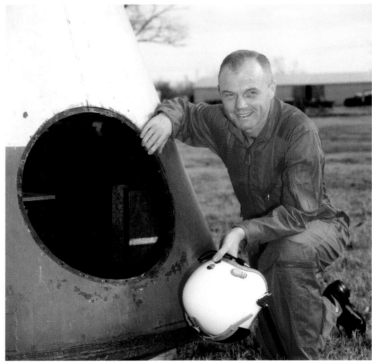

LEFT Glenn sports a Mercury Seven lapel pin in this portrait from a session with Bill Taub in 1960. He was involved in early Project Mercury planning through his job with the Navy Bureau of Aeronautics and underwent extensive centrifuge training. Glenn was sent to McDonnell Aircraft in St. Louis as a service adviser to NASA's spacecraft mock-up board before applying to be an astronaut.

RIGHT Glenn, at 40 the oldest of the seven, poses with a boilerplate Mercury spacecraft at Langley Research Center, Virginia, in January 1960. A US Marine Corps lieutenant colonel, he was a test pilot who had flown eighty-four combat missions during World War II and the Korean War. In 1957, he set a new transcontinental speed record, flying from near Long Beach, California, to New York City in just more than three hours and twenty-three minutes. It made Glenn a minor celebrity, including a *New York Times* profile and an appearance on the CBS-TV show *Name That Tune*.

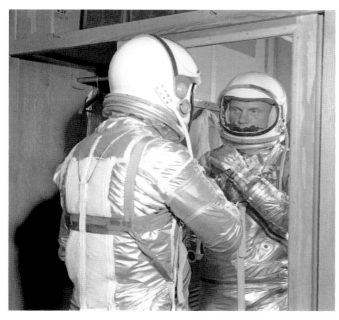

## 1961

**TOP** Glenn makes sure his pressure suit is properly sealed around the helmet's neck ring at Langley AFB in early 1961.

**BOTTOM** Glenn in Mercury Procedures Trainer no. 1 at Langley. The trainers provided an oxygen supply to the cabin and the suit to better simulate space flight. Most sessions were devoted to launch aborts.

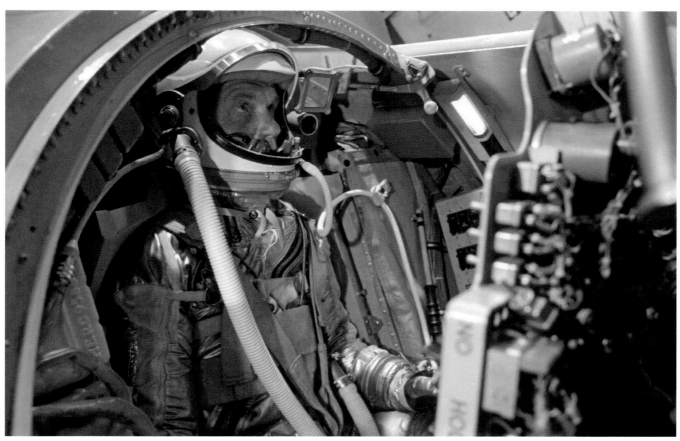

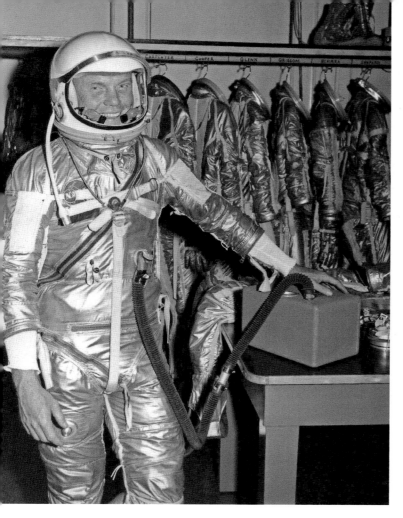
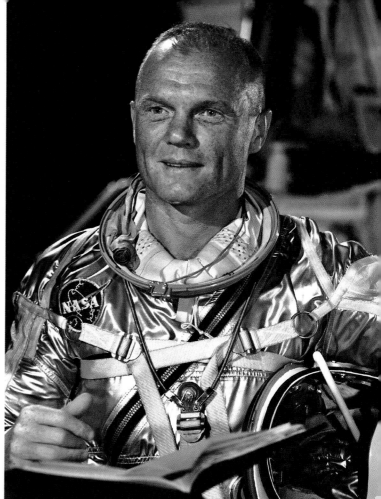
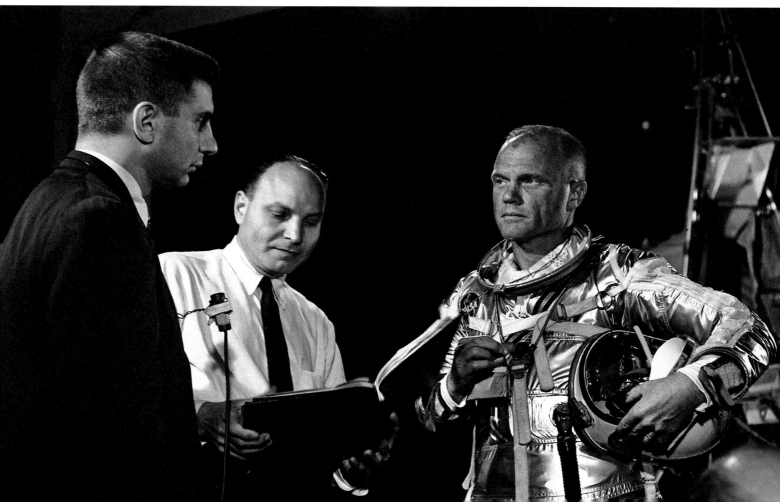

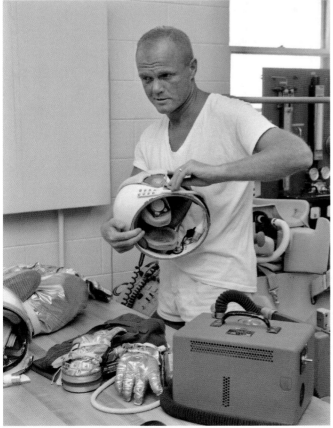

FACING PAGE  Glenn during an interview session with ABC's Jules Bergman in March while filming an interview in the Hangar S suit room prior to Mercury-Redstone 3 (MR-3). Bergman's producer holds a script. Footage would air in the half-hour TV special *Road to the Stars* on April 28.

TOP  Glenn checks out Alan Shepard's MR-3 spacecraft in Hangar S in March. The spacecraft was put through a complete flight simulation before its transfer to the pad.

BOTTOM  Glenn works with a Fiberglas Mercury helmet in the suit room. The rubber earphones were custom-molded to each astronaut.

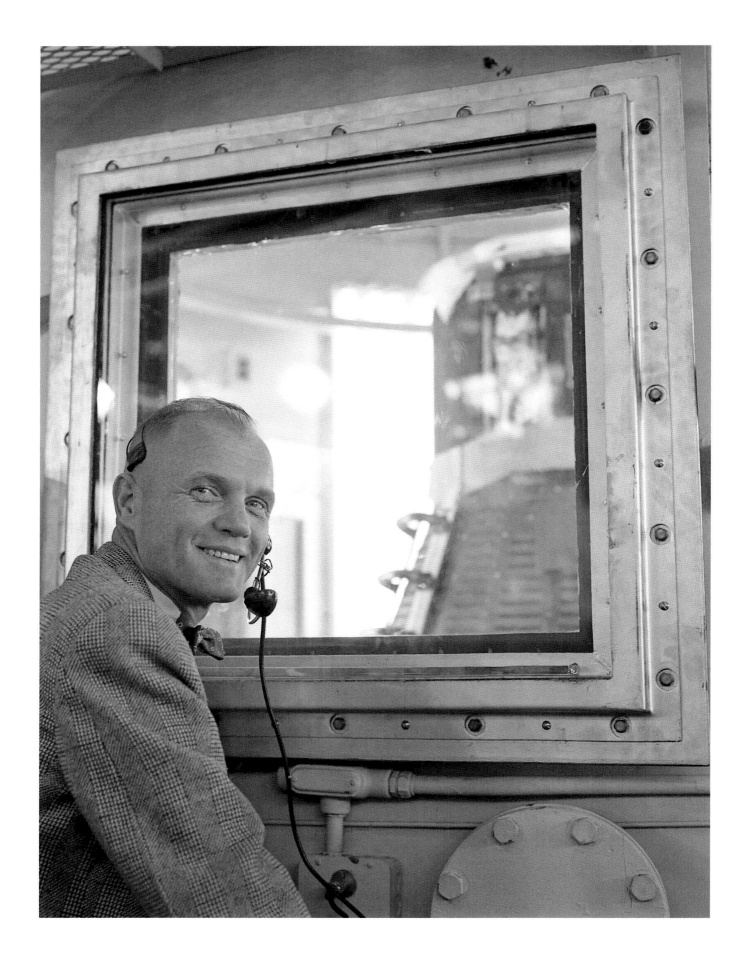

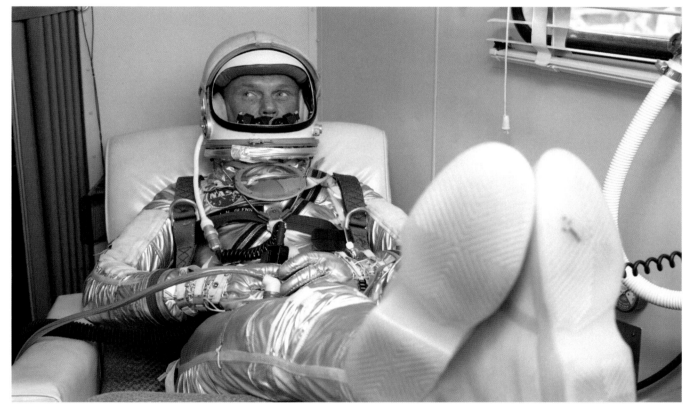

**FACING PAGE** Glenn monitors a *Freedom 7* altitude chamber test in Hangar S with Shepard inside.

**TOP LEFT** Glenn uses screwdrivers to pull on elastic bands during his L–1 (liftoff minus 1 day) medical examination for MR-3 on May 1 at Hangar S. Helmet cases sit on the cabinet behind him.

**TOP RIGHT** Glenn during MR-3 spacecraft checkout in the white room at LC-5 in April, with a documentary 35 mm still camera above him at left.

**BOTTOM** Glenn wears protective plastic boot covers in the transfer trailer before an MR-4 simulation at LC-5 in July in his role as backup pilot.

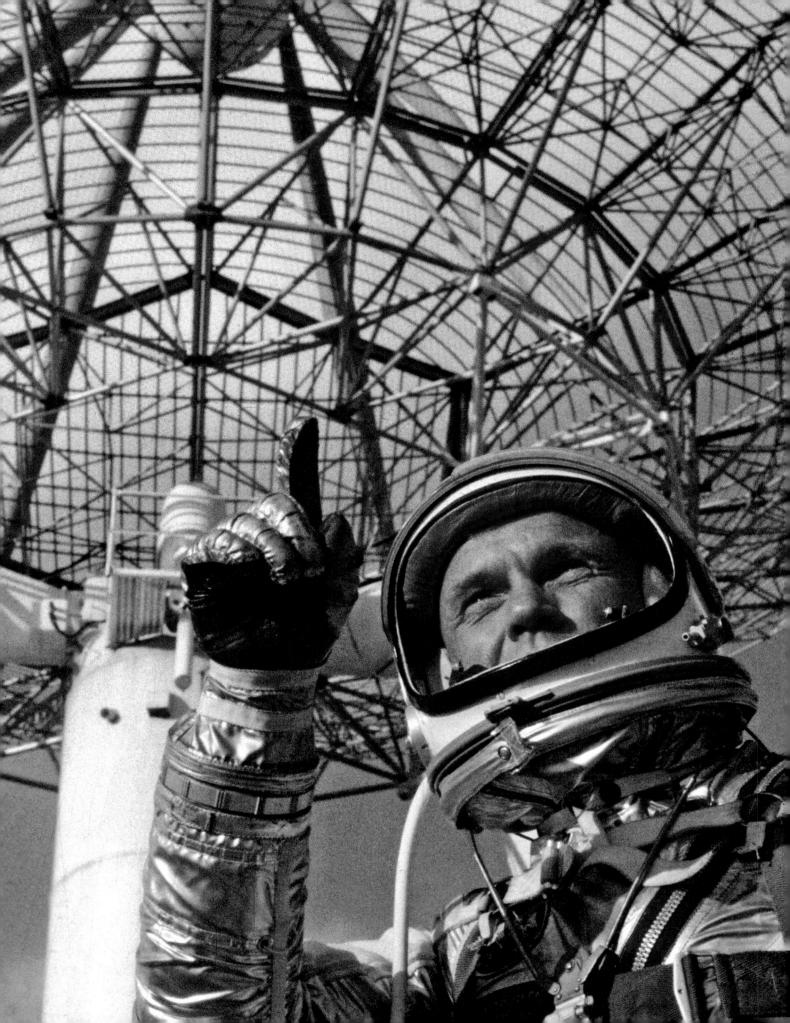

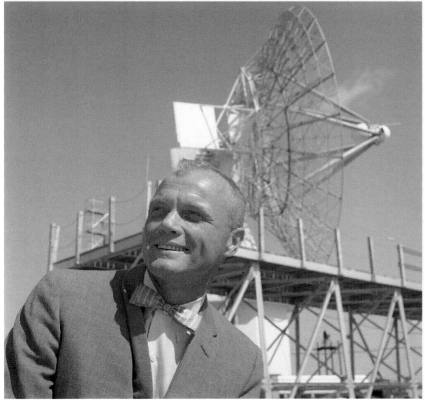

FACING PAGE Glenn poses in front of the S-band radar tracking, communications, and telemetry antenna next to the Mercury Control Center (MCC) on November 29, 1961. The station was known as CNV among the dozen Mercury Network tracking sites worldwide, including ships. NASA was mulling a late December launch date.

TOP Glenn (*left*) and Scott Carpenter remove their sunglasses for a Taub photo at LC-14 on December 2, 1961, as Glenn's booster, Atlas 109D, is being erected. Glenn had been officially named as the pilot three days earlier, to be followed by Deke Slayton and then Carpenter. Carpenter, however, would serve as Glenn's backup, with Slayton closely involved.

BOTTOM Glenn poses for Taub with the Cape tracking antenna.

**TOP** Glenn prepares to move a section of *Friendship 7*'s instrument panel to facilitate his practice egress through the spacecraft's neck after a Hangar S altitude chamber test in mid-December.

**BOTTOM TWO IMAGES** After egressing (*left*), Glenn removes a glove (*right*). He had also trained for this alternative method of leaving a spacecraft in the Langley water tank in 1960. Glenn planned to use this technique after *Friendship 7* was aboard the recovery ship, but he was getting too warm and blew the hatch instead.

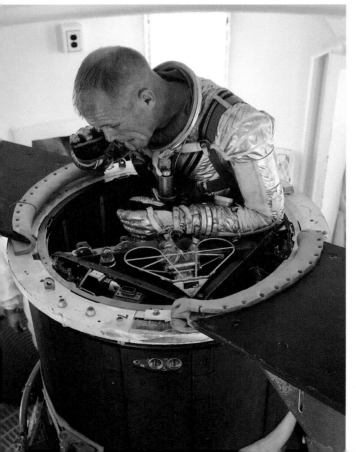

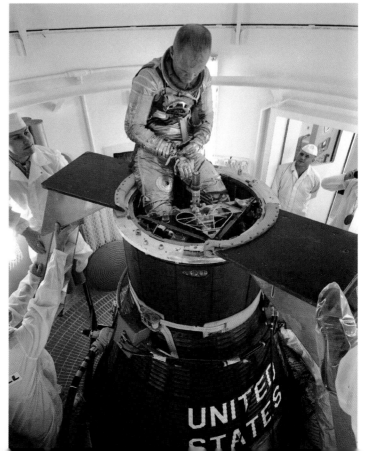

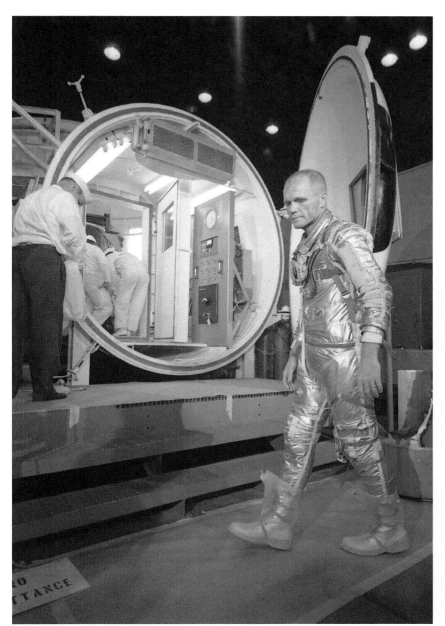

**TOP TWO IMAGES** Technicians help Glenn step down from the top of the spacecraft before he leaves through the air-lock door. *Friendship 7* would be mated to its Atlas booster on January 3.

**BOTTOM** Glenn observes Carpenter preparing for an altitude chamber test in December. The main objective was to check the spacecraft's environmental control system, including the pilot's pressure suit.

**TOP** Glenn shows Taub a tent card he had found with a classic aphorism on December 17 in Pensacola. The astronauts had taken some ribbing from comedians and cartoonists with several primates preceding them into space.

**BOTTOM LEFT** Glenn takes a balance test during his visit to the Vestibular Physiology Lab at the US Naval School of Aviation Medicine in Pensacola, Florida. He and his backup, Carpenter, also spent time there in the Slow Rotation Room, a circular windowless room 20 feet in diameter that could rotate between horizontal and vertical to test their equilibrium, including limited "wall walking."

**BOTTOM RIGHT** Flight surgeon Dr. William Douglas (*left*) makes a point during a meeting with Glenn in Pensacola. Glenn and Carpenter also became familiar with the Navy's night vision training at the school.

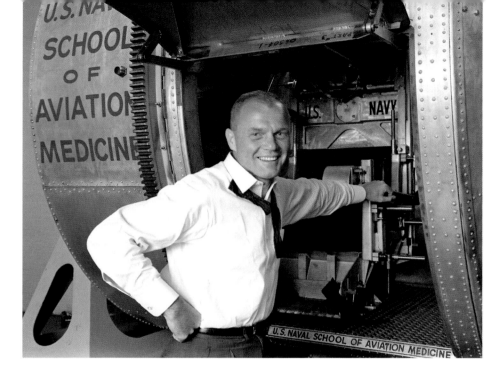

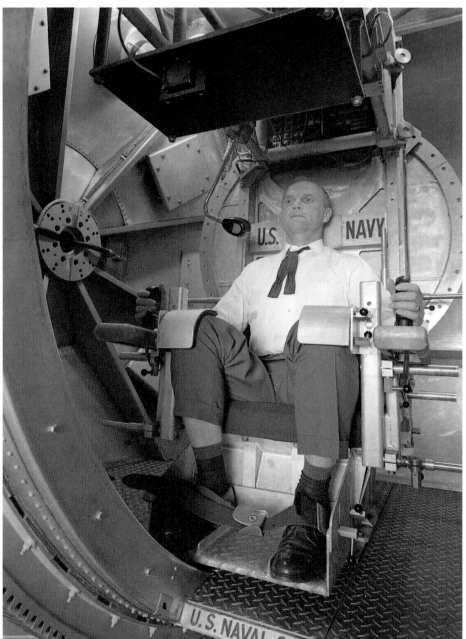

**TOP** Glenn poses at the School of Aviation Medicine with the open door to the Human Disorientation Device (HDD) on December 17.

**BOTTOM** Glenn sits in the HDD chair, which could rotate the subject along both vertical and horizontal axes simultaneously.

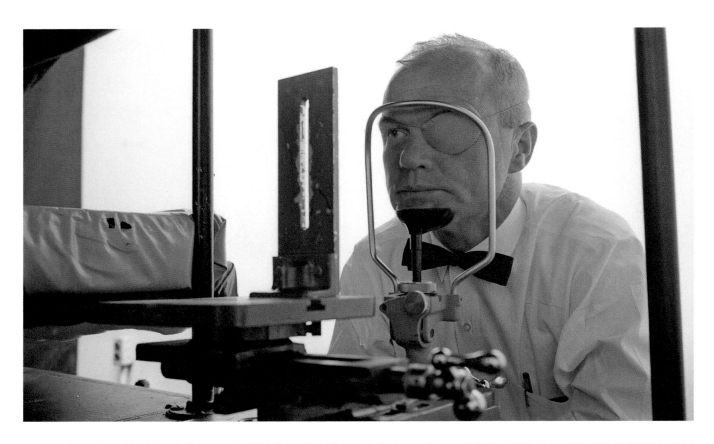

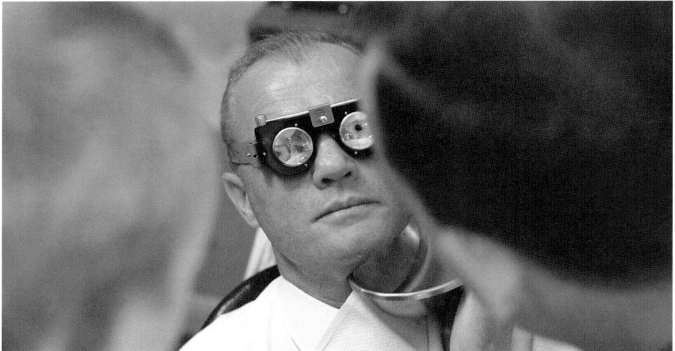

Glenn undergoes ophthalmic examinations in Pensacola.

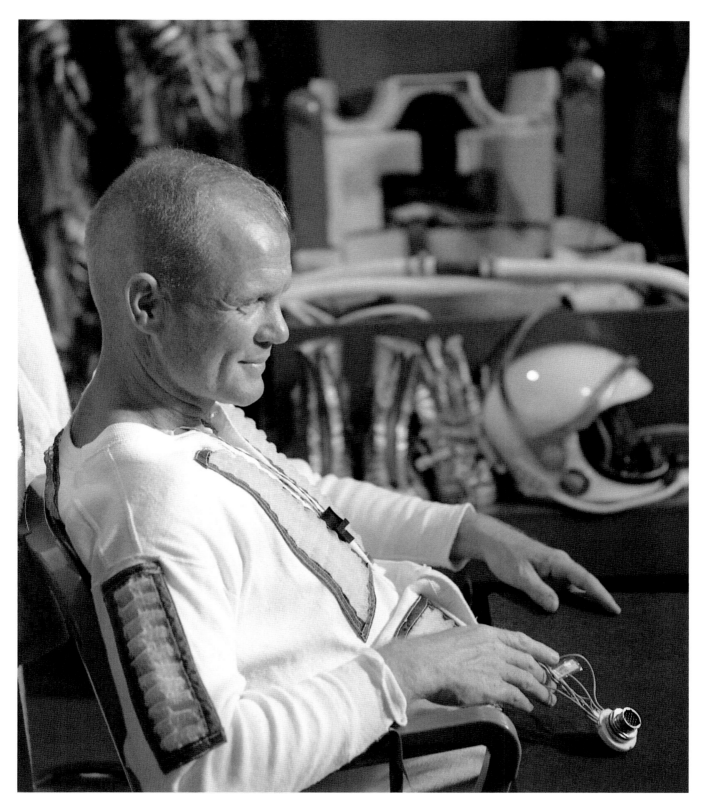

**1962** Glenn prepares to don his training pressure suit for a Johnsville centrifuge session in Warminster, Pennsylvania, in January.

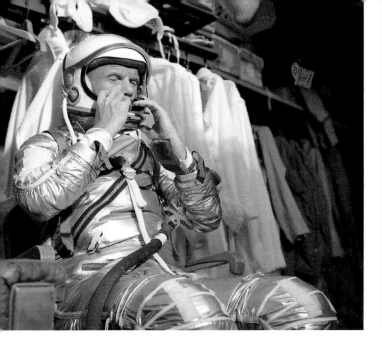
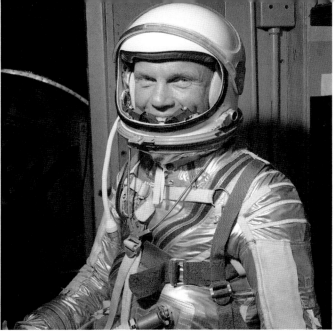
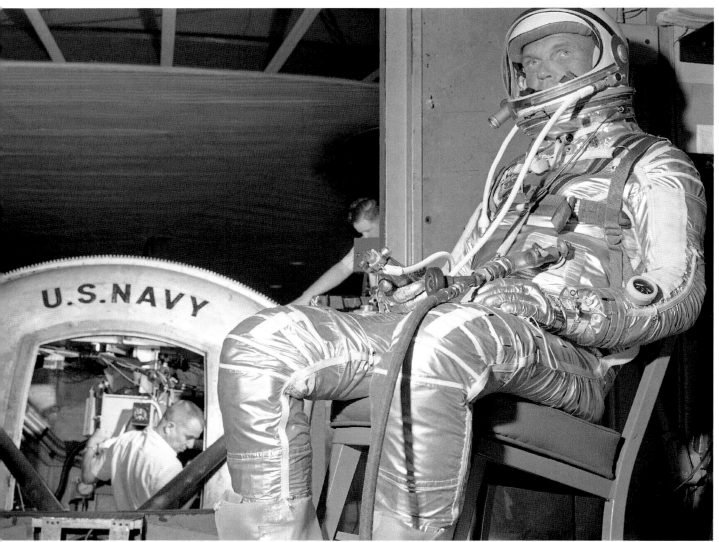

Glenn at the centrifuge session in January. Dubbed "the wheel," the device could whirl the gondola up to forty-eight revolutions a minute on a 50-foot arm. Glenn called it a "dreaded" and "sadistic" aspect of his training.

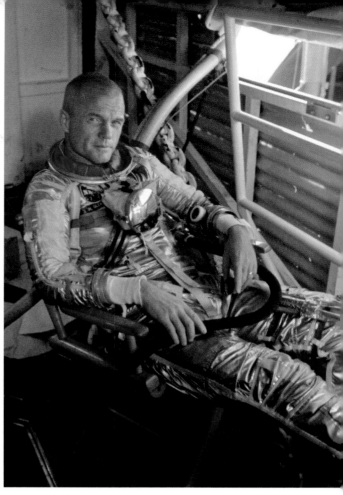

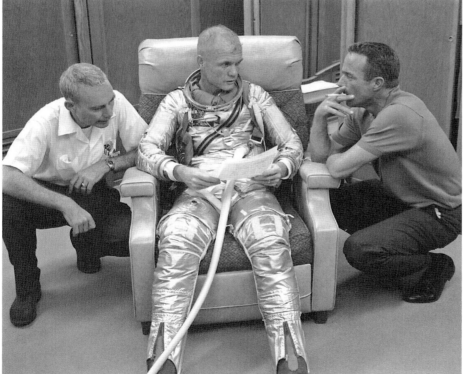

**TOP LEFT** Each astronaut could set his own exercise regimen, and Glenn chose running. He tried to run 5 miles a day, often on Cocoa Beach, in the weeks leading to his flight. He reduced it to 2 miles a day a week before, then down to 1 mile three days before. The final two days he devoted to simulator training. Glenn's wife and two children joined him on at least one beach run.

**TOP RIGHT** Glenn relaxes at LC-14 on January 21.

**BOTTOM** Glenn goes over procedures in Hangar S with Dr. Douglas (*left*) and Carpenter (*right*) on January 19.

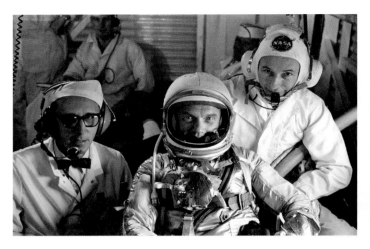

## January 23, 1962

**TOP LEFT** *Left to right:* McDonnell pad leader Guenter Wendt, Glenn, and suit technician Joe Schmitt pose in the LC-14 white room in smocks and caps at about 8:00 a.m. for preflight checks with the planned launch four days away. While waiting for insertion, Glenn talked to his mother in New Concord, New Hampshire, for about ten minutes from the white room.

**TOP RIGHT** Glenn pauses outside *Friendship 7*. His gloves were the first to have small lights at the tips of their first two fingers, originally envisioned to help him see his instruments while on the dark side of the Earth. He later reported that they also helped him read charts and maps in the spacecraft's cramped interior. The battery-powered lights were red to preserve night vision. Arm mirrors will reflect the instrument panel for the pilot observation camera.

**BOTTOM** As Wendt looks on at right, Glenn slides into his spacecraft, where he tested repairs to the oxygen system for about an hour. Carpenter would soon take his place.

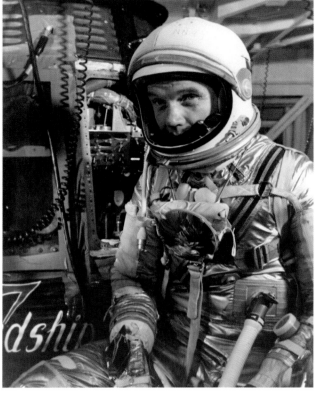

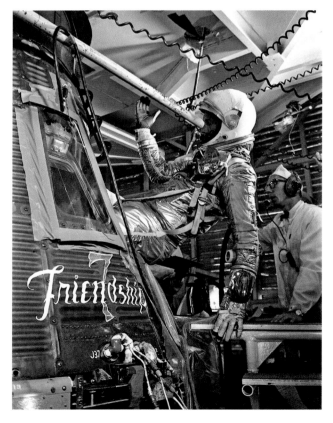

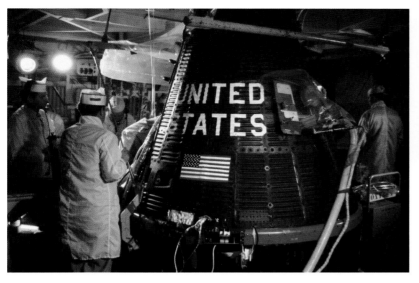

**TOP LEFT** McDonnell technicians work around *Friendship 7* with an unsuited Carpenter inside, who "flew" a full three-orbit mission. The spacecraft, no. 13, spent a total of forty-three days at the pad. Workers managed to hide about two hundred one-dollar bills inside that they had signed, so Glenn could sign them after recovery. The red ring at the spacecraft's base secures it to the Atlas.

**TOP RIGHT** Glenn's children chose the name of his spacecraft to support using space for peaceful purposes.

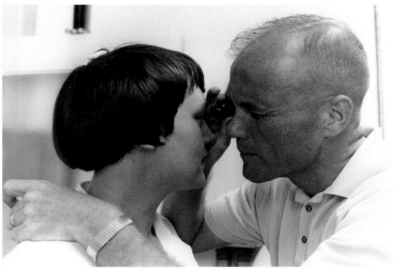

**MIDDLE** After changing from his pressure suit, Glenn examines astronaut nurse Lt. Dee O'Hara's eye using one of the new Welch Allyn medical instruments that had just arrived at the Hangar S clinic.

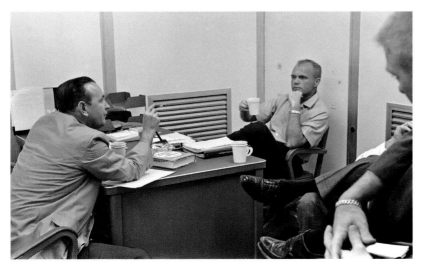

**BOTTOM** Kraft holds a morning flight status session with Glenn and others in Hangar S. Williams is almost out of frame at right. A copy of the *MA-6 Flight Controller Handbook* is on the desk.

**TOP** Glenn reads a back issue of the *Miami Herald* while getting a haircut in Cocoa Beach at 11:30 a.m. He was not restricted to the Cape but only left for an occasional dinner, church, and this trim, which cost $1.50. Wally Schirra said Glenn got frequent trims to ensure a good helmet fit.

**BOTTOM** Glenn returns to Hangar S from the barber shop in his 1962 Chevy Impala and poses for Taub. He then changed clothes and began laps around the hangar. The following Friday, however, Glenn climbed out of *Friendship 7* after heavy cloud cover scrubbed the launch attempt that morning. The flight would later be delayed into February because of problems with the Atlas.

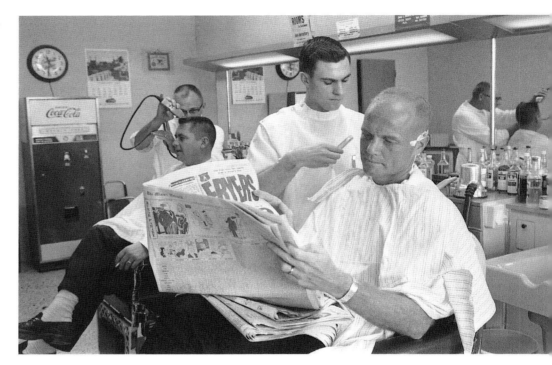

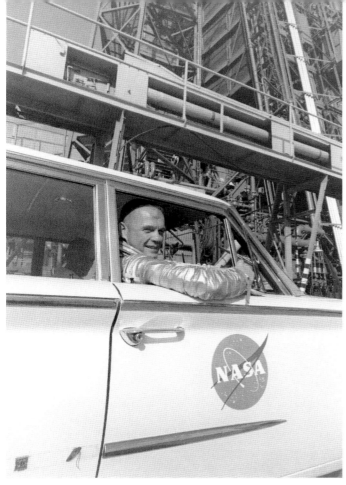

## February 1962

**TOP LEFT** A suited Glenn arrives at LC-14 in a Ford station wagon on February 12 for an expected final preflight session inside *Friendship 7*. A new launch date had been set for the fourteenth, but the weather forecast was not promising and the date slipped again.

**BOTTOM LEFT** Glenn changes records on an RCA Victor player provided by assistant dietitian Bill Olsen. Glenn and his backup, Carpenter, would occasionally listen to music in the crew quarters after dinner. Though not an opera fan, Glenn enjoyed selections from Puccini's *Madam Butterfly*. He also enjoyed watching the TV news and programs about his flight.

**RIGHT** Glenn holds a Leica 35 mm film camera with the lens cap on in Hangar S on February 15. He'd been awakened in the wee hours three days in a row, only to have his launch scrubbed each time.

**TOP** Glenn leaves the MCC with his briefcase and knee board.

**BOTTOM** The astronaut climbs into his Impala to head to Patrick AFB for some flying.

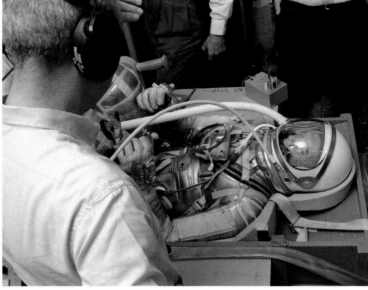

## February 20–22, 1962

**TOP LEFT** Glenn is assisted by suit tech Schmitt at 4:30 a.m. on launch morning. Glenn had been up since 1:30 a.m.

**BOTTOM LEFT** Schmitt helps Glenn stow items in a suit shin pocket.

**RIGHT** Dr. Douglas communicates with Glenn during his suit leak test. The astronaut has a yellow life vest behind his chest mirror, an addition after Grissom's flight.

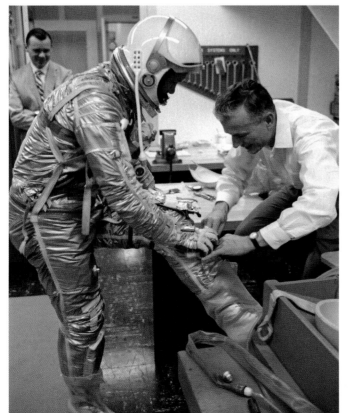

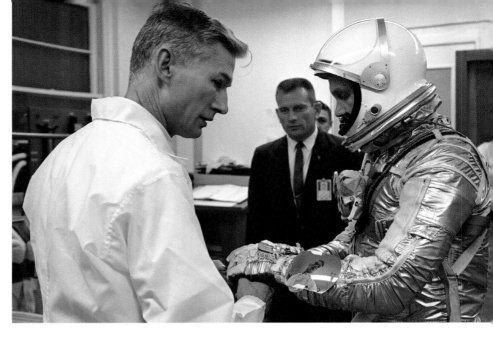

**TOP** Schmitt (*left*) checks Glenn's new battery-powered glove fingertip lights as Slayton, expected to fly next, looks on. Schmitt can be seen reflected in the mirror on Glenn's left arm.

**MIDDLE LEFT** Glenn (*right*) gets final briefings from backup Carpenter and Slayton behind him in the transfer trailer en route to LC-14.

**MIDDLE RIGHT** Glenn bids adieu to Carpenter as he prepares to leave the trailer at about 5:30 a.m.

**BOTTOM** *Left to right:* Slayton, Dr. Douglas, and Glenn walk to the service structure elevator at LC-14 as suit technician Alan Rochford watches from the trailer door.

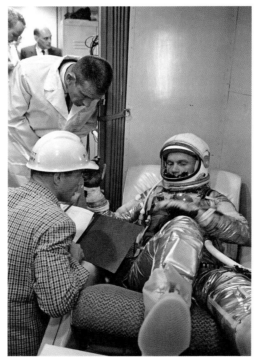

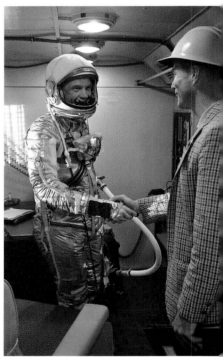

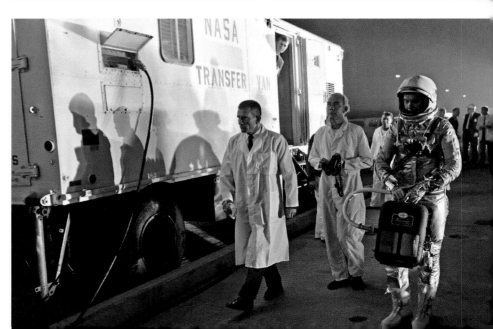

**LEFT** Dr. Douglas (*left*) and Glenn prepare to enter the elevator to the LC-14 white room.

**RIGHT** A General Dynamics technician on a ladder services one of the booster's vernier motors, used to help stabilize the Atlas during launch.

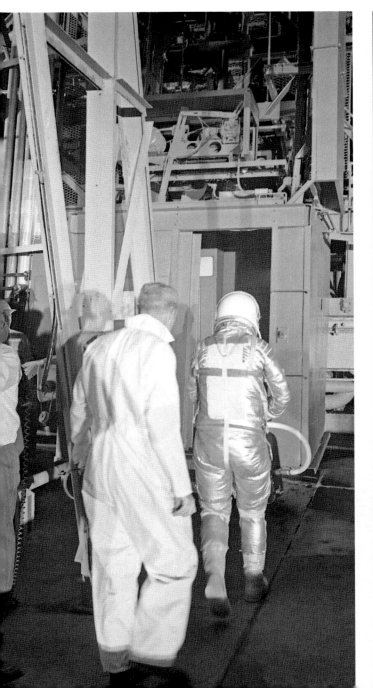

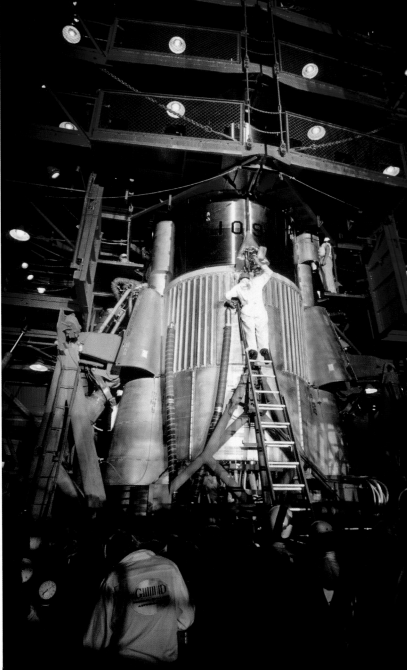

HOPE AND PRAYERS OF
FREE WORLD ARE WITH
COL. JOHN GLENN

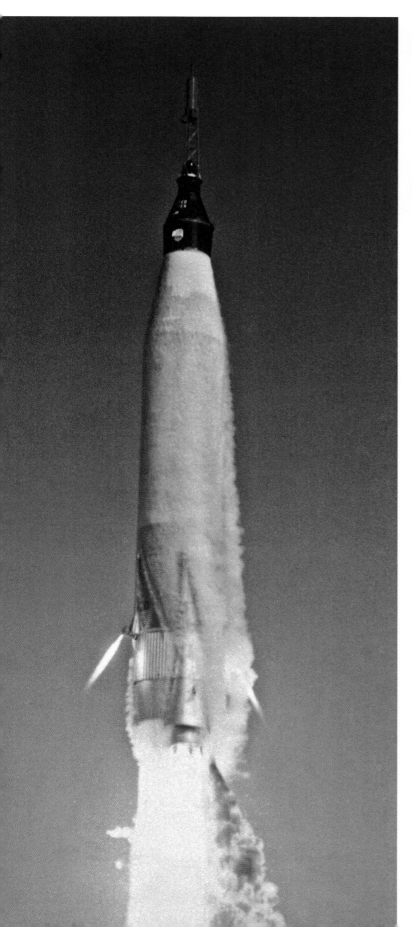

**FACING PAGE** Marquees around the Space Coast focused on the flight. The Holiday Inn Cocoa Beach was managed by Holocaust survivor Henri Landwirth, who made it a haven for the Mercury astronauts before they jointly invested in the nearby Cape Colony Inn.

**LEFT** *Friendship 7* finally heads into orbit at 9:47 a.m. EST after ten delays over three months.

**RIGHT TWO IMAGES** Two still frames from the 16 mm pilot observation camera capture Glenn with his visor open and closed during the mission, just short of five hours. He orbited the Earth at an altitude ranging between 160 and 100 miles, a relatively low orbit. A mission-elapsed time clock is at right; the 16 mm instrument panel observer camera lens is at left with the panel's lights reflected in Glenn's chest mirror.

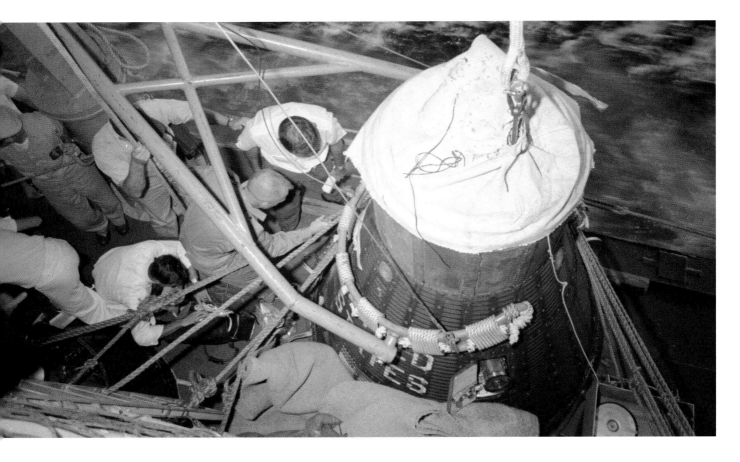

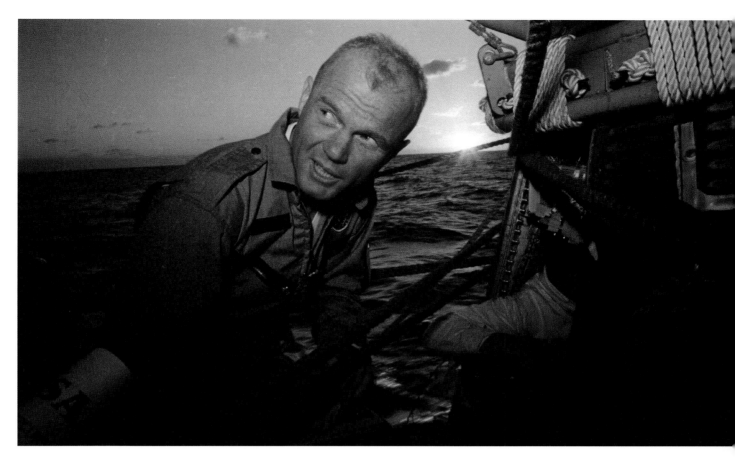

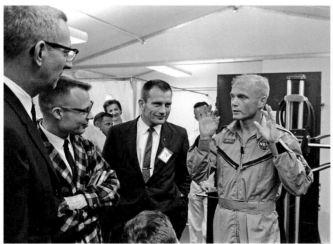

**FACING PAGE, TOP** Glenn (*center*) inspects *Friendship 7* aboard the destroyer USS *Noa*. He had splashed down at 2:43 p.m. EST north of the Dominican Republic, closer to *Noa* than to the prime recovery ship, the aircraft carrier USS *Randolph*.

**FACING PAGE, BOTTOM LEFT** Glenn records his memories and observations with a Webster Electric Ekotape reel-to-reel tape deck.

**FACING PAGE, BOTTOM RIGHT** The astronaut packs his suitcase to get ready to leave the *Noa* before his transfer by helicopter to USS *Randolph*.

**THIS PAGE, TOP** Glenn inspects *Friendship 7* one last time at sunset, with a McDonnell technician inside.

**THIS PAGE, BOTTOM** *Left to right:* Mercury program manager Ken Kleinknecht, Navy lieutenant and psychologist Dr. Robert Voas, and Slayton listen to Glenn following his arrival at a new NASA hospital on Grand Turk Island, a British colony, at about 9:30 pm. He had served as copilot aboard a Navy Grumman S2F Tracker during the one-hour flight from the *Randolph*.

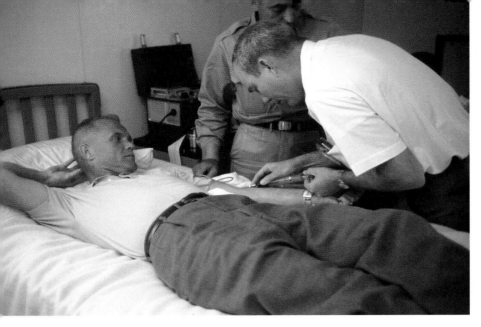

**TOP TWO IMAGES** At left, Dr. Douglas draws a blood sample; at right, sensors are attached for an electroencephalogram (EEG) on February 21. Glenn spent February 21 and 22 undergoing morning examinations and debriefings at the hospital, built to support Mercury orbital missions. Afternoons were devoted to recreation.

**BOTTOM** Glenn relaxes during a second EEG the next day. Doctors described his condition as excellent. That evening, he attended a party given in his honor with the personnel of the tracking station, where he and Shepard sat at a table signing autographs.

**LEFT** Glenn peers through the viewfinder of a Calypso 35 mm camera, capable of underwater photography; it was designed by one of marine explorer Jacques Cousteau's crewmen.

**BOTTOM** Glenn and Carpenter check out a grouper on the afternoon of February 21; Glenn had tried spearfishing and skin-diving. Carpenter, an experienced scuba diver, also rescued a skin diver they were out with. Dr. Douglas helped pull the man, a base technician, into the boat and revived him.

# February 23, 1962

**TOP** Glenn has breakfast with Vice President Lyndon Johnson, who had flown in that morning, in the mess at the Grand Turk tracking station. Manned Spacecraft Center director Robert Gilruth is at left.

**MIDDLE** After flying to Patrick AFB, where Glenn was reunited with his family, Vice President Johnson (*left*) and the Glenns head north through Cocoa Beach on SR A1A to Cape Canaveral in a Buick convertible. Although residents are disappointed President Kennedy isn't with them, about a hundred thousand people line the 18-mile route—almost twice as many as had turned out for Glenn's launch.

**BOTTOM** Vice President Johnson and the Glenns arrive at the Cape Canaveral Skid Strip runway and wait for President Kennedy to land at 10:35 a.m. from Palm Beach AFB, where he had been visiting his ailing father. The three TV networks cover the morning's events live, beginning with Glenn's arrival at Patrick at 8:45 a.m. and the parade north to the Cape.

**FACING PAGE, TOP TWO IMAGES** President Kennedy, center, greets the Glenns' parents with White House press secretary Pierre Salinger at far left. The crowd broke through Secret Service lines and briefly surrounded the VIPs. The president carries his Cavanaugh snap-brim fedora.

**FACING PAGE, BOTTOM** *Left to right:* President Kennedy, Glenn, and Maj. Gen. Leighton Davis, commander of the Air Force Missile Test Center, depart the Skid Strip at 10:40 a.m. for a tour of Mercury launch facilities in the back seat of 1962 Lincoln Continental.

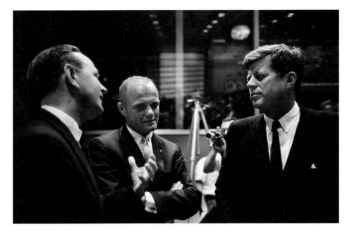

**TOP** Kraft (*left*) talks with Glenn and the president in the MCC.

**MIDDLE** Photographers jostle inside the MCC. *National Geographic*'s Dean Conger is at lower left, with Ralph Morse of *Life* magazine above him with camera.

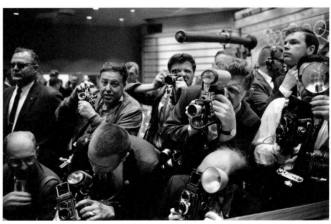

**BOTTOM** President Kennedy and Glenn leave the MCC after about twenty minutes to return to the Lincoln and head for a brief ceremony at Glenn's launch site. Photographer Taub lights a cigarette two people behind Kennedy. NBC News correspondent Peter Hackas is in the doorway in jacket and tie. An ABC-TV pool camera at left also used for Glenn's launch transmits the scene; a news media pool microphone is temporarily mounted above the entrance.

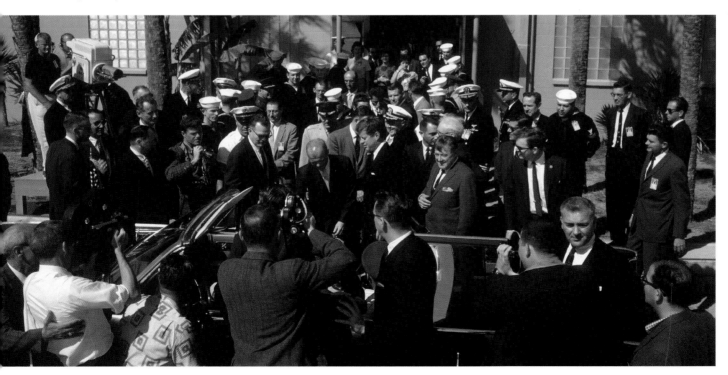

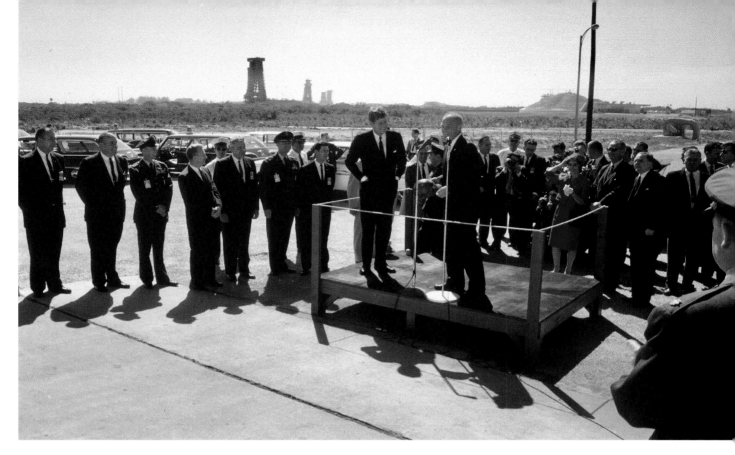

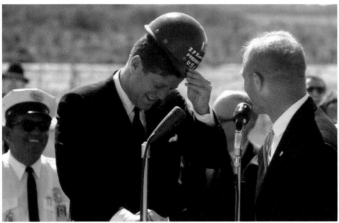

**TOP** At LC-14, Glenn presents President Kennedy with a personalized McDonnell hard hat, which he said makes Kennedy "an honorary member of the launch crew." Annie Glenn, Vice President Johnson, and NASA administrator James Webb look on at right. The service structures at LC-13, -12, and -36 are in the distance to the south; the LC-13 blockhouse is at right.

**BOTTOM RIGHT** The Glenns and President Kennedy prepare to depart for Hangar S.

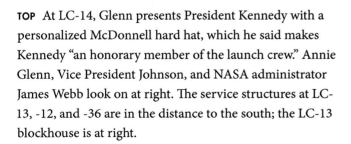

**BOTTOM LEFT** President Kennedy briefly dons the hat after Glenn reached out to try to put it on his head. Like most presidents, Kennedy is reluctant to wear unusual headgear of any sort.

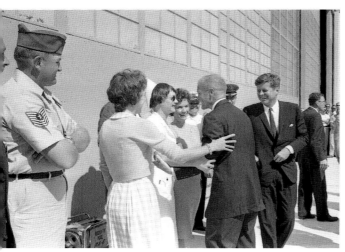

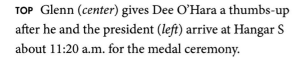

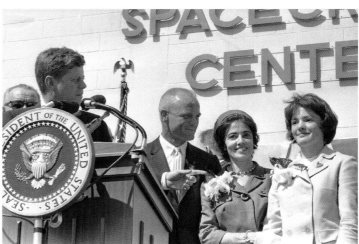

**TOP** Glenn (*center*) gives Dee O'Hara a thumbs-up after he and the president (*left*) arrive at Hangar S about 11:20 a.m. for the medal ceremony.

**BOTTOM LEFT** O'Hara greets Glenn. She had agreed to give Secret Service agents a tour Hangar S if she could meet the president.

**BOTTOM RIGHT** President Kennedy introduces Glenn's family before awarding him NASA's Distinguished Service Medal. "His performance in fulfillment of this most dangerous assignment reflects the highest credit upon himself and the United States," the president says, reading Glenn's medal citation.

**LEFT** During a brief look at *Friendship 7*, Glenn discusses his reentry with his family, the vice president, and the president.

**TOP RIGHT** Glenn holds an afternoon news conference at the Cape, with Gilruth at left. "Someone told me they think I'm an addict to [weightlessness]," he told reporters with a laugh. "I probably am."

**BOTTOM RIGHT** Marshall Space Flight Center director Wernher von Braun and his wife, Maria, attend the news conference. "It is great—just great," he said of the mission.

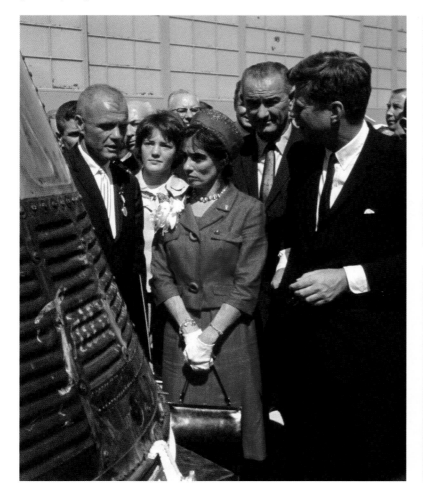

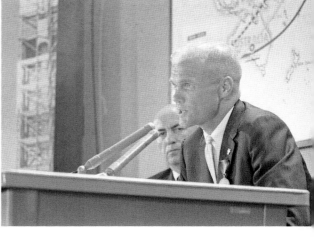

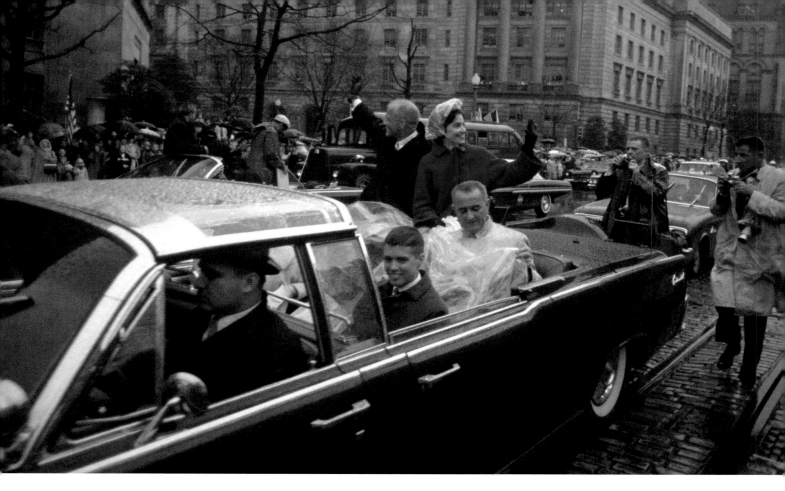

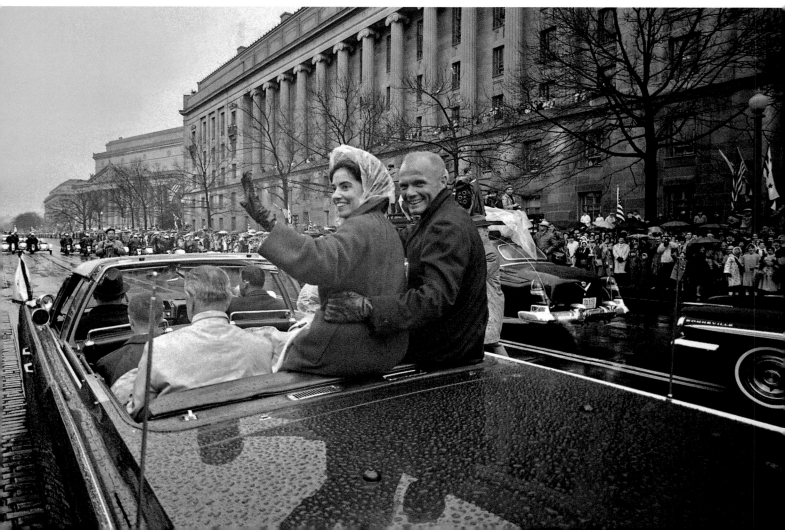

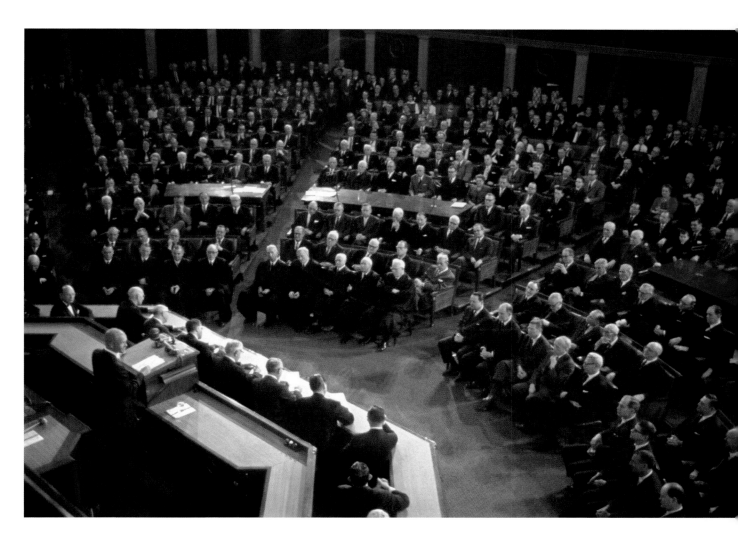

## February 26–August 1962

**FACING PAGE, TOP** After a White House reception on February 26, the Glenns and Vice President Johnson head down Pennsylvania Avenue in President Kennedy's custom 1961 Lincoln Continental limousine under rainy skies. The limo nears the Department of Justice ahead on the left at about 12:30 p.m. Photographer Taub is at far right.

**FACING PAGE, BOTTOM** Annie Glenn waves as the motorcade proceeds toward the US Capitol, shrouded in mist in the distance. The crowd is estimated at 250,000 spectators.

**THIS PAGE** Glenn delivers a seventeen-minute speech to a joint meeting of Congress in the US House chamber with the Supreme Court and the president's Cabinet seated in front. The Mercury astronauts, he says, "are just probing the surface of the greatest advancement in man's knowledge of his surroundings that has ever been made."

**TOP** Glenn (*center*) is served scoops from the commemorative dessert at the State Department luncheon hosted in his honor by Vice President Johnson (*left*), who was chairman of the administration's Space Council. Chocolate and strawberry ice cream formed the *Friendship 7* replica; not seen is a mint ice cream model of USS *Noa* that rested nearby.

**BOTTOM** Annie Glenn and her children pose with the other six Mercury wives at Andrews AFB, Maryland, on May 1. The group, along with Vice President Johnson and NASA officials, will soon board two aircraft to head for New York City for a ticker-tape parade for the astronauts down Broadway. *Left to right:* Trudy Cooper, Rene Carpenter, Jo Schirra, David Glenn, Lyn Glenn, Annie Glenn, Betty Grissom, Marge Slayton, and Louise Shepard.

**TOP** On March 3, 1962, Glenn's tiny home-town of New Concord, Ohio, honored him with a parade along Main Street witnessed by more than fifty thousand.

**BOTTOM LEFT** After the parade, Glenn briefly relaxed at his parents' home, which was along the parade route. Today it is a museum of his boyhood and career.

**BOTTOM RIGHT** The Glenn family attends a dinner at the Cocoa Beach Holiday Inn with members of the Mercury team in March.

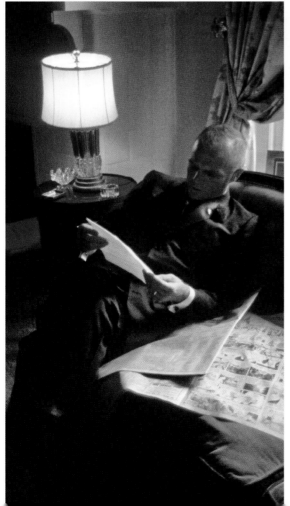

**TOP** Glenn receives a multi-pin launch umbilical connector in Lucite during a party at the Cocoa Armory on April 23. The head table includes (*left to right*) NASA test conductor Paul Donnelly, Glenn, McDonnell's "Luge" Luetjen, Linda Luetjen, and the evening's entertainer, risqué nightclub comedian Woody Woodbury. An Atlas model is on stage.

**BOTTOM** Glenn's new international fame attracted celebrities; here, actor Danny Kaye chats with the couple at their Arlington, Virginia, home in August.

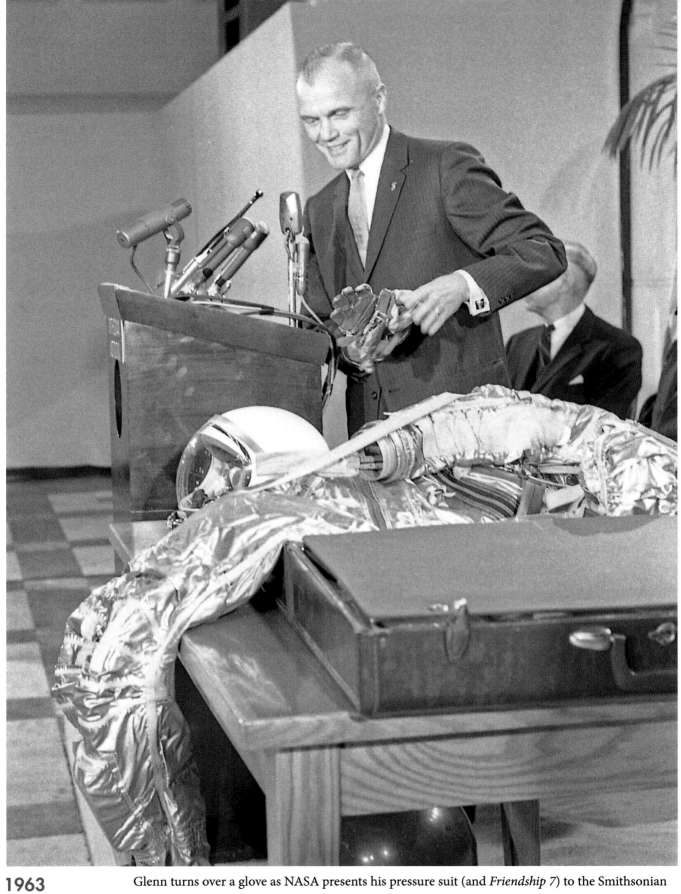

**1963** Glenn turns over a glove as NASA presents his pressure suit (and *Friendship 7*) to the Smithsonian Institution in Washington, DC, on February 20, the one-year anniversary of his flight. Deputy NASA administrator Hugh Dryden sits behind him.

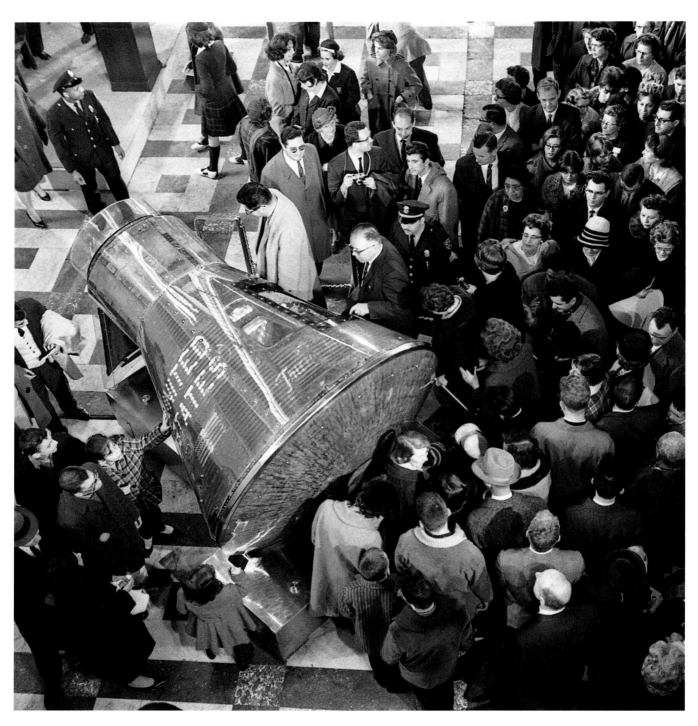

Visitors to the Smithsonian line up at right to see *Friendship 7* at the National Air and Space Museum on February 20, protected by a clear cover. Its heat shield shows scorching from reentry. The spacecraft was put on display beneath the Wright Flyer and Lindbergh's *Spirit of St. Louis*.

**TOP TWO IMAGES** Glenn and his wife shop during a trip to Japan in 1963. Glenn had arrived in Tokyo on May 4 for Gordon Cooper's Mercury Atlas 9 flight on May 15, serving as the communicator from the *Coastal Sentry* tracking ship 300 miles offshore; his family arrived afterward for a twelve-day semi-official visit.

**LEFT** Annie Glenn shops for cuff links. The family also took a ride on Japan's new super express train during a test run, watched pearl divers, and toured Kyoto and Osaka.

**TOP RIGHT** Annie, John, and Lyn Glenn shop for bracelets.

**BOTTOM RIGHT** David Glenn tries out a telescope during the trip.

**BOTTOM LEFT** Glenn participates in a dance program during the trip; he was fascinated by Kabuki.

# 6

# Deke Slayton                                           Destiny Delayed

USAF Maj. Donald K. "Deke" Slayton, 36, was named to fly the next Mercury mission, a planned repeat of John Glenn's three-orbit flight, but he would instead be grounded less than two months before his launch by a heart condition.

Slayton joined the US Army Air Forces during World War II, and flew combat missions in Europe and the Pacific. He left the Army after the war and later joined the Minnesota Air National Guard after working for Boeing as an aeronautical engineer. Slayton joined the USAF, and attended the Air Force Test Pilot School in 1955.

In 1959, he was selected as a Mercury astronaut and was assigned the Atlas launch vehicle as his area of responsibility. Later that year, he was training in a centrifuge and underwent an electrocardiogram; it was found that he had erratic heart activity. Slayton received further medical evaluation at Brooks AFB and was diagnosed with idiopathic atrial fibrillation, but he was considered healthy enough to continue flying.

During the unmanned Mercury-Atlas 4 (MA-4) orbital flight, Slayton worked at the Bermuda tracking station. He was named to pilot the planned second orbital mission in February 1962, but a review of his medical records brought fresh scrutiny to his heart condition.

NASA administrator James Webb opened an investigation, and on March 15, 1962, Slayton was medically disqualified from his flight and was replaced by Scott Carpenter. Officials were concerned about potential public and media second-guessing had any aspect of the mission been affected. It was a decision Slayton found devastating, but NASA stressed no decision had been made about his eligibility for future space missions.

Slayton would instead take charge of the activities and assignments of the astronauts, with nine new men joining the Mercury Seven in September 1962 as NASA geared up for its next space program, Project Gemini, and its two-seat spacecraft.

Slayton musters a smile in this outtake from the 1960 astronaut portrait sessions with Bill Taub at Langley Research Center.

Slayton pauses outside the Hangar S altitude chamber in early February 1962. He wears the original helmet design with a slight dip in front.

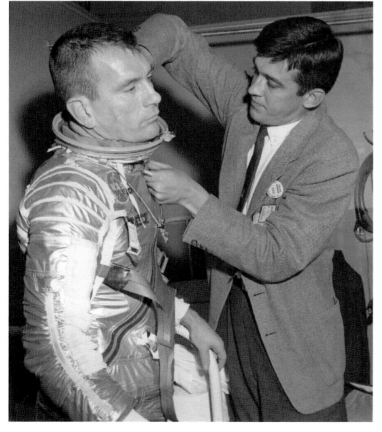

## 1960

**TOP LEFT** Slayton (*left*) listens to a McDonnell Aircraft engineer in St. Louis on August 17 during the design engineering inspection meetings for spacecraft no. 7 for the first manned flight.

**TOP RIGHT** Slayton (*left*) examines the escape tower atop an Atlas scale model in the Hangar S suit room in June.

**BOTTOM** Dr. Carmault Jackson (*right*) helps Slayton get suited for training at the Johnsville centrifuge at the Navy's Aviation Medical Acceleration Laboratory in Warminster, Pennsylvania. The third and final major sessions for the astronauts were held October 3–21. It was before one such run the year before that doctors first noticed Slayton's arrhythmia but were not concerned.

## 1961

Slayton poses at Patrick AFB on January 20 in a Convair F-102 Delta Dagger, an aircraft the astronauts used to maintain flying proficiency. After graduating from the USAF Test Pilot School in 1955, Slayton flew the F-101, F-104, F-105, and F-106 at the Flight Test Center at Edwards AFB, California, but he was first assigned to the F-102.

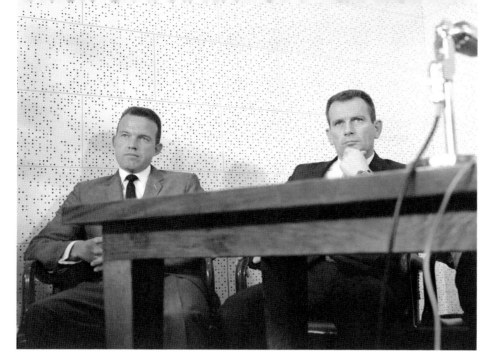

**TOP** Slayton (*right*) and Gordon Cooper are among the six astronauts at a news conference at Patrick AFB on February 22, the day after the successful unmanned MA-2 launch. NASA had just announced that John Glenn, Gus Grissom, and Alan Shepard were the finalists for the first manned Mercury flight.

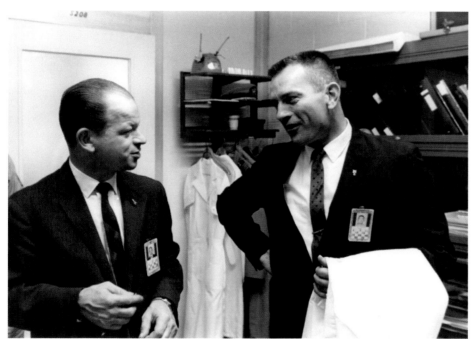

**MIDDLE** NASA public affairs officer John "Shorty" Powers and Slayton chat in Hangar S in May.

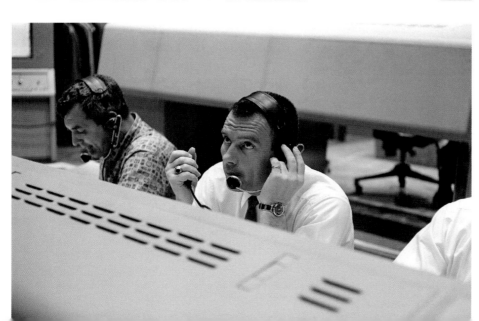

**BOTTOM** Slayton serves as capcom during Shepard's Mercury-Redstone 3 (MR-3) flight on May 5, taking over from Cooper in the blockhouse two minutes before launch.

**THIS PAGE, LEFT** Slayton boards a USAF C-54 Skymaster at Patrick AFB on May 5 that will take program managers and the medical team to Grand Bahama Island to examine Shepard after MR-3.

**THIS PAGE, RIGHT** The astronaut dozes on the flight.

**FACING PAGE, TOP LEFT** Slayton (*left*) with Lt. Dee O'Hara shortly after they arrive on Grand Bahama.

**FACING PAGE, BOTTOM LEFT** Slayton with Wally Schirra (*right*) listens to Shepard during his postflight news conference at the State Department in Washington, DC, on May 8.

**FACING PAGE, TOP RIGHT** Slayton checks out the Sunday comics in the *Miami Herald* on July 16 in Hangar S.

**FACING PAGE, BOTTOM RIGHT** Slayton (*left*) chats with flight surgeon Dr. William Douglas during a suiting session in Hangar S as NASA suit technician Alan Rochford crouches behind the astronaut. Smoking in the US would peak in 1963 before the release of the landmark surgeon general's report a year later.

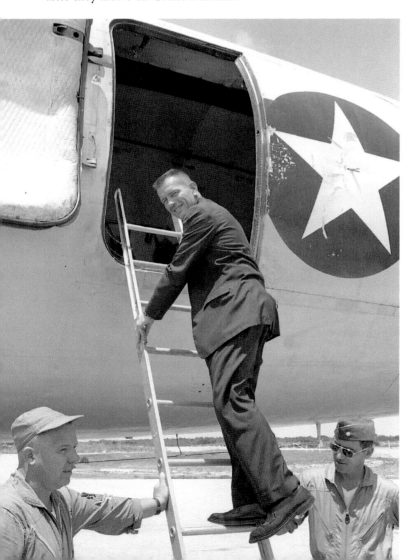

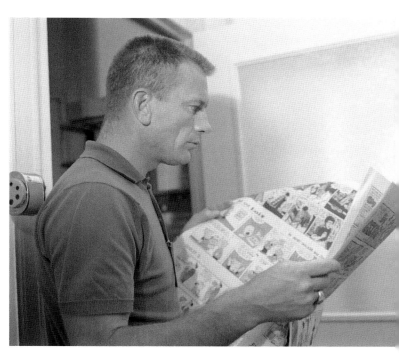
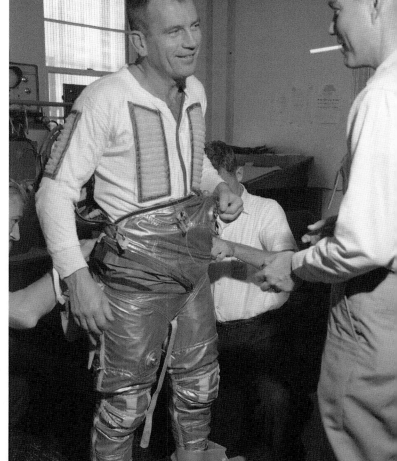

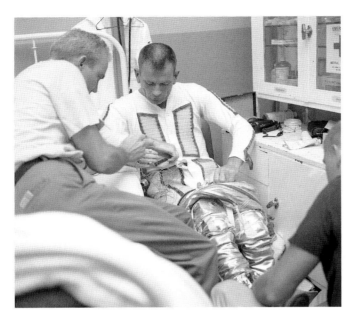
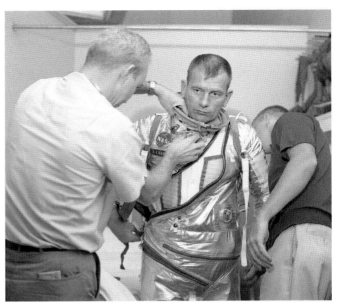

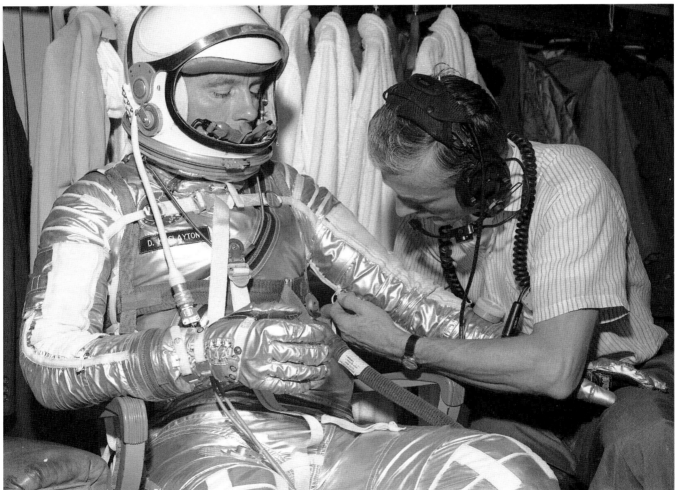

**1962**   Dr. Douglas (*top two images*) and suit technicians Rochford and Joe Schmitt (*bottom*) get Slayton prepared for a run in the Johnsville centrifuge at the Aviation Medical Acceleration Laboratory in Warminster, Pennsylvania, in early 1962.

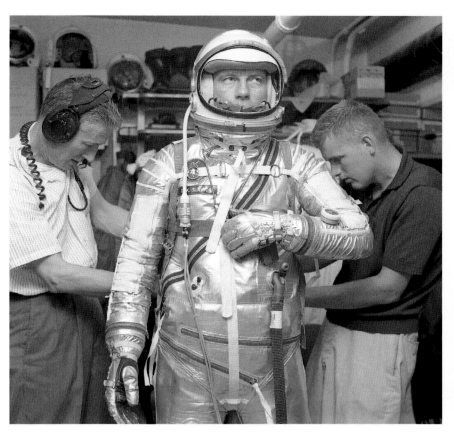

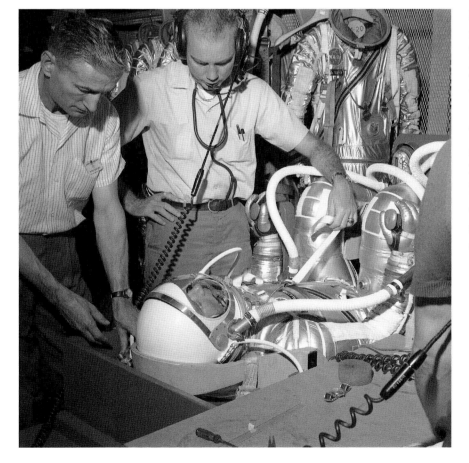

**LEFT TWO IMAGES** A fully suited Slayton next undergoes a leak check, assisted by Schmitt, Rochford, and Dr. Douglas. Each astronaut's custom-molded couch was installed for his centrifuge runs.

**TOP RIGHT** Slayton poses in front of a Mercury tracking network map in Hangar S for this Taub portrait. He had been named to pilot the second Mercury orbital flight on February 20, with a possible April launch that later slipped to May.

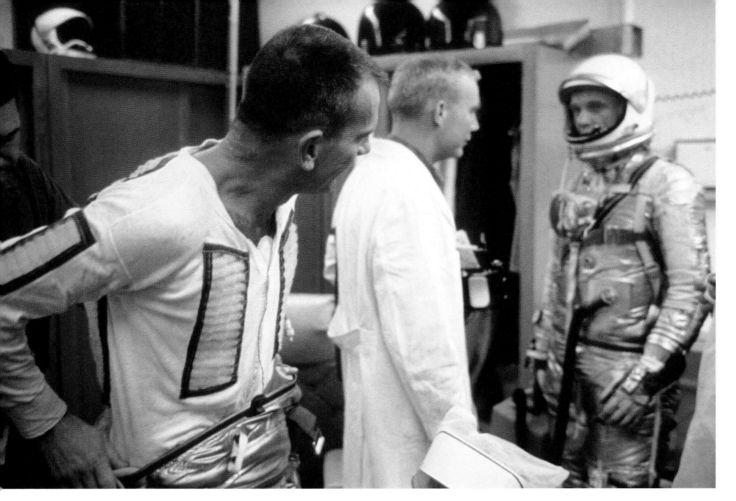

**TOP** Slayton (*left*) suits up in Hangar S in February for an altitude chamber test with Dr. Douglas and Glenn at right. Glenn, meanwhile, was conducting simulations in *Friendship 7* for his upcoming mission.

**BOTTOM** Slayton in the suit room before an altitude chamber test in February.

**FACING PAGE** Suit technician Schmitt (*left*) accompanies Slayton as they arrive at the altitude chamber; Slayton carries his ventilator.

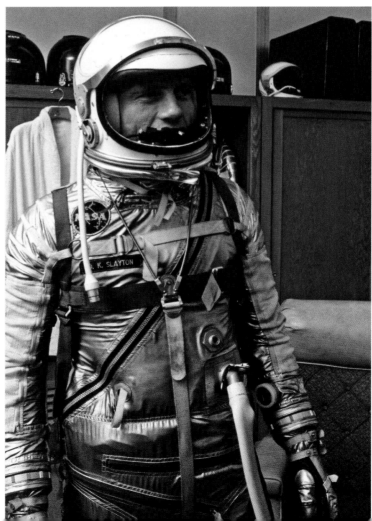

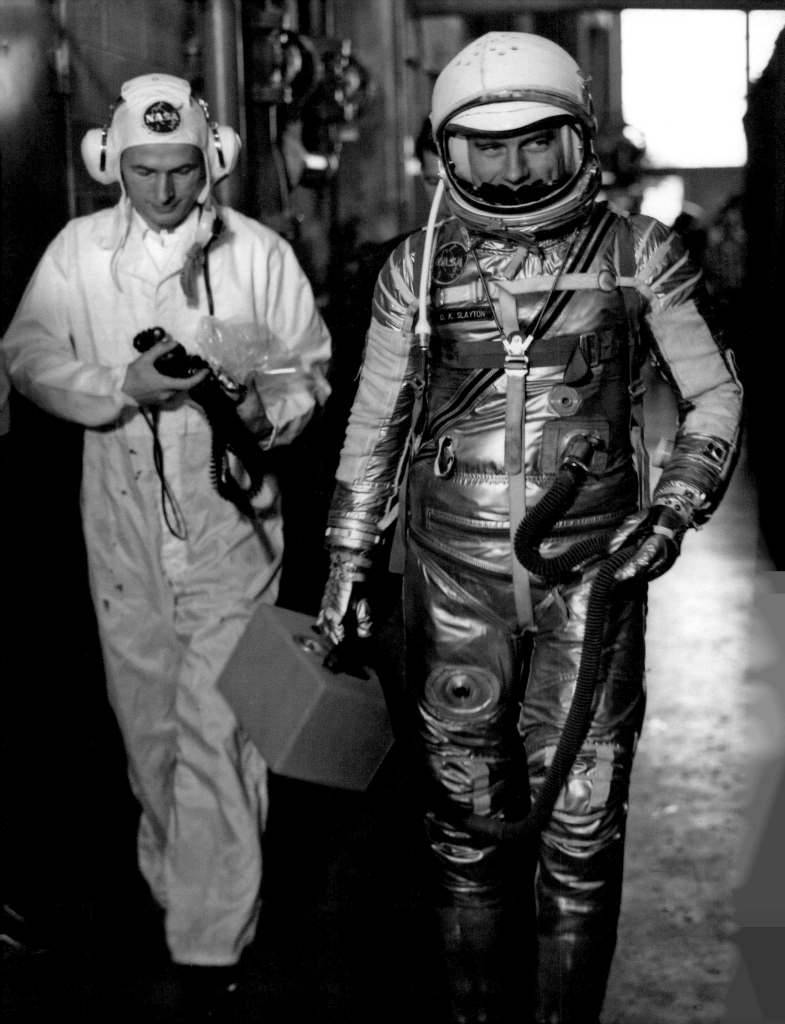

**THIS PAGE** Slayton in front of the Hangar S altitude chamber.

**FACING PAGE** Slayton in the altitude chamber of spacecraft no. 18, which he had planned to name *Delta 7*, in February. Carpenter would instead use it for his MA-7 mission as Slayton's replacement.

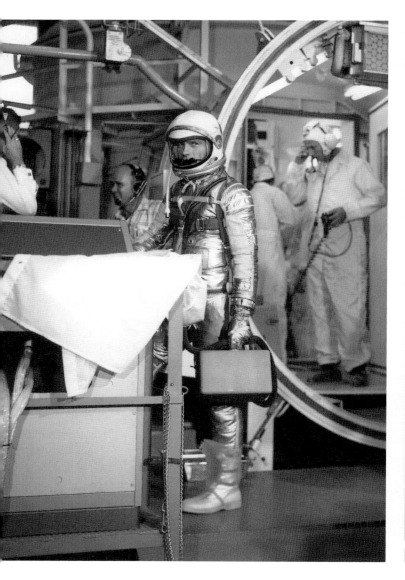

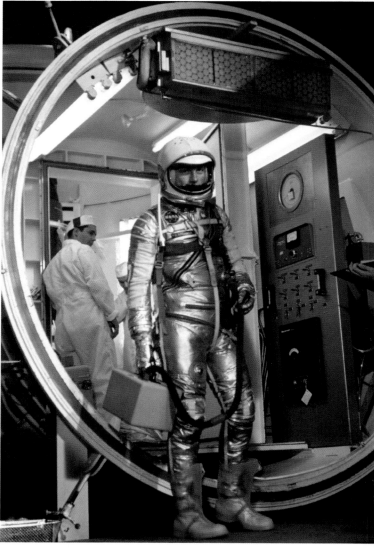

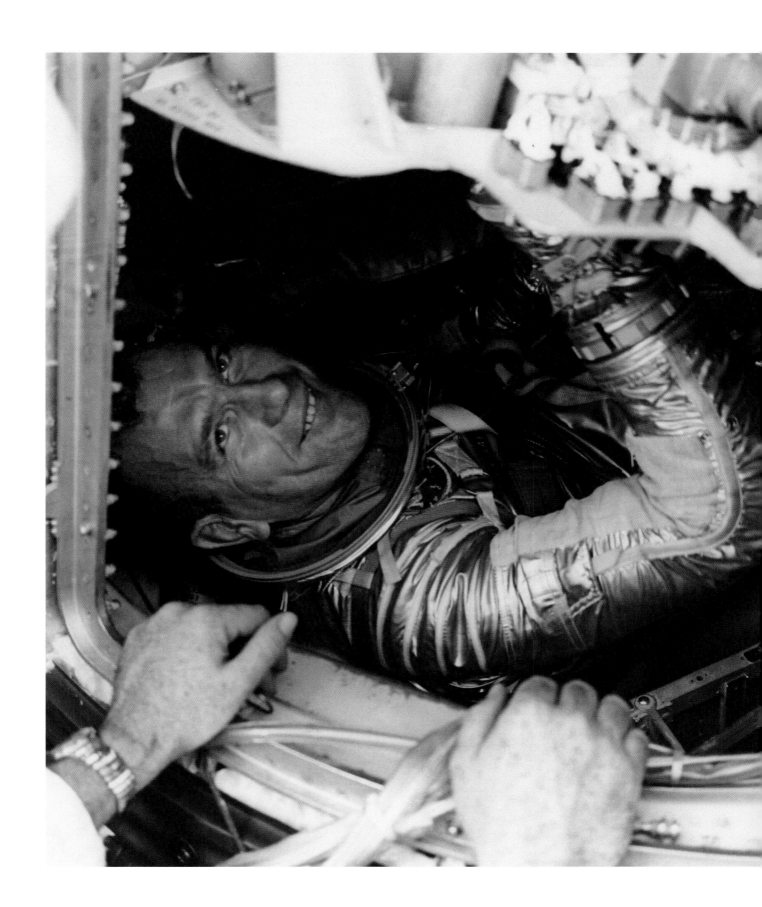

**TOP LEFT** Slayton takes notes during
Glenn's MA-6 debriefing on Grand Turk
Island on February 21.

**TOP RIGHT** Mrs. Cora Glenn, Glenn's
mother, meets Slayton and Schirra at
Hangar S after Glenn's medal ceremony
with President Kennedy on February 23.

**BOTTOM** Slayton (*right*) visits with
Dr. Jackson at the post MA-6 party in
March at the Cocoa Beach Holiday Inn. At
left is training manager Col. Keith Lindell.

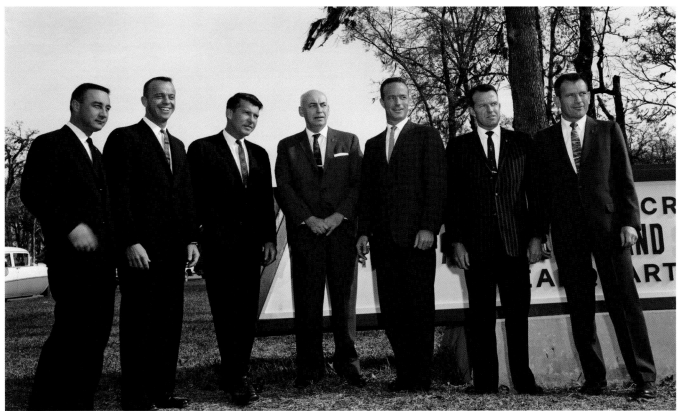

Six astronauts and Manned Spacecraft Center director Robert Gilruth pose at the sign for the new MSC Headquarters in Houston, Texas, on March 7. At the time, MSC was based at 2999 South Wayside Drive while permanent facilities were under construction 20 miles to the southeast. The former Farnsworth-Chambers Company building housed Gilruth, his staff, and the astronauts. Eight days later, Gilruth would announce that Slayton would not pilot the next mission because of his atrial fibrillation.

**TOP IMAGE** *Left to right:* Slayton, Cooper, Shepard, Gilruth, Carpenter, Schirra, and Grissom.
**BOTTOM IMAGE** *Left to right:* Grissom, Shepard, Schirra, Gilruth, Carpenter, Cooper, and Slayton.

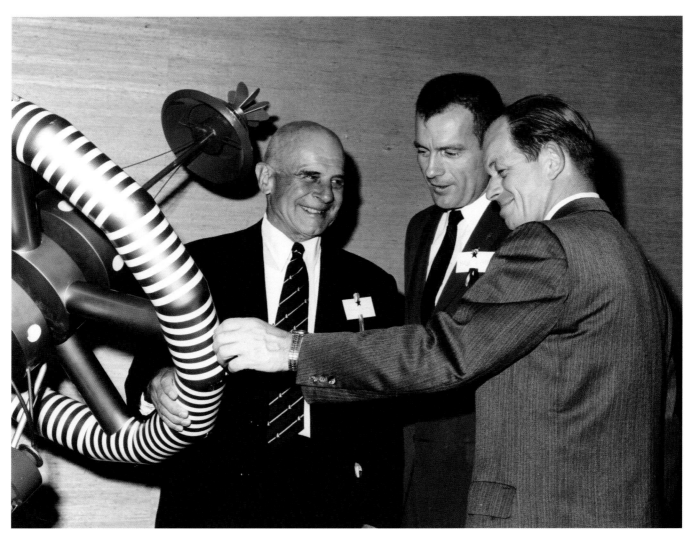

TOP *Left to right:* World War II hero USAF Gen. Jimmy Doolittle, Slayton, and Powers examine a proposed space station scale model at the first awards dinner of the Achievement Rewards for College Scientists, a pioneering women's science philanthropy group, on April 18. Doolittle was the dinner speaker at the Beverly Hilton in Beverly Hills, California. Slayton, Powers, and MSC associate director of operations Walter Williams were surprise guests of honor.

BOTTOM Slayton oversaw the selection of the Group 2 astronauts, announced on September 17; he was named coordinator of astronaut activities the next day. Tasked with making crew assignments, he named Cooper to MA-9. In October 1963, Slayton became assistant director of Flight Crew Operations in addition to managing the astronaut office.

# 7

# Scott Carpenter

<div style="text-align: right">Mercury-Atlas 7</div>

Three months after John Glenn's historic flight, Navy Lt. Cdr. Malcolm S. "Scott" Carpenter, 37, was launched on Mercury-Atlas 7 (MA-7), a three-orbit mission that essentially duplicated Glenn's achievement but with a greater focus on science. The pilot was to have been Deke Slayton, but he was removed from flight status in March 1962 after an irregular heartbeat identified three years earlier came under new scrutiny. Carpenter was named as his replacement on April 26, 1962.

Carpenter's countdown aboard *Aurora 7* on the morning of May 24 proceeded almost perfectly, with only a forty-five-minute hold at T–11 minutes to provide better camera coverage of the launch.

With Glenn's flight a shakedown that qualified the Mercury spacecraft for manned orbital operations, NASA managers had packed Carpenter's flight plan full of various tests during his five-hour mission, so much so that he fell behind in his assigned tasks.

One experiment was the first study of liquids in weightlessness. Another, designed to provide data on atmospheric drag and color visibility in space by deploying a 30-inch-diameter balloon, was largely unsuccessful when it failed to fully inflate. Carpenter's Earth and weather photography went well, but he was unable to see a flare fired from Australia because of cloud cover.

At the beginning of his third and final orbit, Carpenter inadvertently bumped his hand against the hatch and created a bright shower of particles outside the spacecraft, apparently solving the mystery of Glenn's fireflies. He identified them as ice crystals knocked loose from the spacecraft's hull. His interest in the phenomenon, however, was a distraction; and he fell behind schedule in his

reentry preparations, which set the stage for the flight's most dramatic moments.

With time now running short before retrofire, Carpenter suddenly noticed that the spacecraft was not in the proper attitude. He realized the automatic control system was malfunctioning, so he quickly switched to manual. Then the three retrorockets failed to fire automatically, and he was told to fire them manually.

Ignition came several seconds late. The delay, and the fact that the automatic system wasn't controlling *Aurora 7*'s attitude, meant the spacecraft would overshoot its splashdown target point.

To make matters worse, the spacecraft's fuel was running low, in part because Carpenter had executed so many planned maneuvers earlier in the mission—but he'd also accidentally left the automatic thruster system engaged several times while using the manual setting. To conserve fuel, he had spent much of his final orbit in free drift. Then during retrofire, he inadvertently left the balky automatic system on again (for subsequent flights, a modification prevented such double usage). During reentry Carpenter radioed, "I hope we have enough fuel."

*Aurora 7* overshot its intended target area by 290 miles, splashing down north of the Virgin Islands. An aircraft spotted the spacecraft thirty-nine minutes later.

Carpenter, meantime, wiggled free through the neck of the spacecraft, climbed into his life raft in calm waters, and patiently waited about an hour for recovery forces to arrive. His only company, he would later report, was "a black fish . . . and he was quite friendly." When Navy divers swam up from some distance away, they surprised Carpenter, who "broke out the food and asked

them if they wanted any; but they had finished lunch recently." Soon a Navy helicopter appeared and hoisted Carpenter aboard for a flight back to the aircraft carrier USS *Intrepid*. Like Glenn, he spent two days undergoing medical tests and recuperating on Grand Turk Island.

The destroyer USS *Farragut*, about 100 miles southwest of the planned landing site, was first to reach *Aurora 7*

about three hours and forty minutes later. USS *Farragut* monitored *Aurora 7* until it was retrieved by the destroyer USS *John R. Pierce* about six hours after landing.

The astronaut and his family received parades in both Cocoa Beach and his hometown of Aurora, Colorado, and visited President Kennedy at the White House. Carpenter was the only Mercury veteran to not fly in space again.

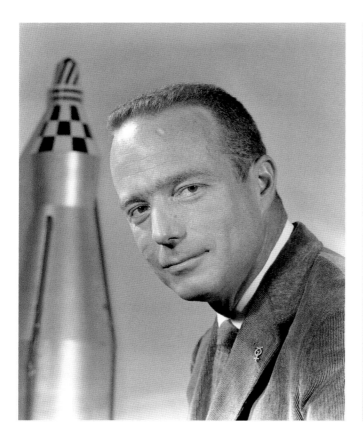 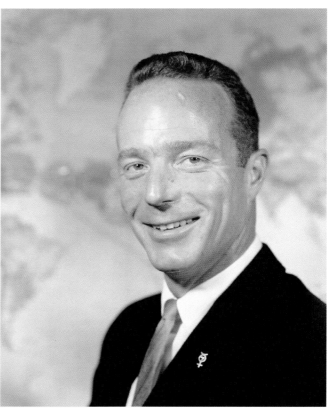

LEFT An outtake from the 1960 Taub Mercury portrait sessions at Langley Research Center. Carpenter, who had been training as a Navy pilot while in college toward the end of World War II, continued his studies after the war ended. He was recruited by the Navy in 1949 and flew patrol planes along the coasts of the Soviet Union and China during the Korean War and the Cold War. He graduated from the US Navy's Test Pilot School in 1954 and became an air intelligence officer before his astronaut selection in 1959.

RIGHT A 1962 portrait by Bill Taub in Hangar S.

FACING PAGE Carpenter suited as Glenn's backup with the Cape Canaveral tracking antenna, likely in December 1961.

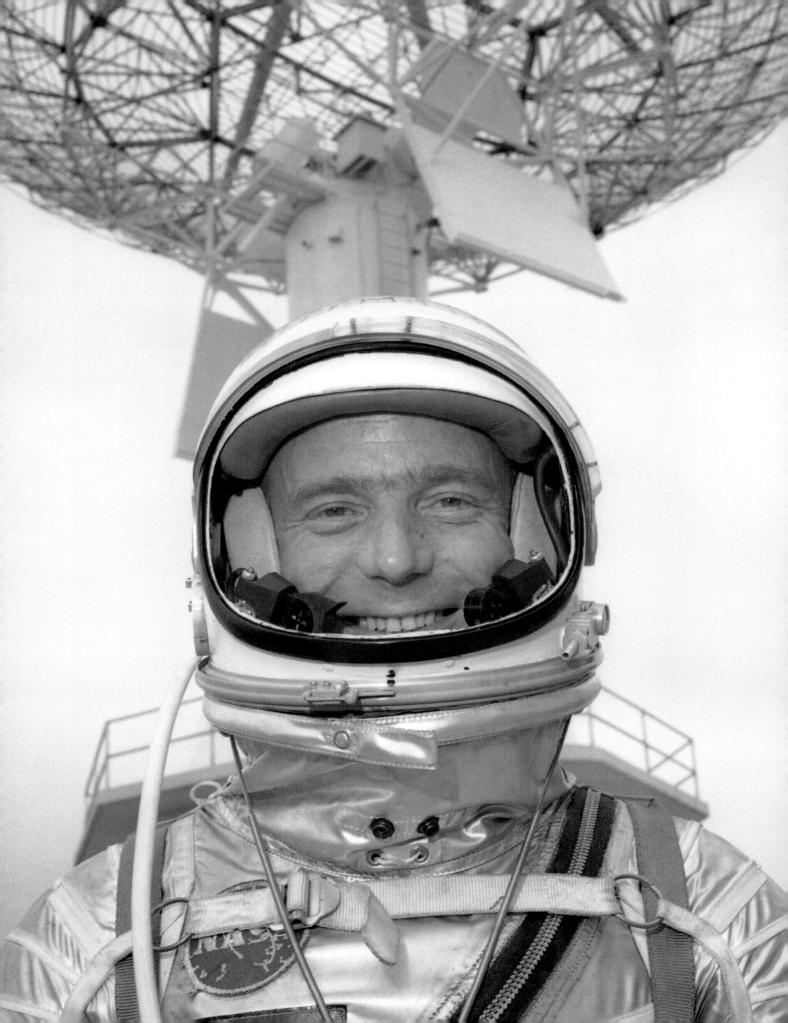

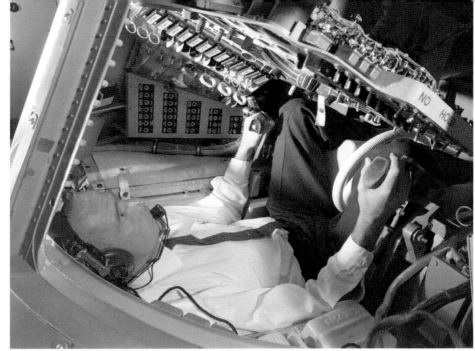

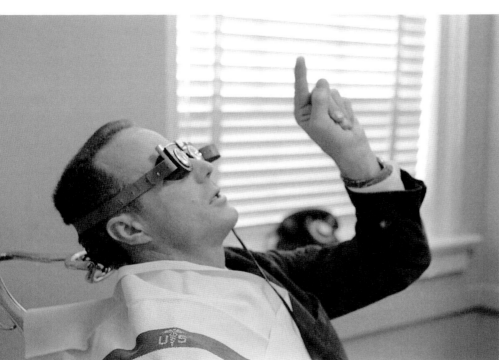

**1961–1962**    **TOP LEFT** Carpenter poses outside Morehead Planetarium at the University of North Carolina in Chapel Hill on April 28, 1962. He received special showings and briefings at the facility to help identify constellations, stars, and planets.

**TOP RIGHT** Carpenter works in Mercury Procedures Trainer no. 2 at the Mercury Control Center (MCC) on May 9, 1962.

**BOTTOM TWO IMAGES** Carpenter's eye movements are measured during a modified caloric test (*left*), and he walks a balance rail (*right*) at the US Naval School of Aviation Medicine in Pensacola, Florida, as Glenn's backup on December 17, 1961. Glenn and flight surgeon Dr. William Douglas were also on the trip.

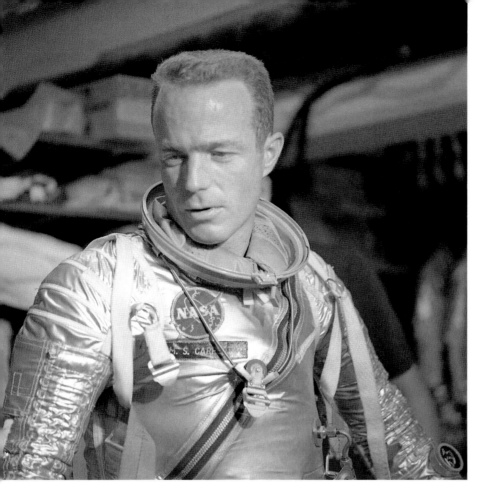

## January–April 1962

**TOP** Carpenter prepares for a run in the Johnsville centrifuge at the Naval Aviation Medical Acceleration Laboratory in Warminster, Pennsylvania, in January.

**BOTTOM** Carpenter sets up an Ultra SARAH rescue beacon from his survival kit during water egress training on April 15 at Pensacola Naval Air Station, Florida. Each item, from the beacon to a chocolate bar, was tied to the kit. The orange life raft was made from the same Mylar and nylon material used for the Echo passive-communications balloon satellites. Wally Schirra, his backup, also took part in the training.

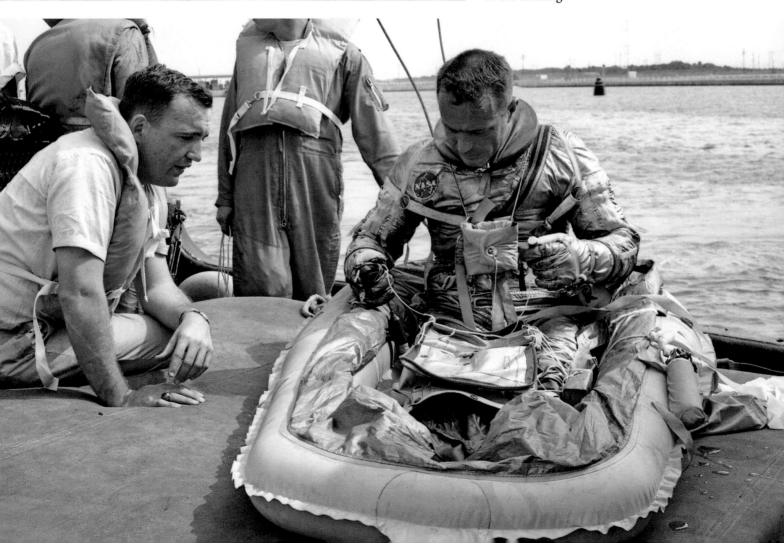

The astronaut deploys his pressure suit's rubber neck dam, intended to prevent water intrusion during a water egress.

With his water wings deployed at left, Carpenter floats free holding an ACR locator beacon.

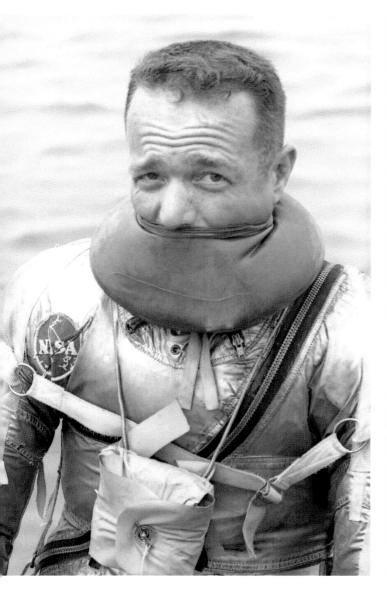

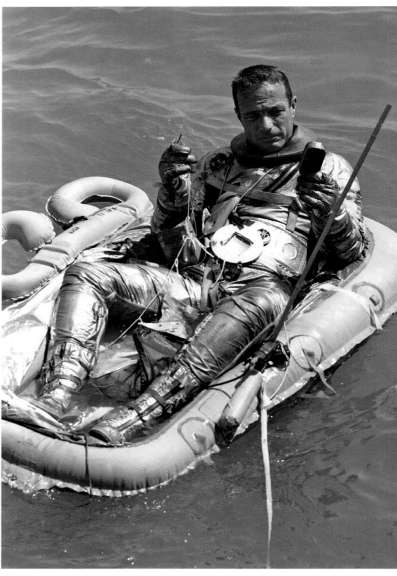

## May 1962

From the roof of Hangar S, Carpenter watches the launch of an Earth-mapping satellite by a Thor-Ablestar booster from Launch Complex 17B (LC-17B) at 7:06 a.m. on May 10. ANNA (Army, Navy, NASA, Air Force) 1A, a joint project of the Army, Navy, NASA and Air Force, however, failed to reach orbit after its second stage did not ignite

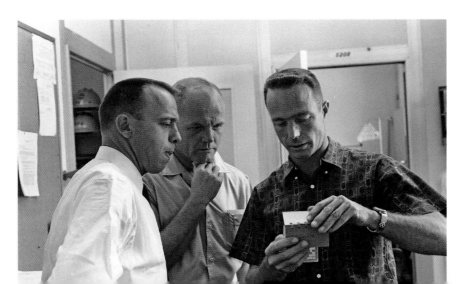

Carpenter (*right*) shares a small notebook with Shepard and Glenn on May 10, possibly for use in-flight.

Later that morning, Carpenter (*second from left*) goes over plans for a launch simulation in the suit room at Hangar S with Glenn (*third from left*) and Space Task Group aeronautical engineer Walter "Kappy" Kapryan (*fourth from left*).

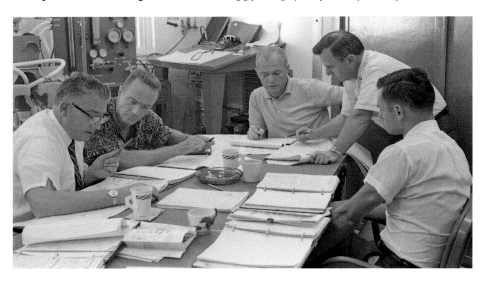

BOTTOM TWO IMAGES  NASA suit technician Joe Schmitt (*left*) helps Carpenter get suited (*left image*). Carpenter then reviews procedures with Dr. Douglas (*right image*). The astronaut flew eight simulated launches or missions during April and May.

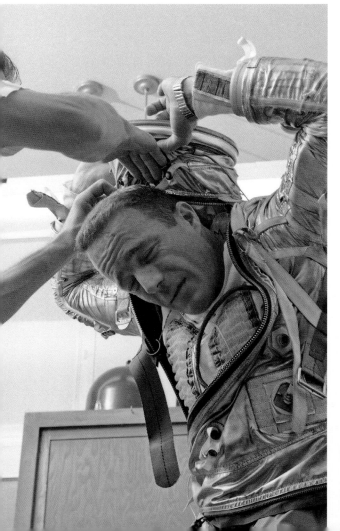

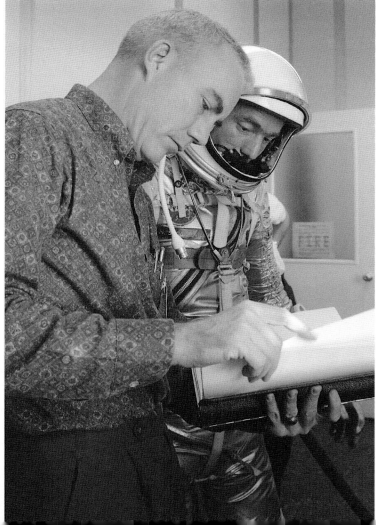

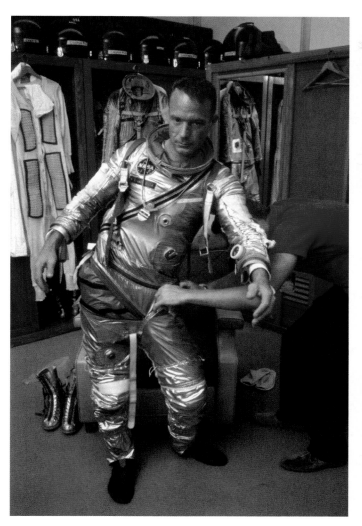

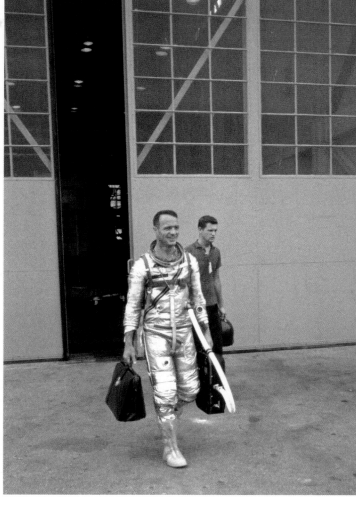

**TOP TWO IMAGES** NASA suit technician Alan Rochford (*right*) helps Carpenter get suited (*left image*) before they depart Hangar S (*right image*).

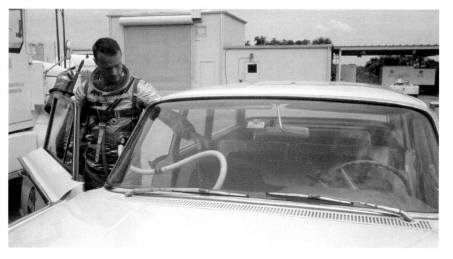

**BOTTOM** Carpenter puts his ventilator into the front seat of the station wagon before leaving for the MCC Procedures Trainer, which became known as the Mercury Simulator.

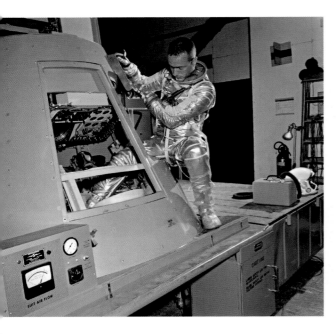
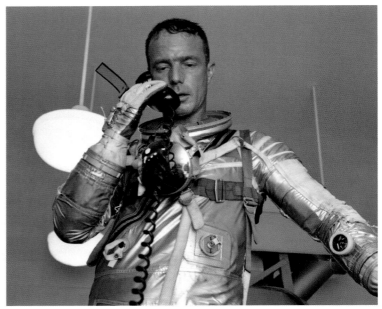
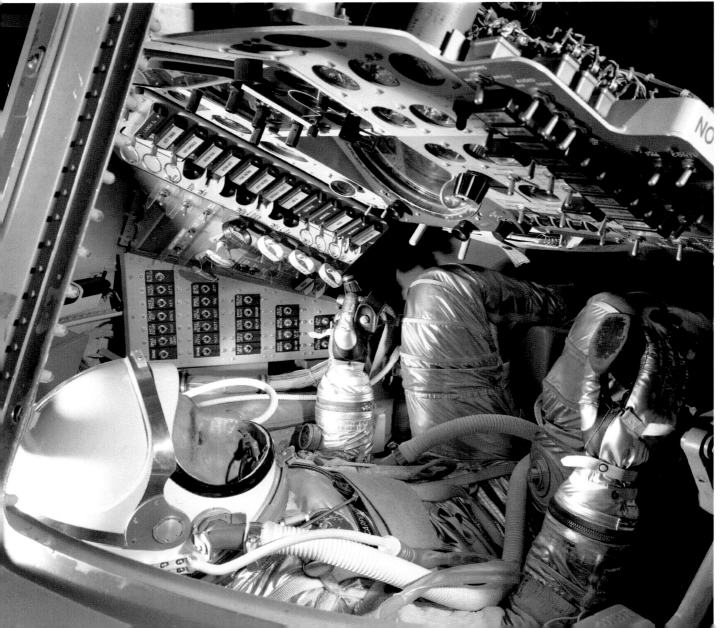

**FACING PAGE, TOP LEFT** Carpenter climbs out of the trainer, with his helmet and ventilator at right.

**FACING PAGE, TOP RIGHT** The astronaut talks to Hangar S. He spent more time in trainers and spacecraft than Glenn, flying seventy-three simulated missions at both Langley and the Cape to Glenn's seventy.

**FACING PAGE, BOTTOM** Carpenter runs through the simulation in coordination with the flight controllers in the LC-14 blockhouse.

**THIS PAGE, LEFT** Outside the MCC after the simulation, Carpenter shows how comfortable the astronauts came to feel around Taub.

**THIS PAGE, RIGHT** Carpenter checks his oxygen outlet hose with his visor open, preparing for his final flight simulation aboard *Aurora 7* at the pad on May 15.

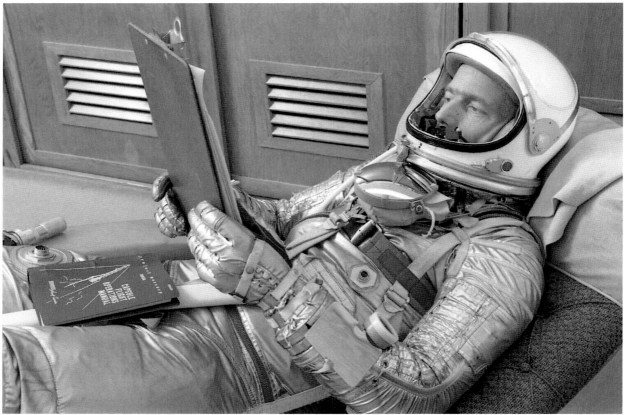

**TOP** Carpenter undergoes a suit leak check with his visor sealed. The fingertip lights on his left glove, like Glenn's, were red to preserve his night vision during the flight.

**BOTTOM** The astronaut studies paperwork with a McDonnell Aircraft *Capsule Flight Operations Manual* on his lap. New pockets have been added to the suit's upper arms and lower legs for the pilot's convenience.

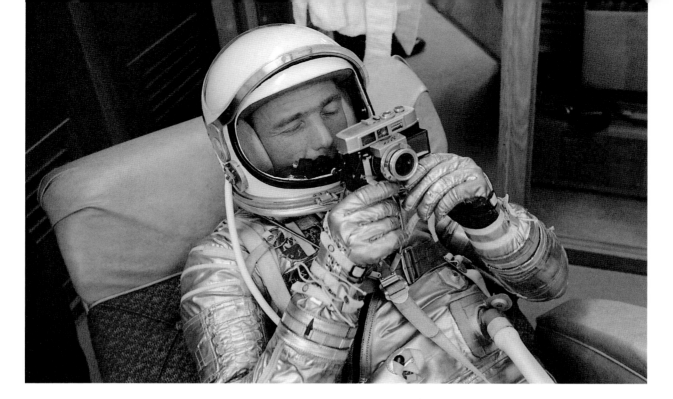

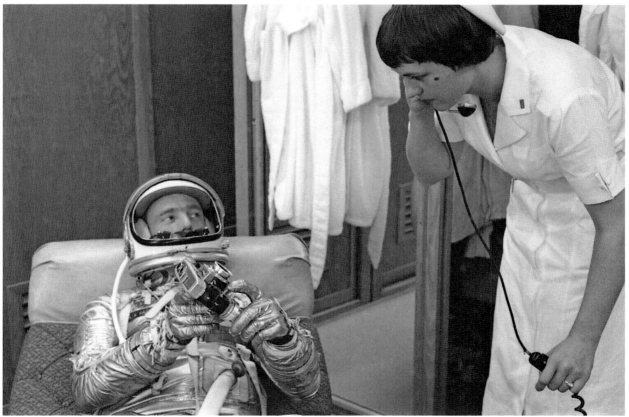

Astronaut nurse Lt. Dee O'Hara (*right*) maintains contact with the white room as Carpenter examines one of Taub's 35 mm cameras, a Kodak Motormatic 35.

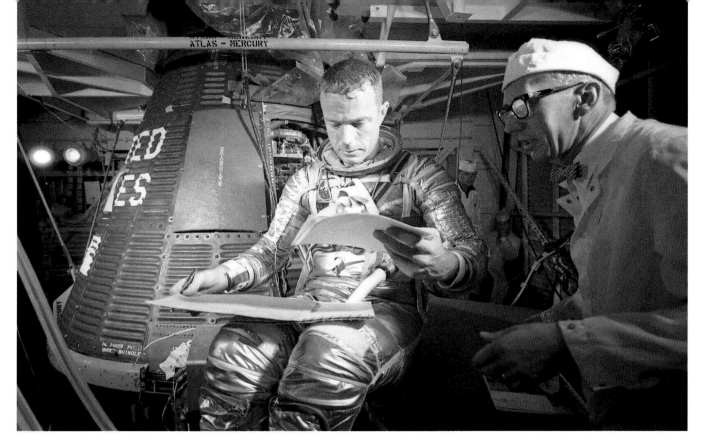

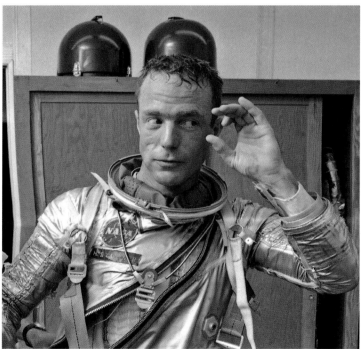

**TOP** Carpenter (*left*) goes over the flight simulation afterward at the pad with McDonnell pad leader Guenter Wendt and spacecraft no. 18, *Aurora 7*, behind them. He had also spent about eighty hours in *Friendship 7* as Glenn's backup.

**BOTTOM LEFT** Carpenter back at Hangar S after the simulation.

**BOTTOM RIGHT** Carpenter poses with MA-7 on the pad at LC-14 in the distance.

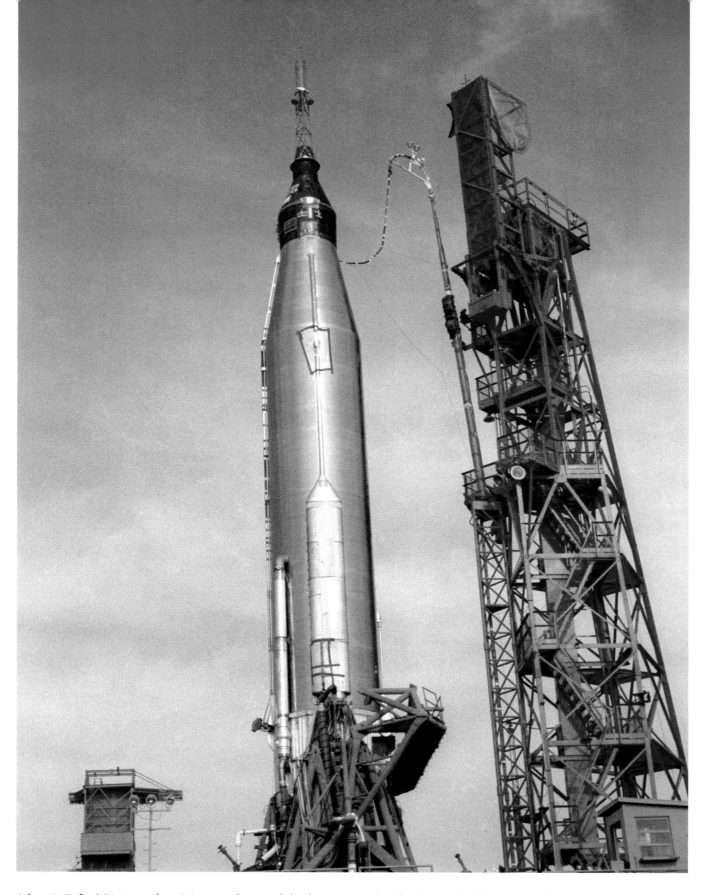

Atlas 107D for MA-7 stands at LC-14, with its umbilical tower at right. The booster had been erected on March 8, and red tape temporarily holds plastic sheeting in place. The Atlases arrived at the Cape's Skid Strip aboard a USAF C-133B Cargomaster.

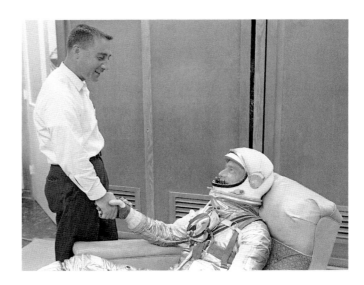

## May 24–26, 1962

**TOP** On launch morning, May 24, Gus Grissom (*left*) wishes Carpenter well at about 3:20 a.m. at Hangar S. Grissom will serve as capcom during the flight.

**MIDDLE** Carpenter boards the transport trailer at 3:40 a.m., followed by Schmitt and Dr. Howard Minners, who was taking over as flight surgeon for Dr. Douglas, who had returned to the Air Force. A Harvard graduate and USAF major on loan to NASA, Minners served in that role from 1962 to 1966.

**BOTTOM** Schirra (*left*) greets Carpenter as he arrives in the white room at 4:36 a.m., flanked by Dr. Minners and Schmitt.

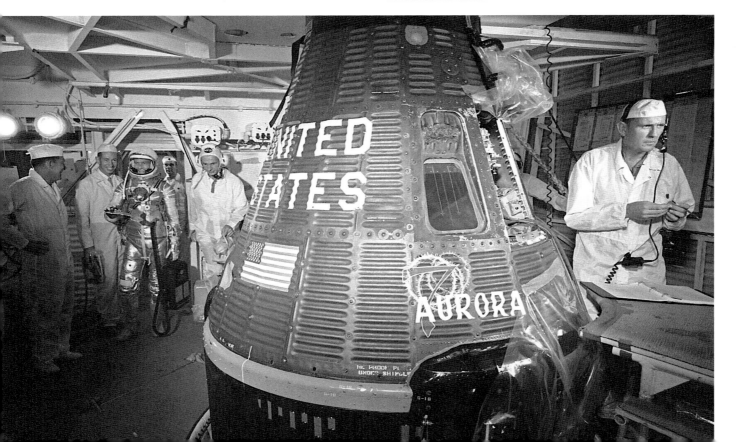

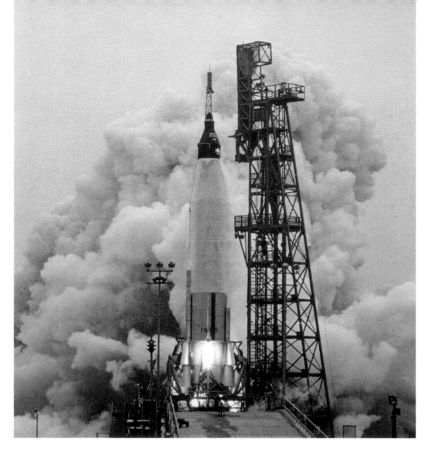

**TOP** The launch at 7:45 a.m. followed several minor delays but it followed the smoothest countdown yet. Carpenter's wife and children were the first astronaut family to attend a liftoff.

**BOTTOM** Carpenter is raised by a sling to a Sikorsky SH-3A Sea King helicopter from the aircraft carrier USS *Intrepid* at 3:35 p.m. He had splashed down at 12:41 p.m., but overshooting his target had recovery forces alarmed for the more than half an hour he'd been lost. *Aurora 7* floats at bottom left with its whip antenna, used for voice and beacon communication, extended.

**NEXT PAGE** Carpenter photographed Earth's horizon during sunsets as part of an experiment for MIT's Instrumentation Laboratory. Engineers wanted to see whether the horizon could be a reliable navigational fix for Apollo astronauts.

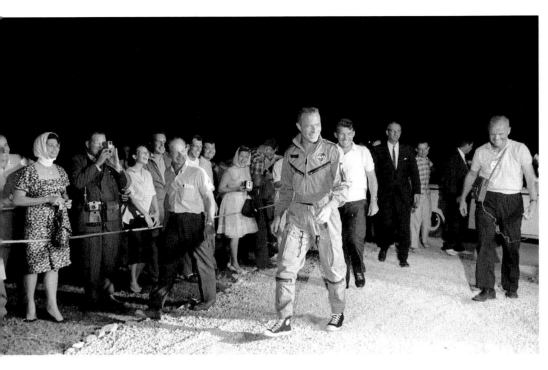

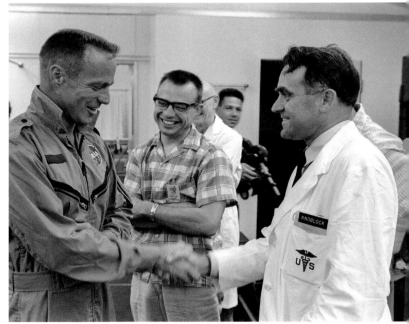

**TOP LEFT** Carpenter arrives at the small NASA hospital on Grand Turk Island at around 11 p.m., followed by NASA public affairs officer John "Shorty" Powers at left and Schirra and Mercury program manager Ken Kleinknecht behind him. At right, Glenn carries a tape recorder to continue Carpenter's debriefings that had begun aboard USS *Intrepid*.

**TOP RIGHT** Powers (*left*) opens the door to the NASA hospital for Carpenter, where he would undergo the standard battery of medical and psychological tests.

**BOTTOM** Carpenter (*left*) greets Edward Knoblock, a US Army laboratory representative to the Mercury medical debriefing team. Navy lieutenant and psychologist Dr. Robert Voas is at center, with NASA film contractor Larry Summers in the background. Despite the late hour, Carpenter wanted to stay up and talk.

**TOP** Carpenter takes a break on a private beach on the afternoon of May 26.

**BOTTOM** Glenn and Carpenter discuss their skin-diving plans with Powers and an unidentified man later the same day.

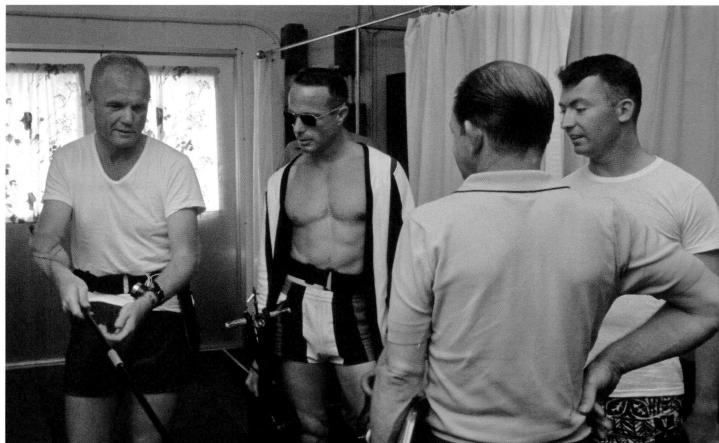

## May 27, 1962

**TOP** Carpenter (*right*), Powers (*left*), and others head toward a USAF VC-118 Liftmaster at Grand Turk Auxiliary AFB shortly before noon on May 27 to return to Florida.

**BOTTOM LEFT** Carpenter greets his children after arriving at Patrick AFB at 2 p.m. *Left to right:* Marc (*partially visible*), Kristen, Jay, and Candace.

**BOTTOM RIGHT** Carpenter is reunited with wife Rene (*left*) and son Marc. "Hi, big boy," he said.

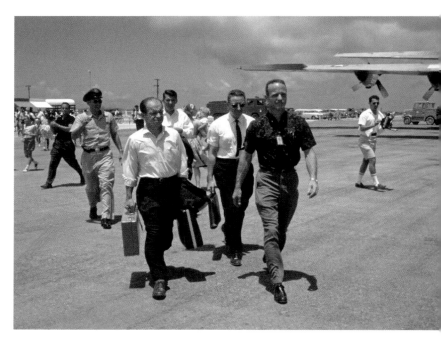

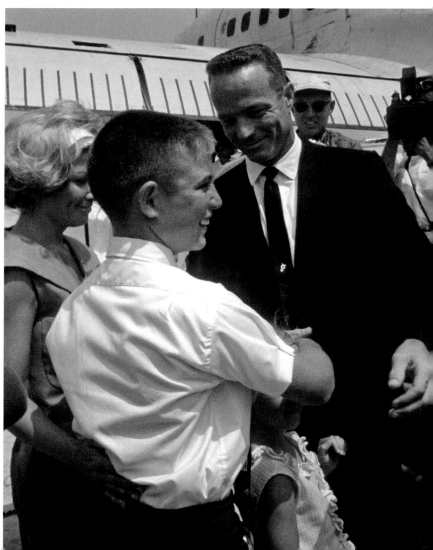

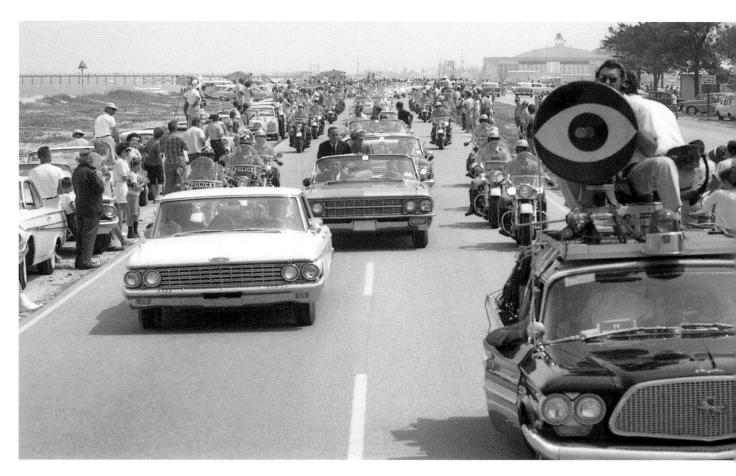

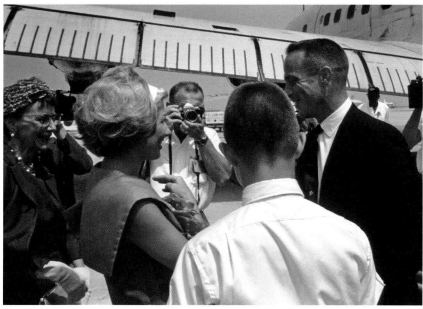

TOP The TV pool camera car is in the right foreground as Carpenter's parade leaves Patrick AFB and heads north on State Road A1A with a police escort. Five of the other astronauts also rode in the procession. The CBS microwave dish allowed live network TV coverage. ABC had overall pool responsibility.

BOTTOM Mrs. Florence "Toye" Carpenter (*left*), the astronaut's mother, who lived in Boulder, Colorado, also attends the homecoming. "I had the supreme experience of my life," he told the well-wishers. "I hope to be able to share it all with you as soon as I get a chance to talk."

The Carpenters' Cadillac, with NASA administrator James Webb in the back seat, proceeds north through Cocoa Beach on North Atlantic Ave. The crowd was estimated at thirty thousand. One of the motels along the route had built a stage, and as the motorcade passed, a combo played Carpenter's favorite tune, "Yellow Bird," a 1961 hit for the Arthur Lyman Group.

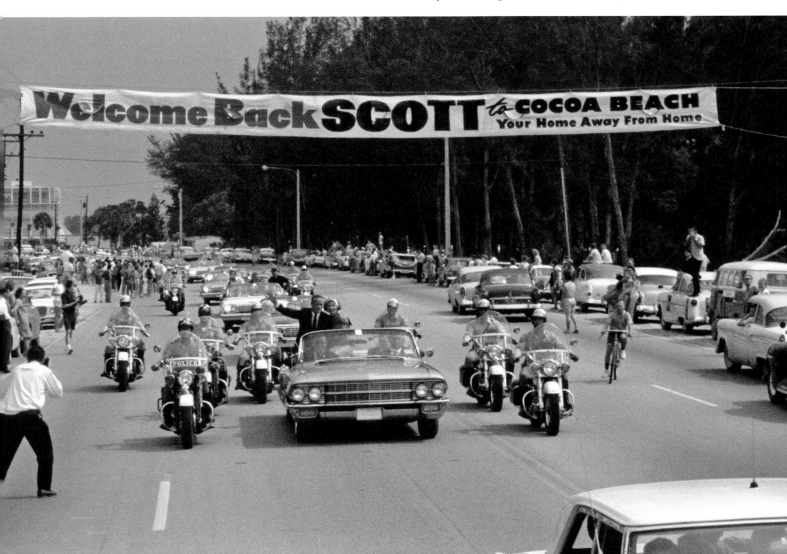

**TOP LEFT** *Left to right:* Launch Operations Directorate chief Kurt Debus, Scott and Rene Carpenter, and Glenn during the NASA Distinguished Service Medal ceremony. The astronaut gave special praise to his mother, whom he asked to join him on the stage. Webb also awarded the medal to Manned Spacecraft Center (MSC) associate director of operations Walter Williams.

**TOP RIGHT** Carpenter in front of Hangar S before Webb awards him the medal. "I am uneasy in this acclaim to some degree," he said, "because I am aware that it is due and merited by at least 1,000 people here. . . . These ground crews are the hardest-working people I have seen."

**MIDDLE** Carpenter, flanked by Webb and MSC director Robert Gilruth, speaks at an hour-long news conference under a tent near the MCC. Powers is at right. The astronaut denied he was tired or confused before reentry but apologized for overshooting his landing and acknowledged that he was preoccupied with his tasks and accidentally used too much maneuvering fuel. Glenn sits in the audience at left.

**BOTTOM** Shepard, Schirra, Grissom, and members of their families are in the audience. Carpenter said his flight was "easy as a bus ride" and he is "ready to go for a two weeks' orbit." The news conference was carried live on network TV and radio, with NBC as pool coordinator.

# May 28–30, 1962

**TOP LEFT** Carpenter prepares to leave Patrick AFB for his hometown, Boulder, Colorado, on May 28. He would travel aboard an aircraft assigned to presidential service.

**TOP RIGHT** Carpenter's mother, Florence (*left*), and wife, Rene, receive bouquets after arriving at Stapleton Airfield near Denver at 4:00 p.m. MST on May 28.

**BOTTOM LEFT** The next morning, on what was designated Scott Carpenter Day, the couple wave to some of the estimated seventy-five thousand spectators along the parade route to the University of Colorado.

**BOTTOM RIGHT** *Left to right:* Kristen, astronaut secretary Nancy Lowe, Candace, and Rene are on stage for a ninety-minute ceremony in the university's Folsom Stadium. Some seventeen thousand people saw Carpenter receive the bachelor's degree he hadn't completed in 1949, and the governor proclaimed it to be Scott Carpenter Week.

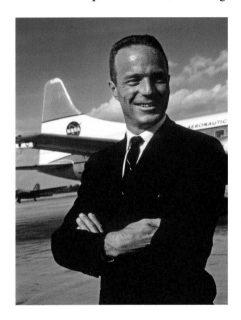
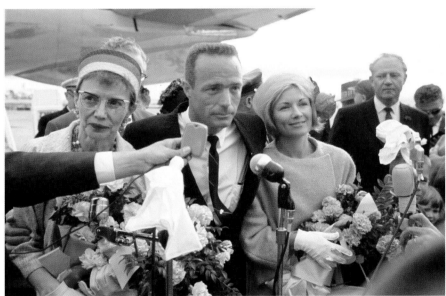
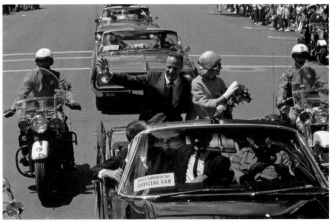

**TOP LEFT** "This is a very humbling experience for me," Carpenter tells the crowd, adding that his aeronautical engineering degree "doesn't mean I'm a better student than I was in 1949."

**TOP RIGHT** Candace Carpenter holds her mother's hand at the ceremony.

**BOTTOM** The next day, the astronaut was feted at the head of Denver's annual Memorial Day parade, which attracted an estimated three hundred thousand spectators. Gilruth (*left*) and Powers ride through the Denver business district two cars behind the Carpenters.

**June 5, 1962**   **TOP**  Kristen Carpenter watches her father sign a stack of portrait lithographs during the flight from Patrick AFB to Washington, DC, on June 5. He was known for being generous with his autographs and shunned using mechanical autopens.

**BOTTOM**  Kristen Carpenter, Elizabeth Ann Williams, daughter of Walt Williams, and Candace Carpenter. Williams and his family were also aboard for the White House visit.

Carpenter and Kristen are the first to disembark at Washington National Airport.

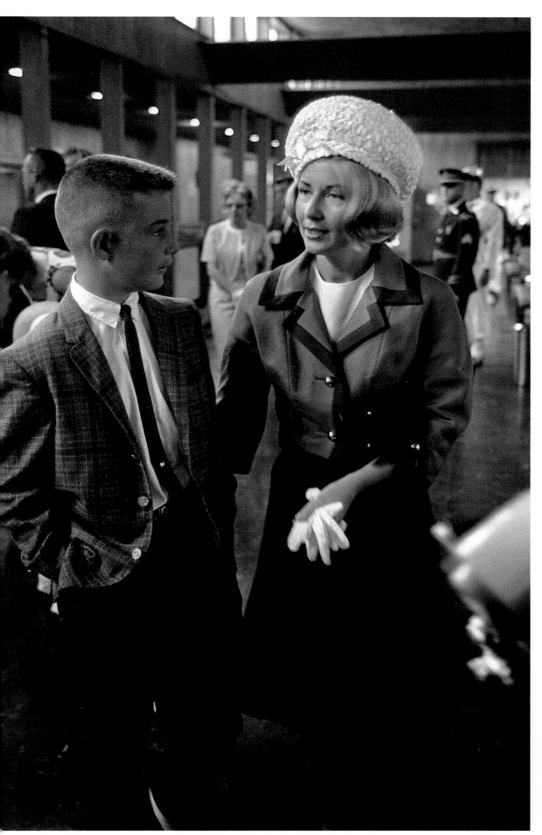

**FACING PAGE** The family heads toward the terminal—Rene, Jay, and Candace (*front*); Scott, Kristen, and Marc.

**THIS PAGE, LEFT** Marc and Rene Carpenter inside the terminal.

**THIS PAGE, RIGHT** Carpenter stops to autograph a flight schedule for a United flight attendant on the tarmac. Of the Mercury Seven, only Glenn signed more autographs.

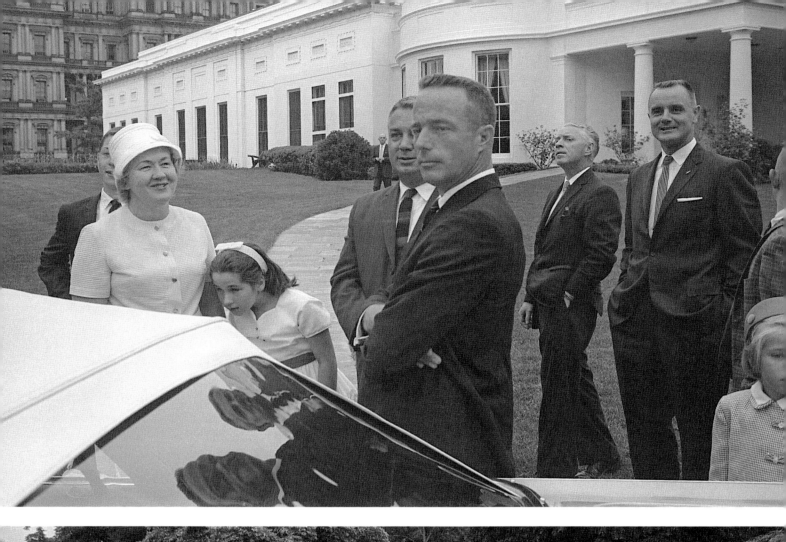
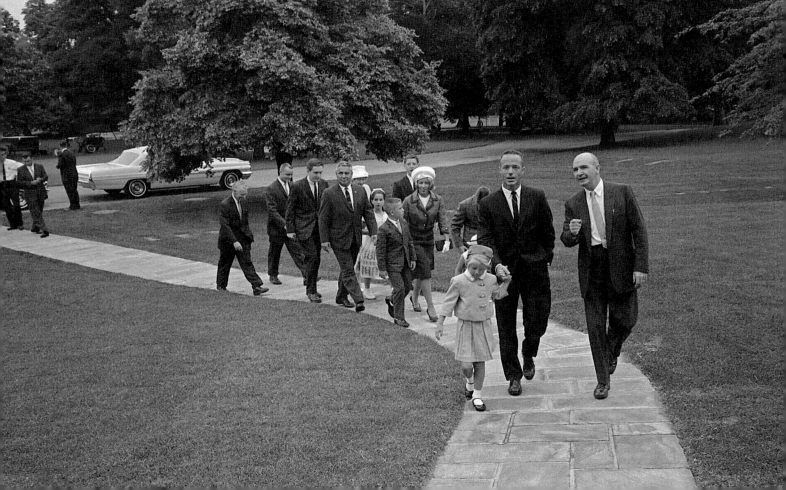

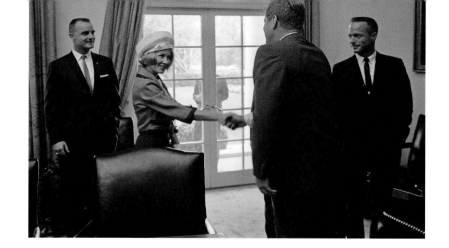

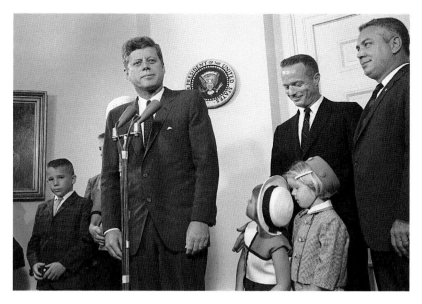

**FACING PAGE, TOP** The Williams family (*left*) and the Carpenters arrive at the White House at 10:00 a.m. with the Oval Office and West Wing colonnade in the background. Kristen Carpenter is at lower right.

**FACING PAGE, BOTTOM** The president's appointment secretary, Kenneth O'Donnell, leads the guests toward the executive mansion.

**THIS PAGE, TOP** Rene greets President Kennedy in the Cabinet room. The two families then chatted with the president for almost twenty minutes in the Oval Office before facing reporters.

**THIS PAGE, MIDDLE** "I cannot imagine better representatives of what we like to think our nation stands for than the four [astronauts] who have taken part in the flights," President Kennedy says, with Carpenter and Williams at right in the Fish Room (today the Roosevelt Room).

**THIS PAGE, BOTTOM** "The feeling I have now . . . is one of humility," Carpenter tells reporters, "because although I happen to be the person who was the passenger, we are doing something more than just to provide the human experience."

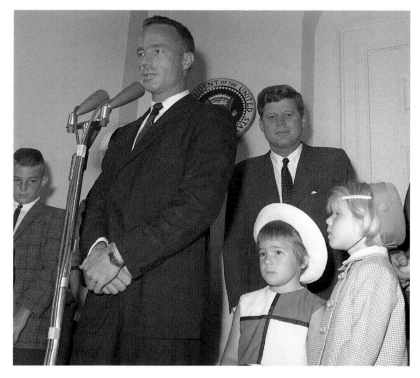

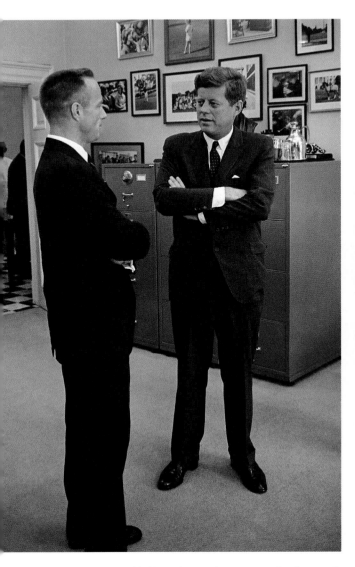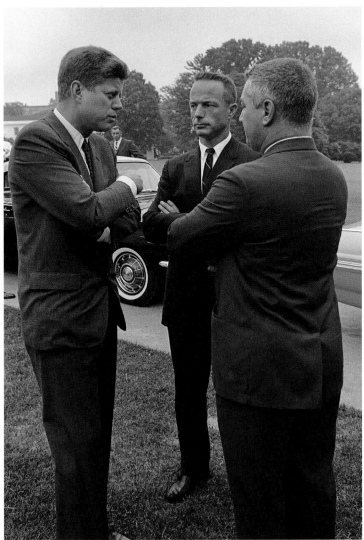

**LEFT** Carpenter (*left*) and President Kennedy chat in the office of the president's secretary, Evelyn Lincoln.

**RIGHT** The president talks with Carpenter and Williams as they prepare to depart. Both families would next fly to New York to receive city honors.

# 8

# Wally Schirra

Mercury-Atlas 8

---

Five months after Scott Carpenter's flight, his backup, US Navy Cmdr. Walter M. "Wally" Schirra Jr., 39, would orbit the Earth six times on Mercury-Atlas 8 (MA-8) in his spacecraft, *Sigma 7*. The nine-hour mission would nearly double Carpenter's duration and was aimed at verifying that the Mercury spacecraft would be ready for a full twenty-four hours in orbit on the program's next (and final) flight. An associated goal was to see how little fuel, water, and power could be comfortably consumed. Both John Glenn and Carpenter had run low on reaction control system (RCS) fuel, so better consumables management was a key objective.

On launch morning, October 3, 1962, Schirra was up at 1:40 a.m. EST and had a fillet from a bluefish he had caught the afternoon before in addition to steak and eggs for breakfast. He arrived at Launch Complex 14 (LC-14) at 4:23 a.m. Noticeably fewer spectators, signs, and banners appeared in Cocoa Beach, and although TV networks carried the launch and landing live, they cut back on coverage. Local traffic was reported to be normal.

MA-8's Atlas D booster launched *Sigma 7* into a clear blue sky from LC-14 at 7:15 a.m., putting Schirra into a 176-by-100-mile-high orbit. Other than a spacesuit heating problem during the first two orbits, the mission was what he would later call "textbook."

Schirra's activities included briefly tracking the Atlas, conducting four science experiments, and observing and photographing Earth. He took fifteen photos for the US Weather Bureau to compare to the video still pictures sent down the same day by TIROS 5 and 6, two weather

satellites launched earlier in 1962 and which had been used to support his launch.

To prevent Carpenter's RCS fuel problems, that system had been modified to disarm the high-thrust jets and to permit using the low-thrust jets only in manual operation. To get a handle on fuel conservation, a considerable amount of time was built into the timeline for *Sigma 7* to drift in orbit, including 18 minutes during the third orbit and 118 minutes during the fourth and fifth orbits. As a result, 78 percent of the RCS fuel remained in both the automatic and manual tanks at the start of reentry.

Extending the mission to a possible six orbits would mean a Pacific splashdown, so MA-8 was the first to have Atlantic and Pacific recovery forces deployed. In case the mission was aborted before orbit or terminated after the first, second, or third orbit, deployment of more than twenty Atlantic Ocean ships was still necessary. *Sigma 7* splashed down in the Pacific Ocean 250 miles northeast of Midway Island, but just 9,000 yards from USS *Kearsarge*.

Although the Soviets sent official congratulations, the media there was dominated by celebrating the fifth anniversary of *Sputnik 1*. Less than three weeks later, President Kennedy went on national television to announce the US discovery of Soviet intermediate-range offensive missiles in Cuba. It had been confirmed to him the morning Schirra visited the White House.

On October 5, the Cape Colony Inn, a Cocoa Beach motel partly owned by the Mercury astronauts, was put on the market as a result of criticism of their investment in the project. Much of the money had come from their *Life* magazine contract.

241

## 1961

**LEFT** An outtake from the 1960 Bill Taub astronaut portrait sessions at Langley Research Center. After graduating from the Naval Academy, Schirra was commissioned as an ensign in the US Navy in 1945. He received his naval aviator wings in 1948 and was deployed aboard the aircraft carrier USS *Midway* at the outbreak of the Korean War in June 1950. He was accepted for an exchange program with the USAF to gain combat experience. Schirra flew ninety combat missions into South Korea and downed two Soviet MiG-15s. He became a test pilot at Naval Ordnance Test Station, China Lake, California. At China Lake he tested various weapons systems, becoming the first pilot to fly with and fire the Sidewinder missile. Schirra was assigned to Miramar Naval Air Station in San Diego to test the newest Navy jet fighter, the F7U Cutlass. Schirra was accepted to the US Naval Test Pilot School in 1958. He graduated that year and was selected as an astronaut in 1959.

**RIGHT** A 1962 portrait by Taub.

**FACING PAGE, TOP TWO IMAGES** Dr. Carmault Jackson (*right*) of the Life Sciences Division and an unidentified man help Schirra suit up for a heat chamber test at the Air Crew Equipment Laboratory at the Naval Air Material Center in Philadelphia in January. The astronaut would undergo a 7.5-hour simulated mission in the environmental control system (ECS) trainer, which consisted of a spacecraft mock-up with an environmental system housed in an altitude chamber.

**FACING PAGE, BOTTOM** The goal was to train the astronauts in operating their pressure suits in conjunction with the spacecraft's ECS. The interior of the chamber was heated to approximately 280°F with quartz lamps outside. The crewmen tried various coolant valve settings during several mission phases. "I could feel the heat from the panels on my cheeks through the clearance section of the visor plate," he reported, "and it was a very low order of heat, like a nice sunny day at the beach."

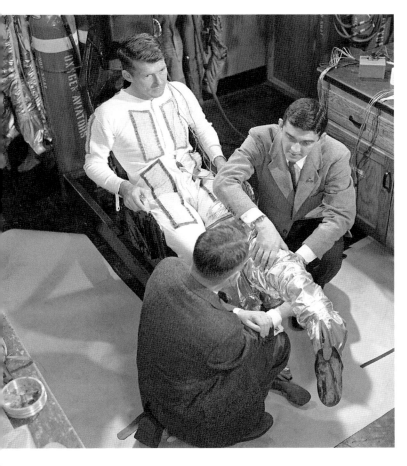
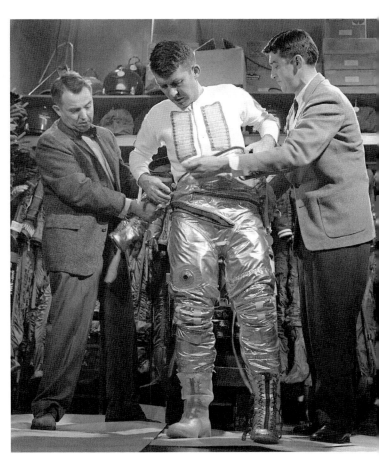
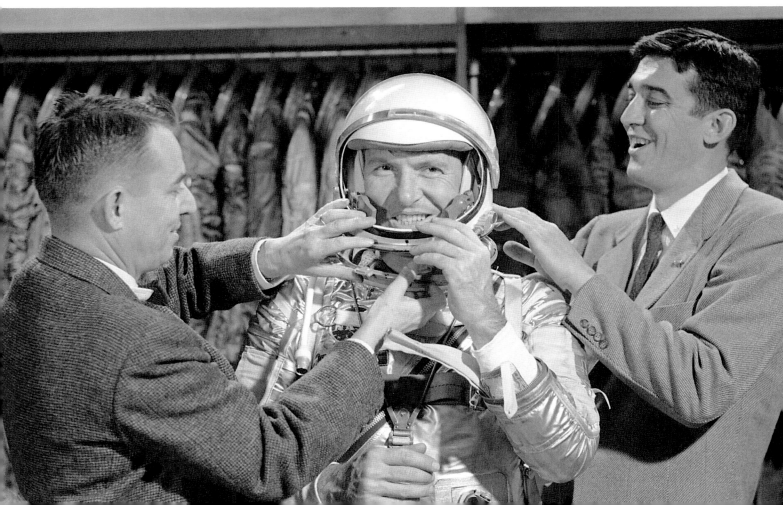

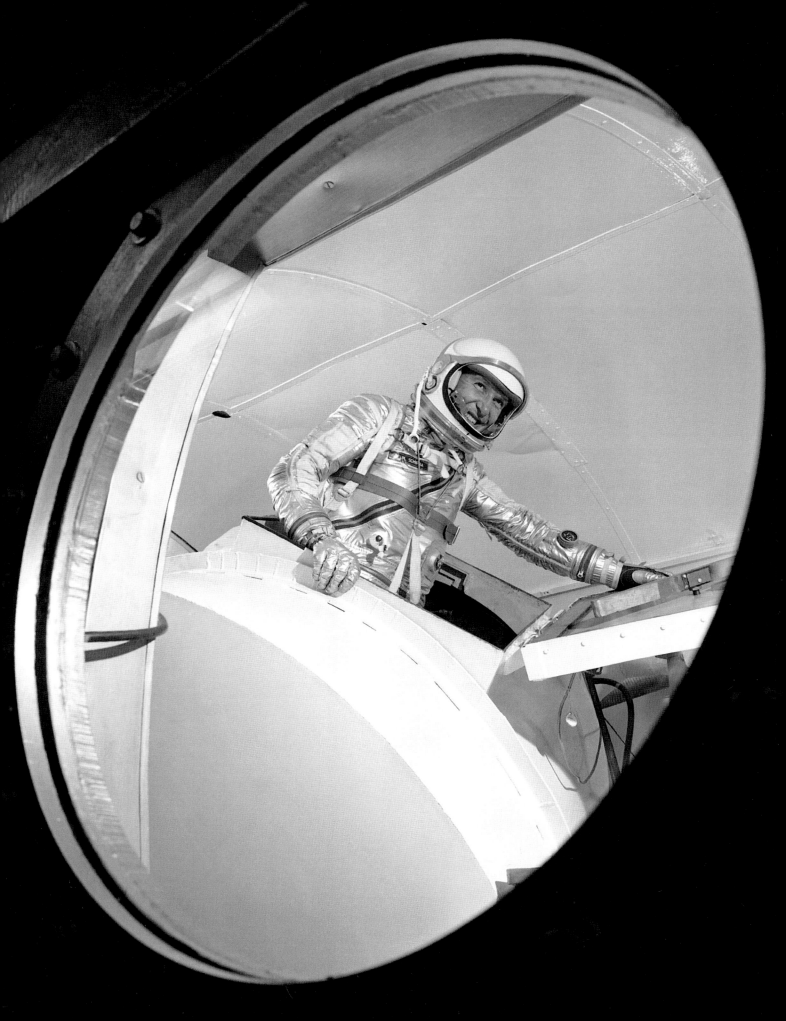

**FACING PAGE** Schirra emerges from mock-up in the ECS trainer. He noted that when the black leather surface on the palms of his gloves faced the spacecraft wall, the heat would build up. "Yet when I had the silver side toward it, it was very comfortable and it only proves that the reflective quality of the silver surface is really worth having."

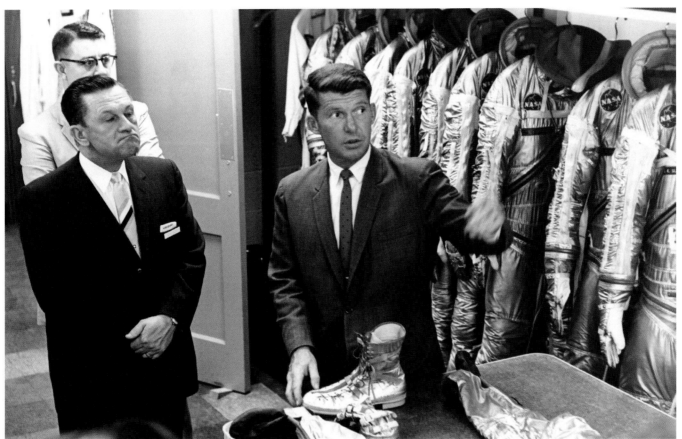

**TOP LEFT** Schirra (*center*) confers with NASA security chief Charles Buckley (*left*) and Manned Spacecraft Center (MSC) associate director of operations Walter Williams on Grand Bahama Island on May 6 as Shepard undergoes his postflight examinations.

**TOP RIGHT** Shepard discusses his flight with (*left to right*) Gordon Cooper (*hidden*), Schirra, Grissom, and Carpenter on Grand Bahama Island. "The best news [from the mission] was that our long, serious training program proves we are training the right way," Schirra told reporters.

**BOTTOM** Schirra (*right*) goes over suiting procedures for US senator Howard Cannon (D-Nevada) (*left*) at Langley in June. Cannon was a member of the Senate Committee on Aeronautical and Space Sciences.

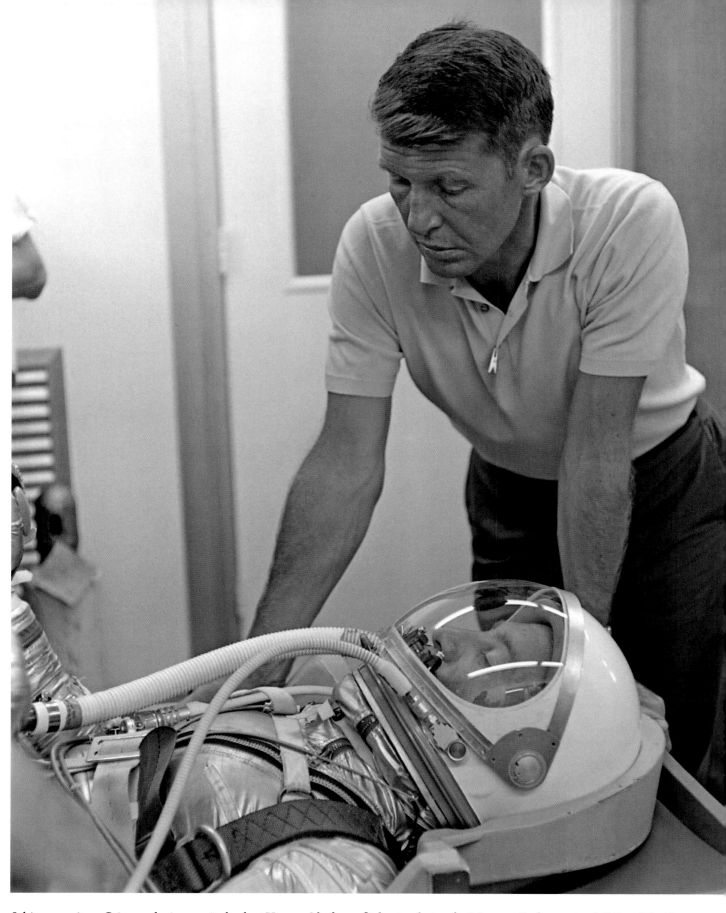

Schirra monitors Grissom during a suit check at Hangar S before a flight simulation for Mercury-Redstone 4 at LC-5 on July 12.

## 1962

**TOP** Schirra prepares for an altitude chamber session in April as Carpenter's backup. He is fully suited with mirror and life vest secured to his chest during a pressure suit leak check in Hangar S.

**BOTTOM** Schirra (*right*) speaks with a McDonnell Aircraft technician as he enters the altitude chamber in Hangar S for the test inside Carpenter's *Aurora 7*.

**FACING PAGE, TOP LEFT** Schirra arrives at LC-14 on May 4 for a simulation aboard *Aurora 7*.

**FACING PAGE, TOP RIGHT** Schirra has inflated his life vest during recovery training on March 5 at Pensacola Naval Air Station. After the delay in recovering Carpenter, Schirra had an extension line so he could speak with recovery forces from his life raft.

**FACING PAGE, BOTTOM** The astronaut works in Mercury Simulator No. 2 at the Mercury Control Center on May 4. Simulator No. 1 would soon be shipped from Langley to MSC in Houston.

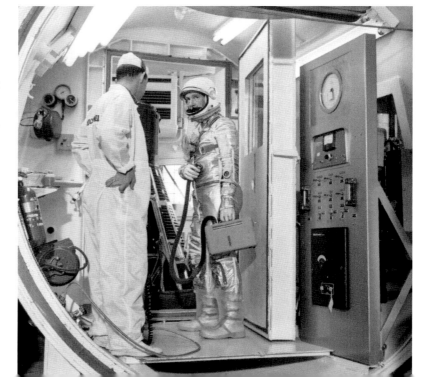

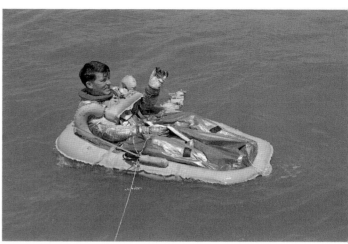

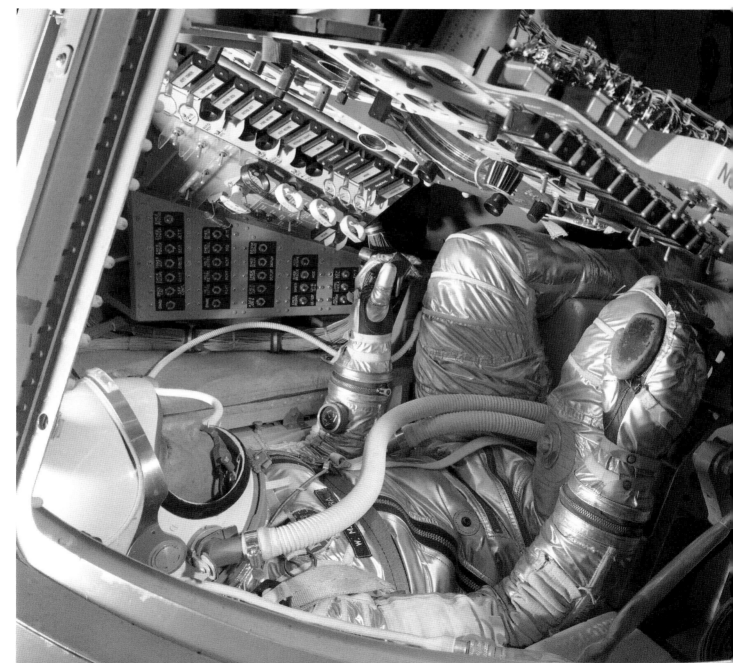

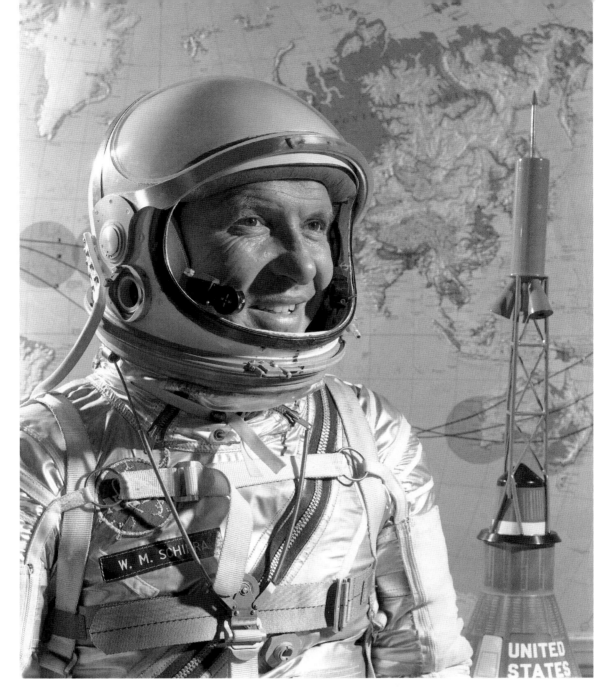

**TOP** Taub's portrait of Schirra in February in Hangar S, with a McDonnell Mercury spacecraft model with escape tower at right.

**BOTTOM** Paul Wignall (*left*), commander of the 6555th Aerospace Test Wing, briefs Schirra and President Kennedy at LC-14 on September 11, 1962. The president had just arrived from visiting Marshall Space Flight Center in Huntsville, Alabama, during a two-day tour of three NASA field centers and McDonnell in St. Louis. *Sigma 7* had been mated to its Atlas booster in the background the day before; the Atlas had undergone a brief static firing on September 8.

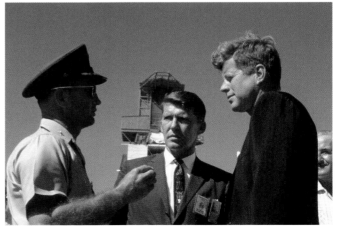

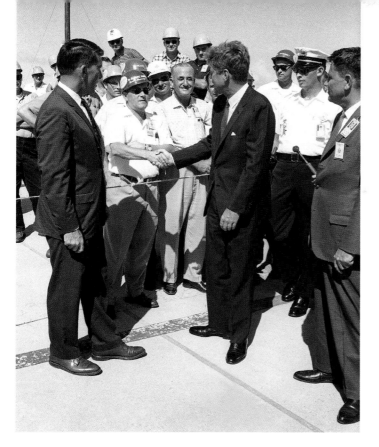

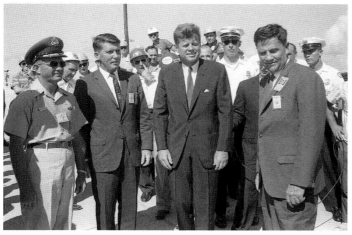

**TOP** President Kennedy shakes hands with B. G. MacNabb, General Dynamics base manager. At right is G. Merritt Preston, manager of MSC preflight operations at Cape Canaveral; Schirra is at left. It was the president's second trip to the Cape; in February he had presented Glenn with his Distinguished Service Medal following his flight.

**MIDDLE** *Left to right:* Col. Wignall, Schirra, President Kennedy, and Preston pose on the ramp to the pad.

**BOTTOM** *Left to right:* Preston, President Kennedy, and British defense minister Peter Thorneycroft listen to Schirra. Thorneycroft was the guest of defense secretary Robert McNamara, partially visible behind Schirra. The president would next fly to Houston, where he'd deliver the second of his moon speeches at Rice University the next day.

**TOP** John Yardley (*left*), McDonnell project engineer for the Mercury spacecraft, meets with Schirra, Glenn, and Grissom (*back to camera*) at Hangar S. The contractor made a number of changes to *Sigma 7* for its seven-orbit mission.

**MIDDLE** NASA suit technician Alan Rochford (*left*) and Schirra in the LC-14 white room on September 28 for a launch simulation.

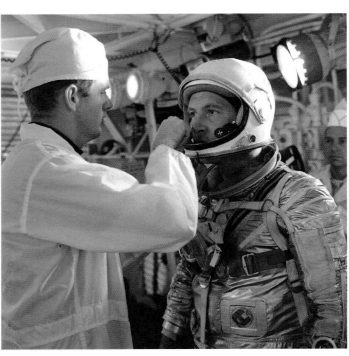

**BOTTOM** Schirra prepares for the launch simulation aboard *Sigma 7* at LC-14 on September 28.

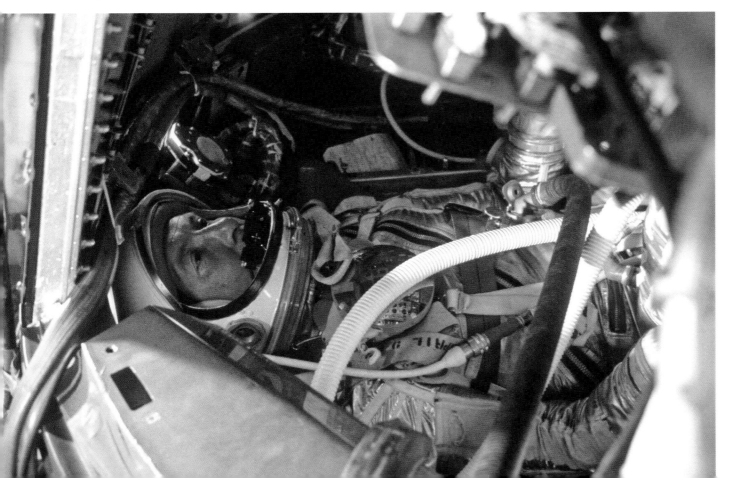

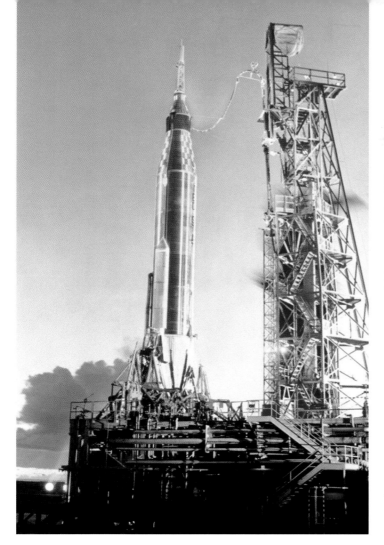

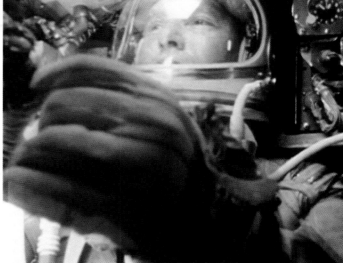

## October 3–7, 1962

**TOP LEFT** MA-8 is poised on the pad early on launch morning, October 3. Although problems with the Atlas postponed the launch several times, the smooth countdown was marred only by a fifteen-minute delay because of a radar problem at the Canary Islands tracking site.

**TOP RIGHT** Sunlight illuminates Schirra in this 16 mm still frame from the pilot observation camera during his six-orbit, nine-hour flight. "I'm real happy with this bird," he told capcom Glenn. "It's a real, real thrill."

**BOTTOM** *Sigma 7* heads toward space at 7:45 a.m. Schirra's orbit would range as high as 176 miles up, about 10 miles higher than Glenn's or Carpenter's.

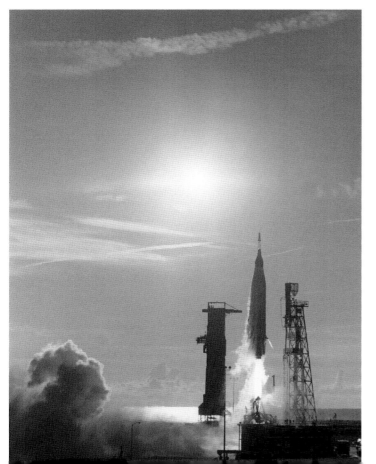

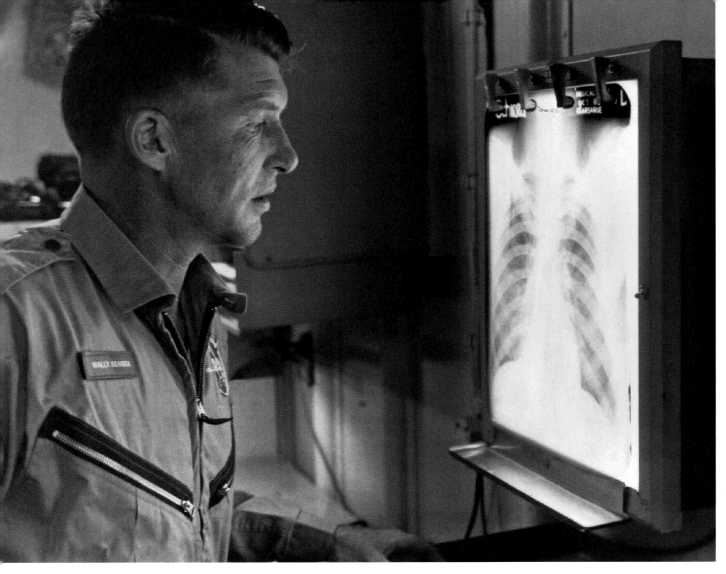

**TOP** Schirra studies his chest X-ray aboard the *Kearsarge*. He spent more than forty-eight hours aboard the ship for his examinations and initial debriefings as the carrier steamed toward Hawaii. *Sigma 7* had splashed down at 10:28 a.m. local time, 270 miles northeast of Midway Island and less than 2 miles from the aircraft carrier.

**BOTTOM** Schirra is adorned by leis as he leaves Hickam AFB, Hawaii, on October 6 after a three-hour stay, followed by Williams at left. NASA public affairs officer John "Shorty" Powers leads the way at right. After a brief public ceremony and a private luncheon, they boarded an afternoon nonstop flight to Houston.

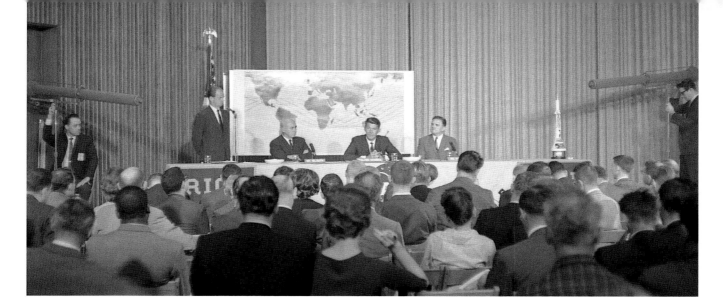

**TOP** Powers stands at left to field reporters' questions during Schirra's afternoon news conference at Rice University's Memorial Center in Houston on October 7. The astronaut (*center*) is flanked by MSC director Robert Gilruth (*left*) and NASA administrator James Webb. Boom mic operators at far left and right capture the questions during the nationally televised session. Schirra and the other astronauts were cheered by some three hundred thousand spectators during a motorcade from MSC to Rice.

**BOTTOM** *Left to right:* Gilruth, Schirra, and Webb. "I would have liked to have gone for 12 more orbits," he said of his "textbook flight." "My intention was to use so little fuel that no one could argue that we did not have enough fuel for 18 orbits," he added. "I think we proved it."

## October 15, 1962

**TOP** On October 15, Schirra is honored by his birthplace, Hackensack, New Jersey, and nearby Oradell, where he grew up. Here the astronaut greets a well-wisher as he briefly meets with reporters in Oradell at 8:15 a.m. "How's the countdown going?" he asked them. "Are we on hold, or are we counting?" He had spent the night at the mayor's home.

**BOTTOM** The Schirras were driven to Hackensack, where the parade gets underway for the 6-mile route back to Oradell.

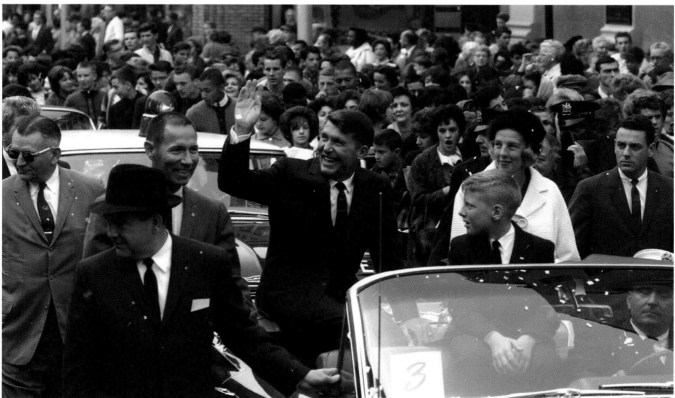

**TOP** Police officers from River Edge and Bergan County (*left*) and the New Jersey State Police (*right*) monitor enthusiastic crowds along the parade route, estimated at forty thousand.

**BOTTOM** Schirra (*center*), his son, Marty, and wife, Jo, ride in the parade. Oradell fire chief Tom Breault is at the wheel.

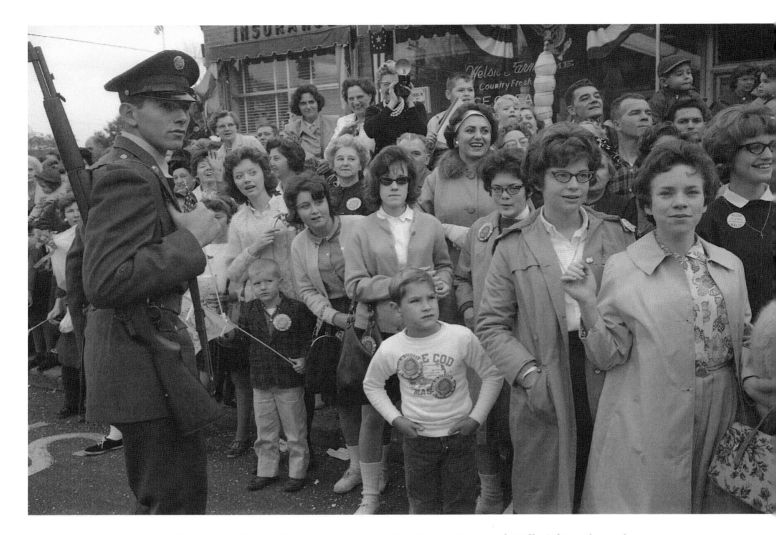

**THIS PAGE** Spectators wear "Hurrah for Schirra" buttons as members of the Army National Guard worked to keep the crowds on the sidewalks.

**FACING PAGE, TOP** Jo and Wally Schirra (*center*) are flanked by the astronaut's parents, their son, Marty, and daughter, Suzanne, following Webb pinning the agency's Distinguished Service Medal on the astronaut's lapel. "It's a great treat to realize that I can, after all this time, still come back to so many friends," he told the crowd of ten thousand. The ceremony was carried live by the national TV and radio networks.

**FACING PAGE, BOTTOM** The astronaut and son acknowledge the crowd before the Schirras attend a luncheon in his honor at the Hackensack Golf Club and the 2:00 p.m. dedication of Schirra Park. The family flew to Washington at 6:00 p.m. for a White House meeting with President Kennedy the next day.

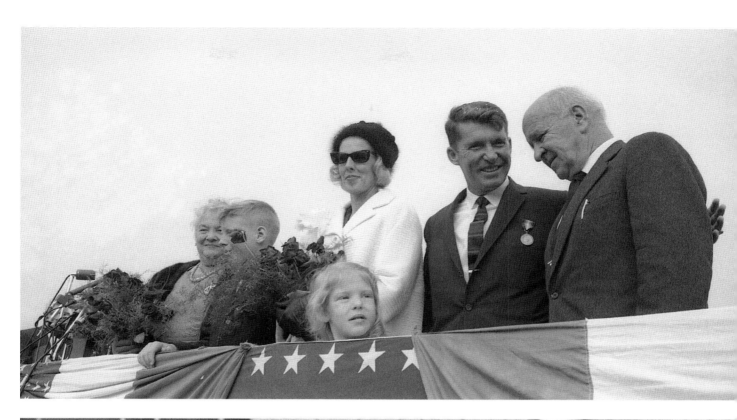

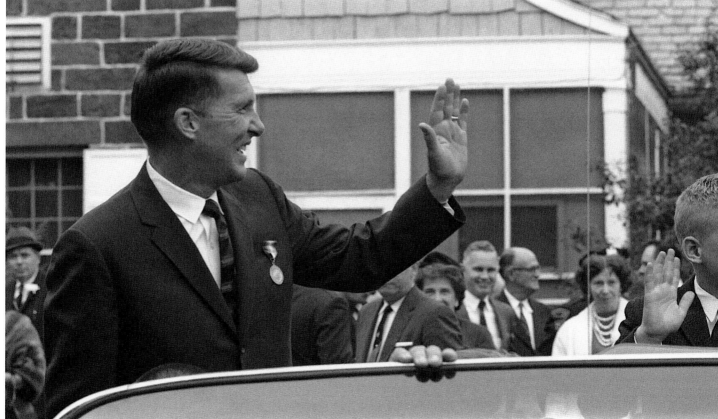

Schirra lights a cigarette for Powers with a gag lighter in this undated photo. Powers was a heavy smoker who would later be a spokesman for Tareyton cigarettes, which claimed to use the same charcoal-activated oxygen filter used in the Mercury spacecraft. He told an interviewer once, "[Walt Williams and I] measure how the mission is going by our cigarette consumption."

# 9

# Gordon Cooper

Mercury-Atlas 9

The sixth US manned space flight, Mercury-Atlas 9 (MA-9) in the spring of 1963, was the final mission of Project Mercury, sending its pilot, USAF Maj. Gordon Cooper, 36, into Earth orbit for thirty-four hours and twenty minutes—more than all previous US space flights combined, and the first American mission to last more than twenty-four hours. The Soviet Union's Vostok 2 had been the first, almost two years earlier; and all subsequent Soviet flights had also lasted at least one day. Cooper's mission was to span twenty-two orbits and total nearly 550,000 miles.

A launch attempt on May 14, 1963, was delayed about two hours when the diesel engine used to roll the mobile service structure away from the pad on rails malfunctioned. While it was being repaired, a computer at the Bermuda tracking station failed, and the launch was scrubbed.

The next day, however, *Faith 7* was launched from Launch Complex 14 (LC-14) after a brief unplanned hold. Cooper became the last American to be launched alone into Earth orbit.

During his third orbit Cooper released a 6-inch-diameter sphere with strobe lights from the nose of the spacecraft, which he could see during the next orbit, the first time a satellite was deployed from a manned space vehicle. The experiment was to test his ability to spot and track a flashing beacon in orbit. Cooper also reported seeing a 44,000-watt xenon lamp in South Africa.

He had planned to deploy a beach-ball-sized Mylar balloon, inflated with nitrogen and attached to a 100-foot nylon tether from the antenna canister. A strain gauge would measure differences in atmospheric drag between the orbit's high and low points. The balloon, however, failed to deploy.

Cooper was able to sleep for about eight hours during his tenth through fourteenth orbits, a first for an astronaut. He had also briefly drifted off to sleep during the second orbit. At the start of the seventeenth orbit over Cape Canaveral, Cooper briefly transmitted slow-scan black-and-white television pictures to the ground, a first for an American astronaut.

The controllers were pleased that Cooper and *Faith 7* used much less fuel and consumables, including oxygen, than had been anticipated, and the mission proceeded largely according to plan.

Late in the flight, however, problems cropped up quickly. During the nineteenth orbit, a warning light falsely indicated that the spacecraft had fallen into an unacceptably low orbit. On the twentieth orbit, Cooper lost all attitude readings; and on the next revolution, a short-circuit left the automatic stabilization and control system without power. Mission managers ordered him to reenter manually—a first.

Carbon dioxide levels began rising and the cabin temperature jumped to more than 100°F. Relying on star sightings, Cooper took manual control and successfully

estimated the correct pitch for reentry into the Earth's atmosphere, drawing lines on *Faith 7*'s window to help check his orientation before igniting his retrorockets.

The final Mercury mission splashed down less than 5 miles from the prime recovery ship, the aircraft carrier USS *Kearsarge*, at 12:24 p.m. local time 80 miles south of Midway Island in the Pacific Ocean. The spacecraft with Cooper aboard was lifted from the water with the ship's crane and set down on deck thirty-six minutes later.

NASA had considered an additional flight, but Project Mercury officially ended on June 12, 1963, when NASA administrator James Webb told Congress that no more Mercury flights were needed and that the agency would proceed with the two-man Gemini program.

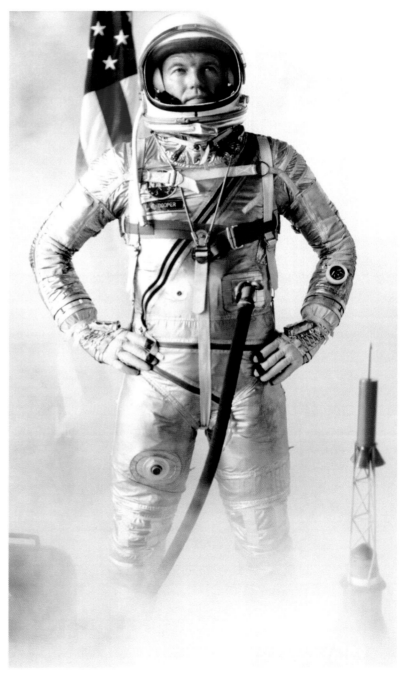

**LEFT** Outtake from the 1960 astronaut portrait session with Bill Taub. Cooper had learned to fly as a boy. He served in the Marine Corps from 1945 to 1946, then attended the University of Hawaii, where he was commissioned a second lieutenant in the US Army. In 1949 Cooper completed pilot training after transferring to the USAF. From 1950 to 1954 he was a fighter pilot in West Germany. Cooper earned a bachelor's degree at the Air Force Institute of Technology in 1956, then completed test pilot school at Edwards AFB, California. He served as a test pilot there until he was selected as a Mercury astronaut.

**RIGHT** Portrait on July 11, 1962. Cooper had the most—and most creative—Mercury portraits.

## 1959–1960

Cooper stands next to the tail unit of a Mercury-Redstone launch vehicle during a visit to Marshall Space Flight Center in 1959. The vehicle's four air rudders are under protective shrouds. Its Rocketdyne A-7 engine has not been installed. Cooper holds a Chrysler brochure. His Mercury Seven responsibilities included the booster, its integration with the spacecraft, and pad safety.

*Left to right:* Cooper, NASA engineer Charles Scarbrough, and Redstone project director Jack Kuettner pose at the Interim Test Stand at Redstone Arsenal in May 1960, with a Mercury-Redstone in place.

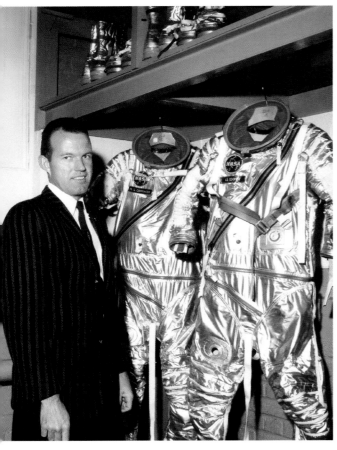

**TOP LEFT** Cooper poses with training suits for him (*right*) and Scott Carpenter at the Johnsville centrifuge in Warminster, Pennsylvania, in October 1960 for fifteen-minute training runs spread over three weeks to simulate MR-3.

**TOP RIGHT** Cooper models the pressure suit's cotton undergarment with its Trilok air vents. The panels were spacers to ensure airflow where the suit might otherwise compress the garment.

**BOTTOM** A Navy corpsman attaches electrodes before a centrifuge run.

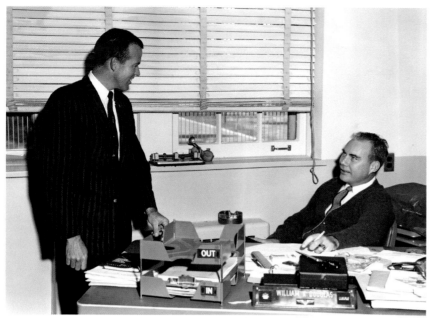

TOP Flight surgeon Dr. William Douglas (*right*) enjoys a cigarette as Cooper (*left*) drops by at Langley AFB on December 7. A McDonnell Aircraft *Capsule Flight Operations Manual* is on his desk at left.

BOTTOM Cooper in Mercury Procedures Trainer no. 1 at Langley in December 1960.

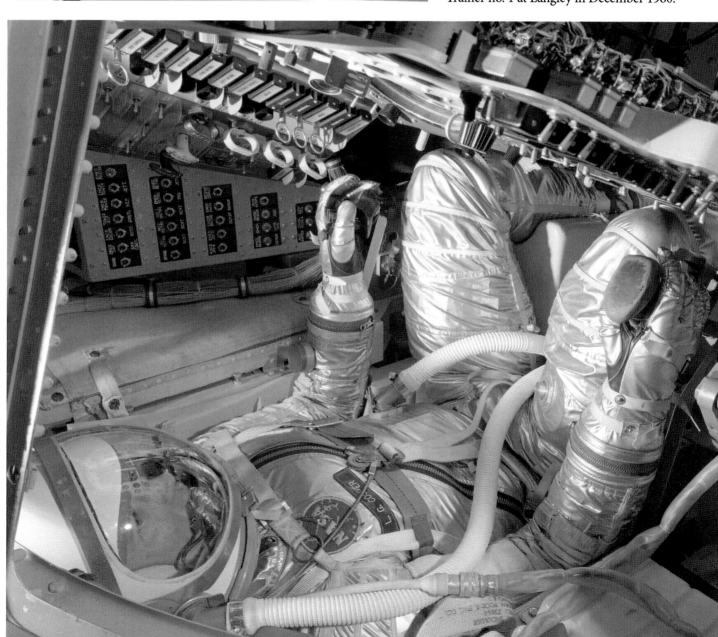

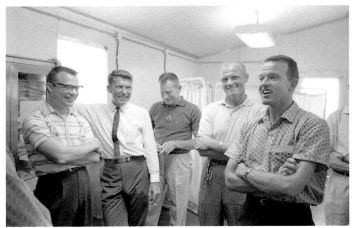

**1961**

**LEFT** Cooper (*left*) arrives on Grand Bahama Island with John Glenn (*background*), Carpenter, and Wally Schirra (*unseen*) to meet Alan Shepard after MR-3 on May 5.

**TOP RIGHT** Cooper (*right*) joins the other six astronauts and Dr. Douglas for lunch at the Forward Medical Station at the Cape in May 1961.

**BOTTOM RIGHT** *Left to right:* Navy lieutenant and psychologist Dr. Robert Voas, Schirra, Deke Slayton, Glenn, and Cooper share a laugh on Grand Bahama Island on May 5.

**FACING PAGE** With one of his pressure suits in the foreground, Cooper undergoes a leak check at Hangar S in September as Schirra's backup for MA-8. For Cooper's flight, the pneumatic visor seal would be replaced by a mechanical seal.

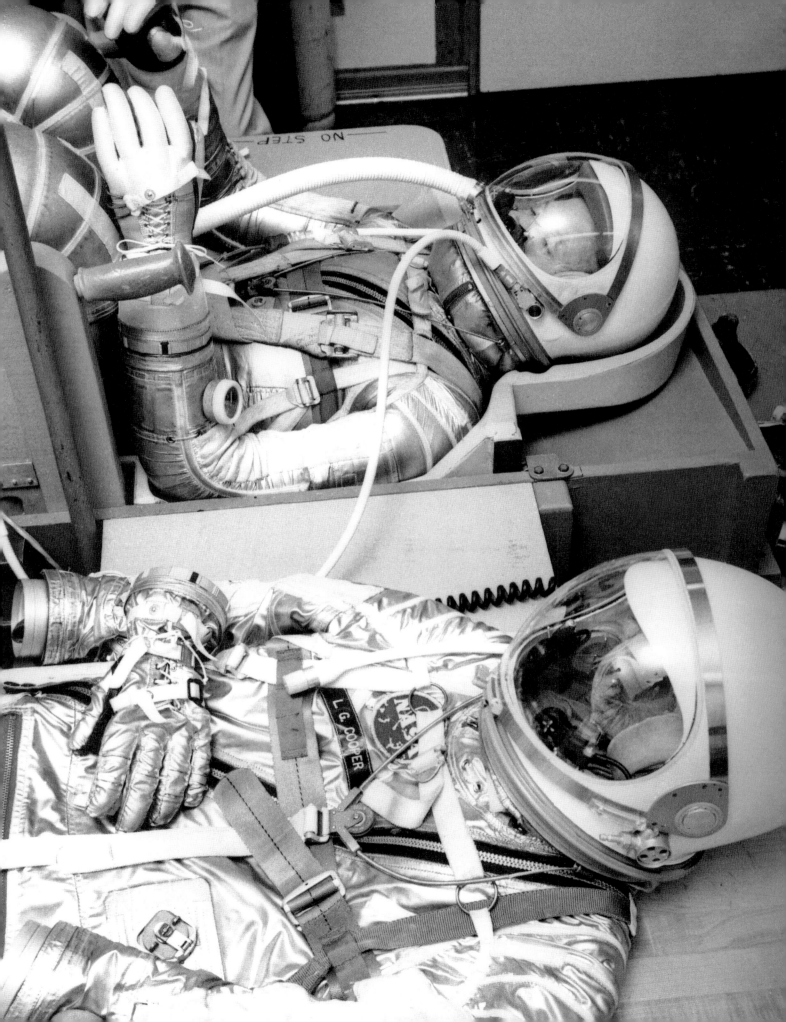

## 1962

Cooper (*left*) discusses Mercury hardware in Hangar S with President Kennedy on September 11. Each astronaut had a specific briefing assignment for the president during Kennedy's two-day tour of three NASA centers and McDonnell. Spacecraft no. 19, the backup for MA-7, is behind them. *Left to right:* Preflight operations division chief G. Merritt Preston (*behind Cooper*), Cooper, unidentified, President Kennedy, Vice President Lyndon Johnson, USAF secretary Eugene Zuckert, and Webb. A striped Mercury retrorocket pack is on display in the background.

Cooper (*left*) chats with the president, with Zuckert at right.

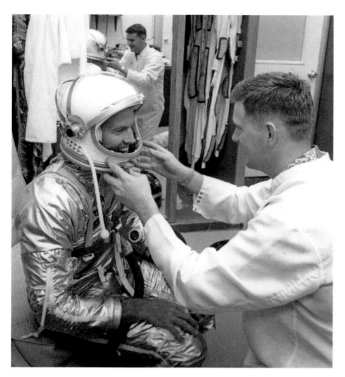

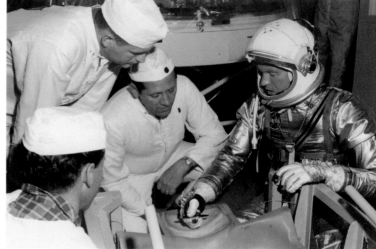

## 1963

**TOP LEFT** NASA suit technician Alan Rochford (*right*) adjusts Cooper's helmet before a session to evaluate the astronaut's form-fitting couch in a pressurized suit on February 6 in Hangar S. The suit is the first to have integrated boots.

**TOP RIGHT** Cooper provides feedback after the session to Rochford (*left*) and McDonnell technician C. R. Coyle.

**BOTTOM** Cooper poses with an F-106B jet on January 20 during the Taub group photo session at Langley AFB.

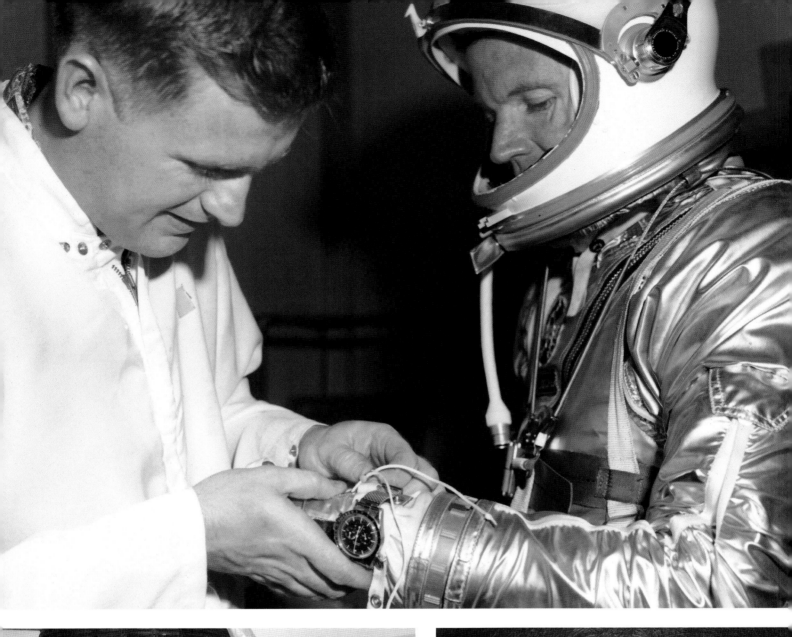

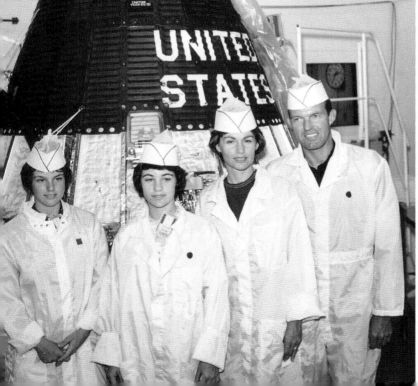

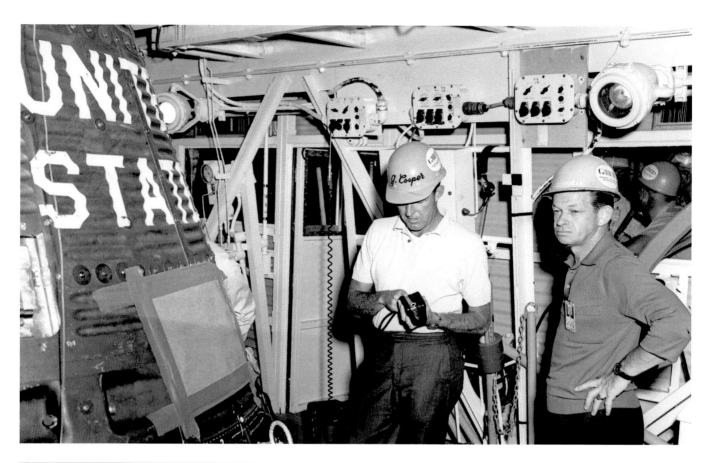

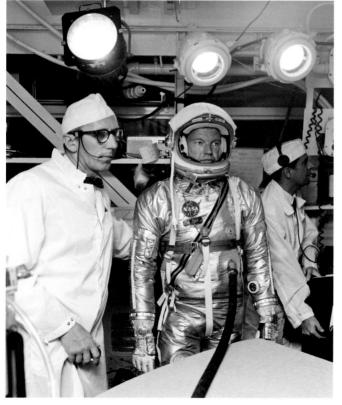

**FACING PAGE, TOP** Rochford (*left*) laces up Cooper's left glove before for a weight and balance test on March 6. The astronaut wears an Omega Speedmaster watch.

**FACING PAGE, BOTTOM LEFT** The Cooper family poses with *Faith 7* in the clean room at Hangar S in April. *Left to right:* daughters Jan, 13, and Cam, 14, and wife Trudy.

**FACING PAGE, BOTTOM RIGHT** Cooper, a devout Christian, chose the name and design for his spacecraft. It was painted on the capsule by B. R. Schuster, a McDonnell engineering draftsman. (April 17 photo.)

**THIS PAGE, TOP** Cooper (*left*) with NASA public affairs officer John "Shorty" Powers at LC-14 after mechanical mating of *Faith 7* (spacecraft no. 20) to its Atlas booster (109D) on April 22.

**THIS PAGE, BOTTOM** McDonnell pad leader Guenter Wendt (*left*) with Cooper in the LC-14 white room on April 23 before the first of his three simulated flights.

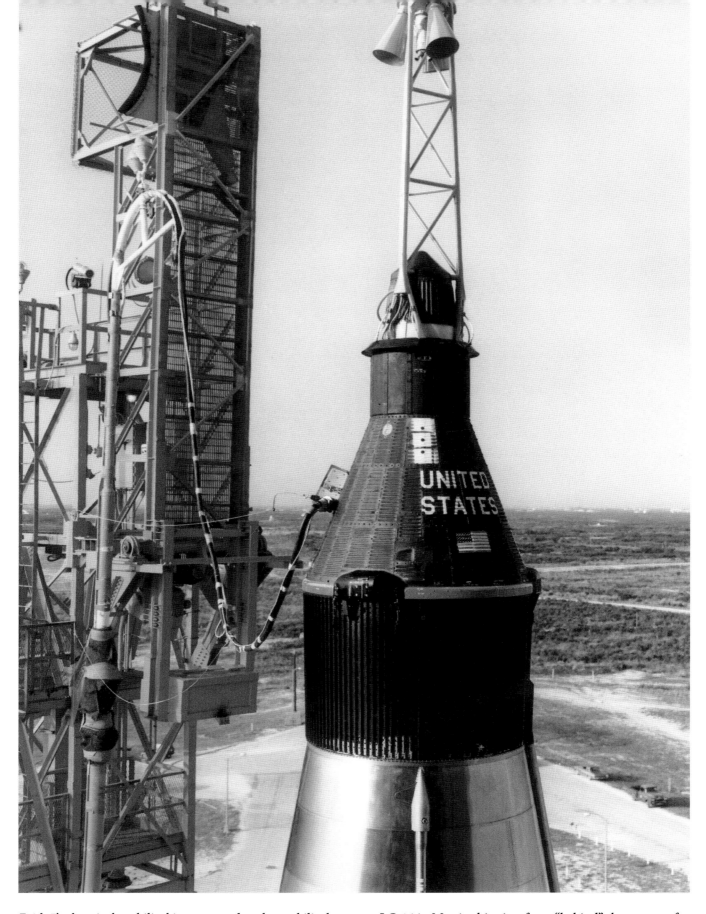

*Faith 7*'s electrical umbilical is connected to the umbilical tower at LC-14 in May in this view from "behind" the spacecraft.

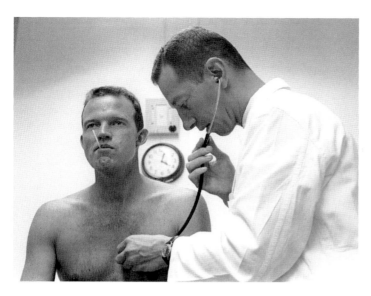

## May 15, 1963

**TOP** Flight surgeon Dr. Howard Minners listens to Cooper's heart at 4:05 a.m. during his medical examination on launch morning.

**BOTTOM** As dawn comes to the Cape, Cooper steps from the transport trailer at LC-14 about 5:15 a.m. carrying his ventilator.

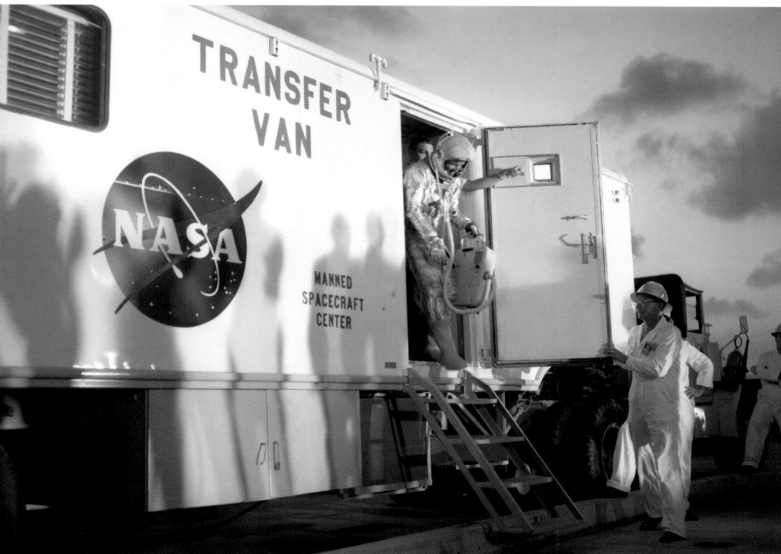

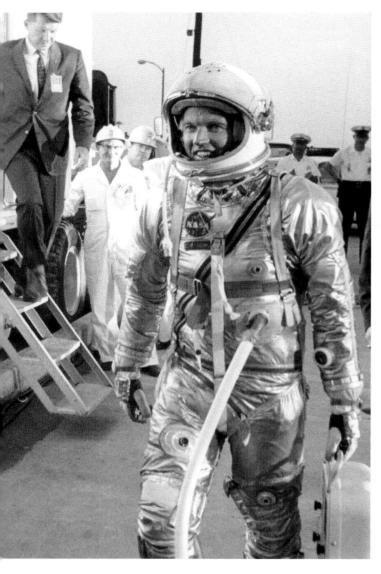
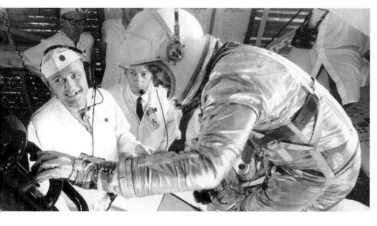
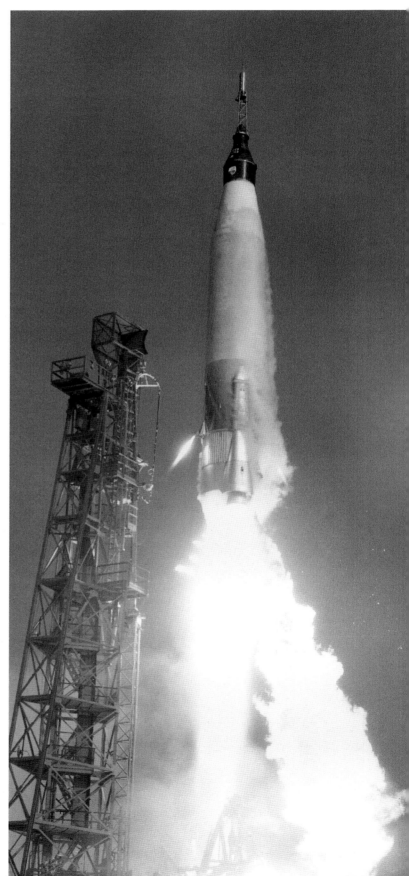

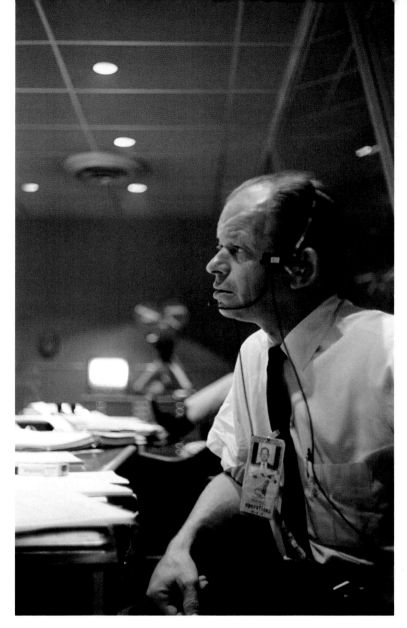

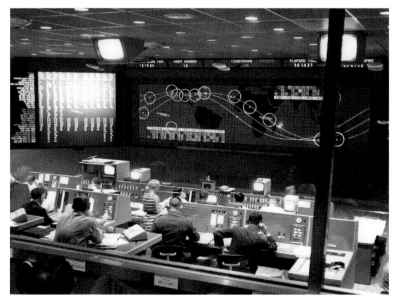

**FACING PAGE, TOP LEFT** Cooper heads for the pad elevator, with Schirra following.

**FACING PAGE, BOTTOM LEFT** Cooper climbs aboard *Faith 7* at 5:32 a.m. as a NASA quality control inspector and Dr. Minners look on.

**FACING PAGE, RIGHT** MA-9 roars skyward at 8:04 a.m. Launch came on the second attempt after problems at the Bermuda tracking station forced a scrub just twelve minutes before liftoff the day before. Cooper's orbit ranged from 100 to 166 miles up.

**THIS PAGE, TOP** Powers at his console in the Mercury Control Center (MCC), wearing the smaller Plantronics headset that had become popular for flight controllers after Glenn's flight. Powers would resign from NASA shortly after he was reassigned by Manned Spacecraft Center director Robert Gilruth in July. The move reportedly followed a dispute with NASA Headquarters; Powers had objected to the decision to release Cooper's full twenty-two-orbit flight plan in advance.

**THIS PAGE, BOTTOM** Flight controllers monitor the mission in the MCC as *Faith 7* passes near the Zanzibar Tracking Station on orbit sixteen as Cooper begins taking a series of photos of the zodiacal light and night airglow layer. John Hodge (*seated far left*) serves as flight director. It was the first mission with three shifts of controllers to cover the twenty-four-hour-plus flight.

**THIS PAGE** Two Navy SH-3A Sea King helicopters sit on the deck of the prime recovery ship, USS *Kearsarge*, south of Midway Island in the Pacific. They bear the markings of Carrier Antisubmarine Warfare Air Group 53.

**FACING PAGE, TOP** Douglas AD-5W Skyraider aircraft in an airborne early warning version with radar installed are parked on the carrier's deck. Eleven ships and eighteen aircraft were dedicated to the recovery effort alone in the Pacific.

**FACING PAGE, BOTTOM** A banner on the *Kearsarge* tower welcomes the carrier's second consecutive Mercury astronaut recovery.

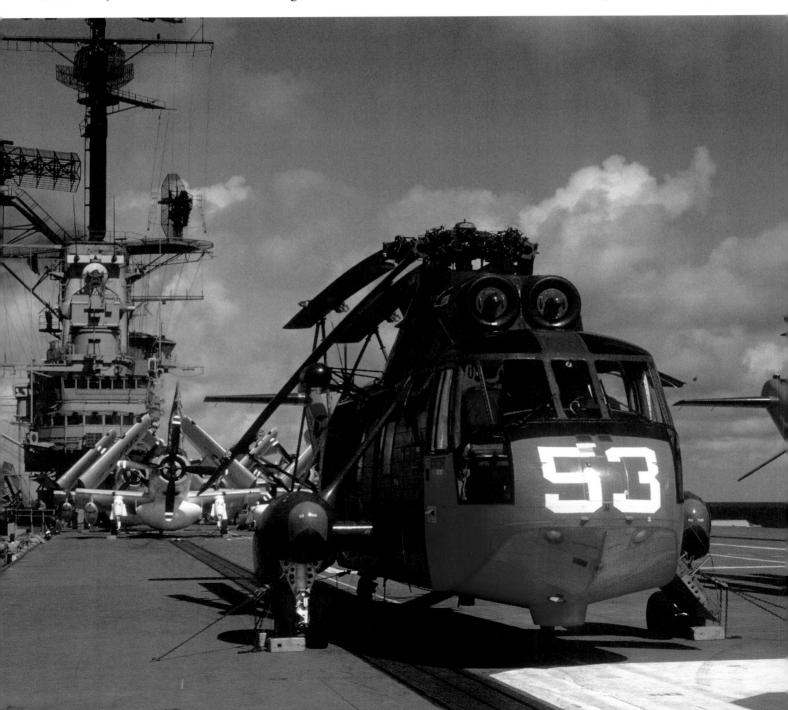

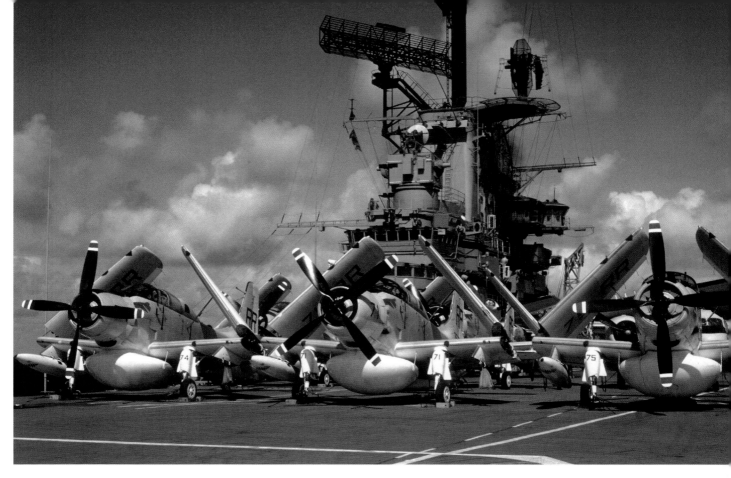

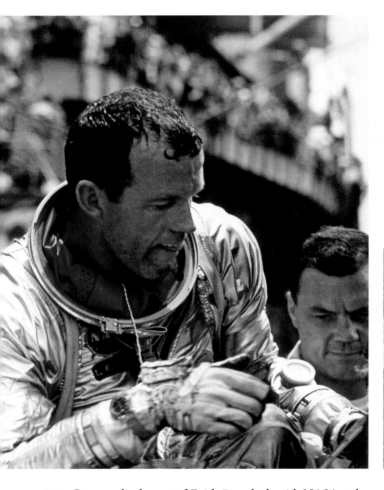

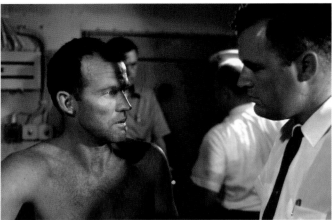

**LEFT** Cooper climbs out of *Faith 7* on deck with NASA public affairs officer Ben James at right. *Faith 7* landed about 4.5 miles away from the carrier, the most accurate Mercury splashdown.

**TOP RIGHT** Cooper undergoes a medical examination aboard *Kearsarge* at about 1:15 p.m. Midway time by NASA physician Richard Pollard. He found Cooper to be a little dehydrated but in good overall shape.

**BOTTOM RIGHT** Artist Mitchell Jamieson, commissioned as part of the new NASA Art Program established by Webb, makes a sketch aboard the *Kearsarge* during the transit to Hawaii. The carrier arrived in Honolulu on May 18, and Cooper was transferred by helicopter to Hickam AFB, where he was reunited with his family.

**FACING PAGE** *Faith 7*'s shingles show the normal discoloration from the heat of reentry. The spacecraft was airlifted to the Cape from Honolulu.

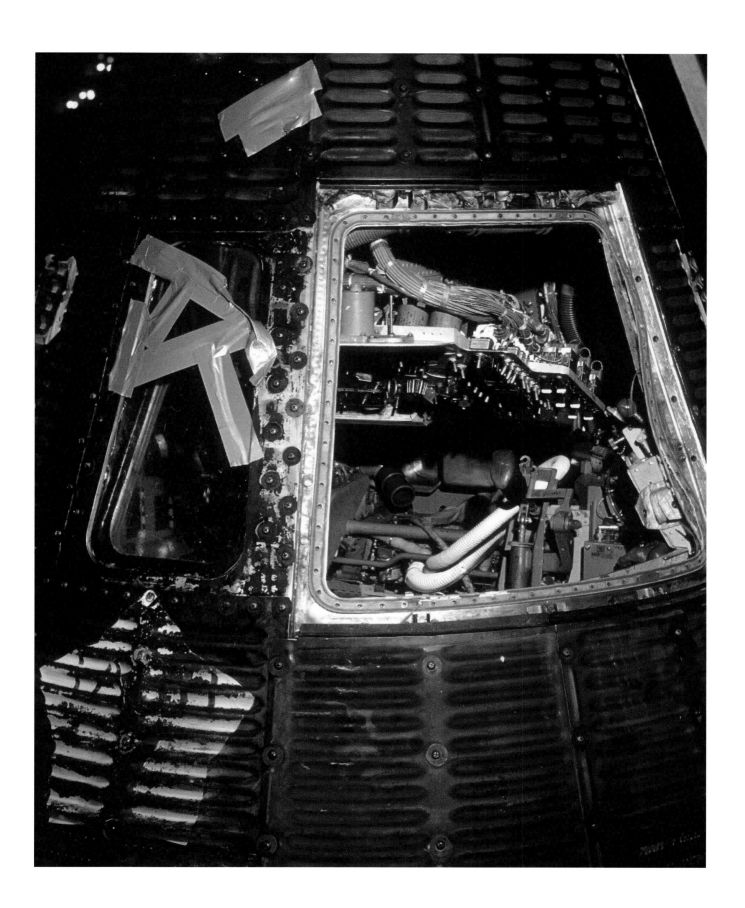

## 1964

Cooper was one of two winners of the 1963 Harmon International Aviation Trophy, awarded by President Lyndon Johnson in the White House Rose Garden on September 14, 1964. The other recipient was aviatrix Betty Miller for her 7,400-mile solo flight across the Pacific—the first by a woman—from Oakland, California, to Sydney, Australia. *Left to right:* Jan, Cam, Cooper, Trudy, and Mrs. James Webb.

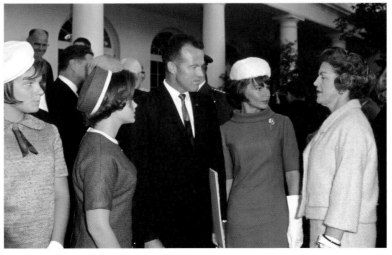

# 10

# Beyond Mercury

The Mercury astronauts received the 1962 Collier Trophy at the White House "for pioneering manned space flight in the United States" and the Society of Experimental Test Pilots' Iven C. Kincheloe Award in 1963. On November 10, 1964, the Mercury Seven monument at Launch Complex 14 (LC-14) was dedicated.

With the lure of the coming Gemini and Apollo programs, the seven astronauts remained with NASA when Mercury ended, although John Glenn, the oldest, was the first to leave in January 1964 to pursue a career in politics. In April of that year, Alan Shepard was grounded for an inner ear aliment.

NASA had selected twenty-three new astronauts in 1962 and 1963, but their immediate boss, Deke Slayton, would assign command of three of the first four Gemini flights to Gus Grissom, Gordon Cooper, and Wally Schirra. The influx of new candidates and a combination of other factors, however, meant that the remaining Mercury veterans would make just four more space flights among them over the next thirty-four years: Schirra commanding Apollo 7 in 1968, Shepard at the helm of Apollo 14 in 1971 after ear surgery restored him to flight status, Slayton finally flying aboard the Apollo–Soyuz Test Project (ASTP) mission in 1975, and Glenn on space shuttle *Discovery* at age 77 in 1998. Only Scott Carpenter never flew in space again, but these pioneers were represented into the twenty-first century on all American manned spacecraft.

The astronauts got together on several occasions during the following years, with Grissom's widow, Betty, representing him after his death in 1967. The first reunion was organized by Henri Landwirth at Walt Disney World in 1974. In 1984, they formed the Mercury Seven Foundation to sponsor college scholarships for science students.

The seven were inducted into the Astronaut Hall of Fame in Titusville, Florida, in 1990. The Mercury Seven Foundation gala the following year was the last time the six men and Betty Grissom were together.

**TOP** *Left to right:* Glenn, Shepard, Slayton, and Cooper catch up at a reception after a ceremony at LC-14 for the tenth anniversary of Glenn's Mercury-Atlas 6 flight on February 22, 1972.

**BOTTOM** Glenn (*left*) chats with Guenter Wendt. More than three thousand attended the earlier outdoor ceremony.

**FACING PAGE, TOP** Shepard (*left*) speaks at the Mercury Seven Foundation gala marking the thirtieth anniversary of Mercury-Redstone 3 on May 3, 1991. *Left to right:* Carpenter, Schirra, Betty Grissom, Cooper, Glenn, and Slayton. The group formed the foundation with Dr Douglas and Henri Landwirth.

**FACING PAGE, BOTTOM LEFT** Shepard received a statuette from the foundation marking the anniversary at the dinner at the Washington (DC) Hilton.

**FACING PAGE, BOTTOM RIGHT** Shepard (*left*) with Mercury Seven Foundation executive director Howard Benedict. The retired AP aerospace writer, considered the dean of journalists at Cape Canaveral, chronicled the US space program for thirty-seven years from before Mercury through the thirty-fourth space shuttle mission in 1990.

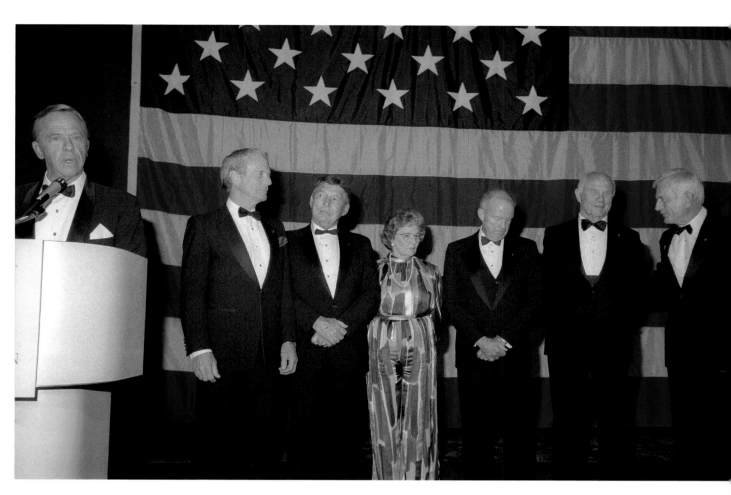

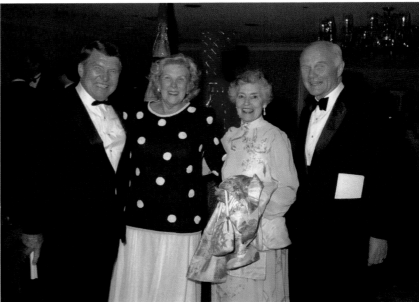

**TOP** Carpenter (*center*) and the others patiently signed autographs after the event. Bob Hope and Bill Dana were also on the program.

**BOTTOM LEFT** Gordon and Suzy Cooper.

**BOTTOM RIGHT** Wally and Jo Schirra (*left*) and Annie and John Glenn pose in front of an ice sculpture of a rocket on the pad. The astronauts visited the Cape the following week.

## Gus Grissom, 1926–1967

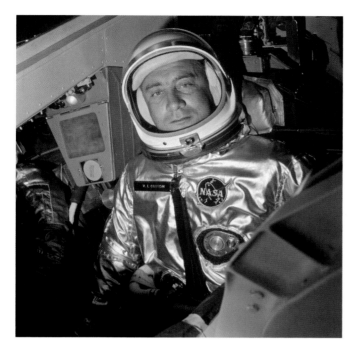

Gus Grissom was named command pilot of the first manned Gemini mission in 1964 after Shepard was grounded by his ear problems; and on Gemini 3 in 1965, Grissom became the first astronaut to make a second space flight, with rookie pilot John Young. He was the original backup command pilot for Gemini VI before he was transferred to the Apollo program and assigned to command its first manned mission.

Less than a month before launch, however, Grissom, with astronauts Ed White and Roger Chaffee, died at age 40 when a fire swept through their Apollo 1 spacecraft during a ground test at LC-34 at Cape Kennedy Air Force Station (AFS) on January 27, 1967. Their deaths were attributed to a range of lethal hazards in the early Apollo design and the conditions of the test.

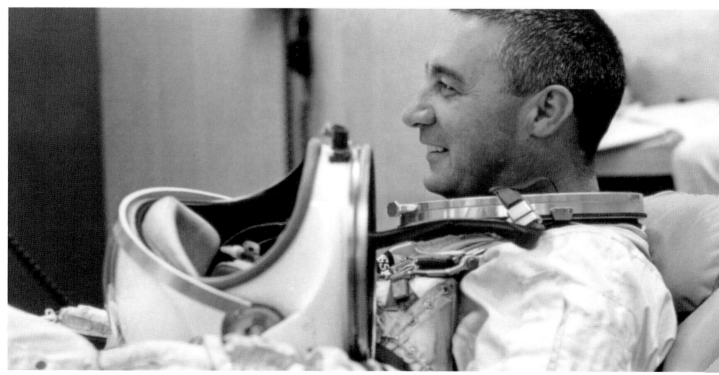

**TOP** Grissom in the Gemini flight simulator at Cape Kennedy AFS on May 22, 1964.

**BOTTOM** Grissom prior to a test on March 18, 1965, during final preparations for Gemini 3.

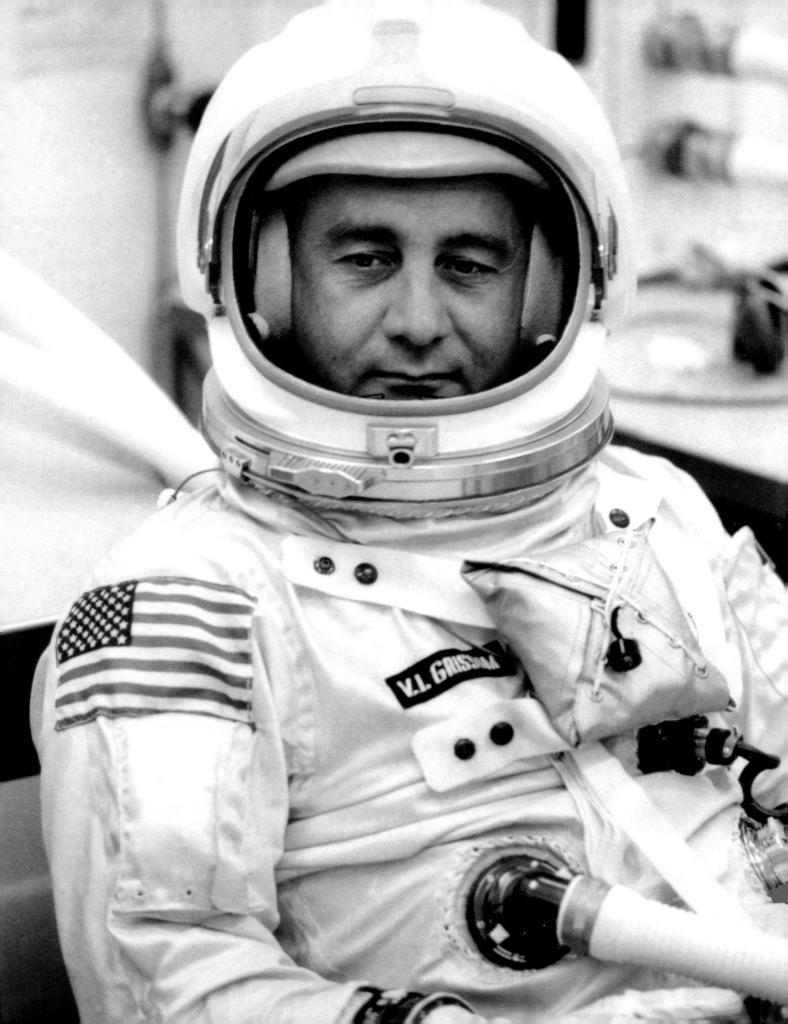

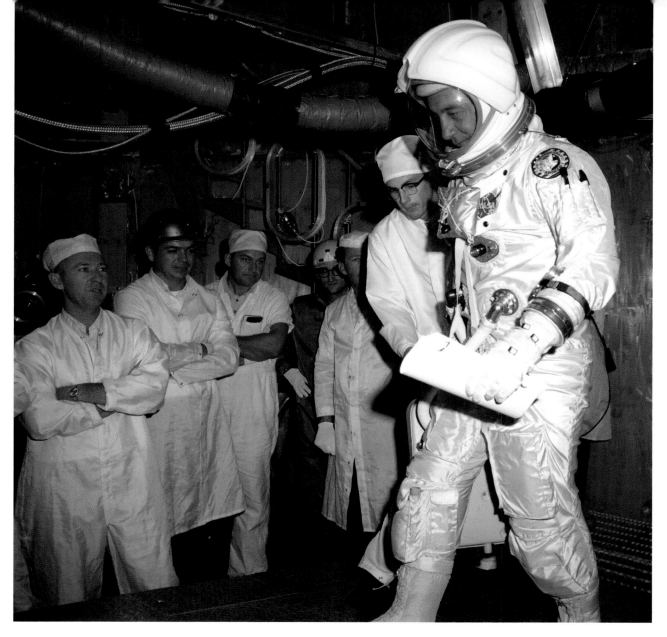

FACING PAGE Grissom undergoes a suit check before an altitude chamber test in the Apollo 1 spacecraft at Kennedy Space Center (KSC)'s Operations and Checkout Building on October 11, 1966.

TOP Grissom prepares to enter Apollo 1 for an altitude chamber test on October 18, 1966.

BOTTOM *Left to right:* Apollo 1 astronauts Chaffee, White, and Grissom during their preflight news conference at the Manned Spacecraft Center (MSC) in Houston on December 16, 1966.

## Deke Slayton, 1924–1993

Deke Slayton was named senior manager of the astronaut office at MSC after he was grounded for his heart condition in early 1962. He became director of Flight Crew Operations in 1966.

After extensive efforts to improve his health, Slayton was found to no longer have a heart condition and he was returned to flight status in 1972. The next year, he was selected as the docking module pilot for the 1975 joint US–Soviet Apollo–Soyuz Test Project (ASTP)

mission with veteran commander Tom Stafford and rookie Vance Brand.

Slayton was then assigned to manage the space shuttle's Approach and Landing Tests and its first four space flights. He left NASA in 1982 and moved to private industry as president of Space Services, Inc., in Houston to develop boosters for small commercial payloads. Slayton was diagnosed with a malignant brain tumor and died on June 13, 1993, at age 69.

Slayton during jungle survival training at Albrook AFS in Panama during the first week of June 1963.

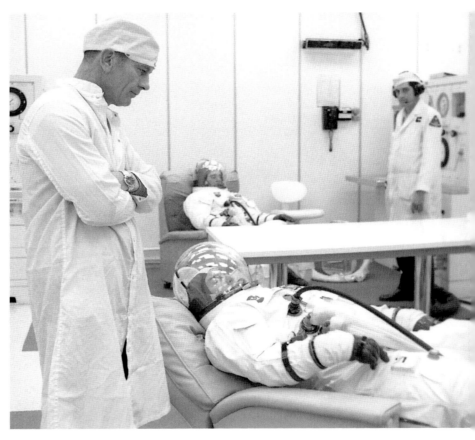

Slayton visits with Apollo 8 astronaut Jim Lovell in the suit room at the KSC Operations and Checkout Building before the mission's countdown demonstration test on December 11, 1968.

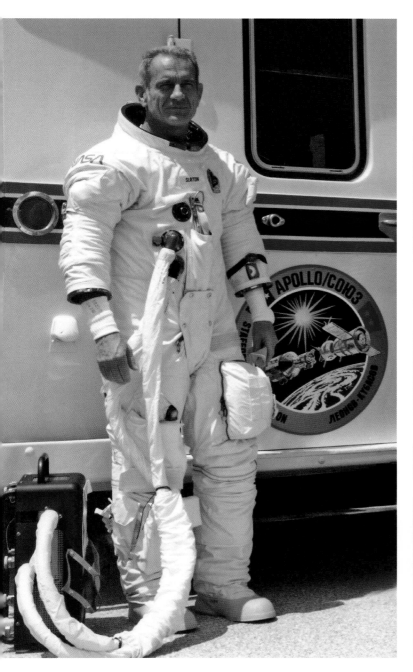

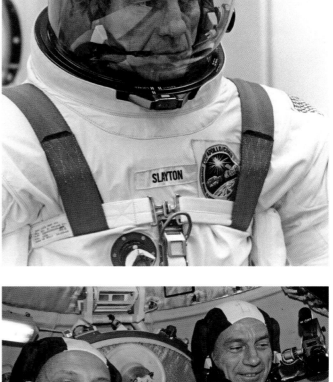

**LEFT** Slayton pauses at the rear of the astronaut transfer van on July 3, 1975, after the countdown demonstration test for the ASTP launch.

**TOP RIGHT** Slayton is suited for launch of the nine-day mission on July 15, 1975.

**BOTTOM RIGHT** ASTP commander Tom Stafford (*left*) and Slayton aboard Soyuz. Stafford holds a Russian tube of borscht (beet soup) over which vodka labels have been pasted as a gag.

# Alan Shepard, 1923–1998

Alan Shepard hoped to pilot a three-day final Mercury flight, but when that plan was dropped, he was named command pilot of the first manned Gemini mission. He was grounded in April 1964, however, suffering from of Ménière's disease, an inner ear ailment causing dizziness.

Shepard was named chief of the Astronaut Office in July 1964. In early 1969, he underwent surgery to resolve his ear problem, and he was returned to flight status by NASA in May. Shepard was selected as commander of Apollo 14 in 1971, the third moon landing mission, with Ed Mitchell and Stu Roosa. He became the fifth, and at age 47 the oldest, man to walk on the moon, and the only Mercury astronaut to do so. He remained Astronaut Office chief until his retirement from the Navy as a rear admiral and from NASA in 1974.

Shepard later served on the boards of many corporations, formed his own company, and became wealthy in banking and real estate. He was diagnosed with leukemia in 1996 and died from complications of the disease in 1998 at age 74.

TOP  Shepard (*left*) and astronaut Frank Borman in front of the Gemini simulator at MSC in April 1964.

MIDDLE  Shepard (*right*) talks with Gemini VII command pilot Borman on launch morning, December 4, 1965.

BOTTOM  Shepard poses during the Apollo 14 crew portrait session at KSC on October 14, 1970.

FACING PAGE  Apollo 14 commander Shepard on February 5, 1971, shortly after stepping from lunar module *Antares* onto the surface of the moon.

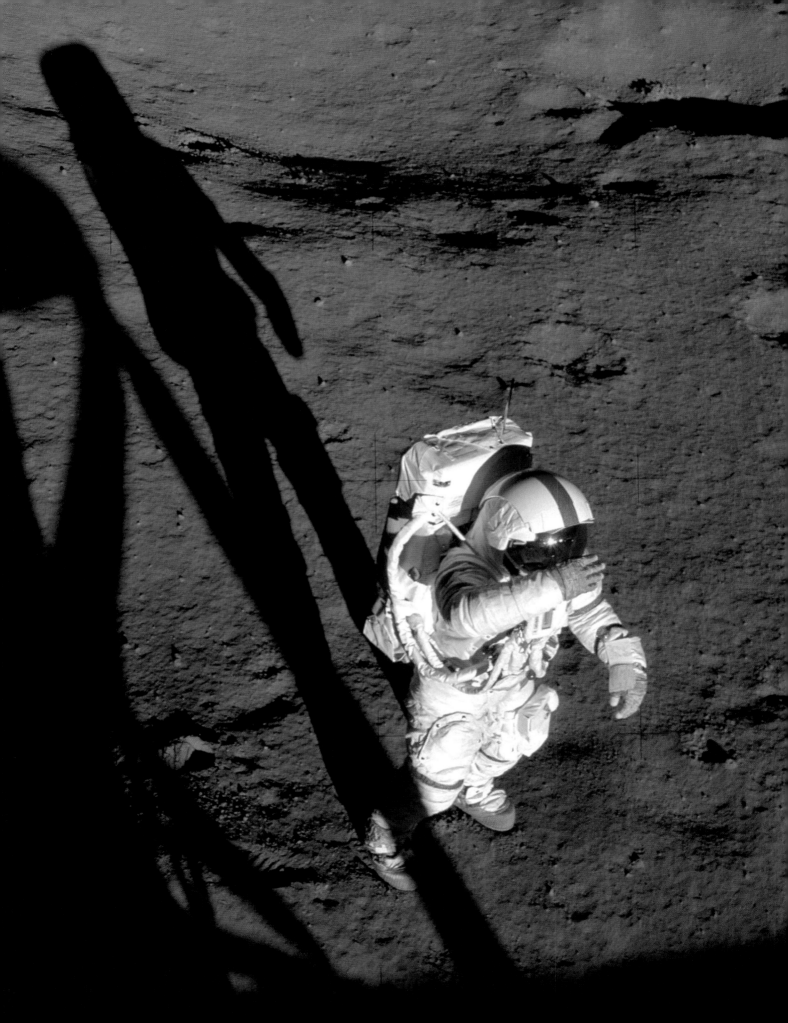

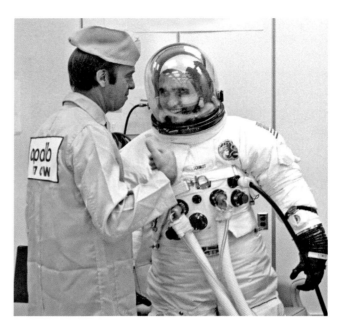

**TOP** Shepard (*left*) with Apollo 17 lunar module pilot Jack Schmitt in the Operations and Checkout Building suit room at KSC before launch of final Apollo mission to the moon on December 7, 1972.

**BOTTOM** Shepard (*right*) served as an analyst for NBC News during the final Apollo missions, and for ASTP. Here he poses with the two commanders, Tom Stafford and his Soviet counterpart, Alexi Leonov, in front of the Apollo 17 command module at the Johnson Space Center in February 1975. (NBC photo)

# Gordon Cooper, 1927–2004

Gordon Cooper was selected as command pilot for the successful eight-day Gemini V mission in 1965 with rookie pilot Pete Conrad. He then served as backup command pilot for Gemini XII, the final mission of the program.

Cooper was chosen as backup commander for 1969's Apollo 10, but Slayton was reluctant to give him an Apollo flight of his own, citing his lax training attitude. Removed from the usual crew rotation, his chances of a moon mission were greatly diminished.

Cooper retired from NASA and the USAF in 1970 as a colonel. He served on several corporate boards and as technical consultant on high-performance boat design, energy, and construction. From 1973 to 1975, Cooper worked for the Walt Disney Company as vice president of research and development for Epcot; and in 1989, he became the chief executive of Galaxy Group, a company that designed private aircraft.

Cooper died at age 77 from heart failure on October 4, 2004.

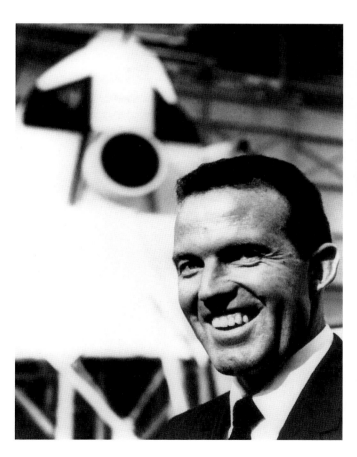

Cooper visits Grumman Aircraft in Bethpage, New York, for lunar excursion module development meetings on September 17, 1963.

Cooper, Grissom, and Ted Foss, chief of NASA's Geology and Geochemistry Branch, during geology training at Grand Canyon National Park in Arizona on March 12, 1964.

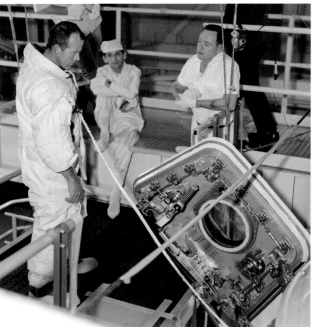

**TOP** Gemini XII backup pilot Gene Cernan (*left*) and backup command pilot Cooper pose in a Gemini mock-up in September 1966.

**BOTTOM LEFT** Cooper at Cape Kennedy AFS on August 14, 1965, one week before he would command the Gemini V mission.

**BOTTOM RIGHT** Cooper during vibration and acoustic testing of Apollo command module no. 105 at MSC on February 10, 1968.

# Wally Schirra, 1923–2007

Wally Schirra was assigned as backup command pilot for Gemini 3, the program's first manned mission, in 1965. Tom Stafford was the backup pilot, and both astronauts then became the prime crew for Gemini VI. Their brief December 1965 flight with Gemini VII achieved the first space rendezvous.

Schirra was then selected as backup commander for the first manned Apollo crew with Donn Eisele and Walt Cunningham. After the Apollo 1 fire, the three astronauts became the prime crew for that first mission in 1968, which became Apollo 7. Schirra was the first person to fly in space three times during the eleven-day Earth-orbital shakedown mission, and the only astronaut to fly during Mercury, Gemini, and Apollo. He retired from NASA and the Navy less than a year later as a captain, a decision made before his Apollo mission. He remained in the public eye, however, serving as an on-air analyst for CBS News with Walter Cronkite from Apollo 11 through ASTP (Shepard filled in for Apollo 15).

Schirra became a successful business executive, serving as president or chairman of several companies. He founded Schirra Enterprises in 1979 and worked as a consultant and served as a board member for corporations including Kimberly-Clark, Rocky Mountain Airways, and Johns Manville.

Schirra died on May 3, 2007, of a heart attack at age 84 while undergoing treatment for abdominal cancer.

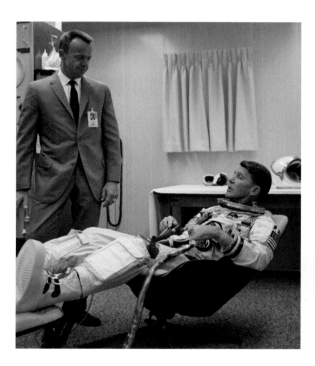

Schirra (*right*) with Shepard in the suiting trailer at LC-16 on the morning of the Gemini VI launch on December 15, 1965.

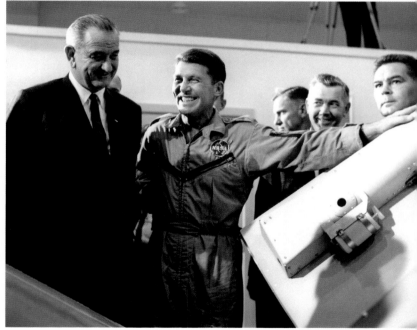

Schirra (*center*) briefs President Johnson on the Gemini flight simulator at the MCC during his surprise visit to Cape Kennedy AFS on September 15, 1964. Schirra was Gemini 3 backup command pilot.

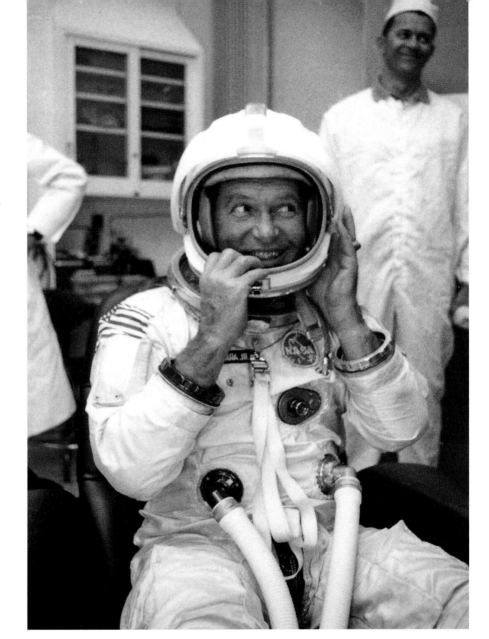

**TOP** Schirra prepares for an altitude chamber test at KSC in the Apollo 1 spacecraft on December 29, 1966.

**BOTTOM** Schirra suited for an altitude chamber test at KSC in the Apollo 7 spacecraft on July 26, 1968.

**FACING PAGE** Sunlight illuminates Schirra during the Apollo 7 mission in October 1968.

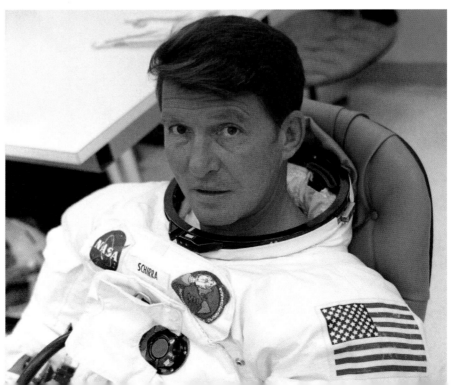

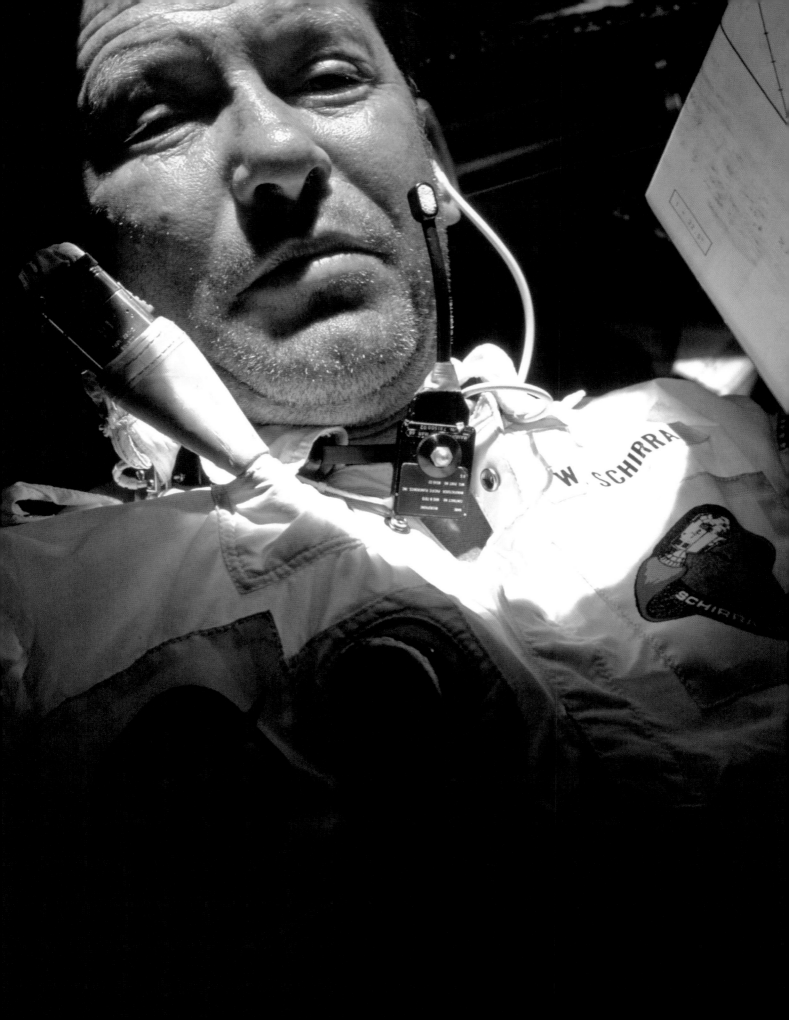

## Scott Carpenter, 1925–2013

As a long-time recreational scuba diver, Scott Carpenter was interested in underwater research, and NASA granted him a leave of absence to join the US Navy's SEALAB project. In 1964 he was scheduled to be part of the first SEALAB team off Bermuda, but he fractured his arm in a motorbike accident days before.

In 1965, however, Carpenter spent a record thirty days on the ocean floor off the coast of California aboard SEALAB II. He returned to NASA as executive assistant to the MSC director, then joined the Navy's Deep Submergence Systems Project for SEALAB III in 1967.

After two surgeries failed to restore mobility in his arm from the 1964 accident, Carpenter was ruled ineligible for spaceflight.

He remained with NASA, developing underwater training techniques for spacewalking, but resigned in August 1967 and retired from the Navy as a commander in 1969.

Carpenter then founded a corporation focused on better utilizing ocean resources. He became a consultant to sport and diving manufacturers and to the motion picture industry on space flight and oceanography. Carpenter died from cancer on October 10, 2013, at age 88.

*Left to right:* Glenn, Carpenter, and Slayton with other astronauts during jungle survival training at Albrook AFS in Panama during the first week of June, 1963.

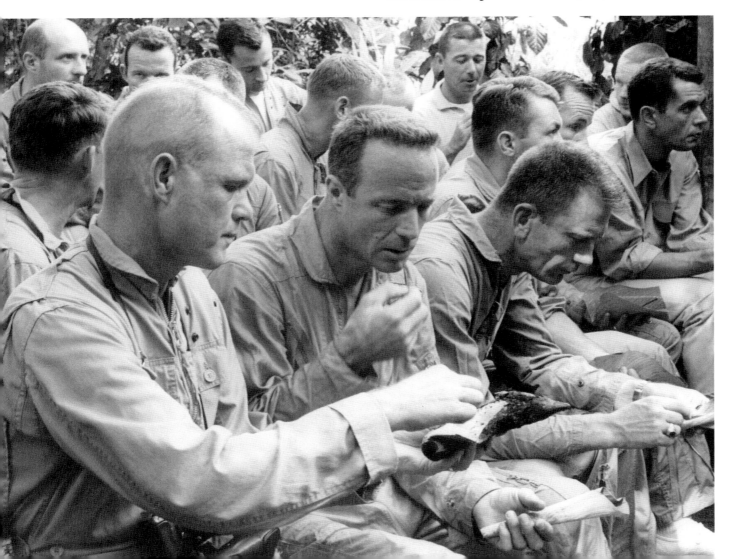

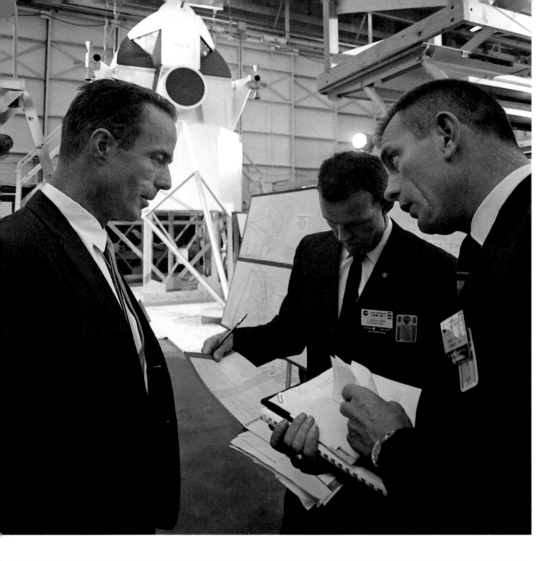

Carpenter (*left*) with Cooper and Slayton at Grumman Aircraft in Bethpage, New York, on September 17, 1963, during lunar excursion module development meetings.

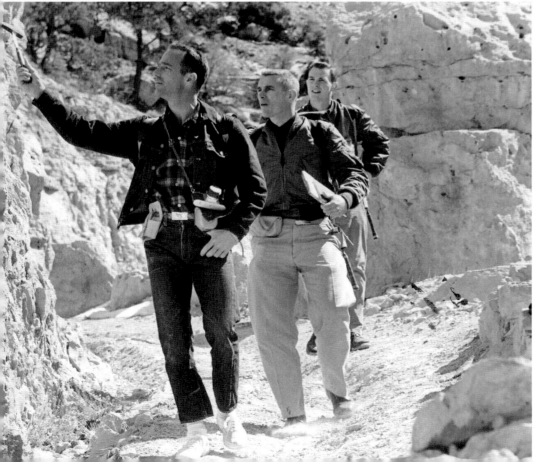

Carpenter (*left*) wields a rock hammer with astronauts Gene Cernan and David Scott during geology training at Grand Canyon National Park in Arizona on March 5, 1964.

**THIS PAGE** Carpenter (*right*) relaxes aboard SEALAB II in 1965. SEALAB II coincided with Cooper's Gemini V mission, and the two held the first conversation between a spacecraft and a habitat on the ocean floor.

**FACING PAGE** Carpenter (*center*) floats near a mock-up of an Apollo command module (*top*) docked to a lunar excursion module (*bottom*) in the Weightless Environment Training Facility pool at MSC in November 1967.

## John Glenn, 1921–2016

At age 42, John Glenn was the oldest astronaut when Project Mercury ended, with Apollo moon missions still six years away. Attorney general Robert Kennedy suggested he should run for the US Senate from Ohio in 1964. Glenn agreed and resigned from NASA that January. But a month later, he fell against a bathtub, suffered a concussion, and withdrew from the race. He retired as a colonel in the Marines in 1965 and joined Royal Crown Cola as an executive and later a board member.

Glenn lost the 1970 Democratic primary for a Senate seat but won in 1974. He sought the presidency in 1984 but failed to catch traction in the Democratic primaries. He was reelected to the Senate, however, for three more terms.

Glenn's Senate career focused on defense, nuclear nonproliferation, and foreign policy. In 1995 he began to lobby NASA to consider adding him to a space shuttle crew to gather data on geriatric medical research, and in 1998 the agency announced he would be included on the STS-95 mission the following year.

Glenn returned to space on October 29, 1998, as a payload specialist on the eight-day flight aboard space shuttle *Discovery*, making him the oldest space traveler at the time at age 77.

Glenn retired from the Senate in January 1999 and he died on December 8, 2016, at age 95, the last surviving member of the Mercury Seven.

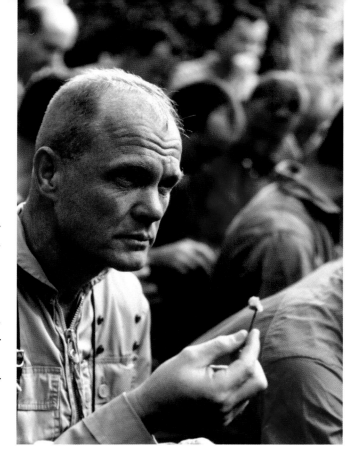

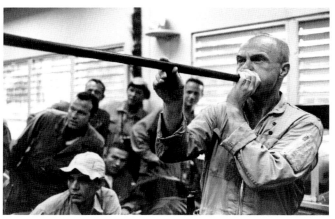

**TOP AND MIDDLE IMAGES** Glenn during jungle survival training at Albrook AFS in Panama during the first week of June 1963. He would resign within seven months to run for the US Senate.

**BOTTOM** *Left to right:* MSC director Robert Gilruth, Glenn, and James Elms, director of NASA's Electronics Research Center, visit in Mission Control after the Apollo 11 splashdown on July 24, 1969. Glenn was an executive for Royal Crown Cola at the time.

Glenn wears his orange pressure suit for the STS-95 terminal countdown demonstration test at KSC on October 9, 1998.

Glenn enjoys his nearly ten-day stay aboard space shuttle *Discovery* during the STS-95 mission, the last flight of the last surviving Mercury astronaut.

# Abbreviations

| | |
|---|---|
| **AFB** | Air Force base |
| **AFS** | Air Force station |
| **ASTP** | Apollo–Soyuz Test Project |
| **EST** | Eastern Standard Time |
| **KSC** | Kennedy Space Center |
| **LC** | launch complex |
| **LOD** | Launch Operations Directorate |
| **LOX** | liquid oxygen |
| **MA** | Mercury-Atlas |
| **MCC** | Mercury Control Center |
| **MR** | Mercury-Redstone |
| **MSC** | Manned Spacecraft Center |
| **MST** | Mountain Standard Time |
| **NACA** | National Advisory Committee for Aeronautics |
| **NASA** | National Aeronautics and Space Administration |
| **STG** | Space Task Group |
| **USAF** | United States Air Force |

# Bibliography

Burgess, Colin. *The Epic Orbital Flight of John H. Glenn, Jr.* Chichester, UK: Springer-Praxis Books, 2015.

Carpenter, Scott, Gordon Cooper, John Glenn, Virgil Grissom, Walter Schirra, Alan Shepard, and Donald Slayton. *We Seven.* New York: Simon & Schuster, 1962.

Graybiel, Ashton. "Aerospace Medicine in Project Mercury—Navy Participation." *Aerospace Medicine* 33, no. 10 (1962): 1193–98.

Grimwood, James M. *Project Mercury: A Chronology.* Washington, DC: Office of Scientific and Technical Information, National Aeronautics and Space Administration, 1963.

Historic American Buildings Survey, et al. *Cape Canaveral Air Force Station, Industrial Area, Hangar S.* HABS FL-583-D. November 24, 2014. Retrieved from the Library of Congress, www.loc.gov/item/fl0803/.

Jenkins, Dennis R. *Dressing for Altitude: U.S. Aviation Pressure Suits—Wiley Post to Space Shuttle.* NASA SP-2011-595. Washington, DC: National Aeronautics and Space Administration, 2012.

Kovachevich, Steven. *Project Mercury and Badges of the Mercury Era.* Self-published, USA, 2011.

Kozlowski, Lillian D. *US Space Gear: Outfitting the Astronaut.* Smithsonian Institution Press, 1994.

Link, Mae Mills. *Space Medicine in Project Mercury.* NASA SP-4003. Washington, DC: National Aeronautics and Space Administration, 1963.

McBarron, James, II. *U.S. Spacesuit Development and Qualification for Project Mercury.* NASA JSC U.S. Spacesuit Knowledge Capture Series. PowerPoint presentation, November 6, 2012.

McDonnell Aircraft Corporation. *Project Mercury Familiarization Manual.* St. Louis: McDonnell Aircraft, 1959.

NASA. *Mercury Project Summary Including Results of the Fourth Manned Orbital Flight May 15 and 16, 1963.* NASA SP-45. Washington, DC: Office of Scientific and Technical Information, National Aeronautics and Space Administration, Manned Spacecraft Center, October 1962.

NASA. *The Mercury-Redstone Project.* Huntsville, AL: Saturn/Apollo Systems Office, George C. Marshall Space Flight Center, National Aeronautics and Space Administration, December 1964.

NASA. *Results of the First United States Manned Orbital Space Flight February 20, 1962.* NASA SP-6. Washington, DC: National Aeronautics and Space Administration, Manned Spacecraft Center, 1962.

NASA. *Results of the First U.S. Manned Suborbital Space Flight.* Washington, DC: National Aeronautics and Space Administration in cooperation with National Institutes of Health and National Academy of Sciences, 1961.

NASA. *Results of the Second United States Manned Orbital Space Flight May 24, 1962.* Washington, DC: National Aeronautics and Space Administration, Manned Spacecraft Center, 1962.

NASA. *Results of the Second U.S. Manned Suborbital Space Flight July 21, 1961.* Washington, DC: National Aeronautics and Space Administration, Manned Spacecraft Center, 1961.

NASA. *Results of the Third U.S. Manned Orbital Space Flight, October 3, 1962.* Washington, DC: National Aeronautics and Space Administration, Manned Spacecraft Center, Project Mercury, 1962.

Purser, Paul E., Maxime B. Faget, and Norman F. Smith. *Manned Spacecraft: Engineering Design and Operation.* New York: Fairchild Publications, 1964.

Swenson, Loyd S., Jr., James M. Grimwood, and Charles C. Alexander. *This New Ocean: A History of Project Mercury.* SP-4201. Washington, DC: National Aeronautics and Space Administration, 1966.

Wilson, Charles L., ed. *Project Mercury Candidate Evaluation Program.* Aerospace Medical Laboratory, Wright Air Development Center, December 1959.

# About Bill Taub

William "Bill" Taub, my father, was born on April 21, 1923, in Lorain, Ohio. His older brother, Fred, had been hired at the National Advisory Committee for Aeronautics' Langley Research Center in Hampton, Virginia, as an aircraft model builder. My father and his twin brother, Will, began working at Langley on January 3, 1942. My father's title was aircraft model maker; however, his job was actually pictorial draftsman. Both twins were self-taught amateur photographers, and through their research and tenacity they devised a new chemical developer mix to increase film exposure speed that led to a long-sought photograph of a spark inside an engine cylinder.

That photo my father took with his own Leica camera captured the image that had eluded the thirty or so NACA photographers. This outstanding feat caught the attention of his boss and others, and my father was eventually named chief photographer at Langley, where he became known for his artistic wind tunnel photography.

When the Space Task Group was formed at Langley in 1958, and subsequently folded into NASA, he continued in that role and was based at agency headquarters in Washington, DC. In 1962 he was named the agency's official senior photographer.

My father captured the crowning aeronautics and space flight achievements, photographing the missions that sent the first Americans into orbit and on to the moon. Though he was rarely credited by name, he took many of the most recognized photos of those who led the nation's early forays into space, which played a pivotal role in shaping public perception of NASA's work.

His photos have been featured in major magazines, publications, and newspapers around the world and have won many prestigious awards. He was often the only photographer granted behind-the-scenes access to engineering meetings and the astronauts' training, preparations, and recovery. His work documented the humanity of those who orchestrated the space program's first-ever feats, as well as the new technology developed for and from these efforts. Having earned the trust and respect of the astronauts and everyone involved, he was not only part of the team but also part of the NASA family.

In sum, he was the right man with the right skills at the right time and place. This dedication earned him the nickname "Two More Taub" for always insisting on taking just a couple more shots. He would often work long hours on his own time with his own equipment to ensure the perfect image was captured. In his NASA oral history, my father said, "But you've got to remember I was an artist, and more than that, and I loved to take pictures, so I was looking to take pictures that were different, you know, to have a sense of the artistry to them."

He remained with NASA through the Gemini and Apollo programs, retiring in 1975 after the final Apollo mission, the joint US–Soviet Apollo–Soyuz Test Project. He passed away in 2010 in Bowie, Maryland, at age 86.

Since my father was always aware that he was often history's sole record-keeper, he dutifully saved a multitude

of images from his career, many of which have never before been seen by the public. It is my goal not only to preserve his collection but also to share and celebrate these historic images with the world. I am therefore very honored and proud to be working with J. L. Pickering and John Bisney, space flight historians and award-winning authors, on our first book featuring many of my father's favorite images from the Mercury era. Thank you for your interest in his work and for helping to preserve and celebrate these historic moments.

**Myra Taub Specht**
Bowie, Maryland

# About the Authors

Photo historian and author J. L. Pickering has conducted photo research into the US manned space program for nearly fifty years—acquiring, organizing, and restoring more than 250,000 prints, slides, transparencies, and digital files, the largest such private archive. His sources include US government archives, NASA retirees, news photographers, private collectors, and auction houses. One of the world's leading manned space photography experts, Pickering is regularly contacted by authors, retired astronauts, and even NASA for photo assistance.

Journalist John Bisney is a retired network news correspondent who reported on the US space program for more than thirty years for CNN, RKO Radio, the Discovery Science Channel, and SiriusXM Satellite Radio.

He covered more than sixty-five space shuttle launches and was one of the few broadcasters who witnessed the *Challenger* disaster. His early interest in space grew when his family moved to Florida in 1964 and he saw his first rocket launch from Cape Canaveral in 1966. He attended the launches of Apollo 11–13 and covered the Apollo 16–17, Skylab 1–4, and Apollo–Soyuz Test Project liftoffs. Bisney is an associate member of the American Institute of Aeronautics and Astronautics and holds a bachelor of journalism and a master of arts from the Missouri School of Journalism. With Pickering he has coauthored five previous space photo history books. After a career based in Washington, DC, he now lives in Seminole, Florida.